# Leonardo

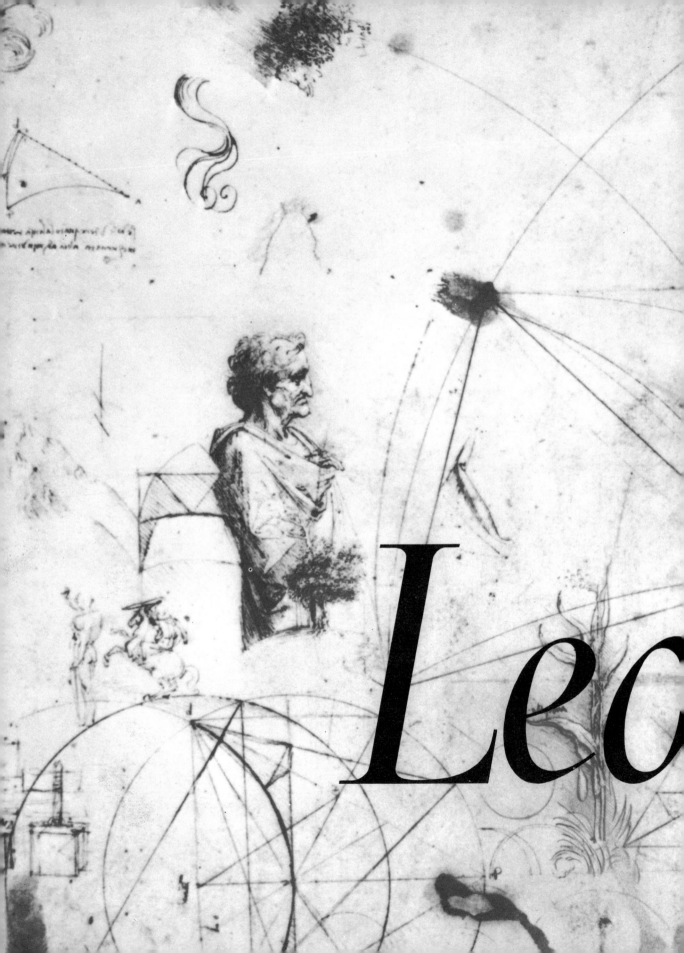

Ritchie Calder

nardo

& the Age of the Eye

Simon and Schuster: New York

Copyright © Ritchie Calder 1970

Published in the United States by Simon and Schuster
Rockefeller Center, 630 Fifth Avenue
New York, New York 10020

First U.S. printing

SBN 671–20713–X
Library of Congress Catalog Card Number: 71–124472

This book was designed and produced by
George Rainbird Ltd. Marble Arch House,
44 Edgware Road, London W.2.

House Editors: Tony Birks, Margaret Crawford
Designer: Michael Mendelsohn

Filmset in Monophoto Ehrhardt 12 on 14 pt
by Westerham Press Ltd,
Westerham, Kent.
Printed and bound by Amilcare Pizzi, Milan.

*for HERSELF*

# *Acknowledgments*

In acknowledging all those authors, dead and alive, who have gleaned the broad acres of Leonardo's talents, I think I may have found a few ears they overlooked in the stubble. Without their scholarship, however, I should not have got my insights.

Especially I want to cite Elisabeth Palmer for services beyond the call of duty as a daughter-in-law and for the verve, as well as qualifications, she brought to our search for materials and to our sorties in Italy. And I thank Elizabeth Mann Borgese for providing our base in *Via Thomas Mann*, Forte dei Marmi.

Among the many authorities I consulted directly, I owe much to Luigi Boldetti, the reconstructor of Leonardo's machines, who, in a waiting-room in Milan, gave me clues for which I had been looking, and which I was able to pursue.

I want to pay tribute to Miss Hilda Laing and her staff at Durning Library, my 'local' in Lambeth, who endured an importunate ratepayer and managed to get, through the remarkable British library system, obscure books from unlikely places.

In compiling and completing the book, in checking, and in finding the illustrations I am deeply beholden to Tony Birks and Margaret Crawford.

Amongst many people who have kindly given advice and help are Madame Marianne Dumartheray, Paris; M. Lecote, Amboise; Mr Walter Shepherd, London; Mr E. Gaskell, Librarian of The Wellcome Institute, London; and Miss A. H. Scott Eliott and Miss Jennifer Sherwood of the Royal Library, Windsor.

# Contents

# List of Color Illustrations

8

9

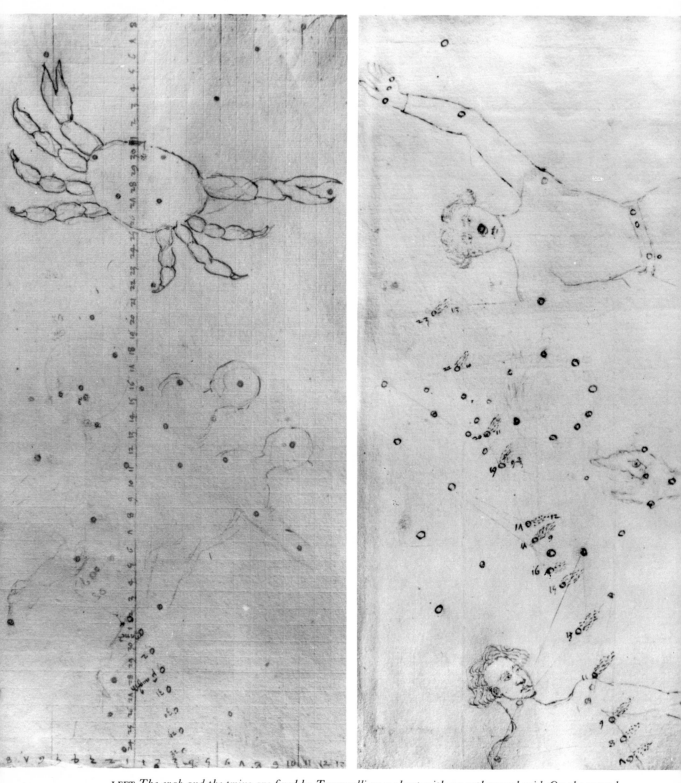

LEFT *The crab and the twins are fixed by Toscanelli on a chart with an orthogonal grid. On the second chart,* RIGHT, *he plots the comet as it passes Serpens Caput in July 1456.*

CHAPTER ONE

# Child of the Comet

The celestial apparition was big and terrible. Its head was round
and as large as the eye of an ox, and from it issued a tail fan-shaped
like that of a peacock. Its tail was prodigious, for it trailed through
a third of the firmament.[A]

In the year of the great comet, 1456, Maestro Paolo, in his house by the Ponte
Vecchio, passed the nights of June and July turning his hour glass, and measuring,
with instruments like the astrolabe and quadrant, the sweep of the flaming star as it
brushed the constellations of the Florentine night.

While the superstitious saw the passing of the comet as a harbinger of calamity,
Paolo dal Pozzo Toscanelli was methodically plotting its orbit on an astrologer's
chart, on which the constellations were drawn as men and creatures. To this chart
he also added an orthogonal grid, sub-divided in squares, and marked the longi-
tudes on its horizontal side, and the northern and southern latitudes on its vertical
sides. This grid was to be more important than the comet.

In the year of the great comet, in a hill-top farmhouse near Vinci about twenty
miles west of Florence, Leonardo, *figlio di Piero non legiptimo* according to his
grandfather's income tax return for 1457, was a sturdy four-year-old. A hundred
and sixty miles to the north in Genoa, the son of a weaver was also in his fourth
year; his name was Christopher Columbus. And in Florence there was a boy of five
called Amerigo Vespucci, also the son of a notary. Their destinies were to be
curiously linked through Maestro Paolo. He was to open Leonardo's eyes to the
heavens, and he was, by applying his orthogonal grid to terrestrial navigation and
by sorting out travellers' tales, to chart mathematically the westward route to India.
This information was to help Columbus discover that New World to which Ves-
pucci was to give his name—America.

The Turks had captured Constantinople in 1453, and were besieging Belgrade.
The new Pope, Calixtus III, had ordered special prayers to be said for deliverance
from 'the devil, the Turk and the comet', and had fixed on 1 March 1456 as the
date for the next crusade. Refugee scholars from Byzantine Greece were beginning
to seek sanctuary in Florence. The Gutenberg Bible had been printed, and a new

[A]References marked by superior letters in the text, and references to Leonardo's own writings marked by
superior numbers, are given at the end of the text, starting on page 279.

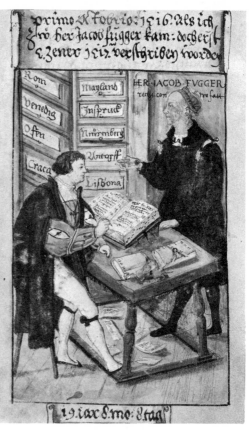

*A servant carved in stone watches from a 'window' in Jacques Coeur's palace at Bourges* ABOVE LEFT. *The merchant's ornate palace was begun in 1443, but confiscated by the King of France in 1451 before it was finished. A century later the Fuggers were the merchants with the greatest power and influence in Europe.* ABOVE RIGHT *Jacob Fugger 'the rich' dictates to a clerk and his files show trading links with Venice, Lisbon, Innsbruck.*

age of communications was being ushered in. Before the end of the century printing presses with movable type were to be set up in every European country. The broadsheet was not yet in the hands of the poor, but books were multiplying for the increasing number of students who, better informed than their teachers, were becoming restless and were demanding a greater say in how and what they were taught. The peripatetic scholars, wandering from country to country seeking out the best masters, were creating a student freemasonry.

The world was shrinking as East and West trafficked together and borrowed ideas. Movement was becoming faster and easier. Gunpowder was being used to blast roads through the Alpine passes. The post was being established with relays of couriers picking up fresh horses *en route*. This was an innovation in the West, although Marco Polo and others visiting the orient had been impressed by Timur's messengers who horse-posted along the roads of the Mongol Empire to Samarkand.

Jacques Coeur borrowed the Levantine idea of aerial post pigeons to keep in touch with his numerous agents in his Mediterranean trading empire. He was so successful that he provoked the avarice and envy of the King of France, who contrived his downfall but found his carrier pigeons useful. In Portugal, speed had been given to sea travel by the development of the caravel, lateen-rigged, with a capacity for sailing to the windward and for running fast before the wind.

In the 1450s the leading powers of Italy established a network of resident ambassadors, whose chief function was to act as news-reporters, passing on not the mere formalities of diplomatic exchanges but daily accounts of happenings. Ambassadors competed like modern foreign correspondents in the speed and frequency of their dispatches. And their courts became more and more demanding. When Ferdinand of Castile-Aragon ordered that he receive daily messages from his embassy in London, his ambassador pointed out that it would mean sixty couriers constantly on the roads.

In the year of the great comet, kings and courts were not alone in wanting international intelligence. Speed of communications was essential to the growing power

*The spectre of Death is a recurring theme in medieval Europe, fearful of the Black Death. Here death figures invade the heart of contemporary technology to carry off printers and a bookseller. This woodcut from Lyons is the earliest picture of a printing works, 1499.*

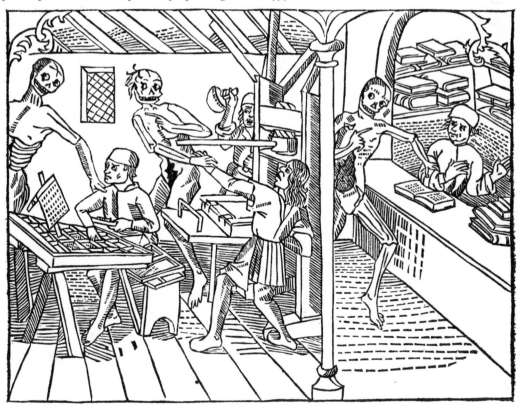

of the great merchant houses who were becoming far more than traders shipping goods hither and yon in a world which was at once shrinking, through faster means of travel, and expanding by the discovery of new lands, through expeditions like those master-minded by Prince Henry the Navigator, of Portugal, along the west coast of Africa. The merchants had become bankers trading in money which was no longer just a token of exchange values, but itself a commodity to be bought and sold. Nor were these financial houses just lending money; they had begun to invest it in a system of industrial capitalism. The Hundred Years War, nominally over in 1420 but dragging on for another twenty years, had put kingdoms into pawn with the money-lenders. The Black Death had killed perhaps one third of the population of Europe, and plague was still endemic. Towns and villages had died. Farming had collapsed into a wilderness of neglect in many lands. The labour force for the mines and the craft workshops had dwindled. Muscle power and finger skills were at a premium. While labour had been abundant and hands had produced enough for home consumption and a surplus for trade, machines had been incidental. Now they had become imperative, and machines had to be paid for before they could earn their keep. So they needed capital and the industrial financiers emerged to back inventions and the making of equipment.

By the year of the great comet, the Fuggers of Augsburg, the Rothschilds of the fifteenth century, had fissioned as a family into two branches, the Fuggers of the Deer *(vom Reh)* and the Fuggers of the Lily *(von der Lilie)*, which were to divide Europe between them; to dominate popes and princes; put the orders of chivalry into fief; obtain mining concessions by foreclosing royal mortgages, and industrialize the mines; buy their way into the commercial empire of the Doges, weakened by the rise of the Ottoman power in the Near and Middle East, and by the plagues brought in by ships despite quarantine laws; and establish a network of trading posts, more influential than embassies, from the Mediterranean to the Baltic, from Cracow to Antwerp and to Lisbon and Seville. Later they were even to establish their own news service, the *Fuggerzeitungen* (Fugger Newsletters), for their own and their privileged clients' purposes.

This positive intervention by merchant bankers in industrial development was a factor of profound political, economic and cultural significance, which is under-estimated when we talk of something called 'Renaissance', and romanticize it merely as the flowering of scholarship and art. It was a period of radical change, not just in thinking but in practice. For example, the bankers financed the mechaniza-tion of the mines of Eastern Europe, to replace the shortage of miners. Mechanical methods of extracting ores from the ground were beginning to be developed, and were systematized in books such as Agricola's *De Re Metallica*, published in 1530. But just as important was the plant-processing of the ores, for this required a new technology, not just a craft-acquired instinct. The Fuggers developed a fifteenth-century Ruhr at Fuggerau in Carinthia and at Hohenkirchen in Thuringia, and for

*An engraving from* De Re Metallica *by Georg Agricola shows a piston pump for extracting water from mines. Crankshafts and connecting rods lie alongside. Agricola, a physician, worked in Joachimsthal, and his book became the standard work on mining for over 200 years.*

their new methods they set up technical colleges to train a new type of artisan. The mechanization, though primitive, of the silver and copper mines of Joachimsthal in Bohemia set the bankers' sign on our present times. The name of the coin which was minted from these mines, the *thaler*, is now familiar as the dollar. (Incidentally, the origins of the atomic age can be traced to Joachimsthal, because these mines produced the pitchblende from which Marie Curie extracted radium, which set us on the path to chain-reaction, and Hiroshima.) The displaced persons from the Middle East brought with them the well-established practices of the Arabs, and what was more important perhaps, the contributions of the well-advanced technologies of China and India. At the same time scope was offered and backing provided for indigenous inventors. Bankers were financing the potential of water-power, long neglected in the West. They encouraged the development of water-wheels for their relevance to factory production.

In the year of the great comet, in Leonardo's Italy, the banker had acquired a similar if more flamboyant role. We think of Venice as the trading metropolis of a commercial empire, and associate Milan with the Lombards, to whom the City of

London nominally admits its banking ancestry. The real financial giants, however, were the Florentines, to whom we owe the word florin.

In the twilight of the feudal era, the Florentines of the Arno Valley established a new social system called the Commune, whose head the *Podestà* was chosen by the people. This development was connected with the economic revival in Italy, of which the Florentines were pre-eminently the makers, and it challenged the feudal arrangement of the powerful families, 'the men of the towers', who had gained their wealth from the serfs of the soil. It is glib but convenient to say that the feudal age was ended by the introduction of gunpowder and the cannon. But as far as Florence was concerned, the day of the feudal lords was over by the year 1250, when the city adopted the constitution of *Il Primo Popolo* (the First Democracy), and established a people's militia led by the *capitano del popolo*.

In theory the Commune was a society of equal opportunity. As Petrarch said, 'One is not born noble; one becomes noble.' But the situation in Florence corresponded more nearly with George Orwell's saying in *Animal Farm*, six hundred years after Petrarch, 'All animals are equal, but some animals are more equal than others'. In 1282 only members of the trade guilds were eligible for the chief magistracy, and the Ordinances of Justice of 1293 made a further attack on the old nobility, now designated 'the magnates', who came under financial and social, as well as political restrictions.

Popular government did not include the *popolo minuto*, the hired workers, but offered opportunities for a new social class, the Aristocracy of the Counter, which was equally opposed to both the nobles and the common people. This attempt at levelling did little to promote either internal or external peace, for the guilds themselves were divided in their outlooks and policies. The dominant crafts, the weavers and the bankers, were not averse to financing a war, or even precipitating one, if it was likely to open up foreign markets and facilitate trade. But the domestic crafts, those of the stonemason, the blacksmith, the innkeeper and so on, wanted only the peaceful conditions which favoured their trade.

All this was complicated further by the factional strife between the Guelfs and the Ghibellines begun in 1215 when a young nobleman Buondelmonti jilted a girl of the Amidei family, and was subsequently assassinated. Florence was split by this affair, and one group appealed to the Pope and the other to the Holy Roman Emperor. To say that the Guelfs were for the Holy See and Ghibellines for the Holy Roman Emperor, is to over-simplify the situation—like trying to define the Democratic and Republican parties in twentieth-century America. The Florentines declared themselves Guelf or Ghibelline, but it had little to do with real attitudes to the Pope or the Emperor. There were anti-clerical Guelfs and anti-imperial Ghibellines. The referential loyalties were invoked as pretexts by powerful citizens trying to dislodge or destroy their rivals. In the People's Republic of Florence there were powerful lobbies, rigged elections, ward bosses who delivered

the 'popular' vote to the highest bidder, or to his nominee. The elections had all the tumult of modern American party conventions, with the citizens rallying to the banners of their candidates, and with rumbustious demonstrations in the streets infiltrated by bullies and braggadocios to foment trouble. The party bosses had their strong-arm men to impress the free men of Florence where their best interests lay. For foreign adventures against rivals like Milan or Pisa, the Florentines could afford to hire armies, buying their way out of patriotic draft by using the *condottieri*, whose professional job was to fight. But there was street violence to resolve civic political issues; the smear, to discredit opponents and drive them into exile; and the ultimate sanction of political assassination.

Although the commercial aristocracy controlled the offices of state, there was a constitutional redress for those excluded from office. This was the popular referendum, and it was to this expedient that Salvestro de' Medici, a wealthy Florentine merchant, had recourse. It led to the first plebeian insurrection, the revolt of the *Ciompi* ('Companions'), hired workers and small artisans, led by the wool carder Michele di Lando, who took over power from the displaced *signori* and established themselves in the Palazzo della Signoria. Di Lando established three new guilds, which included the *Ciompi*. The power of the Wool Weavers' Guild was broken and their records destroyed, and all the guilds placed on an equal footing. But finally di Lando himself, threatened by the violence he had helped to release, went over to the Establishment, and supported the suppression of his own followers.

The old oligarchy of the major guilds soon re-established its rule, first under Maso degli Albizzi and later under his son Rinaldo. The Medici family had started off as doctors, as the name implies, but had turned its attentions to banking. The head of the Medici of this period, Giovanni, had taken a back seat politically, and appeared to devote his time to building up the family fortune. His son Cosimo's early commercial successes, combined with his family's general popularity, roused the jealousy of his rivals, and Cosimo spent two years abroad in France and Germany, and discreetly retired to the family estates outside Florence. Rinaldo degli Albizzi was very anxious to get rid of his potential rival, and in 1433 Cosimo was called upon to appear before the *signori*, arrested and finally exiled for the next ten years to Padua. The charges were that he had plotted against the regime, and had helped to promote the now failing war against Lucca. Cosimo was well received in Padua, and used his exile to build up branches of his bank throughout North Italy. Within a year the entire situation had been reversed. Medici supporters had been able to promote upheavals in Florence, and upon the election of a pro-Medici *balìa* or magistracy, they gained the banishment of Rinaldo and the permanent exclusion of the Albizzi from public office. Cosimo's exile was cancelled and he returned quietly to Florence, declining all public office. He contrived as a private citizen to get rid of his financial rivals. This expulsion of bankers led to the proliferation of Florentine banks in Italy, France and elsewhere. Cosimo never assumed any title,

but by ensuring that the *balìa* was always packed with his supporters, and by providing bread and circuses for the populace, he controlled the oligarchy of Florence for the rest of his life. He used fiscal devices such as *decima scalata* (progressive taxation) to ruin all who stood in his way. To him a Pope was to say, 'You are the arbiter of peace, of war, of the laws. Of kingship you have everything but the name.' The dynasty he founded was to include two popes, many cardinals, dukes and grand dukes and two queens.

In the year of the great comet, Florence was once again securely in the hands of the commercial aristocracy, though in actual fact it was a one-man dictatorship. The Medici wealth was fantastic. In addition to financing wars, buying alliances and maintaining his power by expensive bribery, Cosimo spent vast sums on the arts and on public works. He encouraged architects, sculptors, painters and humanists (which in this sense applies to the revival of learning). Brunelleschi, Donatello, Michelozzo, Ghiberti, Luca della Robbia, Leone Battista Alberti, Fra'Angelico, Paolo Uccello, Poggio Bracciolini and Giannozzo Manetti all worked in Florence during his rule. Cosimo also sponsored the first public library in Florence, protected Marsilio Ficino's Platonic Academy and promoted the teaching of Greek.

In the year of the great comet, Girolamo Savonarola was three years old. He was being brought up by his grandfather Michele, a celebrated physician, in Ferrara. Michele was also a scholar of rigid moral and religious principles. These were to outcrop in his grandson—to make him both a worldly politician, the scourge of the Medici, and an unworldly churchman, the critic of the Pope. In 1498 he was to be burned as a heretic to the doctrines he was trying to restore.

Those doctrines of blind faith were already being undermined, not only by the fleshly excesses of princes-spiritual, but by the professed religiosity of the princes-pecuniary. From their counting houses, they not only exercised political power, they changed the character of the Church. Cosimo could underwrite the early Ecumenical Council of 1439, and arrange for the Council's proclamation of the reunion of the Greek and Catholic Churches to be staged in Santa Maria del Fiore, under Brunelleschi's new dome, one of the architectural wonders of the world.

As the impresario, sparing no expense, Cosimo ensured that it would be a super-colossal production. 'On the side where the Gospel was read were seated Eugenius IV in his pontifical robes, the Cardinals in their copes, and the Bishops wearing mitres of white damask; on the side where the Epistle was read, the Emperor of Constantinople, a handsome, bearded personage wearing a very rich doublet of damascened brocade, in the Greek manner, and a small pointed hat adorned with a splendid jewel; around him the Greek Bishops were arrayed in silken robes.'[B] The decor and the costumes were more impressive than the outcome, which was deferred by more than five centuries. It was a popular success, however, and consolidated Cosimo's political power amongst the gratified Florentines. On the same devotional pretext, he, like other princes-pecuniary, was playing Maecenas to the

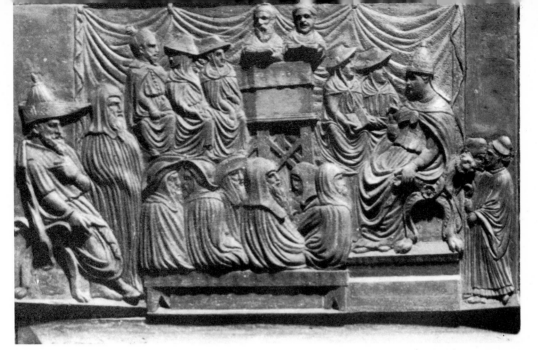

'Cardinals in their copes' seated at the Ecumenical Council of 1439, on the right the Pope, on the left the Emperor. Detail from a bronze door by Filarete at St Peter's, Rome.

church-builders, the artists and the sculptors, who were themselves becoming more concerned with perspective than with faith.

Under Cosimo's protection and endowment was the Platonic Academy embodying the humanism which, by enshrining Greek letters and philosophy with their insistence on individual and critical assessment, shifted the emphasis from religious to rational concern. Florence already had a university, based on compulsory education and supported by an annual subsidy of 2,500 florins from municipal funds. It had twenty Readers, half of whom lectured on law. Six taught Medicine, Surgery and Anatomy, and these beyond their poor stipends had the right to collect the corpses of malefactors. The most respected chairs were those of Logic, Philosophy and Rhetoric, concerned with the mental gymnastics of abstract reason. The boast of the university was that it 'brought the dead to life', meaning the resurrection of the dead languages. They renounced the Italian language of Dante and Boccaccio and encapsulated learning in Latin and Greek (so that Leonardo was to lament his ignorance of these languages and to try to teach himself Latin in middle age).

But the neo-Platonists, however stilted in their pedantry, were a subversive influence because they started a mood of free-thinking, began asking awkward questions and producing a panoramic, instead of blinkered, vision. Intelligent people started looking around and seeing things as they actually were and not as the scholiasts had insisted they should be. And, in a migratory world in which ideas as well as merchants travelled, they began to see virtues in other people and other religions. Even that Committee of Unchristian Activities, the Inquisition, could

not discourage free-ranging minds. Some were formulating questions as a result of extensive geographical travels; others were arriving at some of the same points through access to source-books, read with new insight; others were (as Leonardo was to do) assimilating what they heard from travellers in regions they had never seen with what they had read, synthesizing new theories and borrowing new practices. Thinkers, as geographically remote from each other as the English heretics and the Italian humanists, were independently reaching the same conclusions. Scepticism was asserting itself against dogmatism when people began to say that what can be traced to natural causes ought not to be ascribed to miracles; and science emerged, when the supernatural was challenged by an active search for natural causes.

In the year of the great comet, when Pope Calixtus III was trying to rouse Christendom to embark on a crusade against the Turks, having the Koran was like having a copy of Karl Marx in Senator Joseph McCarthy's America. Two remarkable clerics, however, were courageously studying it. Nicholas of Cusa, wandering in Germany, was exchanging views with John of Segovia, in Spain. The motivations of their researches were different, but equally commendable. While the victorious Turks were at the gates of Belgrade, just across the Adriatic from the nervous Pope, the Moorish rule in Spain, the relic of the Islamic conquests of the eighth century, was in final decline. Moslems and Jews were being compulsorily integrated. The Christian Inquisition had only one method of conversion—baptize or burn. John of Segovia, the ecclesiastical humanist, thought that this kind of conversion did not make much sense. He wanted to win converts by discussion and persuasion. Christianity, he insisted, must prevail by convincing argument. He had, with enormous trouble, obtained a reliable text of the Koran; he had it scrupulously translated from the Arabic, and had checked conflicting source-materials. His was a domestic problem, a concern for minority rights.

Nicholas of Cusa, on the other hand, was the medieval equivalent of a 'Kremlinologist'. With the threat of a Holy War, he wanted to know what was 'on the other side of the hill'. His object was to understand the ideology of Islam, and find points of agreement or of divergence. He, too, set about reassessing the Koran and examining Moslem source-books. We are bound to believe, he said 'that ignorance is the cause of error and evil'. As a Christian theologian he had no doubt that he could establish 'the truth of the Gospel out of the Koran'. While accepting the fact that in questioning Christ's divinity and resurrection, the Koran denied the true nature of Christ and the basis of the Catholic Church, he nevertheless contended that the Moslems admitted the testimony of the Old Testament prophets, accepted the Virgin birth and, while rejecting Christ as the Messiah, acknowledged him as a prophet and as a precursor of Mohammed. Nicholas was convinced that the Koran, with its imperfections, could be used to demonstrate the greater truths of Christianity. One can find in his fifteenth-century policy of conciliation the analogy for

20

RIGHT *Turkish flags fly on the fortresses south of Belgrade (centre, left). The military engineer Taccola drew this map of the state of affairs in Eastern Europe about 1455.*

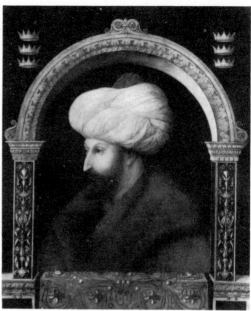

LEFT *Nicholas of Cusa, from his funerary monument in Rome.* RIGHT *A portrait by Gentile Bellini of Sultan Muhammed II who in 1453 besieged and conquered Constantinople.*

the present-day arguments about the corollaries of communism and capitalism and for a policy of peaceful co-existence.

Nicholas of Cusa wanted a 'Summit Conference' of Islam and Christendom to assemble in Jerusalem, the Holy City common to both. But he wanted, in preparation for it, a forgathering of merchants, with their matter-of-fact experience and their highly developed intelligence system, to provide first-hand objective information about Islam.

He might have succeeded. After Calixtus, whose crusade had proved a fiasco, the next Pope was Pius II, an old friend of Nicholas. He had travelled widely, with experience of Italy, Germany, Bohemia, Burgundy, England and Scotland, and it was he who first coined the word 'European'. As pontiff he became an arch-politician who, in order to gain (for other reasons) the support of Philip the Good, concurred in the idea of a fifteenth-century NATO, a Western Alliance against the East. Nicholas hurried to Rome to avert it, intending to propose his great conference instead but he died *en route*.

It was the year of the great comet, and the whole world saw it—not just the Tuscan boy, Leonardo, in the square-built farmhouse of Anchiano, but people everywhere. They saw it in Africa, but their forebodings did not include the slave-trade which would follow Henry the Navigator's caravels; in a distant hemisphere, still to be discovered by Columbus; in the frozen north, forgotten since the Vikings; and in the Cathay and Cippangu of Toscanelli's version of China and Japan.

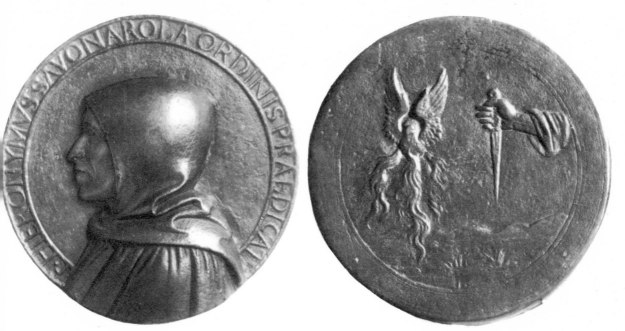

*Savonarola prophesied 'The sword of the Lord shall come upon the Earth soon and speedily'. This medal of 1492 bears Savonarola's portrait, and on the verso a sword threatening Florence.*

Helpless people everywhere saw it and cowered in their caves, their wattle-huts, their wigwams, their igloos, their hovels and their ghettos, and it made them afraid.

They were afraid, as the superstitious had been, every time it had appeared. It had been observed as far back as 240 B.C. It was seen in 1066, 1145, 1223, 1301, and 1378. It was to come again in 1531, 1607, 1682, 1758, 1835, and 1910. For the great comet of Leonardo's childhood was Halley's Comet, called after Edmund Halley who in the eighteenth century established its recurring appearance. It will be back in 1986. One does not have to be superstitious to recognize the great comet as a bracket-mark of history. One is being whimsical rather than mystical in suggesting that its tail has swept the doorsteps of epochs.

The second half of the fifteenth century was certainly such an epoch. In the trail of the comet, the world shrank as the speed of communications increased and the world expanded as unknown regions were discovered. It was an age of unfolding, not only spatially but also mentally. Plato had said 'Every soul possesses an organ, the intellect, better worth saving than a thousand eyes because it is our only means of seeing the truth.' St Augustine advised 'Go not out of doors. Return into yourself; in the inner man dwells truth.'[c] By such tenets, true enlightenment, the function of thought, was to be achieved. The eye, because it was subject to optical illusions, was the most distrusted of the senses. Seeing was *not* believing. Scholars were enjoined that the only sense to be relied on was the sense of touch. To accept anything one saw, one must confirm it by touch. Images could be seen in positions

where touchable objects did not exist. A reflection was not tangible, like the three-dimensional person it reflected, and therefore was a deceit of the eye. And, of course, it could be argued that the mind's eye in a dream was often sharper in detail, although the images were not 'real'. The dominating and dogmatic distrust of the sense of sight, and conversely the reliance on cerebral insight, was a philosophical error, which delayed for centuries scientific achievements that only required external recognition of self-evident facts.

Then like the aperture of the camera-lens, the eye opened. Sight became the paramount sense. Men saw things and saw their relevance. Some saw the raptures of nature in radiant colours. Some saw the elementary facts of nature with prosaic precision. Some saw the jigsaw pieces and how they could fit. Perceptual Man became Conceptual Man, putting apparently disparate things and ideas together. Inquisitive awareness became imaginative construction. In the common vision of the artist and the scientist, perception and conception were shared by the recorder and the inventor, the dreamer and the maker, the thinker and the doer.

If we follow convention and date the Renaissance from the fall of Constantinople and the brain-draining of its scholars, then it was not a 'rebirth' it was a 're-awakening'. It was not just a matter of giving the kiss of life to dead languages or reviving old archives or forgotten arts; it was the age of the eye.

The eyes of the child, who saw the crags of Monte Albano lit by the macabre glare of the comet, were to remain wide open and to see in the things around him revelations more wondrous than the comet. Leonardo was to become a man with talents so diversified, skills so versatile, inquisitiveness so unrestrained, and with a comprehension so all-embracing, that he has been called 'The Universal Genius'.

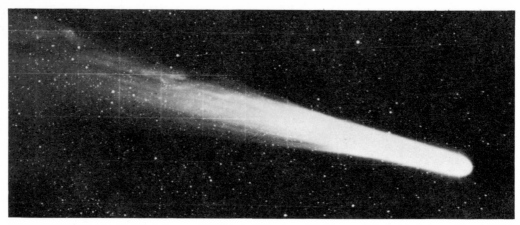

*The comet plotted by Toscanelli is now called Halley's Comet. This photograph of the comet, with an orthogonal grid, was taken at the Union Observatory, Johannesburg in 1910.*

24        *The first globe of the Earth was commissioned by the burghers of Nuremberg in 1490. It was made by Martin Behaim before Columbus' voyage.*
*OVERLEAF The elliptical Genoese map of 1457 was source material for Toscanelli. It shows the Mediterranean sea in detail, but in Asia and Africa are strange animals and monsters.*

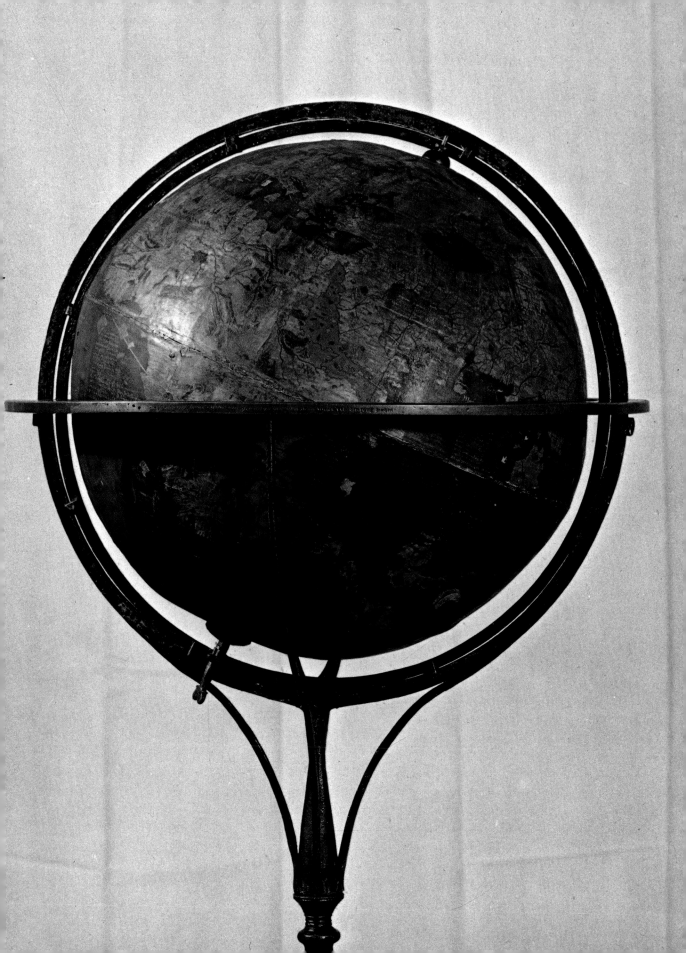

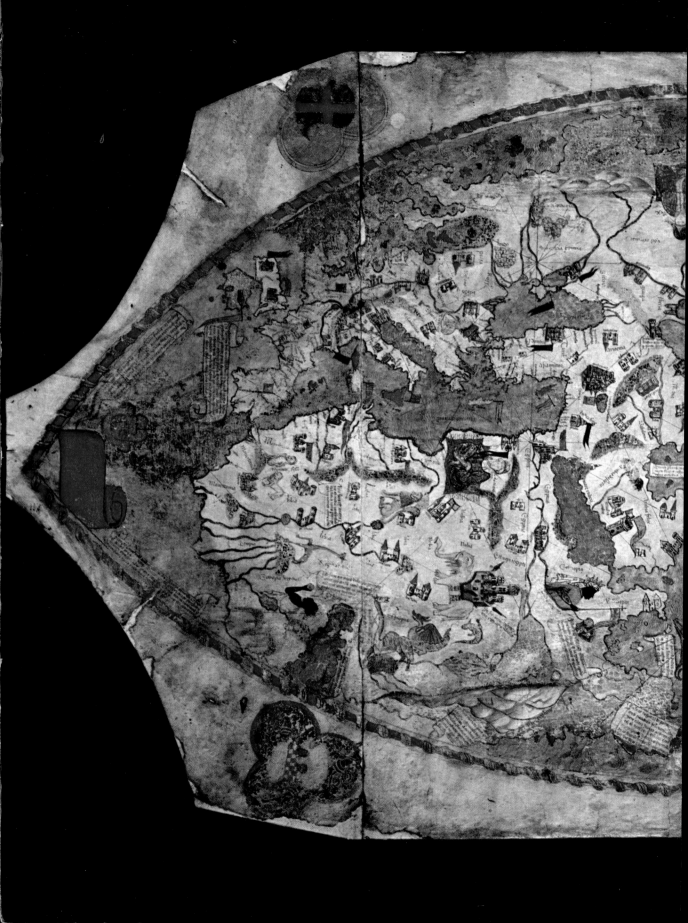

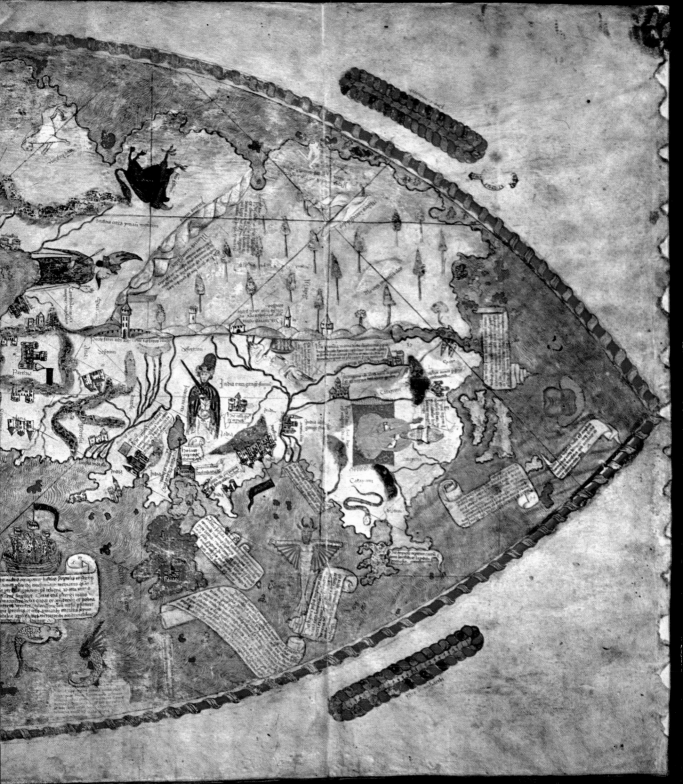

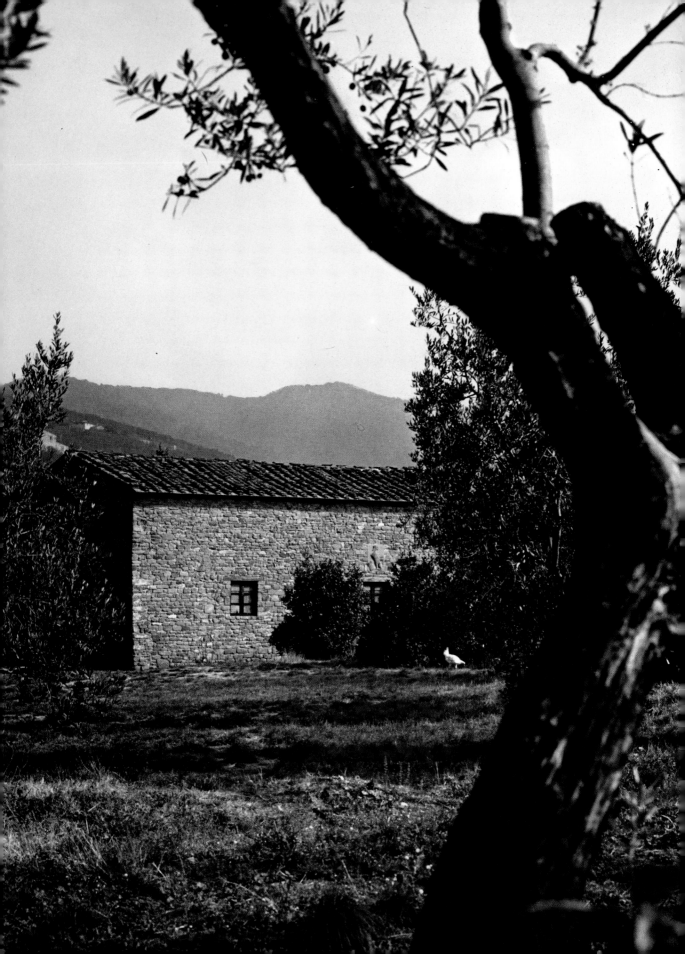

# The Opening of the Eyes

On Saturday at three o'clock at night on April 15 a grandson of
mine was born, son of my son Piero. He was named Lionardo . . .
                                        Antonio da Vinci, 1452.[A]

There was nothing in Leonardo's origins to account for his attributes. For genera-
tions on his father's side his ancestors had been notaries, the registrars and
interpreters of deeds and documents in property deals and trading transactions, as
well as farmers and winegrowers on the side. By the time he was born, they were
local gentry, with pretensions to a coat of arms and with a claim to be identified as
'of Vinci', the castle town on the slopes of Monte Albano. His mother, Caterina,
was 'of humble station', which only means that because she had no dowry she was
not acceptable in marriage among the squirearchy of Tuscany. In the sentimental
terms of one biographer she 'became the plaything' of the son of Antonio da Vinci,
which simply means that in a permissive age she begat a natural son.

The birth was recorded, notary-wise, by his grandfather Antonio. The names of
ten witnesses were listed, but not the name of the mother. Caterina did not count.
In the convention of the times, the offspring belonged to the father, and was openly
accepted by the paternal grandparents. Caterina herself presently married a local
man nicknamed *Accattabriga* (the brawler). Because there is only one reference in
Leonardo's writings which might refer to his mother's later death (he was not very
fulsome in his references to his father either) scholars and biographers alike have
built up a picture of Leonardo, the deprived child, snatched from his mother's
nipple and prevented from ever seeing her again. There is, indeed, an historical
quibble as to whether he was actually born in Vinci itself (presumably in the home
of his unwed mother), or in the paternal home at Anchiano, on the western slopes
of Monte Albano (to which the signposts now direct the traveller). One is at liberty
to imagine the patriarchal Antonio descending upon the unfortunate mother,
claiming and carrying-off the flesh of his flesh and the bone of his bone; or alterna-
tively driving the cast-off wench out of the farmhouse. Either way, the infant
Leonardo is supposed to be developing complexes.

*Leonardo's childhood home, and probably his birthplace, at Anchiano near Vinci,
with the Monte Albano hills behind.*

*'On Saturday at three o'clock in the night on April 15 a grandson of mine was born, son of my son Piero. He was named Lionardo.' Leonardo's birth was noted by his grandfather in 1452.*

The only reference which Leonardo makes to his childhood is that overworked note, written over thirty years later regarding the birds he was then studying: 'Writing about the kite seems to be my destiny since among the first recollections of my infancy it seemed to me that as I was in my cradle a kite came to me and opened my mouth with its tail and struck me several times with its tail inside my lips.'[1]

*Par che sia mio destino.* How many destinies have been concocted for Leonardo from that single sentence? It is like taking the paring of a child's toenail and deducing his manhood from it. The most presumptuous (in the sense of presuming most) reconstruction was that of Sigmund Freud who, 450 years later, did a complete psycho-sexual analysis of Leonardo, explaining his personality, his attributes, his deviations, his pictures—all from the psychiatric couch of a single sentence. To Freud the bird was all important—it disclosed a mother fixation, and accounted for Leonardo's homosexuality. The trouble was that in the German version of Leonardo's notebooks from which Freud was working, *nibbio* had been mistranslated as 'vulture', instead of 'kite'. It is interesting (as he points out) that in Egyptian hieroglyphs, the words 'vulture' and 'mother' were both represented by the figure of a vulture for phonetic reasons, since both were pronounced *mut*. Lord Clark says that Freud's conclusions 'have been rejected with horror by the majority of Leonardo scholars'.[B] 'Horror' attaches too much importance to an absurdity.

Whether it swooped on his cradle or not, the kite was of great significance in Leonardo's life. When he progressed from the observation of birds to studying the aerodynamics of flight, the kite was important. He noted that its deeply forked tail served as a powerful stabilizer, enabling it, while soaring on its wide wings, to keep

its course with movements that can scarcely be discerned by the observer. There is no Freudian dream quality in the following entry:

> The kite which descends to the east with a great slant with the wind in the north will have its movement bent to the south-east by this wind unless it lowers the right tip of its tail and bends its movement slightly to the north-east. This is proved thus: let $a\ b\ c\ d$ be the bird, moving to the east in the direction $n\ m$, and the north wind strikes it crosswise by the line $f\ n$, and would cause it to bend to the south-east if it were not that it has the right tip of the tail lowered to meet the wind, as it strikes it behind the centre of gravity over a longer space than existed in front of this centre of gravity, and so its straight movement is not deflected.[2]

From a non-Freudian point of view this might be seen as a description of a jet airliner and not as a tendency to homosexuality, and the unsophisticated might read no more into *par che sia mio destino* than 'I've been fascinated by kites ever since my cradle days'.

There is no real reason to assume that Leonardo was in any way a deprived child, robbed of maternal affection. In the year that Leonardo was born, his father Piero married Albiera di Giovanni Amadori, who was sixteen years of age. She had no children of her own, and died some twelve years later. Donald Peattie says that Piero 'bought his love child from its mother and took Leonardo as an acknowledged son'.[c] If there were such a transaction, the Vinci notaries made no record of it.

This was an age when bastards could be popes, and popes avowed their bastards, and when princely houses scarcely distinguished between legitimate and illegitimate children even in matters of succession, so Leonardo would probably have had no sense of stigma. It was a rural community with his mother living in the vicinity. Although there is no evidence it is fairly safe to say that she would suckle him—the peasant wet-nurse—so he would not be looking for the tail of a *mut*. Indeed, there is no evidence that she was not around the patriarchal homestead, until her marriage in 1457.

The grandparents were old. According to Antonina Vallentin, Ser Antonio was eighty-five and his wife seventy-four when Leonardo came into the family. That means that the grandmother must have been fifty-one, according to Vallentin, when she gave birth to Leonardo's father. Though this is unlikely, it is unimportant; incidental ages in the Leonardo story are all questionable. But Albiera the stepmother was young, childless herself, and quite probably attached to the boy. Freud, in what Lord Clark describes as a 'beautiful and profound' interpretation of the painting *The Virgin and St Anne*, now in the Louvre, concluded that Leonardo spent the first years with his mother but that Piero brought the boy to solace his childless wife, and that Leonardo therefore had two mothers. 'And', to quote Clark, again agreeing with Freud, 'it is the unconscious memory of these two beloved beings, intertwined as if in a dream, which led him to dwell with such tenderness on the subject of the Virgin and St Anne.'[D] Certainly, looking at the picture which was painted when Leonardo was over fifty, one knows that he had

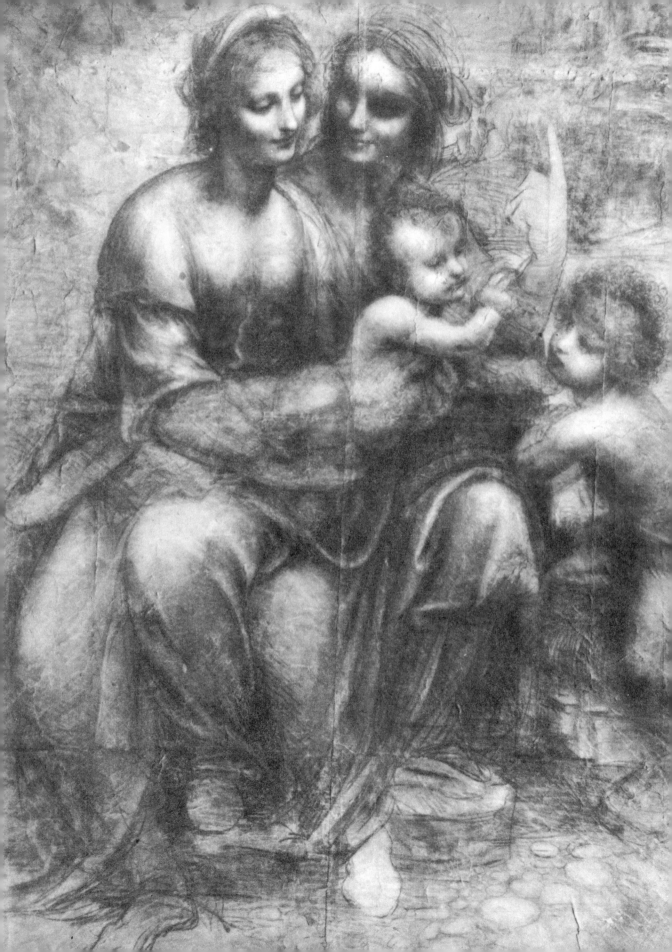

known the love and compassion of women and, assuming it represented Caterina and Albiera, one cannot distinguish who is the more fond of the child.

In such a situation he was more likely to be spoiled than neglected. We can safely assume—from the striking man he became—that he was a handsome and attractive child and, from the enduring impressions that Monte Albano and the Tuscan Hills made upon him, a venturesome one. Beyond that, the accounts of the solitary boy who 'neglected his school-books' and went off on premonitory forays into the hills to anticipate his later scientific interest in geology, water, the flight of birds and botany, are harmless fantasy: 'Leonardo! Rascal—come back here! The schoolmaster will beat you, you truant . . .'E or 'Scarring his hand as he groped, he felt his way between the dank walls (of the cave) . . .'F And this was true of much earlier biographers, whose narratives, according to the schoolmasterly strictures of MacCurdy, 'are as inadequate to reveal his work and personality as the fables of Vulcan's forge and the like are unsatisfying as an origin for Etna's fire.'G

The one substantial link with his childhood is the house at Anchiano about two kilometres from the town of Vinci. Externally it is much as it was in 1452. An attempt to restore the interior was abandoned in the quincentenary year, because it had been altered so frequently in the intervening time as to remove all authentic evidence. So what we have on the western slopes of Monte Albano is a solid stone, square-built house consisting of two parts—the stores for farm implements and farm-produce and the living quarters, which were commodious enough to house the grandparents, the father and mother and a layabout uncle, who figures as a liability in Ser Antonio's income tax returns. Outside is the farmyard with its threshing platform and nearby the site of the olive press. That is as much as we have to share with the fifteenth-century Leonardo, apart from the view, which is still (because the cultivation remains traditional) very much as it was in his time. The landscape is breathtaking—a vast panorama from the valley of Nievole to the lower valley of the Arno, including a stretch of the Pistoian Apennines, the hills around Lucca, and on the south side those around Siena.

The sweep of the valleys to the west gives a sense of distance which, to a child, must have seemed to reach to the other side of the world. The slopes were, then as now, clothed with vineyards and olive groves, with the green umbrella shapes of Tuscan pines, and with shrubs and flowers: enough to turn any artist into a botanist and any botanist into an artist. Behind is the Monte Albano range, of more sinister attraction, with the cliffs and crags and tumbling streams which suggest the background of the *Virgin of the Rocks,* or, in the violence of the thunderstorms which assault those parts, produce the horrendous effects of Leonardo's descriptions and drawings of the Deluge. Any impressionable child would respond to the sight, and a talented child would be forced into visual expression. An exceptionally inquisitive child would look hard and closely, and ask the questions which only later research would be able to answer. Leonardo was all of these children.

LEFT *The cartoon for* The Virgin and St Anne *by Leonardo, made in Florence* c. *1510.*

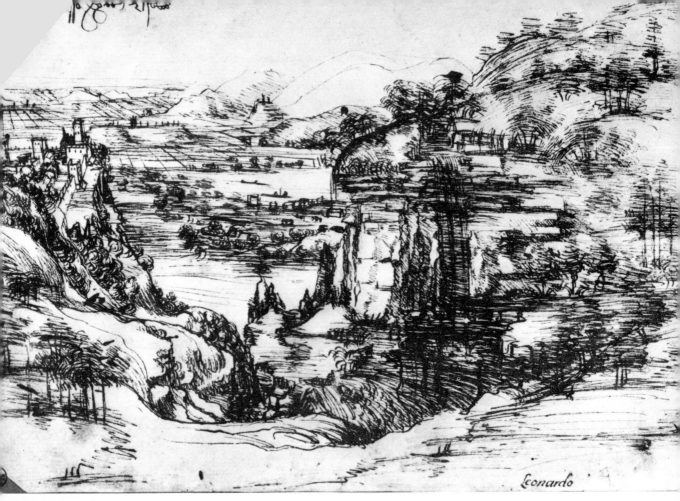

*The earliest known drawing by Leonardo shows the Arno valley and the landscape near Vinci. The sketch is inscribed and dated 5 August 1473, when Leonardo was twenty-one.*

Although we cannot find confirmation in contemporary records, there is no harm in imagining a hardy adventurous boy of inquiring mind, wandering off into that challenging countryside. There is little doubt that he was a mischievous imp, because in terms of mischief, he never grew up. All his life he indulged in japes and conjuring and practical jokes, and planned outrageous tricks to play on his friends. Ultimately he was given a salary for it as Master of Ceremonies at courtly festivals, devising mechanical monsters and automata. There is Vasari's story of the Medusa shield. Giorgio Vasari was a painter and architect of the Late Renaissance and distinguished in his own right. We owe the term *rinascimento* to him. He was rich, well-born, a courtier and a friend of Michelangelo. As a labour of love he compiled *Lives of the Artists*, first published in 1550. Although it contains much dubious information, this anecdote is still worth recounting, for although Leonardo died when Vasari was a child of eight, Leonardo was already a legend, and there were still people around who had known him and who could give circumstantial accounts of him and his youth.

34

'There is a story', wrote Vasari, 'that a peasant on Ser Piero's country place brought a homemade shield, a piece of a fig-tree he had cut down, and asked that Ser Piero have it painted for him in Florence. As the countryman was a very able huntsman and a great favourite with his master, the latter willingly promised to have it done. He took the wood therefore to Leonardo, not telling him for whom it was, and asked only that he paint something on it. Leonardo took the shield in hand, but since he found it crooked, coarse and badly shaped, he straightened it before the fire and sent it to a turner who returned it smooth and delicately rounded. Leonardo covered it with gypsum (plaster) and prepared it to his liking. He then considered what to put on it and thought of the head of Medusa and the terror it struck in the hearts of those who beheld it. He, therefore, assembled in a room that no one entered but himself a number of lizards, hedgehogs, newts, serpents, dragonflies, locusts, bats, glow-worms, and every sort of strange animal. . . . He fashioned a fearsome monster, hideous and appalling, breathing poison and flames and surrounded by fire issuing from a rift in a rock. He laboured on while the room filled with a mortal stench, of which Leonardo was quite unaware in his interest in his work. When it was done . . . Ser Piero went himself to fetch it. When he knocked, Leonardo asked him to wait a little. He darkened the room and placed the shield where a dim light would strike it, and then asked his father in. Ser Piero drew back, startled, and turned to rush out but Leonardo stopped him, saying "The shield will serve its purpose". The work seemed more than wonderful to Ser Piero, so he bought another shield, which was decorated with a heart transfixed with an arrow, and this he gave to the peasant who cherished it all his life. Leonardo's shield he secretly sold to a merchant for a hundred ducats. It subsequently fell into the hands of the Duke of Milan who paid three hundred ducats for it.'[H]

There is no trace of the Medusa shield but it is entirely consistent with the idea of a boy with a passion for the wild and weird creatures around him on a Tuscan farm, with his later practice and also with his father's business acumen. According to the legend, it was this boyish performance which determined his career because his father finding that his propensities had a market-value decided to apprentice him to Verrocchio, the Florentine artist, instead of making the boy a notary.

There is no reason to look for habitual truancy to account for the shortcomings in education which Leonardo later lamented. Notaries were clerks not scholars and 'of the people' in the sense that, whatever dog-latin they used in their deeds, they communicated in the Italian language. Italian was the product of this part of Tuscany, the language rich enough for Dante and Boccaccio, and as one can see from the highly literate prose of Leonardo's own notebooks, versatile enough for the most versatile man of the century. Leonardo's regrets for his lack of Latin and Greek, and his efforts at self-education in the dead languages were foolish inversions; he felt he had to apologize to the schoolmen who, if they had had their way, might have stultified his genius.

The most remarkable fact about his education is that no one tried to whip him out of his left-handedness. It is interesting that a country schoolmaster, or for that matter Leonardo's family, tolerated a boy who wrote, as he painted, with his left hand and wrote backwards, from right to left, like the orientals. In his adult note-books he not only used this 'mirror-writing' but also grammalogues, as steno-graphers do, amalgamating words or using phrase symbols. This is evidence either of a strong-minded boy or of sympathetic and understanding adults.

None of this suggests the flaws in character or the deviations of deprivation to which so much has been attributed. It is much simpler to regard him as a normal, healthy though precocious child and to look at later circumstances for explanations of what have been regarded as his abnormalities. We are always reminded that he was accused of sodomy at the age of twenty-four; that he had boy models and boy assistants; that he made his John the Baptist effeminate; that he never married and never had mistresses; that therefore he was a confirmed homosexual.

In the evaluation of his achievements, the question of homosexuality is im-material. He was a man of his times, and the times were, to use the modern jargon, permissive. By every responsible account Leonardo was a paragon of manly qualities. Vasari, borrowing from those who had known him, writes that he had 'besides the beauty of his person (which was such as has never been sufficiently extolled), an indescribable grace in every effortless act and deed. His talent was so rare that he mastered any subject to which he turned his attention. Extraordinary strength (he could bend an iron horseshoe like lead with his bare hands) and remarkable facility were here combined. He had a mind of regal boldness and magnanimous daring.'[1]

We have to put this remarkable person in the Florence of his day. It was a 'swinging city'. It was, for the favoured and wealthy, an exciting place. The young aristocrats and the successful tradesmen (such as the artists) swaggered their way from one excess to another. They were indiscriminately heterosexual with mis-tresses from inside or outside their own set, or homosexual in the sense that they rousted in their male society. They roystered in the streets, to the disturbance of the populace and the alarm of the *Signoria*; they swashbuckled to the danger of one another's life and limb; they duelled; they jousted; they wrestled; they tamed horses.

The young Leonardo was one of them. He was a lute player with a beautiful voice. He was a muscular athlete with a mastery over horses. At a time when the conventional male dress was a long robe of sober colour, he wore short doublets and tights of blue and crimson velvet and silver brocade. He was (although we have no guaranteed portraits of the young Leonardo, only remembered impressions) tall, and remarkably handsome. He belonged to three worlds: to that of the son of the successful notary to the *Signoria*, the magistracy of Florence; to that of the *bottega* (workshop) of Verrocchio the master-artist, which was frequented by the

36        *The young Leonardo may have been the model for Verrocchio's* David, *made in Florence in 1472.*

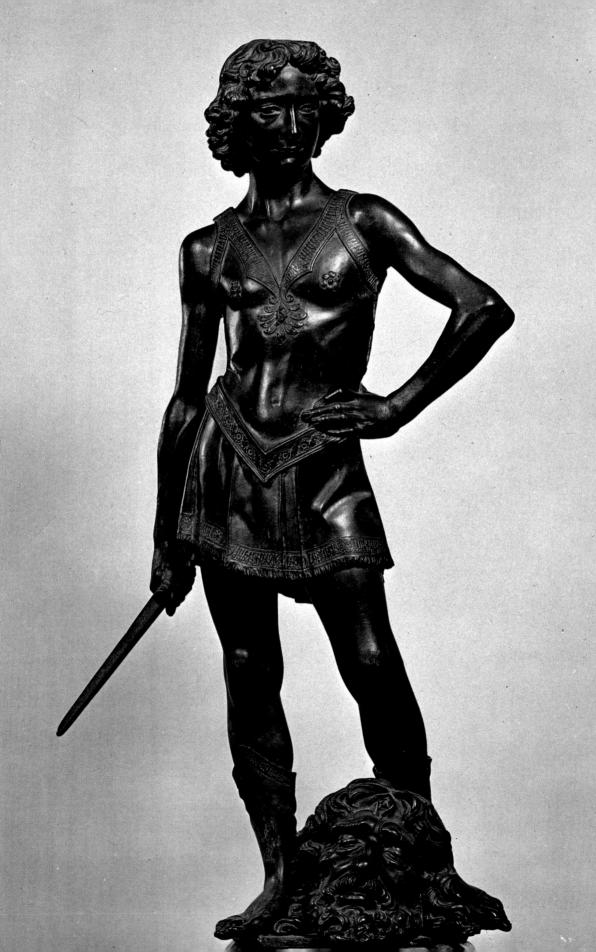

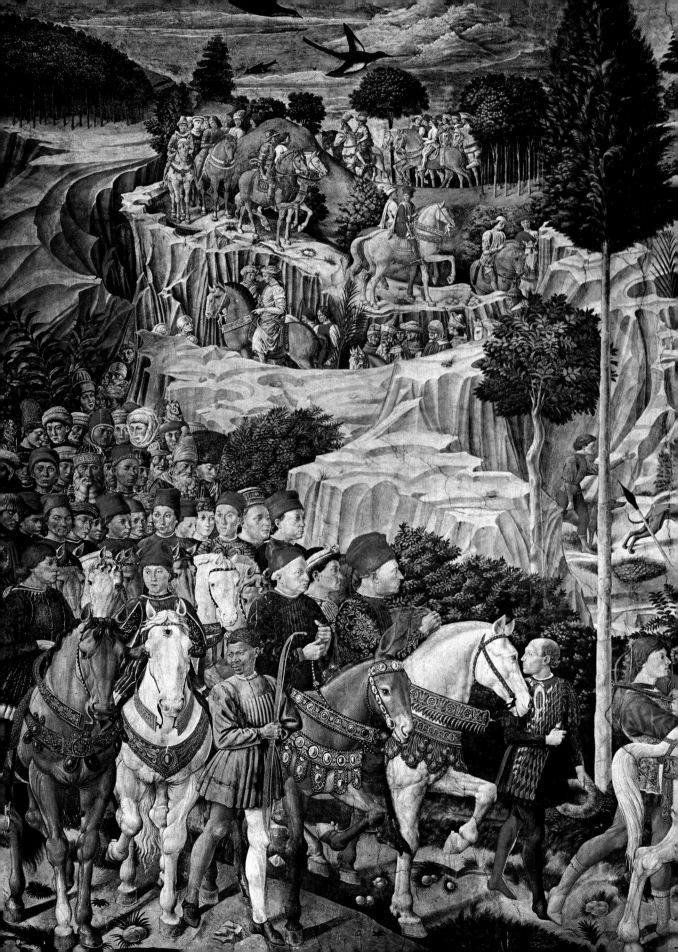

liveliest minds of the day; and thirdly, as a protégé of the Medici, to t[...]
power and luxury.

Then, at twenty-four years of age, a calamity overtook him. It woul[...]
seemed so disastrous to him (as his letters and appeals show it was) if he [...]
committed homosexual. With four other young Florentines he was a[...]
having sexual relations with a seventeen-year-old youth, Jacopo Salta[...]
8 April 1476, the *tamburo* outside the Palazzo Vecchio was opened. This d[...]um was
where anonymous informers left their denunciations for the vice-squad, the
*Ufficiali di Notte*. The note in it named Leonardo, the son of Ser Piero da Vinci,
living in the house of Andrea del Verrocchio. The four accused were held for
interrogation, and acquitted two months later. During that time he suffered shame
and humiliation. He felt himself abandoned by his friends and relatives. He wrote
petitions to influential acquaintances. He railed against calumny.

This traumatic experience coincided with the death of his step-mother, and the
re-marriage of his father to another sixteen-year-old girl, and it may be that these
events also affected his attitude to sex. Lord Clark says, 'We cannot look at
Leonardo's work and seriously maintain that he had the normal man's feeling for
women. And those who wish, in the interest of morality, to reduce Leonardo, that
inexhaustible source of creative power, to a neutral or sexless agency, have a
strange idea of service to his reputation.'[J]

But we have to think of Leonardo also as a fastidious artist and, furthermore, as a
practising anatomist. In his later years he wrote, 'The act of coitus and the mem-
bers that serve it are so hideous that, if it were not for the beauty of faces . . . and
the liberation of the spirit the human species would lose its humanity.'[3] He had his
own answer to the lot of them: 'Intellectual passion drives out sensuality.'[4]

Leonardo was abnormal in the sense of combining in his personality the abilities
of many men—which suggests that he was a once-and-for-all, never-to-be-
repeated human mutation, 'The Universal Genius'. Certainly he was an interesting
concatenation of genes, from the unlikely stock-pot of rural Tuscany, from the
lusty notary and the peasant wench.

There was an interesting and deliberate attempt to repeat the experiment.
Leonardo had a step-brother, Bartolommeo, by his father's third wife. The step-
brother was forty-five years younger than Leonardo, who was already a legend
when the boy was growing up and was dead when the following experiment took
place. Bartolommeo examined every detail of his father's association with Caterina
and he, a notary in the family tradition, went back to Vinci. He sought out another
peasant wench who corresponded to what he knew of Caterina and, in this case,
married her. She bore him a son but so great was his veneration for his brother that
he regarded it as a profanity to use his name. He called the child Piero. Bartolom-
meo had scarcely known his brother whose spiritual heir he had wanted thus to
produce and, by all accounts, he almost did. The boy looked like Leonardo, and

*Members of the Medici family are included in Benozzo Gozzoli's fresco*
Procession of the Magi *in the Palazzo Riccardi, Florence. Wearing a blue coat
and riding a mule is Cosimo de' Medici. Ahead of him, on a white horse, rides
Piero 'the gouty'. Between them is Piero's brother, Giovanni.*

*The* Virgin and Child with Two Saints, *by Pierino da Vinci, the step-nephew of Leonardo, who in his short life became a respected sculptor.*

was brought up with all the encouragement to follow his footsteps. Pierino da Vinci, this experiment in heredity, became an artist and, especially, a sculptor of some talent. He died young, and the da Vinci genes reverted to the commonplace.

The shuffled genes of hereditary talents can be compared to the deck of cards in the game of poker. In the deal, one would recognize as genius anything from a 'full house' to a 'royal flush'. Leonardo held the ace, the king, the queen, the knave and the ten—supreme in the talents in many fields—but in our awe we tend to throw in the joker as well and regard him as unique for all time—The Universal Genius. Rather we should regard him as the Universal Man who added to his innate talents an avid awareness of what was going on around him, and could exercise his skill in expressing and amplifying his manifold interests.

He was to die a frustrated man. He was a perfectionist who, even in painting in which many would rate him supreme, fell short of his own standards. He was so fertile in ideas that only a few of them could be implemented. He was so far ahead of his time in his inventions that the means did not exist to make them effective— his idea of a heavier-than-air flying machine had to wait four hundred years for the internal combustion engine. He was interested in everything and experimented continually. Once, having just accepted a commission for a picture, he began to distil oils and herbs for the varnish. One can sympathize with Pope Leo X who complained, 'This man will do nothing at all, since he is thinking of the end before he has made a beginning'.K

He was a painter, a sculptor, a musician, a poet, an architect, an engineer, a

geologist, an anatomist, a botanist, a physiologist, an astronomer and a philosopher. He was, in fact, the 'adventurous polymath', the type of man with free-ranging mind, embodying the humanities and sciences alike, who is conspicuously lacking today. He was the wide-eyed philosopher, looking at nature with the eye of an artist, finding it wonderful in its diversity but wondering about its meaning in the particulars and asking the most profound questions with a child-like curiosity. He perceived, questioned and researched; listened to experts and understood more than they themselves comprehended; created new concepts by the cross-reference of experience and saw what lesser men and the pedants ignored.

But if we think that all those ingenious ideas that we find in his notebooks sprang from his inner consciousness as ready-made Minerva sprang from the head of Zeus we shall miss the lesson that Leonardo has to teach. If we think of him as a human being, albeit exceptional, as a creature of his circumstances, living and reacting in an age of exciting change, frequenting his friends, arguing with them, quarrelling with them, plagiarizing their ideas or reading books and borrowing from them, and travelling around, we may recognize him as one of ourselves and not as an unattainable, unrepeatable paragon.

Vasari wrote thirty years after Leonardo's death: 'He might have been a scientist if he had not been so versatile.' L

*Lorenzo de' Medici compiled a book of songs,* Canzone a Ballo. *In this woodcut from the book,* LEFT, *a figure much like Lorenzo himself attends the song and dance.* RIGHT *Detail of Florentine bystanders, from a fresco by Rosselli,* c. *1485.*

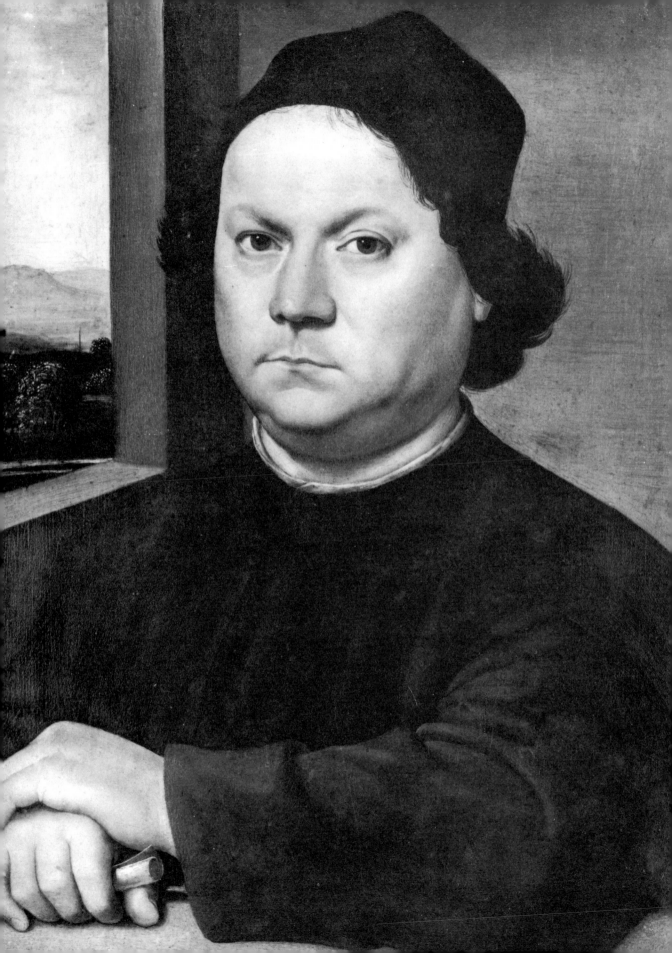

# The Magnet of the Mind

The instant the atmosphere is illuminated, it will be filled with an infinite number of images which are produced by the various bodies and colours assembled in it. And the eye becomes the target and loadstone of these images.[1]

People from everywhere came to Florence. By 1468, when Leonardo was apprenticed to Andrea del Verrocchio (whose name means the true eye), the merchants of Florence had extended their commerce all over the world, housing their agents abroad in impressive palaces and living at home 'above the shop'. They imported materials in their own ships and exported their manufactured goods to the limits of the known world. Benedetto Dei, Leonardo's friend, could remind the Venetians that Florence's customers, who included kings and sultans, were taking more silk stuffs and gold and silver brocades from Florence than they did from Venice, Genoa and Lucca put together. In Florence the woollen guild had 270 booths, the silk weavers 83 workshops and the bankers 33 counting houses. There were 44 jewellers' shops attracting buyers from all countries. It was said at the time, 'In Florence there is a fair on every day.' There were visitors from England and Flanders, selling their wool cloth for Florence's special treatment and buying the bric-a-brac of the Ponte Vecchio. There were merchants from the orient, in their swathed robes, flat turbans and peaked hats which were to become the academic dress, and mitres of the learned Christian hierarchy. There were the dark-skinned Moors from Spain with their black slave escorts from the Ivory Coast. There were Tartars from Muscovy and slant-eyed Mongols from far Cathay. There were refugee scholars and wandering students from all over Europe, with Latin as their *lingua franca* spoken in outrageous accents, from Scotland to Bohemia, and, like students from that day to this, conspicuous in their behaviour. Part of the merchandise was the beautiful women, 'modelling' the soft-ware in peach, crimson or dark violet and the rings and brooches and jewelled garlands (from which Ghirlandaio, the goldsmith turned artist, took his name). They were matched in colourful elegance by the young men, including Leonardo, with their long flowing locks, their short doublets and their mini-trunks. These male coquettes, with their

LEFT *Andrea del Verrocchio* c. *1485, by his pupil Lorenzo di Credi.*                    43

well-turned legs, were vaunted in the Florentine paintings of the day. The boy of fashion was glorified in Florence as nowhere else in the world.

Leonardo's father, Ser Piero, had now established himself as a successful notary in Florence. He no longer commuted from Vinci, but had an office opposite the Bargello, the palace of the *Podestà* or chief magistrate. By the dispensation of the times there was no reason why his eldest, natural, son should not have followed in the family business, but Piero (perhaps because of the pecuniary success of the

*A Renaissance doorway leads to the Hill of Knowledge. A Florentine miniature of the fifteenth century. Up the hill are seated the Seven Liberal Arts, each represented by a maiden. At the summit above St Augustine is Theology pointing upwards to God in the sky.*

Medusa painting) had acknowledged his son's talent, and had shown Leonardo's sketches to Verrocchio, who had accepted him as a pupil. At this time painting and sculpture were not regarded as belonging to the arts but to the crafts. Artists were tradesmen hired to embellish. The Arts, Liberal and Mechanical, formed an integral part of the scholastic system with philosophy (the theology of scholasticism) enthroned, with the abstract disciplines immediately below—grammar, dialectic, rhetoric, geometry, arithmetic, astronomy and music. The Arts Mechanical

RIGHT *Lorenzo di Credi, 1458–1537. Self-portrait.*

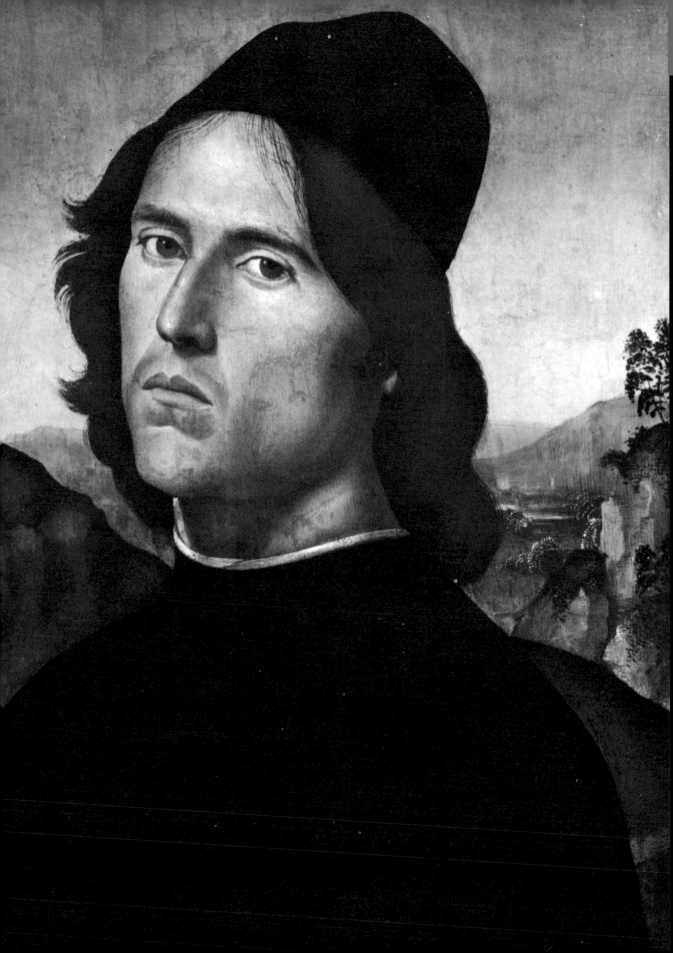

were likewise limited to the mystic number seven—weaving, building, navigation, agriculture, hunting, medicine and drama. Below these stood what we now call the Fine Arts. Architects and sculptors were also masons; artists and craftsmen were organized in guilds. The art of painting, that is to say, the art of observing and recording, was not entitled to a place in the Liberal Arts. In commercial Florence the crafts through their guilds were very powerful; nevertheless Michelangelo's father who claimed noble descent though only a local mayor, was humiliated when his son entered Ghirlandaio's studio. The educated class, with the concentration on classical studies, enhanced by the humanism introduced by the rediscovery of Ancient Greece and Rome, set itself apart. Leonardo, throughout his life, resented the condescension of the scholars. He wrote, 'Many will think that they can with reason blame me, alleging that my proofs are contrary to the authority of certain men held in great reverence by their inexperienced judgments, not considering that my works are the issue of simple and plain experience, which is the true mistress.'[2]

Verrocchio, Leonardo's master, was according to Vasari 'numbered amongst the distinguished masters'. His hands were ceaselessly creating with brush, mallet, palette, knife or file. He imparted the same industriousness to his assistants, including Piero Perugino and Lorenzo di Credi, Leonardo's contemporaries. He taught them thoroughly. He himself had turned from being a goldsmith into an engraver, from engraving to sculpture, from sculpture to perspective and from perspective to painting. He had wide interests in music. He made a study of man in various stages of life, and of plants and animals. One thing that Leonardo, in his impressionable youth, had learned from him was that to do anything properly one needs a thorough knowledge of it and that one must investigate it oneself and not rely on the findings of others. Leonardo wrote later, 'Those who fall in love with practice without science are like a sailor who enters a ship without a helm or a compass, and who never can be certain whither he is going. Practice must be founded always on sound theory.'[3]

Also in Florence at this time was Paolo Uccello, now an old man (he died in 1475). He was a man of original and inventive genius, and he became so fascinated with the problems of perspective, that he was regarded by some as crazy. According to Vasari, 'He established the rules of linear perspective. From the ground plan to the cornices and the summit of the roof, he reduced all to strict rules by converging the lines toward the centre, after having fixed his point of view higher or lower to suit himself. He found means to make his figures seem to be standing on the floor plane and showed how they must diminish in the distance. Paolo also discovered a way . . . of foreshortening floors by converging the beams; of carrying a line of columns around the sharp corners of a building. . . . To pore over these things he remained in seclusion for months at a time. . . . When he sometimes showed this labour of love to his intimate friend Donatello, the latter said, "Ah,

46

Paolo, with this perspective of thine, thou art losing the substance for the shadow. This is for men who work at the inlaying of wood . . .".'A But it was the Italian painters, and conspicuously Leonardo himself, who pushed ahead with the study of portraying three-dimensional space.

A close friend of Leonardo was Sandro Filipepi, called Botticelli or 'little bottle'. In his younger days he was fat, sensual and jolly and a practical joker, like Leonardo, but in later life he became a follower of Savonarola, with puritanical views. He was a stylist, while Leonardo was a realist, in art form. Botticelli despised the study of landscapes as a vain occupation and said that if a sponge soaked in various colours were thrown at a wall it would serve the same purpose. This outraged Leonardo, who wrote 'Our Botticelli painted very sad landscapes' and, more violently, he lectured him 'Sandro! You do not say why these second things seem lower than the third'; Botticelli did not understand 'the perspective of diminution'.[4]

Verrocchio, caught up in the lively cult of perspective, applied himself with night-school enthusiasm to the study of geometry and infected his pupil, who started a self-education course. Leonardo borrowed books and sought the help of the local mathematicians, plaguing them and often bamboozling them with his questions. Later, in his notebooks we find him admonishing himself in the second

*'Little bottle' Sandro Botticelli followed tradition,*
*and painted a portrait of himself in the right-hand corner*
*of his* Adoration of the Magi, c. *1475.*

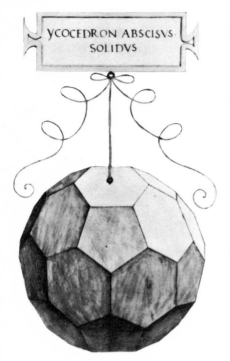

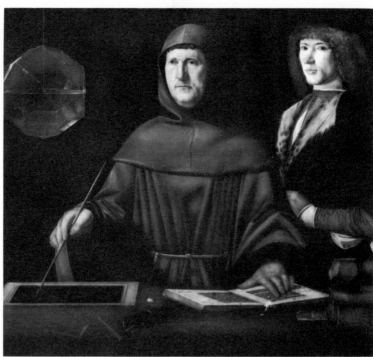

RIGHT *Luca Pacioli, mathematician, with a pupil—a painting by Jacopo de' Barbari. Leonardo and Pacioli worked together in Milan from 1496, and Leonardo drew diagrams like the many-sided solid* LEFT *for Pacioli's book* De Divina Proportione, *1498.*

person: 'Let Maestro Luca show you how to multiply roots.'[5] Maestro Luca was Fra Luca Pacioli, who was two years older than Leonardo, a Franciscan monk, inventor of the square root, and he was working on a book on geometry, *De Divina Proportione*, for which Leonardo drew the diagrams. Leonardo further lectured his readers, 'Let no man who is not a Mathematician read the elements of my work.'[6]

In Florence was Benedetto d'Abbaco, also called Benedetto Aritmetico, who is described by Vallentin as 'the most prominent scholar of the time'.[B] He directed Leonardo's interest to engineering and made him aware of his deficiencies in physics, which he, typically, begun to study intensively. Another influence was the refugee Greek, John Argyropoulos, who lectured at the *Studium Generale* of Florence on the natural philosophy of Aristotle. Leonardo attended his lectures and studied his translations of Aristotle's *Physica* and *De Coela*.

The most profound influence of all, however, was Maestro Paolo dal Pozzo Toscanelli, whom we left logging the course of the great comet. Toscanelli was a practising physician but a mathematician *par excellence*. His house by the Arno had been for years a rendezvous for the liveliest minds and the most adventurous artists. Before Leonardo there had been Filippo Brunelleschi, Donatello, Leone Battista Alberti, Luca della Robbia, Paolo Uccello and Ghirlandaio.

48

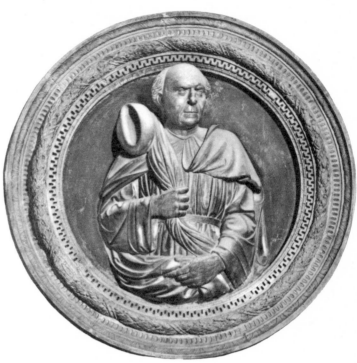

LEFT *John Argyropoulos, refugee scholar who taught in Florence 1456–71.* RIGHT *Filippo Brunelleschi, designer of the dome of Santa Maria del Fiore, Florence. A self-portrait from a monument in the same church.*

These were the days when men's minds exploded outwards and upwards. A goldsmith, like Brunelleschi, could become an architect and achieve the seemingly impossible—the dome of Santa Maria del Fiore. This was the cathedral which the original architect, Arnolfo di Cambio, had left unfinished at his death. In 1420, the wealthy Florentines decided that something must be done about it. They instructed their agents throughout Europe to seek out and recruit the finest architects; they financed Tuscan architects to go abroad and study similar structures. Vasari tells us that there was an assembly of the talents to decide how a dome of the proportions which Arnolfo's cathedral demanded could ever be constructed with the materials and engineering methods then available. One proposal was that it be made of pumice-stone for lightness of weight. Another suggestion was that a huge mound of earth should fill the centre of the cathedral to enable the workmen to reach the dome area and that this mound should have coins scattered through it (like sixpences in a Christmas pudding) so that when the dome was completed people would remove the soil in a giant treasure hunt. At this point, Brunelleschi was thrown out of the discussions for making rude remarks. According to the legend, he later proposed to the baffled city fathers that whoever could make an egg stand on end should be given the assignment. The maestros of architecture

49

rejected the dare because it was impossible. Brunelleschi gently pressed an indent in the shell and it stood up. His solution was finally adopted. He contrived it as an inner vault, using eight arches springing from the eight angles of the wall. When loaded with the lantern, the arches would support one another. Over the inner dome he constructed a protective outer dome with a space between. In the imaginative calculations, he owed much to Toscanelli who had taught him mathematics. To Brunelleschi's cupola Toscanelli added the great gnomon. This shadow-caster, like a giant sundial, was described as 'the noblest astronomical instrument in the world'.[c] The sun's rays threw a finger-shadow on to a dial made of marble flagstones in the floor of the cathedral. Although an impressive show-

*Leone Battista Alberti's self-portrait on a medal c. 1430.*
*Below his chin is his personal emblem, a winged eye,*
*symbolizing knowledge and power.*

piece it was for Toscanelli a practical means of determining the summer solstice by which the movable feasts of the Church were reckoned.

Another member of that early coterie, Leone Battista Alberti, was still alive when Leonardo was serving his apprenticeship. Alberti was a builder of cathedrals and palaces, wrote *De Re Aedificatoria*, the famous architectural treatise in ten sections, and a three-part treatise on painting, in which the first section deals with perspective and geometry. He despised the languages of scholars, and insisted on writing in the 'vulgar' Italian which had been good enough for Dante and Boccaccio.

He was the son of a noble banking family, but instead of becoming involved in commerce had broken loose to study mathematics and natural sciences at Venice and Padua. He was an acrobat, and it was said that he could jump with both feet together over the shoulders of ten men in succession. He fenced with a pike instead of a sword. He could balance with his foot against the Duomo wall and throw an apple over the 300 foot high cupola. He wrote much prose and poetry, and popular accounts of horse breeding, women's underwear, statistics and navigation. He invented recipes for pigments, distorting mirrors and the pantograph for enlarging drawings to scale. He painted a panorama of Rome, salvaged a galley from Lake Nemi, and was the sought-after guest at every party. In many ways he was the early prototype for the 'Complete Leonardo'.

Toscanelli did more for Leonardo than teach him mathematics. Although he himself never left Tuscany, the world beat a path to his door. He encouraged travellers from foreign parts and listened avidly to strange tales from strange places. He had an advantage because his family traded in silks and spices. In one sense the caravans of the orient converged on Florence. One of the visitors around 1444 was the Venetian, Niccolò de' Conti whose journeys in central and eastern Asia can be compared with those of the better known Marco Polo.

Toscanelli was a painstaking geographer who did his utmost, not always successfully, to sort out the true from the false and give some sort of measurable precision to the imprecise wanderings. He was also able to give useful information to the Medici and so to open new roads for commerce and for banking.

He combined his astronomical and his terrestrial interests. The determination of places on the surfaces of the globe is directly related to the determination of the heavens above it. In those days latitude could be fixed with reasonable accuracy (plus or minus 25 miles) by means of the armillary sphere, the astrolabe, and the cross-staff, all predecessors of the sextant, by taking the height of the sun above the horizon at true noon and, at night, the height of the Pole Star. The other co-ordinate, longitude, was a very different matter and it was not solved satisfactorily until marine chronometers were constructed, long after Toscanelli's time. The only way that fifteenth-century travellers by sea and land could fix longitude was by judging their hourly speed and the direction of their journey.

*Two surveyors measure the height of a building with cross-staffs. The instruments shown in this woodcut were also used to measure latitude by fixing on the sun at noon and the pole-star at night.*

Toscanelli had inherited a collection of cartographic documents from a grateful patient. Those, and his travellers' tales, impelled him to undertake an ingenious task never before attempted by other geographers. The first problem he tackled was to establish the value of unity of measurement in order to gain knowledge of an accurate meridian arc and thus achieve a better evaluation of the Earth's circumference. Toscanelli adopted a grid system founded on geographic co-ordinates. In one of his manuscripts he gives a list of the latitudes and longitudes of about a hundred cities east of Portugal. He looked westwards into the unknown and compiled a map by which the globe could be circumnavigated from east to west. His Atlantic Ocean, between Europe and Asia, had a width of only 126° longitude and placed Japan in what is now the Gulf of Mexico. Later he corresponded with Columbus and influenced him to attempt to find a westward passage to India.

Leonardo's talks with the ageing Toscanelli aroused in him a fascination for astronomy and a longing to see distant countries. But they did even more than that: they aroused in him a scepticism about the Creation and the Flood, and about the nature of the world itself which affronted the prevailing dogmas and could have brought him to the stake.

Fortunately, Leonardo, according to the standards of his time and much to his own regret, was uneducated—'fortunately', because otherwise we might have missed his contribution to The Age of the Eye.

We would not have found, for instance, recorded in his notes (about a century before Galileo first used the telescope to study the skies) 'Make glasses in order to see the moon large'.[7]

To use such a device, according to the Florentine scholars who followed Plato, would have been no more than a disreputable conjuring trick. Sight, according to them, was the most untrustworthy of the senses and although some of them secretly did wear spectacles, lenses were misleading tools. For more than fifteen centuries the problem concerning the function of the eye had been academically discussed but it had never been solved. But, about lenses, the mathematicians and the philosophers had no doubts. The logic ran like this: 'Glass lenses show images larger or smaller than the real ones seen about them. They show objects nearer or

*Hugh of St Cher, painted by Tommaso da Modena in a fresco, c. 1352.*
*The Dominican monk is wearing pince-nez spectacles.*

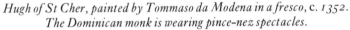

further away, at times even upside down or distorted and iridescent. Therefore we must not look through lenses if we do not want to be deceived.'

According to some accounts, the Emperor Nero used to quiz the gladiatorial bouts in the Coliseum through a beryl crystal, but artificial glass lenses seem to have been known from at least the time of Archimedes, and were studied by Arabian investigators like Al-Kindi (ninth century), and Al-Hazen (eleventh century). Vasco Ronchi of the National Institute of Optics, Florence, claims that spectacle lenses came into general use in the years following 1280, but it was more than three centuries after this that the first telescope was made with just two spectacle lenses placed at the ends of a tube.

The very name '*lens*' reveals its humble origin—from its resemblance to the seed of the lentil plant. No philosopher would have given such a workaday name to a discovery. Only an artisan, with no philosophical culture, could have accepted the evidence of his own eyes and have recognized when working with 'lentils' of glass that a convex 'lentil' corrected shortsightedness and a concave 'lentil', long-sightedness. And only Leonardo, uninhibited by philosophic doubts, could have abetted the artisan and proved the manner in which glasses aid the sight:

> Let *a b* be the glasses and *c d* the eyes, and suppose these to have grown old. Whereas they used to see an object at *e* with great ease by turning their position very considerably from the line of the optic nerves, but now by reason of age the power of bending has become weakened, and consequently it cannot be twisted without causing great pain to the eyes, so that they are constrained of necessity to place the object farther away, that is from *e* to *f*, and so see it better but not in detail. But through the interposition of the spectacles the object is clearly discerned at the distance that it was when they were young, that is at *e*, and this comes about because the object *e* passes to the eye through various mediums, namely thin and thick, the thin being the air that is between the spectacles and the object, and the thick being the thickness of the glass of the spectacles, the line of direction consequently bends in the thickness of the glass, and the line is twisted, so that seeing the object at *e* it sees it as though it was at *f*, with the advantage that the position of the eye with regard to its optic nerves is not strained and it sees it as near at hand and discerns it better at *e* than at *f* and especially the minute portions.[8]

Leonardo applied the principle of the 'lentil' to the eye itself. He asked why nature made the pupil convex, that is raised up like parts of a ball. And answered his own question, 'Nature has made the surface of the pupil situated in the eye convex in form so that the surrounding objects may imprint their images at greater angles than could happen if the eye were flat.'[9]

Leonardo, however, in the privacy of his notes, was challenging the scholars on an issue more fundamental than the lenses. He was denouncing the idea of the eye-transmitted ray. With the egocentricity which set Man at the centre of the universe, scholars of that time maintained that the eye emitted rays which made an image visible; nothing existed until the mind of Man through the magic lantern of the eye so determined and created the simulacrum. It is difficult for us to grasp such fatuity, but the maestros of learning held it as a conviction beyond discussion, and

**54**      ABOVE *A scene of jousting in the streets of Florence, painted on the side of a fifteenth-century bridal chest or 'cassone'. Unknown artist.*
BELOW *The coat of arms of the* Arte della Lana, *the Florentine guild of wool traders. Terracotta roundel by Luca della Robbia.*

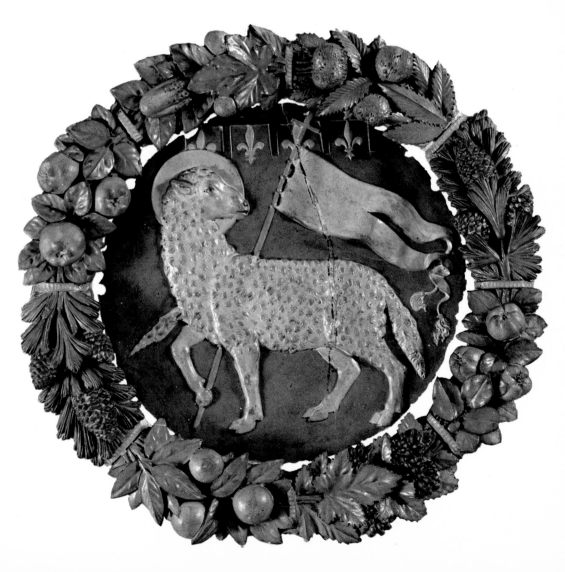

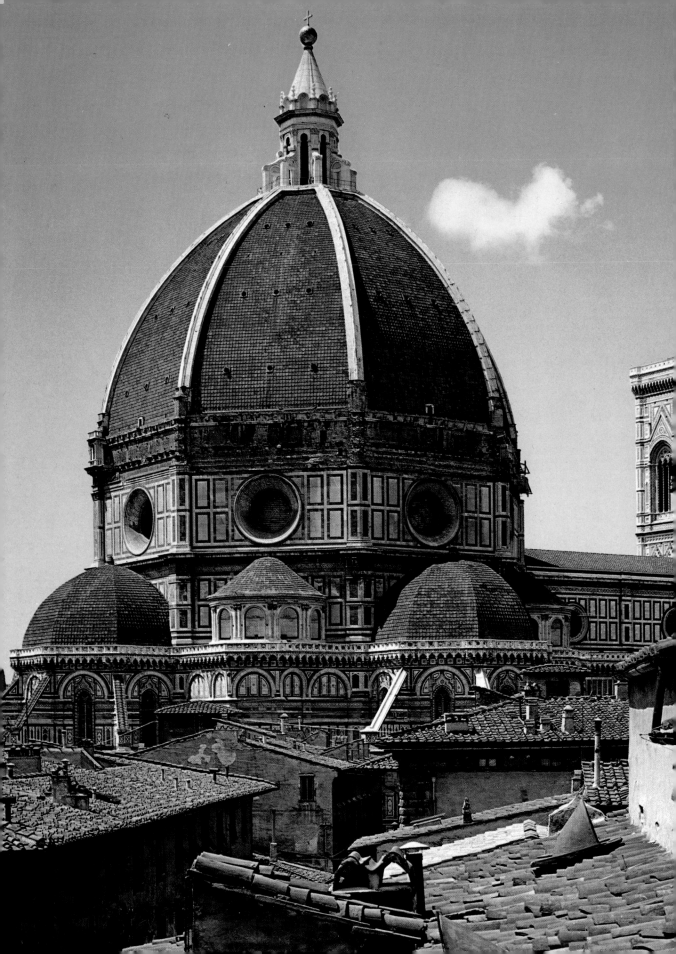

they rejected out of hand all those discoveries which conflicted with this tenet.

Even before Leonardo, artists in their study of perspective and their recognition of straight lines diminishing to infinity, had, without tangling with the scholars, recognized the absurdity of eye-generated rays. But Leonardo, although he protested that he was a man without letters, was a more thorough scholar than most of the maestros, and it is clear that he made a very careful study of the classical texts and their approach to the phenomena before he trusted the evidence of his own senses and committed himself to his own findings. Then he said, quite firmly, 'It is impossible that the eye should project from itself, by visual rays, the visual power...'[10]

He went on to show that the emanation of power 'would have to go forth to the object and this it could not do without time'. He did not know about light-years but it was quite clear to him that a power transmitted from the eye could not reach a distant object in the instant in which, by actual experience, it became visible. 'It could not travel so high as the sun in a month's time when the eye wanted to see it.' And again 'if the eye consisted of a million worlds, it would not prevent its being consumed in the projection of its power; and if this power would have to travel through the air as perfumes do, the winds would bend it and carry it into another place.'[11] In another note he said, 'If you look at the sun or some other luminous body and then shut your eyes you will see it again inside your eye for a long time. This is evidence that images enter into the eye.'[12]

A great deal of this remarkable recognition of the properties of vision came from his work on perspective which he owed to Uccello, by way of his own master Verrocchio. Leonardo defined perspective as 'a rational demonstration by which experience confirms that every object sends its image to the eye by a pyramid of lines. . . . By a pyramid of lines I mean those which start from the surface and edges of bodies, and, converging from a distance, meet in a single point.'[13] There is no doubt that in his development of 'the pyramid of sight' composed of visible rays, Leonardo was doing a great deal of scholarly homework. Apart from the discussions then going on among his fellow-painters, the idea of visible rays dates back to Plato's *Timaeus*, ignored by the schoolmen, to Euclid's *Optics*, and to Vitruvius's *De Architectura*. There is little doubt that through his friend Fazio Cardano he was familiar with the work of John Peckham, Archbishop of Canterbury, who died in 1292, in which the theory of rays is explained, and of the work of Roger Bacon, Peckham's contemporary. It is known that Leonardo was aware of Bacon's ideas— Bacon is specifically referred to in a notebook in the British Museum. He was never prepared to accept the conclusions of others, but he insisted on checking by experiment and he worked out the applications in his own original manner.

He recognized the weakness of a geometric scheme which is 'one-eyed', for it is not one mathematical point to which the rays of visibility converge but two, which have to be reconciled in the mental image. He tested and abandoned book

*The cathedral of Santa Maria del Fiore, Florence (the Duomo). Leonardo, in Verrocchio's workshop, helped to make the golden ball which surmounts Brunelleschi's dome.*

57

*Schematic drawings of the eye in cross-section from* Optics *by Roger Bacon,* c. *1268. Leonardo knew of Bacon's work, but he mistrusted the established concept of vision and experimented for himself. 'What I say is born out by experience', he wrote emphatically.*

borrowed ideas. He took a sheet of paper with a small hole in it, looked through the hole at the source of light and saw how the rays from the source came together in a cone. When he allowed them to pass on to a white wall he observed how they spread out again. He manipulated the sheet of paper with its pin-hole and made the hole itself different shapes and re-established Euclid's law—that light spreads in straight lines. He went further; he employed the *camera obscura*, an idea he may have derived from Aristotle or from Peckham. He confidently described the effect:

I say that if the front of a building—or any open piazza or field—which is illuminated by the sun has a dwelling opposite to it, and if, in the front which does not face the sun, you make a small round hole, all the illuminated objects will project their images through that hole and be visible inside the dwelling on the opposite wall which should be made white; and there, in fact, they will be upside down, and if you make similar openings in several places in the same wall

you will have the same result from each. . . . If these (reflected) bodies are of various colours and shapes the rays forming the images are of various colours and shapes, and so will the representations be on the wall.[14]

The hole in the wall is a cyclopean eye; Leonardo recognized, as none of his possible sources had done, the problem of binocular vision and the stereoscopic effect. He set out to explain the creation of the three-dimensional image of objects through the different angles of convergence on the two eyes set apart in the head. 'Things seen with both eyes will seem rounder than those seen with one eye.'[15]

To get at reality he studied illustrations. Without knowing that light travels at 186,000 miles a second, he accepted the conclusion that light did not require time for its transmission because the sun on rising instantaneously flushed the landscape with light. But he did recognize that the eye itself had a built-in time factor and he showed that when impressions followed rapidly they either fused as a continuous motion (like the frames of our present-day motion-picture film or the rapid scanning of the cathode rays of the television tube), or they became confused as a false image. The latter he demonstrated by throwing a stiletto into a table so that as it trembled there seemed to be two knives, and by swinging a torch so that it appeared to produce a complete circle of light.

Others of his observations are still standard; that an object placed against a bright background seems smaller than it is; that a brightly illuminated body seems

*'Through the interposition of the spectacles, the object is clearly discerned. . . .' Leonardo's diagram* BELOW RIGHT *illustrates his notes (p. 54) on how eye glasses aid the sight of the old. In the drawing* BELOW LEFT *Leonardo may be representing a pair of hinged spectacles worn by a man.*

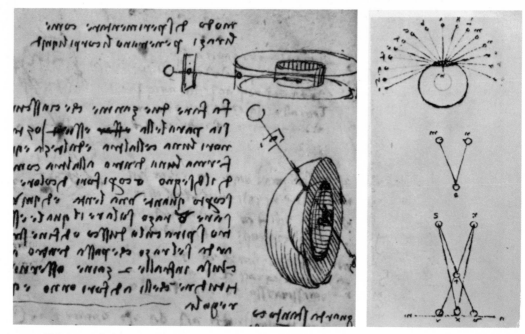

LEFT *Using a pinhole and trays of water, Leonardo showed the refraction of light.* RIGHT *'Nature has made the surface of the pupil convex . . . so that the surrounding objects may imprint their images at greater angles.'*

larger than an identical one less brightly illuminated; that if one end of an iron rod of uniform thickness is made red–hot, it seems thicker than the other end; and that the angle of reflection is always equal to the angle of incidence. The last (which was first discovered by Euclid) he demonstrated neatly by posing two people in front of a mirror and noted: 'if you touch the eye of the other man in the mirror it will seem to him that you are touching your own'.[16]

All those years before Newton and his spectrum, and Clerk Maxwell and his electromagnetic theory, he did not know about the variable wave-lengths of colours but he had a pretty shrewd notion: 'white is not a colour but is capable of becoming the recipient of every colour'.[17] He placed two panes of glass, one blue and the other yellow, in close contact, and noted that: 'the rays in penetrating them, do not become blue or yellow but a beautiful green'.[18] With some premonitions of Newton he proposed to use the rainbow as a means by which painters could mix their colours.

His exhaustive studies of the physics of light-rays in which he tried out, discussed and discarded, the prevailing ideas on perspective made him the sensitive master of chiaroscuro in his paintings. The physicist became the poet and he wrote: 'Very great charm of shadow and light is to be found in the faces of those who sit in the doors of dark houses. The eye of the spectator sees that part of the face which is in shadow lost in the darkness of the house, and that part of the face

60

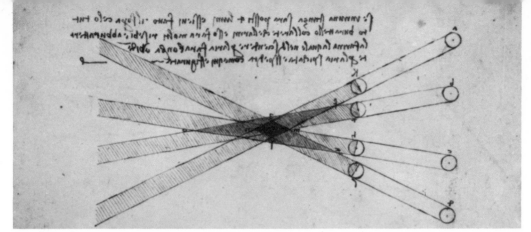

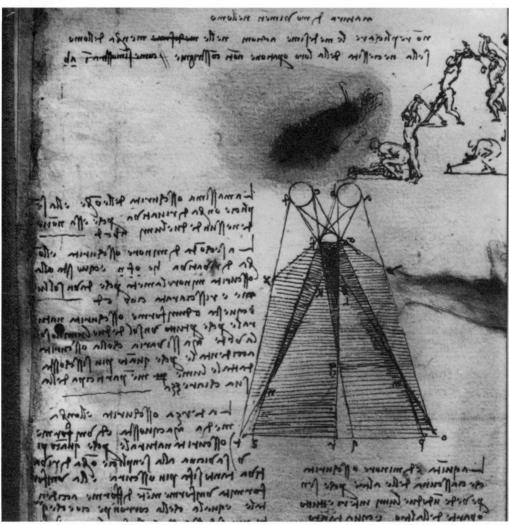

'*The shadow may be darker that is derived from a greater number of different shaded and luminous bodies*', notes Leonardo with the drawing, TOP. '*Compound [derived] shadows are a mixture of light and shade and simple [primitive] shadows are simply darkness.*' *The drawing* BELOW *notes five degrees of shade.*

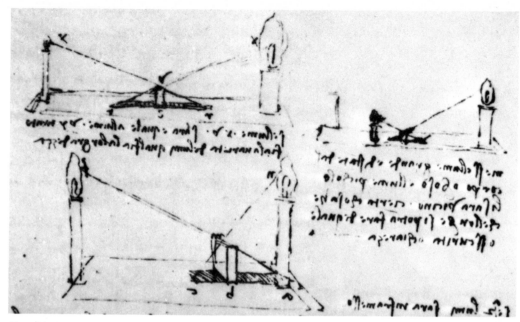

*Equal light sources at equal distances will cast shadows of equal depth, and so may unequal light sources at unequal distances (right). But equal light sources at unequal distances will not (lower left). Candles illustrate Leonardo's understanding of photometry.*

which is lit draws its brilliancy from the splendour of the sky. From this intensification of light and shade the face gains greatly in relief and in beauty. . . .'[19]

He differentiated between 'primitive' and 'derived' shadows and illustrated his theory by geometrical drawings. He also occupied himself with the measuring of light intensity by comparing the depth of shadows cast by different light sources—a method of photometry which was suggested again by Count Rumford over two hundred years later.

Ultimately, however, the whole thing depended on the eye of the observer and in one of his self-injunctions we find him saying, 'Write in your Anatomy how in the tiniest space the image can be reborn or reconstituted in its full dimensions.'[20]

The tiniest space was the eyeball, one inch in diameter, which he proceeded to explore by a process of dissection which was ingenious and, as far as can be judged, original. He probably used not a human eye but an ox's eye because he described the lens as being in the centre of the eye, instead of towards the front. Another explanation of the misplacement might be that, if it were a human eye, the hard lens was pushed out of position in cutting. He identified the various parts of the eye: the pupil, the pigment layer, the iris and the 'vitreous humour', all of which had been known before, certainly to the Arabs.

The images which penetrate into the vitreous humour by the pupil of the eye meet together in the sphere of the crystalline humour, as to which two considerations present themselves;

LEFT *Leonardo compares the human head with an onion, and in slicing it through the middle, cross-sections the eye. He draws the lens as a sphere in the centre. In the plan view below, he shows correctly the nerves from the eye balls crossing at the optic chiasma.*

namely whether the visual faculty resides in it [the crystalline sphere] or at the extremity of the optic nerve, which extremity catches these images and transmits them to the common sense as do the nerves of the sense of smell. And if this faculty resides in the centre of the crystalline humour it catches the images with its surface, and they are referred there from the surface of the pupil, where the objects are mirrored or reflected there from the surface of the uvea which bounds and clothes the vitreous humour which has darkness behind its transparency, just as behind the transparency of the glass we find the darkness of the lead in order that objects may be better mirrored in the surface of this glass. But if the visual faculty is in the centre of the crystalline sphere all the objects which are given it from the surface of the pupil of the eye will appear in the true position. . . .[21]

He went on wrestling with the problem of how the components of the eye as he saw them anatomically could form a mental image, the right way up and the right way round.[22] His difficulty was obvious: he had proved to his own satisfaction that the lines of light which build up the image must appear right to left as in a mirror and upside down, as when the rays pass through a pin-hole. Having discovered the lens in the eye, he knew that its purpose was to focus the light, admitted through the aperture of the iris, on to the uvea which was the pigmented inner lining of the capsule enclosing the vitreous humour. But the inevitable inversion of the image by its passage through a double convex lens troubled him. He tried to account for it by considering that the first inversion occurred as the light passed through the pupil like the pin-point hole in the *camera obscura* and that the correction, the re-inversion, occurred in the lens and that the right image, like the positive of a photograph, impinged on the end of the optic nerve and was conveyed to the brain—the 'Common Sense' which coped with all the senses. In fact, the end of the optic nerve is the one blind-spot in the retina.

We now know of course that the retina which he regarded as the coating of a mirror is the extremely complex structure, formed by an expansion, or delicate branching, of the optic nerve, the trunk of which he was observing. It consists of no less than ten layers. The pigment layer, the coating of the inside of the eye, covers a layer of rods and cones which, like the mosaic of a television camera is the percipient element. Thus the whole retina, with the exception of the blind-spot which he thought was the sensitive spot, is a ray-receiver. A century later, Kepler, the astronomer, gave the correct explanation of the inversion of the image on the retina. He also gave the correct explanation of myopia (shortsightedness) as being due to the convergence of luminous rays before reaching the retina. It is ironical to think that a myopic ox might have misled Leonardo about the position of the lens.

Nevertheless, Leonardo, in his concern to enthrone the eye as the king of the senses, was remarkably observant. He studied sight not only in man but in all kinds of animals: 'As regards the pupil of the eyes of all animals both those of the land and those of the water, nature has so ordained that when they are affected by greater or less brightness the pupil that is the black portion of the eye contracts or expands. This happens because as the excess of brightness causes a change in the

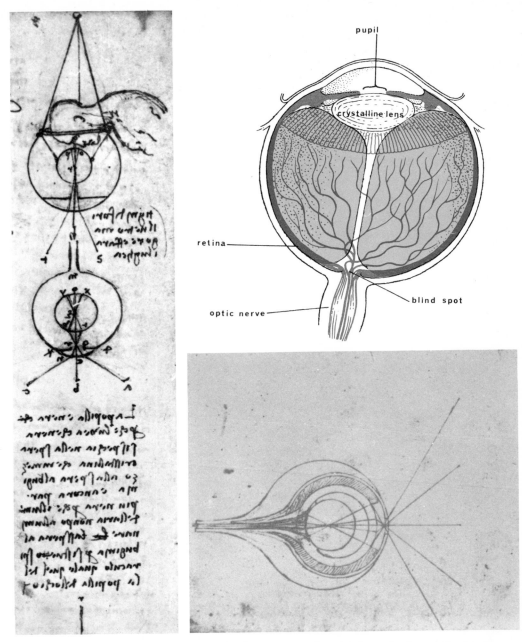

pupil

crystalline lens

retina

optic nerve

blind spot

'The eye, whose use and operation are so clearly shown to us by experience, has been defined in one way by an infinite number of authors, up to my time, and I find it is completely different.' Leonardo proceeded to make his investigations with drawings and models LEFT, and enthroned sight as king of the senses. He wrote: 'The images of the objects placed before the eye pass to the vitreous sphere by the gate of the pupil, and they intersect within this pupil. . . .' He thought the image had now been inverted, and drew a schematic eye, LOWER RIGHT, which shows a second inversion in the misplaced spherical lens, so that the image was the right way up when it reached the 'common sense'. The modern diagram TOP shows the lens correctly placed. Images striking the retina are inverted, and are adjusted in the brain.

eye . . . the pupil closes up after the manner of a purse. . . . When these pupils are in darkness they become large. . . .'[23]

He pointed out that in birds the variation of the contraction and dilation of the pupil was much greater, particularly in nocturnal birds; and that in one species of owl 'the pupil dilates in such a way as to occupy nearly the whole eye, or diminishes to the size of a grain of millet, and it always preserves the circular form. But in the lion tribe, as panthers, pards, ounces, tigers, wolves, lynxes, Spanish cats, and other similar animals, the pupil diminishes from the perfect circle to the figure of a pointed oval.'[24] He went on to explain that in the case of the horned owl the power of vision increases so much that in 'the faintest nocturnal light (which we call darkness)' the bird can see more distinctly than humans do in 'the splendour of noonday', but that owls have to keep out of sunlight because its brightness contracts their pupils and their power of sight diminishes with the quantity of light admitted.

Some of this comparative ophthalmology was probably derived or suggested by books and conversations with others. There is evidence in his own notebooks and library list of his acquaintance with Aristotle, with Pliny, with Galen (likely to mislead him on the eye) and with Avicenna. Nevertheless, most of it was by direct observation, research and dissection. Like a man talking to himself, he was forever exhorting and directing himself in his notebooks, obviously churning over what he

LEFT *Leonardo's drawing of the head of a dog.* RIGHT *The* Marzocco, *the heraldic lion symbolizing the power of Florence, made by Donatello* c. 1418.

had read or heard. Everything was grist to his mill but he separated the chaff from the grain and applied himself to direct study with an objectivity and continual self-criticism, as scrupulous as that of the modern research-worker.

For example, one might ask how he, in Tuscany, could have known about the behaviour of the pupils of the eyes of 'the lion tribe, as panthers, pards, ounces, tigers, wolves' and so on. The lion (as witness his own name) was part of the Florentine tradition. It was the emblem of the city's independence. The *Marzocco*, the heraldic lion, is supposed to date back to the Etruscans. During the Middle Ages, the Florentine *Signoria* kept a den of lions in the dungeons of the Palazzo. They were beasts of augury: the sickness or death of a lion was supposed to presage catastrophe and if a lioness bore many cubs it was a matter of civic celebration because it meant prosperity. In Leonardo's day there was a regular menagerie near the Palazzo, which was replenished by animals either presented by foreign potentates or brought back by traders from distant parts.

At festivals the beasts were set against one another. The market place was turned into an arena, with the booths boarded up and grandstands built above street level. In the open were 'tortoises', movable structures, from which men goaded the animals with lances. The wild boar was hunted in the streets. Buffaloes charged. Bears were baited. Lions and leopards were turned loose to fight one another. On one such occasion, when Leonardo might have been present, 40,000 people witnessed a blood-orgy, in which, apart from the animals sacrificed, three men were savaged to death.

Leonardo was able to obtain the body of a civic lion to dissect. He claimed to show that the lion was furnished with much keener senses than humans:

I have seen in the lion tribe that the sense of smell is connected with part of the substance of the brain which comes down the nostrils, which form a spacious receptacle for the sense of smell. . . . The eyes in the lion tribe have a large part of the head for their sockets and the optic nerves communicate at once with the brain; but the contrary is to be seen in man, for the sockets of their eyes are but a small part of the head, and the optic nerves are very fine and long and weak, and by the weakness of their action we see by day, but badly at night, while these animals can see as well at night as by day. The proof that they can see is that they prowl for prey at night and sleep by day, as nocturnal birds do also.[25]

Apart from his voluminous notes and instructions on his optical theories with regard to perspective, light and shade, and colours, as well as his anatomical studies of the eye, Leonardo applied his knowledge to the construction of optical devices.

Contrast the conditions under which the artists in the visual media work today in, say, a colour-television studio with its racks of powerful lights, with those of Leonardo's time. The only brilliant and constant source of light was the sun itself and Leonardo devoted a great deal of attention in his notes to the natural lighting of the artist's studio. But artificial lighting, on a winter's day, in the interiors where

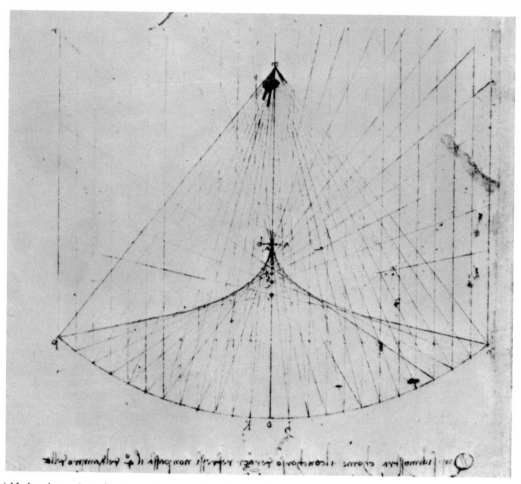

*'Make glasses in order to see the moon large' wrote Leonardo beside a drawing for a concave mirror. Perhaps he was thinking of a reflecting telescope. He certainly used parabolic mirrors to focus light, and experimented with concave lenses.*

artists painted their frescoes, or in the mortuary where Leonardo carried out his anatomical studies, was, for the artist, almost as primitive as the firelight by which our prehistoric ancestors did their cave-drawings. The smoking resin torches in their sconces on the wall played tricks with the shadows. The tallow candles, which were then being moulded, flickered constantly and the wicks of the oil-lamps spluttered and wavered. Leonardo, applying his researches in optics, devised a clear steady light. He had a glass cylinder fitted into the middle of a big glass globe and he filled the globe with water so that the glimmer of the wick soaked in olive oil was magnified into a constant radiance. His later improvement was an adjustable wick. Thus we can recognize, in Leonardo's contrivance of 1490, the oil-lamp which was to be adapted to kerosene and to remain the source of light until gas and electricity came along in the nineteenth century.

Leonardo described a magic lantern (which has been attributed to Roger Bacon). This was a projector fitted with an enlarging lens, and an enclosed light, which threw images on to a screen. He used parabolic mirrors to focus light and he experimented with concave and convex lenses. Beyond all others of his time Leonardo insisted on the dominance of the eye over all other senses:

> The eye whereby the beauty of the world is reflected by beholders is of such excellence that whoso consents to its loss deprives himself of the representation of all the works of nature. Because we can see these things owing to our eyes the soul is content to stay imprisoned in the human body; for through the eyes all the various things of nature are represented to the soul. Who loses his eyes leaves his soul in a dark prison without hope of ever again seeing the sun, light of all the world. . . .[26]

He even maintained that the nobility of the sense of sight is three times greater than any of the other senses:

> It is the lord of astronomy and the maker of cosmography; it counsels and corrects all the arts of mankind; it leads men to the different parts of the world; it is the prince of mathematics, and the sciences founded on it are absolutely certain. It has measured the distances and sizes of the stars; it has found the elements and their locations; it divines the future from the course of the stars; it has given birth to architecture, and to perspective, and to the divine art of painting. . . . With the help of the eye human industry discovered fire, by means of which the eye regains that whereof darkness had formerly deprived it. The eye decorated nature with agriculture and delightful gardens.[27]

# The Lute-playing Engineer

Science is the observation of things possible, whether present or past; prescience is the knowledge of things which may come to pass.[1]

For some reason, or possibly for many reasons, Leonardo in 1481 abandoned his great composition the *Adoration of the Magi*, now in the Uffizi Gallery in Florence. The *Adoration* never progressed beyond its brown and gold groundwork, yet it is one of the most powerful of all his compositions. In his art it was an end and a beginning—an end because it embodied all his searchings as a pupil in Verrocchio's studio; all his experiments with perspective and geometric forms, his interest in architecture and his fascination with the human body; and it was a beginning because it was a foresight of all Leonardo's later work, full of themes, actual and dreamlike, sensitive and at the same time full of foreboding. It was the final breakaway from orthodoxy, revolutionary and anti-classical.

The many sketches and experimental drawings which obviously referred to the Uffizi *Adoration* show how much detailed and scientific preparation Leonardo put into it. On countless sheets Leonardo drew the attitudes and expressions of men confronted by the supernatural. The horses were sketched and re-sketched, naturalistic, impressionistic, prancing and docile. He rehearsed in his drawings the architecture which fills the background of the picture. His study-sheet in the Uffizi shows precise geometry and an insight beyond the formal perspectives of his contemporaries. It remained unfinished. Why?

The painting had been ordered in 1481 by the monks of San Donato a Scopeto who had received a bequest of property. Their notary, Ser Piero da Vinci, suggested that they should commission a painting from his son. Their proposal was more complicated than a Hollywood contract. The monks offered Leonardo one third of the property they had inherited, but he was not to sell it for three years and during this period they were free to re-purchase it from him for 300 florins. But he was also supposed to pay an outstanding legacy and, contrary to the custom, to provide all his colours and any gold needed for the painting. There was a penalty

*Six figures. A study for the* Adoration of the Magi, c. *1481.*

*'The youth ought first to learn perspective'* wrote Leonardo in his precepts for the painter. His drawing *c. 1481, for the* Adoration, *shows how he constructed an architectural setting based on a central perspective, and drew in the figures afterwards.*

clause by which he lost everything if the painting was not delivered within thirty months. One can almost see the hard-headed father dictating the terms to harness his son whose artistic waywardness he distrusted—and with good reason, if lack of sympathy.

Leonardo did not find the money for the legacy because, as the monks recorded in their ledger, 'he had no means of doing so'. They grudgingly helped him with some subventions—scraps from the refectory table as far as the artist was concerned. And while he was struggling with his masterpiece on such a pittance, three of his fellow artists, Domenico Ghirlandaio, Cosimo Rosselli and Sandro Botticelli, and his fellow student Perugino, were working on the most important assignment in the art-world of the day, the frescoes of the Sistine Chapel in Rome.

Perhaps one of the reasons why Leonardo left the painting unfinished can be found in the very painting itself. The composition is extremely ambitious; sixty-six human figures and eleven animals have been counted in it. The main group of figures is arranged in a semi-circle around the Virgin and Child, and only the figure on the extreme right looks away. A practice of the time was for artists to include themselves in their paintings but if Leonardo wanted to immortalize himself as that tall, muscular, supremely handsome young man whom his contemporaries later

recalled, all we have here is an unfinished fragmentary figure of disenchantment.

Political disturbances of the time may have unsettled Leonardo. His famous drawing of the hanged conspirator Bernardo di Bandino Baroncelli is a horrific reminder of the Pazzi plot. It was the ghoulish custom of the day for distinguished artists to be hired to paint at forty florins apiece the portraits of the hanged in the palace of the chief magistrate. Bandino had been the hired assassin in a conspiracy in 1478 which involved the Pope, Sixtus IV (who at about that time was also engaged in glorifying the Sistine Chapel). It was intended to remove Lorenzo de' Medici from control of Florence. Lorenzo had fallen foul of the Pope, and was financing the operations of *condottieri*, hired mercenaries, against papal territory.

Lorenzo had intractable enemies, including Francesco de' Pazzi of the rival Florentine banking family, Archbishop Francesco Salviati and Girolamo Riario, nephew or, more probably, son of the Pope Sixtus IV. (Those were the days of permissive 'celibacy' when the pontiff was 'papa' to his nephews and 'uncle' to his sons.) The Pope was cognizant of the plot and approved the removal of the Medici provided it did not involve bloodshed, saying sanctimoniously, while well apprised of the probable outcome, 'It is no part of my Holy Office to occasion the death of a man'.

The plot was to dispose of the two sons of Piero de' Medici, called 'the Gouty', who for five years had ruled after the death of Cosimo. Lorenzo was the elder, later known as 'the Magnificent'. Giuliano, his brother, was a sickly young man of twenty-five. Both had to die.

The Pope had replaced a Medici Archbishop by Francesco Salviati, whom Lorenzo refused to recognize. He had also appointed Girolamo Riario's nephew, a boy of eighteen, as Cardinal and as Papal Legate to Perugia. On his way to take up this post the new Cardinal visited Florence and invited the Medici brothers to a reception at a villa belonging to the Pazzi family. Giuliano was ill and could not attend, so the plot temporarily misfired. The following week Lorenzo held a fête at Fiesole in honour of the Cardinal but again Giuliano was absent, so again the plot misfired. The Archbishop Salviati then persuaded the Cardinal to celebrate High Mass in the Duomo, the cathedral of Florence. The Medici brothers could not refuse to attend. While the hired troops of the conspirators were posted around Florence to move in once the assassinations had taken place, the bells pealed on the morning of Sunday, 16 April 1478.

The signal was to be the elevation of the Host but the assassin Montesecco, who was supposed to murder Lorenzo, balked at the sacrilege. His place was taken by two priests, Antonio and Stefano. Again it looked as though it might misfire because Giuliano was still indisposed but Bandino, the rakish son of a Neapolitan noble, and Francesco de' Pazzi, the banker, went to his palazzo and 'jollied' him into going to the Duomo. With a great show of concern they assisted him into the church, satisfying themselves in the process that he wore no mail shirt. Lorenzo,

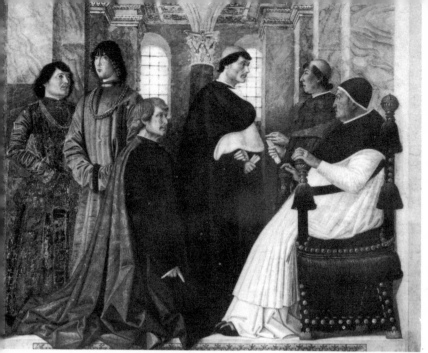
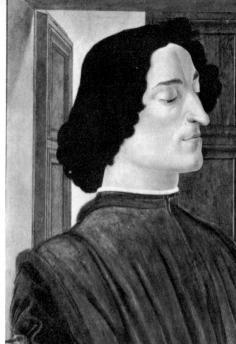

LEFT *With Pope Sixtus IV are some of his Riario nephews. They plotted against the Medici, and Giuliano, shown* RIGHT, *in Botticelli's portrait, was assassinated.*

with the two monks in murderous attendance, was already there. As Giuliano joined him, the Host was raised. Bandino and Pazzi drew their daggers and stabbed their victim. But a friend of Lorenzo, seeing the monks about to attack, threw himself in between and was killed. Lorenzo was able to draw his sword to defend himself, and suffered only a slight wound before he vaulted into the choir with Bandino and Pazzi in bloodthirsty pursuit. He reached the sacristy where, with the help of a friend, he succeeded in barricading the door. Bandino, the hunter turned hunted, bolted out of the cathedral and up the stairs of the campanile, where he crouched among the great bells, which were still pealing.

The boy cardinal had collapsed in hysterics in front of the altar, a heap of purple vestments, screaming to heaven that he had known nothing of it. Lorenzo was smuggled out, although he had nothing now to fear because the screaming mob was on his side.

The Archbishop Salviati tried to brazen it out. He went to the Palazzo Pubblico to protest his innocence, but he behaved so unconvincingly that the members of the *Signoria* locked the door to hold him prisoner. The hired bravos of the Pazzi, however, attacked the Palazzo to rescue him. They battered down the huge doors but the mob which had swept in with them then turned against them. The Archbishop was seized just as Francesco de' Pazzi was dragged in, badly beaten up. They were at once hanged from the windows of the Palazzo, the Archbishop's purple-stockinged legs dangling below his cassock. Others were lynched in the same way, and when their bodies were lowered into the piazza they were carved up like butcher's meat. The monks had been captured and had their noses and ears cut off

74

before they were executed. Montesecco, the hired assassin, who had recoiled from sacrilege, gave himself up, signed a full confession and was immediately beheaded.

In this orgy of killing, one man could not be found—Bandino. For four days, without food, he crouched amongst the great bells that were clanging continuously, celebrating the escape of Lorenzo and tolling the death of his brother. He escaped and fled from one country to another, with every Medici agent alerted to capture him. He reached the Bosphorus where he thought himself safe in Constantinople. But the Medici power was such that he was arrested by the order of the Sultan and handed over to Antonio de' Medici, the representative of the family at the Ottoman Court, who personally brought him back in chains to Florence to be hanged.

The execution of the other leading conspirators had earlier been portrayed by Botticelli, the artist of *The Birth of Venus, The Allegory of Spring,* and *The Adoration of the Magi.* He had depicted the dead hanging by their feet, like the later Mussolini. He collected forty florins per corpse. In later years, sickened by the excesses of the Medici (who systematically obliterated the Pazzi family), Botticelli abandoned painting nudes and became a morose follower of Savonarola. Vasari, who was born the year after Botticelli's death, reports, 'he might have died of hunger had he not been supported by Lorenzo de' Medici, for whom he worked at the small hospital of Volterra'[1]: Lorenzo, the very man whose cruelties and licentiousness Savonarola had died denouncing.

Leonardo's death-picture of Bernardo di Bandino Baroncelli, who was executed a year and a half after his escape, was not a commission. Vallentin suggests that Leonardo was so hard up that he was looking for forty florins, which he did not get. This is plausible because, while it is a pen-and-ink sketch, the notes on the side are obviously intended as directions for a painting: 'A tan-coloured small cap. A doublet of black serge. A black jerkin, lined, and the collar covered with black and red stippled velvet. A blue coat lined with fur of foxes' breasts. Black hose', and the name 'Bernardo di Bandino Baroncelli'.[2]

The year which had followed the Pazzi conspiracy had been one of violence. The purge which Lorenzo launched to revenge his brother and remove his rivals had been utterly ruthless. No person was really safe from the Medici secret police. The city was full of informers, betraying for money or for private vengeance. Patriotism was a pretext for murder. Bodies floated down the Arno and nobody asked who they were. On top of all this, Sixtus IV had provoked a holy war against the Medici. The execution of the archbishop and the imprisonment of his nephew, the boy cardinal, so enraged him that he excommunicated Lorenzo. He put the city under interdict, and called on King Ferdinand of Naples to join him in reducing Florentine presumption. The combined armies were commanded by the Duke of Urbino and Ferdinand's son, the Duke of Calabria. The Florentines who might be bloodthirsty in their own streets had little stomach for set battles. The shopkeepers preferred to hire others to do their fighting and in this case they were badly served.

 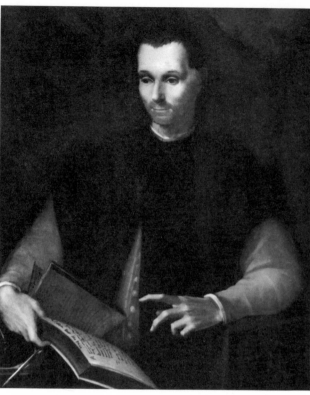

LEFT *Bernardo di Bandino Baroncelli, hanged.* RIGHT *Niccolò Machiavelli (1469–1527). In 1502 Leonardo met Machiavelli and they became friends.*

Machiavelli, who was to become the archetype of political chicanery, was a boy of ten but old enough to be humiliated by the poor showing of the citizens; it was to influence his whole career. 'So cowardly and poor-spirited that army was become', he wrote later, 'that the turning of a horse's head or tail gave either victory or defeat.'ᴮ He himself was later to initiate a national militia for Florence but in dealing with its enemies he believed in the non-principle of 'if you can't beat them, cheat them'. This was what Lorenzo de' Medici proceeded to do in the papal war. In the summer of 1479, the papal troops had routed the Florentine army and had advanced to within eight miles of the city to besiege the fortresses in the surrounding hills. When the papal commanders had reduced the fortress of Colle after a long siege, they shirked a winter campaign and agreed to a three months' truce. Lorenzo took the opportunity of the respite to double-cross the Pope by going to the King of Naples personally and using his wealth to buy a settlement. The Pope, left in the lurch by his ally, had to agree to terms. These left Lorenzo undisputed master of Florence, while imposing heavy financial burdens on the merchants. As always they cut back on culture, and the artists, including Leonardo, had a hard time.

Leonardo who, it is said, could break a sword by the strength of his wrist, showed

76

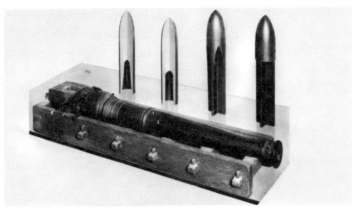

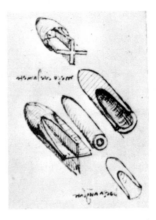

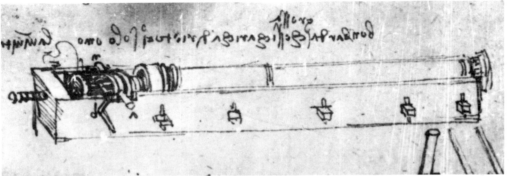

*Leonardo's drawings for streamlined shells* TOP RIGHT *and a breech-loading cannon* ABOVE *have been constructed as models* TOP LEFT *in the Science Museum, Milan.*

no disposition to wield it. The effect of the Florentines' reluctance to fight had a different effect on him than it did on Machiavelli. He who wrote 'just as courage imperils life, fear protects it'[3] decided that the age of chivalry was well and truly over and that mechanical ingenuity could more surely win battles. He was a scientific observer of the war which humiliated his city. He discovered the science of war with the same enthusiasm that he showed for all new ideas. He recognized that man's new mastery over iron and steel and of mechanical contrivances could be decisive on the battle-field. His notebooks and sheets around this time are bespattered with drawings and suggestions for military devices. He even used old sketches as a scratch-pad for drawings of arms and war materials. He studied the military treatises of Vegetius, Valturio, and his contemporary, Francesco di Giorgio.

The cannon, which our school textbooks always assure us 'put paid' to the cavortings of knights in armour, were clumsy affairs, difficult to mount and to manipulate. Leonardo applied his mind to the casting and boring of cannon, and left notes for the compounding of good bronze for mortars. He worked out the scientific dimensions for the thicknesses and length for projectiles of different

77

materials. He drew a three-wheel gun-carriage with a screw fitting terminating in large forceps which gripped the gun-barrel. He designed 'a bombard which will not recoil when it is fired'.[4] He invented a breech-loading gun. He even proposed a steam gun. He studied the trajectory of cannon balls and the mathematics of ballistics. He recognized the effects of friction and demonstrated that cannon balls must be smooth and that they compressed the air ahead of them. The noise of cannon balls in the Tuscan hills was very different from the sound of jet planes rupturing the sound barrier, but Leonardo with his interest in air as compressible matter and in sound waves, was anticipating the sonic boom-makers four and a half centuries later. He proposed the stream-lined cone of the modern bullet and shell.

His most ingenious device at this time, however, was a sort of machine gun. It forestalled the Colt revolver, the Winchester repeater rifle and Hiram Maxim. And like all good ideas (as he kept reminding himself in his notes) it was simple. It consisted of three racks of eleven cannons, mounted in triangular shape on the common axis of the gun carriage. While the barrels in one rack aimed longitudinally were being discharged simultaneously, the gunners would be loading the second rack to be rotated presently into firing position. The third rack would come up to be charged while the first was cooling off. His assembly also included the screw-

*Cannon mounted on a wooden turntable,*
*drawn by Konrad Kyeser in his treatise of 1405.*

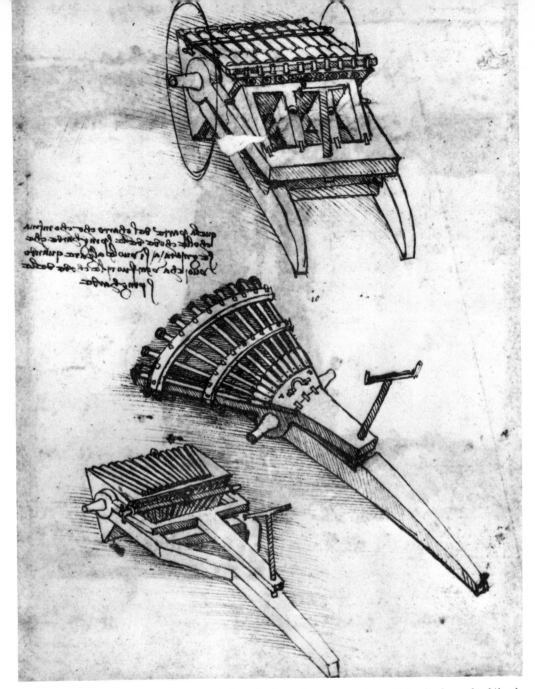

*Leonardo's machine guns. In the top design, the barrels in one rack could be discharged while the gunners were loading the second rack, to be rotated presently into the firing position. The third rack would come up to be charged while the first was cooling off.*

jack method for setting the packaged battery at variable angles. He borrowed and improved upon the designs for composite guns shown in the works of the German, Kyeser. Leonardo's drawing shows ten barrels arranged in a fan formation, so that the salvo could be spread over a wide arc of the attacking forces.

With the Florentine garrisons under siege, Leonardo was naturally preoccupied with methods of repelling assault. During the long siege of Colle, Leonardo may have been thinking up ideas to prevent the assault-troops from forcing entry. Assault towers and methods of repelling invaders are continually described in the works of medieval military engineers, and some of these Leonardo may have seen. To prevent attackers from scaling the walls he proposed that there should be a system of beams, rather like a horizontal portcullis, along the outside of the wall. As the attackers came swarming up their ladders, the beams, operated by a lever and pulley system from inside the fortress, would push forward and topple them. And go on doing it every time scaling ladders were used. Another was imaginative

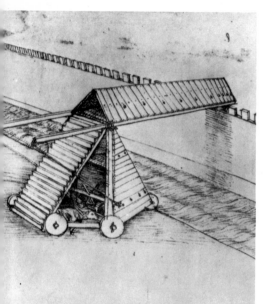 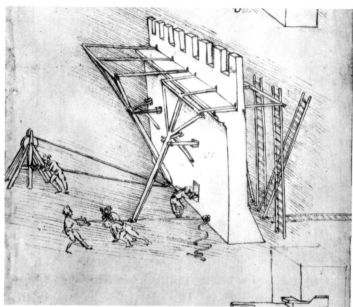

*A movable covered scaling ladder* LEFT, *and* RIGHT, *a device operated by a system of levers to overturn the ladders of would-be invaders, from Leonardo's repertoire of military machines.*

but unlikely; it was a giant cogwheel which set in motion horizontal sails to sweep the invaders aside like a windscreen wiper.

Of course, if you consider defence, you dream up the kind of things you would do if you were the other fellow. Leonardo sifted through many peoples' ideas. He drew a scaling ladder mounted on a movable carriage, like the modern fireman's. He refined that idea, and designed a covered assault staircase, like the all-weather gangways to modern jet-liners, to protect the attackers from the hail of missiles from the battlements. Some of his ideas, like the saps for explosive mines, to be tunnelled by mechanical diggers under the enemy's emplacements, he self-censored because it might give the other fellow ideas.

*Leonardo:* Adoration of the Magi *1481–2.*
OVERLEAF, ABOVE *Lunette of the Medici villa of Poggio a Caiano, painted by Giusto Utens.* BELOW *Four humanists from a fresco by Ghirlandaio. On the far left is Marsilio Ficino.*

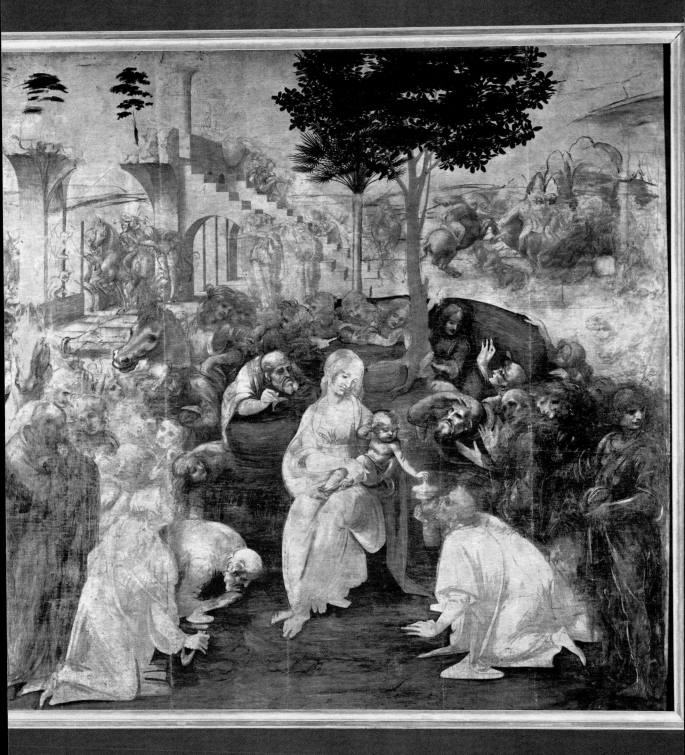

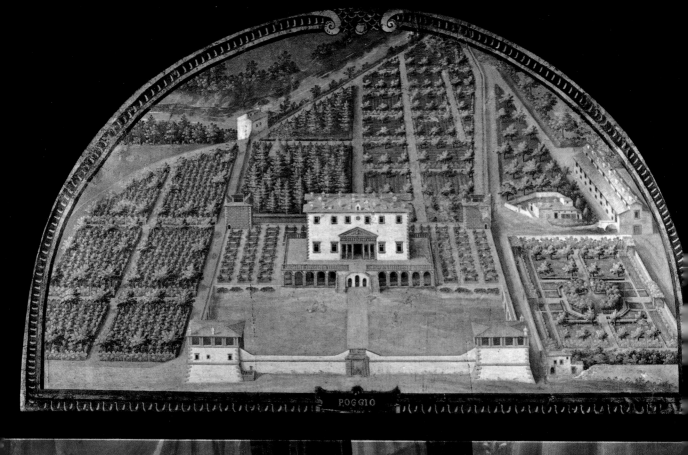

POGGIO

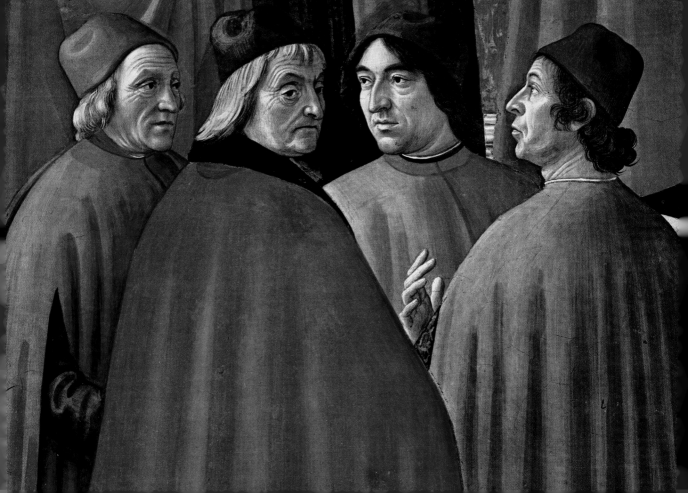

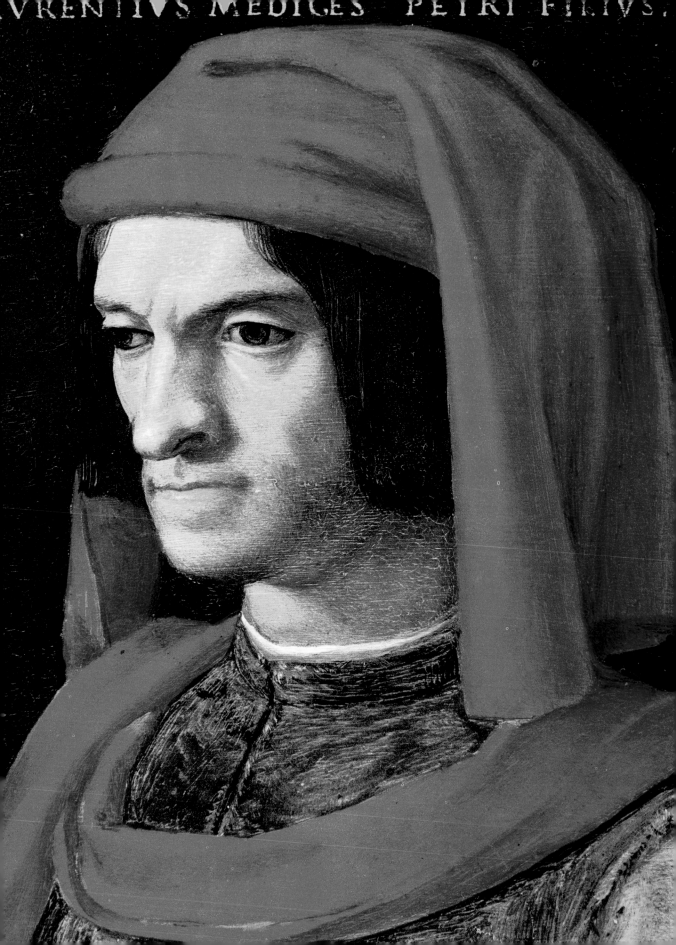
LAVRENTIVS MEDICES PETRI FILIVS.

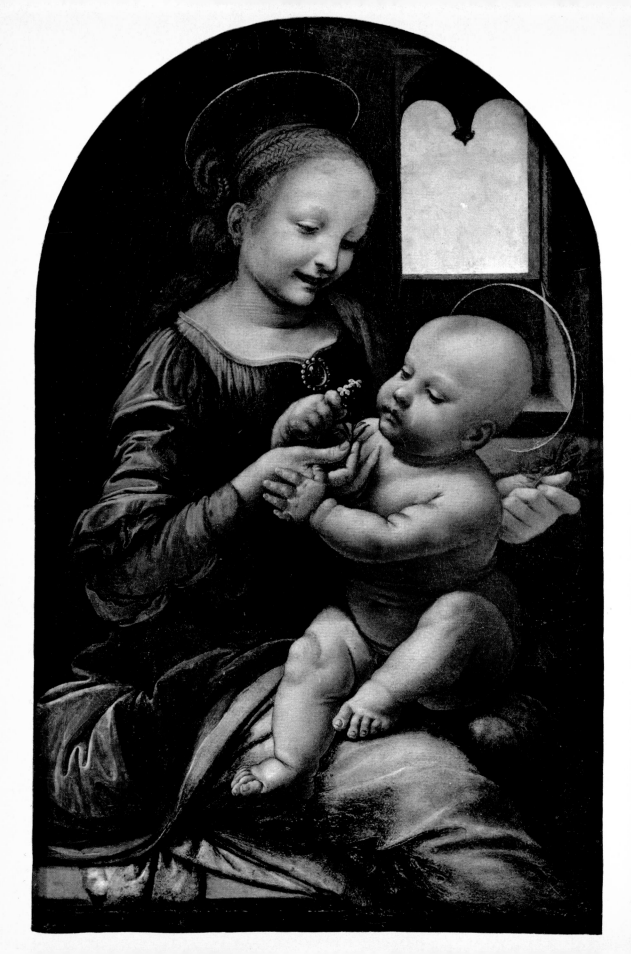

Another idea has a very modern relevance. The drawbridge was by then a familiar fortification feature. He proposed a swing bridge, operated by capstans, which could be swung over not just a moat but a river in order to make an island fortress secure.

This was the man who was drawing the smiling Madonnas and the cherubic children, who was so fond of living things that he was a vegetarian and whose practice in the market place of Florence of buying caged birds only to set them free probably aroused derision. He was a gentle giant keeping violence at arms length in an age of brawling and who, if not a conscientious objector, was certainly not a frontline volunteer. For all his scruples he became an armchair expert on warfare with a draughtsman's delight in creating fantastic weapons. He was like the 'War Games' enthusiasts and button-pushers of the nuclear age: his scruples diminished with the range of weapon. He de-personalized his killing. He would not have killed anybody himself, any more than he would have eaten the pig into whose throbbing heart he would push a stiletto for purely scientific purposes.

There is no doubt that at this savage time, the end of his first Florentine period, he was unhappy. He was certainly hard up. Some of his lesser contemporaries were getting the commissions which he thought he ought to have had, and although his feelings did not compare with his rivalry with Michelangelo later, he obviously felt slighted. This was combined with his distaste for the ugliness of the ruthless politics of his time.

Florence itself was a contradictory place. It was a city of jealously-guarded crafts, where the rare traditional skills of weaving, for instance, were heavily protected and innovation discouraged. But there is no doubt that Leonardo, the inquisitive, had access to the workshops and the studios of the craftsmen and was observant of their techniques, an insight which was to reveal itself later in his inventions of machines which mechanized those skills. Florence was wealthy, and its trading wealth was taxable by the overlords and profitable to those middle-men, the bankers. The Medici were both overlords and bankers. Lorenzo de' Medici, called 'the Magnificent', devoted rather less time to business and finance than his forbears had done. He assumed the role of patron of the arts, and also arranged extravagant festivals and tournaments. He wrote poetry and regarded himself as a philosopher. A school of sculpture, later to include Michelangelo among its pupils, was established in the garden of San Marco, and the Medici palazzi and country villas were decorated by the leading artists. Marsilio Ficino presided over the Plato Academy. Ficino dedicated a translation of Plato's dialogues to Lorenzo and defined the mission of the Academy, 'In the gardens of the Academy, beneath the laurels, poets will hear the singing Apollo, orators on the threshold will catch sight of Mercury declaiming poetry, jurists and rulers of governments on the portico and in the hall will hear Jupiter himself giving laws, defining rights, ruling states. Finally, philosophers within the building will recognize their Saturn, the contemplator of heavenly

*Leonardo:* The Benois Madonna, *1478.*                                                              85
PREVIOUS PAGE *Lorenzo de' Medici (il Magnifico) by Bronzino.*

mysteries. And everywhere priests and clergy will find weapons with which to defend piety steadfastly against the profane.'<sup>C</sup> The declared objective was a reconciliation of Platonism and Christianity. These were the humanists who were supposed to be revitalizing learning but the very term itself was confused. Humanism was supposed to be a belief in the higher qualities of man, but could also mean that pedantic and arid scholarship in which 'humanitas' was concerned with the cultivation of the 'noble' or 'good' arts, primarily classical philosophy. This had produced an aristocracy of 'learned persons' in opposition to the 'unenlightened rabble'. Leonardo, the self-avowed 'man without learning' was bitterly resentful of this type of supercilious and introspective scholarship which Lorenzo was encouraging at the expense of the visual arts and the mechanical arts.

Those were hard times for Leonardo and his fellow-artists. They were like actors waiting for a call from the casting office, their princely patrons. Leonardo, despising the hangers-on of the Court, was, nevertheless, anxious to attract princely attention. He made the most of his appearance. 'Anonimo' Fiorentino says, 'He was beautiful in person, well proportioned, graceful, and of fine appearance. He wore his red coat short to the knee, whereas the custom at that time was to wear garments long. Reaching to the middle of his breast he had a fine beard, curling and well shaped.'<sup>D</sup> He was no more successful with his civic patrons than with his princely ones. In 1478, he received his first major commission: an altar-piece for the chapel of the Palazzo Vecchio. His conscientiousness and pride of craftsmanship was taken as dilatoriness. He made extensive experiments with colours and innumerable sketches, but the commission was taken from him and given to another. In great need Leonardo painted the clock of San Donato—nothing more creative than a house-painter's job. Nor did he get the commission for the finished picture for which he made the sketch of the hanged Bandino.

It was, therefore, a rather dissatisfied and temperamentally erratic young man in his late twenties whom his father, the notary, tried to swaddle in a penalizing contract with the monks of San Donato a Scopeto. It showed peculiarly bad psychology on the part of the father but, throughout their lives, there was an apparent lack of understanding between the two. The father's intentions may have been for the best but the arrangement could not work and so the *Adoration of the Magi* never got beyond the groundwork which tantalizes us with the powerful promise of the painting it might have been.

He obviously tried a bit of freelancing. On a sheet of drawings he wrote '——ber 1478 I began the two Madonnas'.[5] One was probably the *Benois Madonna* now at the Hermitage in Leningrad.

He was already disenchanted with the Medici, although he never entirely escaped from them until his very last phase. In his latter years he was to write: 'The medici made me and ruined me'.[6] It depends on how one interprets his words; 'medici' could mean the *doctors*, whom he distrusted, and not 'Medici', the princes.

86

*The* lyra. *Leonardo took to the Duke of Milan a silver musical instrument he had made in the shape of a horse's head.*

Whatever the exact reasons were, Leonardo left Florence. It has been suggested that Lorenzo abetted his decision, and sent him to the court of Milan, not as a famous painter, scientist and engineer, but as a singer and lute player. Vasari, writing from hearsay, says that Leonardo had begun to study music and 'resolved to learn to play the lute, and as he was by nature of exalted imagination, and full of the most graceful vivacity, he sang and accompanied himself most divinely, improvising at once both verses and music.'[E] Paolo Giovio, a contemporary Milanese historian, confirms 'He sang beautifully to his own accompaniment on the lyre to the delight of the entire court.'[F]

The tyrant of Milan, Ludovico Sforza, called *Il Moro* (the Moor), because of his swarthy complexion, knew of the Florentine musician. His tastes ran to entertainment rather than art or high thinking, and he dropped a hint to Lorenzo. The pretext which the Medici had for sending him was the fact that Leonardo was in possession of a new and bizarre instrument which he had designed and made himself. This was the *lyra*, a kind of lute. It was such as had never been seen before: it was fashioned in silver in the shape of a horse's skull with the teeth as the frets. It was an instrument producing sound of 'great volume and purity'. Leonardo was not only to play it for the edification of *Il Moro*; he was to present it as a gift of the Medici for political favours to come. So Leonardo set off for Milan accompanied by Atalante Migliorotti, an actor and musician.

Leonardo was not only a musician and a singer. He went further as usual and studied the physics of music. He understood the fundamentals of acoustics:

> Although the voices penetrating the air spread in circular motion from their sources, there is no impediment when the circles . . . meet. Because in all cases of motion there is a great likeness between water and air. . . . I say if you throw two small stones at the same time on a sheet

87

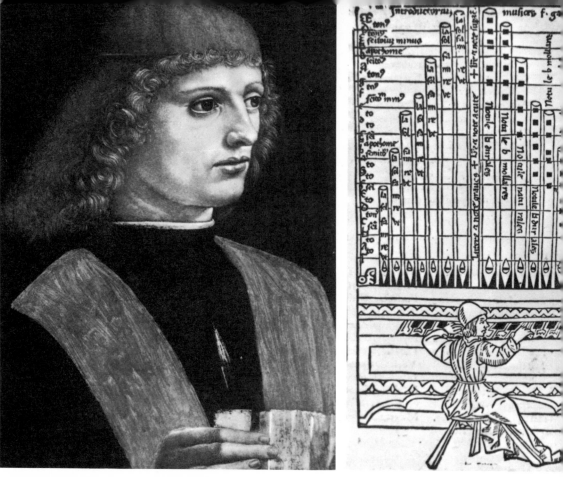

*Franchino Gafori, musician and choirmaster in Milan, is probably the subject of this portrait* LEFT *c. 1485–90, by Leonardo. Gafori wrote two books on the theory of music, and the woodcut of an organist* RIGHT, *was first used in his book of 1480.*

of motionless water at some distance from one another, you will observe that around the two percussions quantities of separate circles are formed which will meet as they increase in size and then penetrate and intersect one another, while all the time maintaining as their respective centres the spots hit by the stones.[7]

He also understood the physics of the echo:

... the sound of the echo is reflected to the ear from the percussion, just as the shapes of the objects are reflected from the mirror into the eye. And as the likeness is reflected from the object into the mirror and from the mirror to the eye at equal angles, so sound will also fall and be reflected....[8]

He knew that sound took longer than light to travel and calculated the time-interval between thunder and the lightning. While he insisted that the eye was superior to the ear in the hierarchy of the senses he described music as the sister of painting. He lamented the 'unhappy fate of music' because it was born to fade away, while the contours of painting which he compared to the harmonies of music remained.

He dissected the human voice mechanism. He explained how the expansion and contraction of the thorax acts as bellows, driving the air through the trachea, or windpipe. He showed how the trachea, the cartilaginous elastic passage from the lung to the larynx, by contracting and expanding, controls the quantity of breath which passes. He compared the windpipe with organ pipes, and showed the muscles of the mouth and lips which shaped the sounds. He carried out practical experiments with instruments to calculate for instance, the size of organ pipes. He drew designs of a mechanism to operate bell chimes. He invented a hurdy-gurdy and sketched the idea of a mechanized harpsichord. The *Codex Atlanticus* contains a drawing of a zither and of a mechanical drum.

The court to which Leonardo took his lute would seem to have offered little improvement on that of the Medici court in Florence. The Sforzas had acquired their power by treachery. Francesco, father of Ludovico, had been a successful *condottiere*, an ennobled brigand, selling himself and his mercenary army to the highest bidder. Milan, at war with Venice, had hired him. At the crucial moment he switched sides and took possession of Milan for himself, on the pretext that having married the illegitimate daughter of the last Visconti duke he could claim the succession. He had two sons, Galeazzo Maria, the elder, and the swarthy Ludovico. Galeazzo, who had succeeded to the dukedom, was murdered by three citizens of Milan in 1476. He had married a sister of the Queen of France, called Bona of Savoy who, left with a weak-minded son of seven, assumed the regency. Ludovico by guile and violence managed to displace her and had just confirmed his despotic powers when Leonardo moved to Milan.

While he played his lute and sang songs, Leonardo also engaged in a piece of market research. His cultural talents had not paid off in Florence so he set about finding out what this particular customer wanted. The result was a remarkable

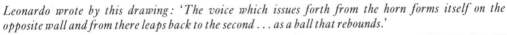

*Leonardo wrote by this drawing: 'The voice which issues forth from the horn forms itself on the opposite wall and from there leaps back to the second . . . as a ball that rebounds.'*

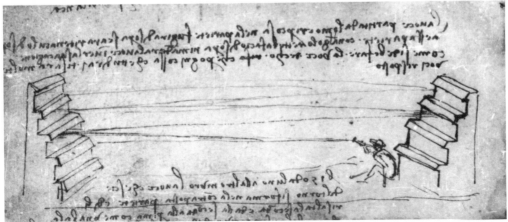

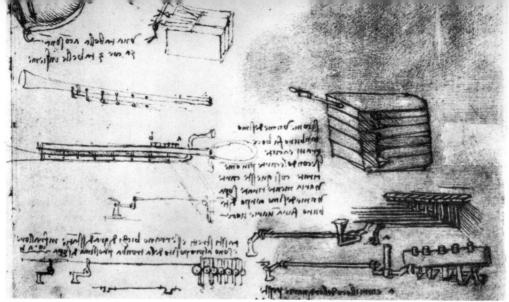

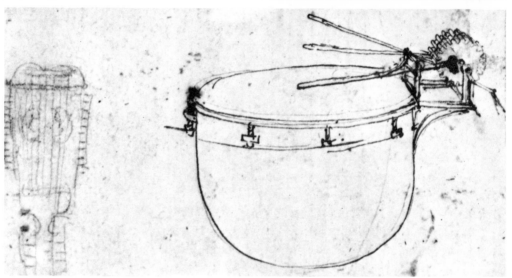

'Keys narrow . . . and holes will be far apart; these will be right for the trumpet' wrote Leonardo by the drawing CENTRE. His orchestra also included, TOP, a mechanical drum 'for harmony', and RIGHT, a bell struck by a mechanical clapper.

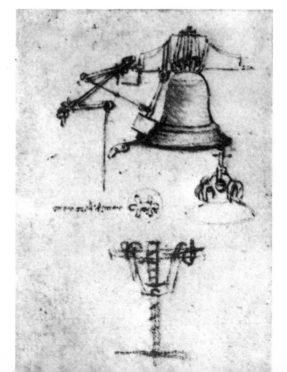

90

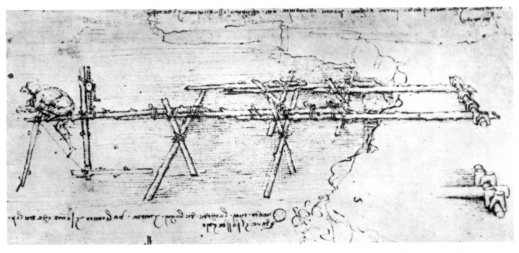

*Leonardo's designs for military bridges included this trestle bridge which could be adjusted by the jack seen at the left.*

document which reads more like a mail-order catalogue than one man's request for patronage. Here is his self evaluation:

> Most illustrious Lord. Having now sufficiently seen and considered the proofs of all those who count themselves masters and inventors of instruments of war, and finding that the invention and working of the said instruments do not differ in any respect from those in common use, I shall endeavour without prejudice to anyone else to explain myself to your Excellency, showing your Lordship my secrets, and then offering at your pleasure to work with effect at convenient times on all these things which are in part briefly recorded below.

*Leonardo's most significant bridge was the swing bridge, which was turned by operating the capstans placed on both sides.*

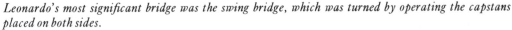

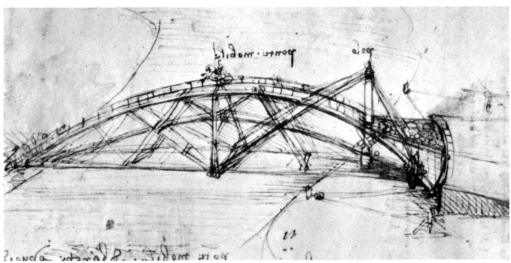

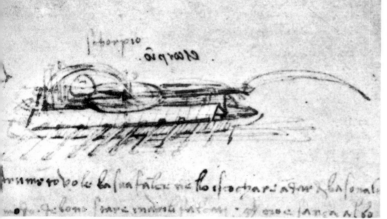 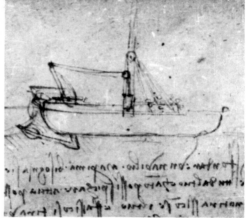

*'If it should happen that the fight was at sea I have plans for many engines'. The drawing* LEFT *has been reversed deliberately to show Leonardo's writing as in a mirror. The name 'escorpio' is not in Leonardo's hand. The ship* RIGHT *has a holing mechanism hidden under the water.*

1. I have plans of bridges, very light and strong and suitable for carrying very easily, and with them you may pursue, and at times flee from, the enemy; and others secure and indestructible by fire and battle, easy and convenient to lift and to place in position; and plans for burning and destroying those of the enemy.

2. When a place is besieged, I know how to remove the water from the trenches, and how to construct an infinite number of bridges, covered ways and ladders and other instruments having to do with such expeditions.

3. Also if a place cannot be reduced by the method of bombardment either owing to the height of its banks or to its strength of position, I have plans for destroying every fortress or other stronghold even if it were founded on rock.

4. I have also plans of mortars most convenient and easy to carry with which to hurl small stones in the manner almost of a storm; and with the smoke of this cause great terror to the enemy and great loss and confusion.

5. Also I have means of arriving at a fixed spot by caves and secret and winding passages, made without any noise even though it may be necessary to pass underneath trenches or a river.

6. Also I will make covered cars, safe and unassailable, which will enter among the enemy with their artillery, and there is no company of men at arms so great that they will not break it. And behind these the infantry will be able to follow quite unharmed and without any hindrance.

7. Also, if need shall arise, I can make cannon, mortars, and light ordnance of very useful and beautiful shapes, different from those in common use.

8. Where the operation of bombardment fails, I shall contrive catapults, mangonels, *trabocchi*, and other engines of wonderful efficacy and in general use. In short, to meet the variety of circumstances, I shall contrive various and endless means of attack and defence.

9. And if it should happen that the fight was at sea I have plans for many engines most efficient for both attack and defence, and vessels which will resist that fire of the largest cannon, and powder and smoke.

10. In time of peace I believe I can give perfect satisfaction, equal to that of any other, in architecture and the construction of buildings both private and public, and in conducting water from one place to another.

Also I can carry out sculpture in marble, bronze or clay, and also I can do in painting whatever can be done, as well as any other, be he who may.

Moreover, the bronze horse may be taken in hand, which shall endue with immortal glory and eternal honour the happy memory of the Prince your father and of the illustrious house of Sforza.

And if any of the aforesaid things should seem impossible or impracticable to anyone I offer myself as most ready to make the trial of them in your park, or in whatever place may please your Excellency, to whom I commend myself with all possible humility.[9]

Leonardo thought he knew his man. In his prospectus he was deliberately playing down his artistic attainment—sculpturing in marble, bronze or clay and 'painting whatever can be done, as well as any other' is a throwaway offer, but he emphasized the bronze horse because he knew that before Ludovico had come to power there had been a project to erect an equestrian monument in bronze in commemoration of his father, Francesco, 'the Thug'.

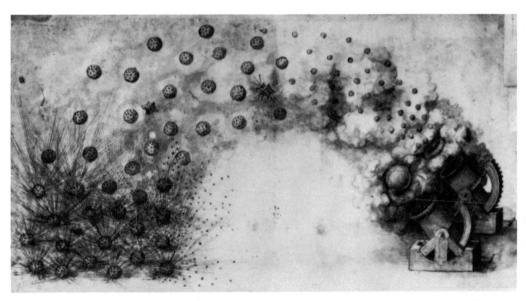

*Leonardo described the shrapnel shell to be fired from a bombard as 'the most deadly machine that exists . . . the ball in the centre bursts and scatters the others which fire in such time as is needed to say an Ave Maria.'*

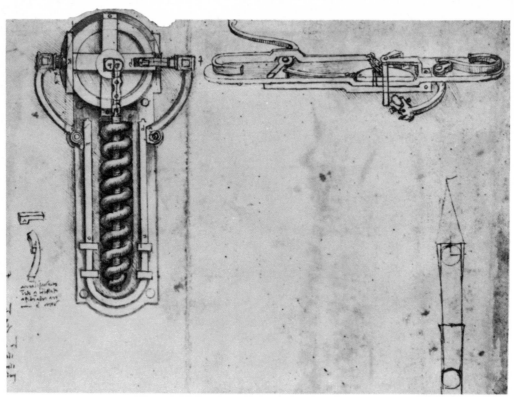

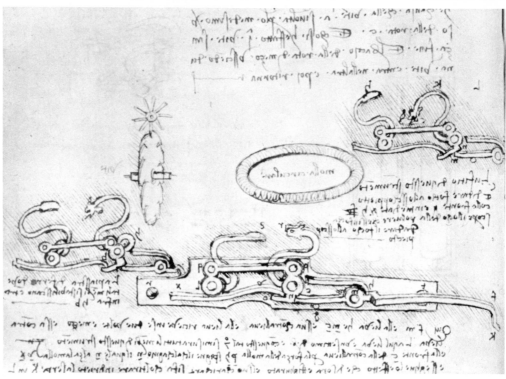

TOP *A steel wheel turned with a key winds a spiral spring in Leonardo's wheel-lock mechanism. On the right is a flint-lock. The flint-locks* ABOVE *show the serpent-headed cock to hold the flint. When the spring is released, the flint strikes a metal bar, to make a spark.*

# Earning a Living

Perhaps Your Excellency did not give further orders to Messer
Gualtieri, believing that I had money enough. . . .[1]

The relationship of Leonardo to *Il Moro* was a curious one. Obviously the brooding
despot liked having Leonardo around and humoured him, but there is very little
evidence that he listened to his advice on military matters or put into effect any of
the ingenious ideas for weapons and the like which Leonardo proliferated. The
sketches of these—and some were valuable innovations—were scattered through
the notebooks and sheets, some of them almost doodles, others suggesting a 'this-
is-how-it-could-work' sketch, and others carefully detailed with full instructions
for both construction and use.

Leonardo drew a novel pistol, with a wheel-lock instead of a match-lock, al-
though technological historians ascribe the invention to a Nuremburg watchmaker
thirty years later. But there it is in Leonardo's notebook: a steel wheel, which
turns with a key and winds a spiral spring. As soon as the ratchet-lever is dropped—
triggered—the wheel rubs against the flint (as in a modern cigarette lighter), a
spark is produced and the powder in the pan is fired. He also proposed an incen-
diary bomb, reviving 'Greek fire', and describes with gusto his own recipe: 'Take
charcoal of willow, and saltpetre, and sulphuric acid, and sulphur, and pitch, with
frankincense, and camphor, and boil them all together.'[2] To this composition he
added liquid varnish, bituminous oil, turpentine and vinegar. All this was reduced
to a kind of dough, and cooked in an oven. Then it was moulded into a round form,
studded with spikes, and given a fuse. This was to be directed against wooden
ships. He also went thoroughly into the question of poison shells. He proposed to
catapult these at the enemy with an explosive tar to release sulphide of arsenic,
lime and verdigris, in the form of powder 'and all those who, as they breathe,
inhale the said powder with their breath will become asphyxiated'.[3] He foresaw
the possibility that the wind might blow the poison back at the assailants, and he
took care of them by the invention of the mask of thin damp cloth. Instead of the

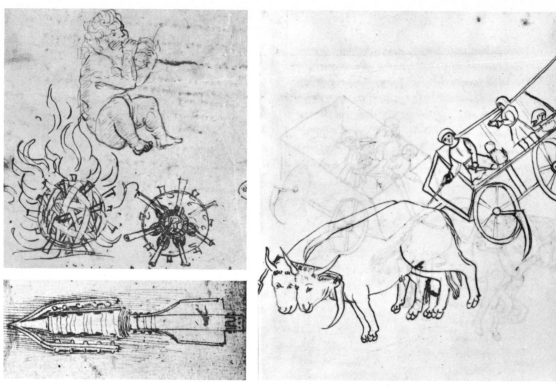

*'As it reaches the ground, the canes . . . are driven into it, thus igniting the powder.'* LEFT ABOVE *An incendiary bomb.* LEFT BELOW *A finned projectile also designed to explode on impact.*

solid cannon ball he wanted to substitute a conical streamlined shell with a built-in propellant. He designed a projectile—the first shrapnel shell—which he described as 'the most deadly machine that exists . . . the ball in the centre bursts and scatters the others which fire in such time as is needed to say an Ave Maria. . . .'[4] Whether he invented, or was merely familiar with, the idea of percussion-firing, he certainly drew projectiles with a heavy conical base which on impact penetrated a thin copper partition and fired the explosive contents. He drew a flame-thrower based on the ancient javelin. His explosive tubes for hand-to-hand fighting were the fore-runners of the Mills bomb. He always insisted that weapons should be of the most inflammatory material or should have a self-destroying charge so that they would be destroyed before the enemy could benefit by learning the idea of the invention.

For all this, he had briefed himself very thoroughly by examining the practices of the ancients and the works of his contemporaries. His library included an Italian edition of Valturio's *De Re Militari*. From Valturio he learned of the chariots with projecting sickles and proceeded to elaborate a mechanized version. He sketched a car provided with cog-wheels, and road-wheels equipped with four projecting sickles, set in motion by a huge screw. He drew another unit, like a

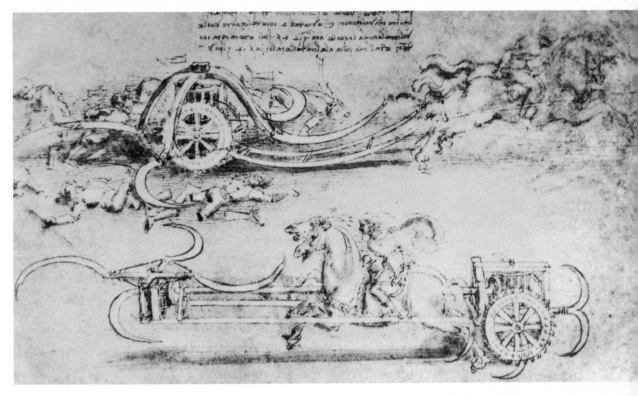

*Valturio's* De Re Militari *is the source of many of Leonardo's ideas. The 'chariot' on the facing page is from a manuscript of Valturio. Leonardo's design* ABOVE *is more terrifying.*

modern reaping machine, which was to harvest human bodies. These carriages of carnage were mounted on shafts, fore and aft of the two horses which powered them. For variety, he substituted for the scythes, flails and spiked maces. There was one snag. Leonardo recognized it in a typical self-scolding entry, 'These cars with scythes were of various kinds and often did no less injury to friends than they did to enemies, for . . . the use of these . . . created fear and loss among their own men.'[5]

He invented a military tank, over four hundred years before Winston Churchill's version went into action in World War I. Covered assault cars had often been drawn and described, but Leonardo may have got his idea from another source. In Florence, as has been mentioned, men went into the street-arena to goad the animals, carrying their own carapace like the tortoise. Leonardo's 'tank' was like an animal with overlapping metal scales. The armour was pierced by a series of loop-holes for sharpshooters. Its 'turret' had similar openings. Most important—it was mobile, with its own mechanical means of locomotion to avoid the use of draught animals which might panic, which would be awkward in the confined space of its interior. The car was set in motion by man-power, by means of crank-handles

97

attached to horizontal trundle-wheels—these turned the spindles of pin-wheels which drove the locomotive wheels. He obligingly drew a cutaway version, like a tortoise without its shell, to show how it worked.

In a recent newspaper article a precedence was claimed for the invention of the tank for Valturio and for an even earlier inventor, Guido da Vigevano, who had designed a fighting car, wind-propelled by rotating sails, in 1335. None, including Leonardo's, was ever built and the article pointed out that his would not have worked because 'through an error Leonardo arranged the crank in such a way that the front wheels would have rotated one way and the rear wheels the opposite way'.[A]

This was no error; it was a deliberate mistake, typical of Leonardo's sardonic habit of putting a 'spanner in the works' in his machine drawings. Was it mischief, or was it Leonardo's way of 'patenting' his ideas so that only he could make them? That many mistakes were deliberate there is little doubt, as Luigi Boldetti has shown. Boldetti, as a lecturer at a polytechnic in Milan, was asked by his professor to conduct research into Leonardo's technical work, and to construct actual machines for the Leonardo Quincentenary in 1952. He did so until the funds for the project had been used up, and afterwards he continued making the models as a labour of love. He consistently found, working from Leonardo's diagrams, that there was frequently 'something' which prevented the machine from working—an extra cog-wheel, a misplaced crank, or an unnecessary ratchet. When he had 'de-bugged' it, the machine would work. Boldetti was convinced that Leonardo, who borrowed much without acknowledgment from other people, was using such devices to mislead possible rivals—a medieval security precaution against industrial espionage. The irony was that, with few opportunities given to construct his inventions, they remained buried in his private notebooks with little or no effect on the development of technology during the next four hundred years, and we recognize their cleverness only by hindsight.

Much has been said and written about Leonardo's invention of the submarine and about his magnanimous suppression of it. Sermons have been preached on it; moral theses have been written about it; it has been invoked as an example for all scientists. The idea of a diving machine was not new to Leonardo. It had fascinated engineers and visionaries for centuries. We know that he was acquainted with the works of Roger Bacon, a century before him. Bacon wrote in *Epistola de secretis operibus artis et naturae*, his vision of the future:

> Vessels can be made which row without the strength of men, so that they can sail onward like the greatest river, or sea-going craft, steered by a single man; and their speed is greater than if they were filled with oarsmen. Likewise carriages can be built which are drawn by no animals but travel with incredible power, as we hear of chariots armed with the scythes of the ancients. Flying machines can be constructed, so that a man, sitting in the middle of the machine, guides it by a skilful mechanism and traverses the air like a bird in flight. Moreover instruments

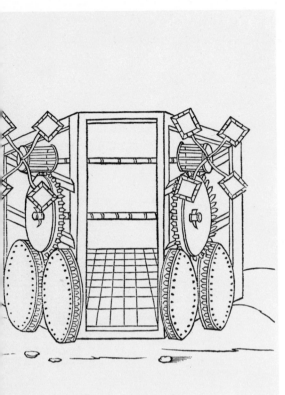 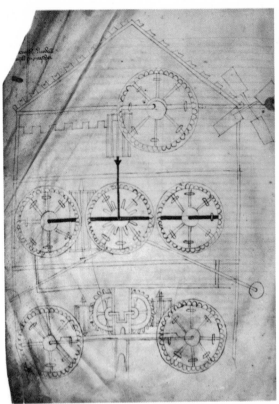

*Valturio's 'tank'* ABOVE LEFT *was supposed to progress by the pressure of wind on its tiny sails. The earlier design by Guido da Vigevano, 1335,* ABOVE RIGHT *also has sails. It is difficult to understand the mechanism but there is a crank, clearly drawn, for use if the wind fails. Leonardo's tank,* BELOW, *also has cranks, and he obviously expected it to go fast.*

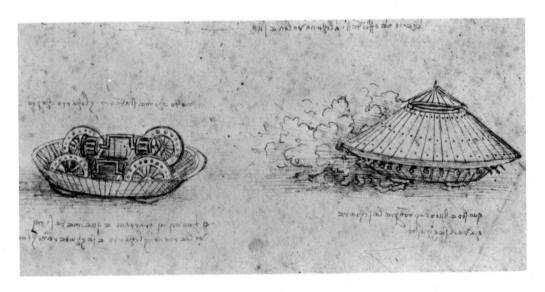

can be made which, though themselves small, suffice to raise or press down the heaviest weight. They are but one finger in length and the same in width; and by their means, a man can raise himself out of prison. Furthermore an apparatus can be constructed by means of which a man can draw a thousand men up to him despite their resistance. Similar instruments can be constructed such as Alexander the Great ordered, for walking on water or for diving without the least danger.[B]

The legend of Alexander the Great was familiar in tapestries and medallions: how he dived to the bottom of the sea in a glass ball with an airpipe to the surface. Aristotle had referred to the diving bell which was filled with air and covered the diver as he worked on the sea bed, and the anonymous Manuscript of the Hussite War (*c.* 1430) shows a diving suit in some detail. Then again Alberti had used divers from Genoa to help to raise the sunken Roman galleys in Lake Nemi, about 1447.

*Surrounded by lobsters, eels and big fish, Alexander the Great descends in a diving bell like a cage. A miniature from a fifteenth-century manuscript.*

LEFT *Divers fighting. Konrad Kyeser (b. 1366) shows two hazardous ways of breathing under water.*
RIGHT *Leonardo's design for a lifebelt and a webbed glove like a frogman's flipper.*

Leonardo had heard, probably from travellers back from the East, about the diving dress used by pearl fishers in the Indian Ocean. 'It is made,' he wrote, 'of leather with numerous rings so that the sea may not close it up. And the companion stands above in the boat watching, and this [diver] fishes for pearls and corals, and he has goggles of frosted glass and a cuirass with spikes set in front of it.'[6]

Leonardo tried his hand at improving the design of diving equipment, and the precise reconstructions from his designs in the *Museo Nazionale della Scienza e della Technica* in Milan have a decidedly present-day look. The suit, following his description, consists of coiled armour-plate under the sealed tunic (to protect the chest from compression); the feet were encased in a combination suit of boots and trousers (which thoughtfully contained a built-in 'convenience'); the helmet has glass eye-panes and a bifurcated mouthpiece with pliable tubes leading to a snorkel apparatus of stiffened tubes, their apertures supported at the surface of the water by discs of cork. From his anatomical studies he introduced an effective valve for the intake and expiration of the air. To assist swimming under water he provided webbed gloves and webbed foot-fixtures—exactly like those of modern frogmen. A further refinement was the provision of the equivalent of the present-day oxygen cylinder—a huge skin or bladder connected by tubes to the mouthpiece of the helmet. His instructions were that this skin bag was to be empty of air

FAR LEFT *Francesco di Giorgio's versions of a diving suit. Drawings of breathing apparatus for diving are scattered through Leonardo's notebooks.* LEFT *A snorkel, strapped to the back of the neck.* RIGHT *A more complicated breathing tube bound by a number of rings, with a face mask.* FAR RIGHT *Breathing apparatus with a bladder, face mask and floating turret with air ducts.*

when the diver, weighted with sand, dropped in the water (suggestive of the air-steward's injunctions not to inflate the life-jacket until one leaves the aircraft). A sensible instruction but it was coupled with Leonardo's addendum 'so that the secret may not be disclosed'. The breathing bag and two other bladders to help the diver to surface were to be inflated under water. This is a tantalizing instruction, because the method of inflation was not described but suggests that Leonardo had contrived or was thinking about some sort of compressed-air apparatus. This diving apparatus for total submersion was frankly military. On the sheet illustrating his diving suit he described his method for sinking enemy ships. The diver, anticipating the naval frogmen of World War II, was to swim under water, come up under the wooden galley, bore a small hole in its hull and then fit a frame over the hole. In the frame was a screw to which folded prongs were attached. These prongs would open up as soon as the screw fully penetrated, and by attaching a sling to them, a cradle would be formed, from which the diver could go on boring until the ship was leaking beyond repair. Leonardo calculated a four-hour air supply for this submerged sabotage operation. This does not seem like conscientious objection to underwater skullduggery.

*'Do not impart your knowledge and you will excel alone.' All the information on this page of Leonardo's notebook, dating from 1500 when he was in Venice, suggests a cloak-and-dagger operation devised by Leonardo for sinking enemy ships. At bottom left is his detailed description of a diving suit; at bottom right, his borer for holing the ships below the water line. Even his special agent is mentioned by name.*

The much-cited recantation is as follows: 'I do not describe my method of remaining under water, or how long I can stay without eating; and I do not publish or divulge these by reason of the evil nature of men, who would use them as means of destruction at the bottom of the sea, by piercing a hole in the bottom, and sinking them with the men in them. And although I will impart others, there is no danger in them; because the mouth of the tube by which you breathe is above the water, supported on bags of corks.'[7]

But surely the secret weapon which he is too horrified to disclose is the self-sufficient non-snorkel diver. It is true that we do not know from him what apparatus was to supply the four hours of air. But what he is writing about does not suggest a submarine ship. The nearest hint, or approach to one, is 'a ship to be used to sink another ship'.[8] This is illustrated by a sketch of a round shell with room inside for one person crouching. Above his head is a primitive conning tower and a lid to close it. There is also a cryptic reference which suggests that it had its own air supply.

The first navigable submarine did not materialize for another hundred years. Drebbel, a Dutchman, in a wooden contrivance covered with waterproof leather, *rowed* it under the Thames, at a depth of fifteen feet; the oars were manipulated through sealed sleeves. The first aggressive use of the under-water boat was during

The Turtle, *1776. The first submarine to be used in battle, it had one man at the controls, turning the propeller by hand.*

the American War of Independence when *The Turtle*, a one-man submersible with a hand-operated screw propeller tried to attach a charge of gunpowder to the HMS *Eagle* in New York harbour but, because the ship was copper-bottomed, the screws would not go in. During the Napoleonic Wars, the American inventor, Robert Fulton, offered his steel, cigar-shaped *Nautilus* to both the British and the French. It was sail-driven on the surface and screw-driven manually under water. Funnily enough, the British and French admirals shared Leonardo's scruples.

Leonardo's ingenuity as a military engineer did not make much impression on Ludovico. Perhaps if he had listened to his 'tame magician' he might have been more effective against the French who, eventually, were to drive him from power and throw him into prison. Nevertheless, Leonardo was a useful handyman to have around the house—as an entertainer, as an intellectual jester, and as a plumber. He invented the tip-up closet seat to cover the privies. Another 'mod. con.' he designed was a bathroom for Isabella d'Este, with running hot and cold water and a proper waste-pipe. He tried his hand, successfully, as a clock maker. The first spring-driven clocks appeared in Milan at this time. Leonardo's drawings embody ideas which were known already—he copied a chiming clock from Francesco di Giorgio. The fusee was already known and embodied in time-pieces. This is the mechanism which is necessary for stabilizing the force transmitted to the gear-wheels, to counteract the diminishing effect of the uncoiling spring. It is a conical pulley on the axis of the main gear-wheel. Gut strings coiled round it are connected to the drum containing the spring. As the spring unwinds the conical shape of the fusee spindle, being pulled round by the gut, adjusts the system to the weakening strength of the uncoiling spring. An improvement which Leonardo drew was an apparatus for prolonging the run of clockwork. Four separate spring barrels were fixed obliquely on top of each other, each connected by catgut with a fusee. As one fusee turned, the next one screwed into it, and as one spring ran down the next spring-drum came into play. This gave the clock a twelve-hour run before rewinding. He introduced a thumb wheel to wind up the string. His alarm clock was a much more clumsy affair. It was a water clock. Water dripped slowly into a basin which, when it reached a certain weight, operated a lever which suddenly tipped up the sleeper's feet. It was ingenious for the calculation of the number of drips—water ticks—needed to fix the waking hour, but it would need a hardy sleeper to ignore a deliberately dripping tap.

His domestic engineering included a mechanical turn-spit. He realized the driving capacity of heated air just as, in his abortive idea of a steam-cannon, he realized the force of steam vapour. His spit was driven by a vaned turbine, which he installed in a chimney, and which worked by convection. The turbine was geared to the spit. This, he insisted, was the right way to roast meat because the joint would turn slowly or quickly according to whether the fire was moderate or fierce.

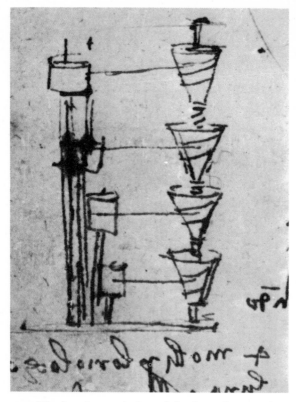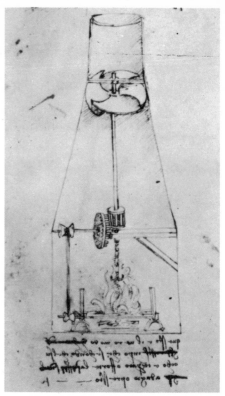

LEFT '*During the revolution of the first, the second remains fixed. The first fastens itself upon the second by means of a screw.*' Starting from the bottom, Leonardo's four fusees *wind into each other to give a twelve-hour run of clockwork.* RIGHT *A turn-spit operated by convection.*

Another premonitory contraption which came to nothing in practice was his horseless carriage. There is a working model of it in the museum at Vinci, but it would scarcely compete in a Grand Prix. Nevertheless, it is a remarkable mental breakthrough. It is a light cart with three wheels under the body like a tricycle car, and a forewheel ahead, controlled by a rudder-bar for steering purposes. The power system (adequate for practical travelling, as the reconstructions have proved) was a system of springs which operated two large horizontal cog-wheels, connected together by a toothed crown wheel. This compensated drive was the differential gear, to take care of the different revolutions of the inner and outer road wheels on curves. Variable speed transmission appealed to him. One design shows cog-wheels of different diameters on a common axis all driven by the same sprocket-wheel, which consisted of a cone of rods angled to fit into the notches of the cog-wheels.

He invented a chimney cowl, a wind-driven device mounted on the chimney pot to extract and disperse the smoke and prevent back-draught. His geared olive-press was guaranteed, according to him, to 'press the olives so thoroughly that

they would be left almost dry'.[9] In addition to using a pendulum to manipulate a fan, he described systems of ventilation and air-conditioning and cooling for houses, based on his understanding of the physics of the outside climate, of air movements and temperature gradients and of the expansion and condensation of vapours. These inventions were not just the 'visions' of a Roger Bacon: Boldetti and others have followed his instructions, winkled out the gremlins and constructed many of his devices (which can be seen in the museums at Vinci and Milan) and proved that they work. He did not invent movable type and give us printing, but he contributed a screw and weight-loaded spinner, and improved the flat-bed press that persisted in printing until the advent of the rotary presses, and in office copying until Gestetner and Xerox brought their refinements.

The handyman about the house was also the impresario around the palace. Leonardo's resourcefulness could be turned to account for the entertainment of a dissolute and extremely bored court. All his life he had been a practical joker, a conjurer and an illusionist. Now he was expected to amuse people he must surely have despised. On the other hand, as master of ceremonies for court revels, he had the opportunity to indulge his flair for setting fashions. With his height and carriage and great muscular strength, with his arresting countenance, his reddish-fair beard and his long, wavy locks, he had the personal material to work on. He dressed for the part with colour and elegance in his short tunics, at a time when men of his position went around (according to him) 'with their arms full of cloth in order not to tread on the hems'. He favoured pink as the colour that suited him at

*Francesco di Giorgio's design for a car* BELOW LEFT *has rack and pinion steering, but the power unit is man-power, turning capstans. Leonardo's spring-driven car, with differential, is shown on p. 118, and* BELOW RIGHT *is his transmission unit for the axle of a wagon.*

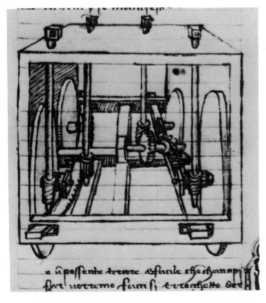
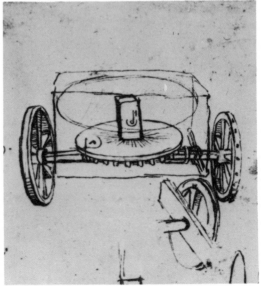

this time. But he was also the medieval Dior setting the women's fashions by designing the costumes for the court masques, so that the women of nobility vied to be the models of his fashion parades. He excelled in millinery.

When he got the opportunity to stage the wedding of Ludovico and Beatrice d'Este he did it with the lavishness of a Hollywood spectacle. He could commission the foremost painters of Lombardy, and fine them twenty-five ducats if they failed to respond. The walls of the vast ballroom, 165 feet long, were covered with frescoes, and the artists thus conscripted, but well rewarded, portrayed Francesco Sforza's victories under a sky-blue roof picked out with golden stars. Leonardo himself painted the triumphal arch at the entrance to the ballroom, complete with a painting of Francesco on a horse—a try-out for the giant equestrian statue which he had promised to make. The scenic effects for the great tourney which lasted for three days in the Piazza d'Armi were designed by Leonardo. The night carnivals, allegorical plays, and costly charades, were under his stage-management. For such performances he had to design the decorations and the costumes, and devise the stage apparatus. Here his mechanical ingenuity combined with his mechanical inventiveness, and with gears and pulleys and clockwork he produced the most

*'You will see . . . outlandish costumes.'* Leonardo designed hats and costumes for the court masques in Milan. The drawings BELOW, c. 1490, are from a tiny notebook measuring 9 × 6 cm.

*Costume for a masquerader*, c. *1513*.

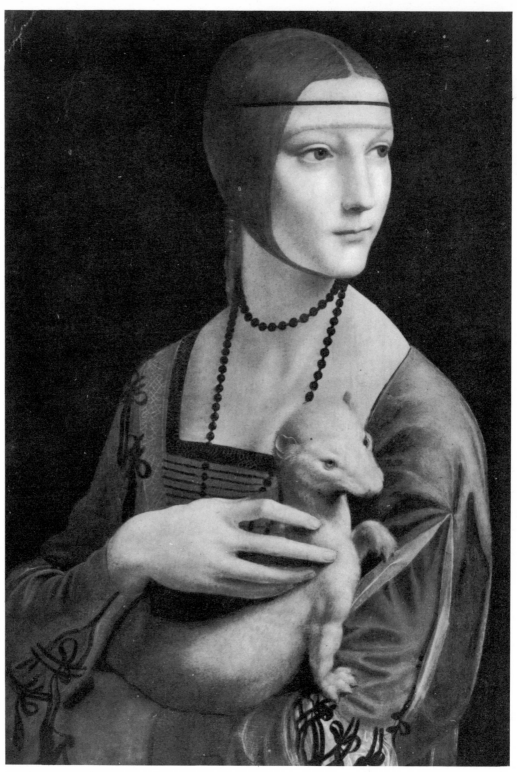

The Lady with the Ermine, c. *1483. Leonardo's portrait of Cecilia Gallerani, mistress of Ludovico Sforza.*

extravagant stage illusions of those times. Birds would fill the theatre sky. Mechanical animals would roar. Towards the end of his life he entertained the King of France with an allegorical lion which stalked across the stage, stopped and scattered symbolic lilies from its breast.

He had another function, of course—painter to the household. In this capacity he painted a portrait of Ludovico's mistress, Cecilia Gallerani, which has survived as *The Lady with the Ermine*. The zoological intrusion (she is holding the live animal), is an example of Leonardo's ironic humour, as the ermine was Ludovico's emblem and its Greek name offered a pun on her name. In addition, the expressions on the face of the woman and the face of the animal are identical, and although Cecilia is a beautiful weasel it is obvious that the artist distrusted her. His faithful treatment of the ermine—absolutely lifelike—is much more sympathetic. Cecilia, judging by her correspondence with Isabella d'Este, realized this and she disliked the picture, and probably the artist as well.

At the same time that Leonardo was playing the courtier, he was also wrestling with his giant work of sculpture, the colossal monument to *Il Moro*'s father. He humoured Beatrice by designing scenery and costumes for the masques and carnivals 'scripted' by her personal poet and playwright, Gaspare Visconte. He sang his songs and recited fables for the grown-up children who formed this frivolous court. And he acted as an interior decorator for the new palace being designed by Bramante. Leonardo was, however, in financial difficulties. Ludovico the despot was insecure in his power. He was marrying-off, with lavish dowries, his relatives in dynastic alliances; bribing the Holy Roman Emperor and the King of France, and then bribing Italian princelings to double-cross the King and the Emperor—and each other. He was building up a Milanese militia and hiring foreign troops. To arm his brother-in-law, the Duke of Ferrara, he sent him 150,000 pounds of bronze for the casting of heavy cannon. This was the bronze that Leonardo had hoped to use for the casting of his colossus.

To meet the mounting debts, Ludovico had imposed insufferable taxes on the Milanese, and had conveniently forgotten to pay people like Leonardo. In Leonardo's notes we find drafts of his protests to Ludovico such as, 'I am greatly vexed to be in necessity, but I still more regret that this should be the cause of the hindrance of my wish which is always disposed to obey your Excellency', and again, 'It vexes me greatly that having to earn my living has forced me to interrupt my work and to attend to small matters, instead of following up the work which your Lordship entrusted to me . . . if your Lordship thought that I had money, your Lordship was deceived because I had to feed six men for thirty-six months, and have had 50 ducats'.[10]

He developed a sense of persecution. He believed himself surrounded by jealous and malicious enemies—he was probably right—and he even sought to protect himself by writing to *Il Moro*, warning him not to listen to one evil detractor

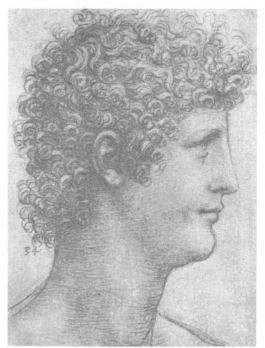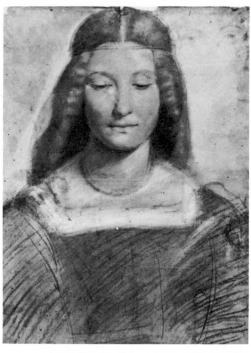

*'Having fair locks abundant and curly, in which Leonardo much delighted'* — *Vasari writes about Salai, who is probably the model for Leonardo's drawing,* LEFT. RIGHT *A drawing of a lady by Boltraffio.*

(un-named). In another he wrote about his colossus in discreet reproach: 'Of the horse I will say nothing for I know the times'.[11] He finally 'walked off the job'. He made a scene and stormed out of the rooms which he was decorating for Beatrice, and the artist Perugino was appointed in his place.

A professional courtier has to keep up appearances. A fashionable artist cannot afford to seem other than successful. The accounts, therefore, of Leonardo's establishment in Milan, with horses and retainers, and his elegance in dress, may not be as inconsistent as might appear either from the pleas of poverty he made to his inconsiderate patron, or from his household accounts, kept as thriftily as a prudent housewife. He had to have his helpers and the six he mentions were probably student-apprentices, learning their trade as artists and earning their board and lodging. Two of his pupils of that time are identifiable by name—Giovanni Antonio Boltraffio and Marco d'Oggioni. They achieved some reputation in their own right, but like all Leonardo's pupils, they were obviously so overawed by the Master that they were never really more than just competent. Leonardo profoundly influenced great painters, including Raphael, but they were not subject to his dominant personality as were his pupils. Of Boltraffio, whom he calls the most respectable of all Leonardo's pupils, Lord Clark says, 'It is reasonable to suppose that Leonardo, occupied in multifarious commissions for the Sforzas [around

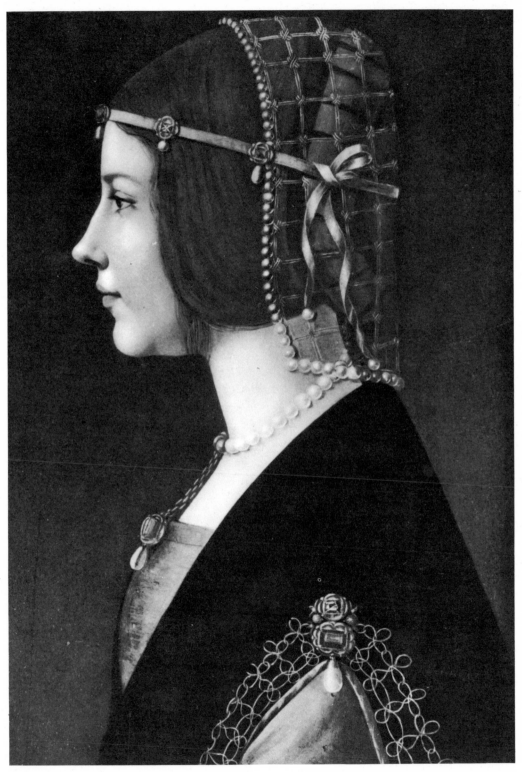

*Beatrice d'Este, wife of Ludovico Sforza, by Ambrogio de Predis, c. 1490. De Predis was working with Leonardo at the time, and he may have received some help with this portrait.*

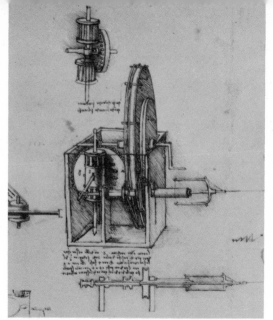
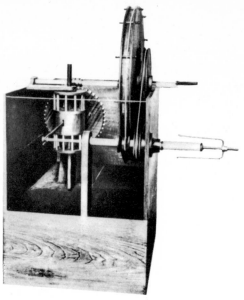

*A flyer spindle in the centre-foreground of Leonardo's drawing* RIGHT *is moved back and forth by the gears on the left to distribute the thread evenly on the spool.* Left *A working model.*

1490] allowed this promising youth to complete work from his designs, and that under his guidance the pupil achieved a delicacy absent from his later, independent work.'[c]

The least respectable of all Leonardo's pupils was Salai. Leonardo had picked up and adopted a ten-year-old ragamuffin called Giacomo, on St Mary Magdalen's day, 1490. He was a problem child whom Leonardo called 'little Devil', 'thief', 'liar', 'glutton', 'obstinate', and whom he execrated and spoiled by turns. He became a third-rate artist. Clark identifies him with the androgynous types favoured by Leonardo in so many of his works, such as *John the Baptist*.

Thus Leonardo, apart from the expense of playing court dandy, had a considerable household to maintain and if he was not being paid for his neglected engineering activities, or for his work as court painter or for the huge sculpture of Francesco Sforza, on which he worked sporadically, how was he paying the bills which he kept so methodically?

He was, as he told Ludovico, earning his living. He had 'gone commercial'. One has to remember what has been said about the Florentine artist; he was an artisan, a member of one of the craft guilds. Apart from the bankers the dominant trade group in Florence was the *Arte della Calimala*, which imported raw undressed cloth from Flanders, England and France to be machined into fine clothes. In the same company were the woollen manufacturers, who imported the raw wool from Spain, Portugal and England and carried out the process of spinning and weaving. And there was the *Arte della Seta*, the guild of the silk manufacturers. Although craft secrets were jealously guarded, wandering, note-taking Leonardo with the inquisitive mind and the observant eyes could learn a great deal about spinning and weaving and the processing of textiles. In the 'closed shop' of

Florence, attracting by its fine cloths the custom of princes and potentates, there was no encouragement for inventiveness. Milan, however, was different. It, too, had a prosperous textile industry but, in 1490, it was like nineteenth-century Manchester—pushing and thrusting. It wanted expanding markets for its textiles, and textiles for its expanding markets. The guilds were not snobbish about the Carriage Trade; they just wanted trade and they were not as conservative in their methods as the Florentines; anyone who could cheapen or speed up production was good for their money.

Leonardo, the lute player and, presently, the painter of *The Last Supper* in the refectory at Santa Maria delle Grazie, was quite prepared to turn his versatile mind to mundane industrial matters, and he applied himself to the study of textile machinery. He was quite mercenary about it. He invented a needle-sharpening machine and was at great pains with the details. He calculated that it would make him a lot of money: 'a hundred times an hour with 400 needles each time makes 40,000 an hour and in twelve hours 480,000. But let us say 4,000 thousands, which at five *soldi* per 1,000 gives 20,000 *soldi*. That is in all 1,000 *lire* every working day and with twenty days worked each month, it is 240,000 *lire* or 60,000 *ducats* a year.'[12] A princely income! There is no evidence that he ever achieved it.

Spinning was the slowest part of the textile process. Even after the introduction of the treadle-wheel, on the crank principle which Leonardo had used in his drawing of a treadle-lathe, three to five spinsters were necessary to keep one weaver supplied with yarn. Leonardo, in 1490, had had a look at the whole spinning process and made important labour-saving improvements. The flyer of the spinning-wheel twists the yarn before winding it onto a bobbin. Leonardo designed a double flyer to produce two threads simultaneously. He also made a drawing of a machine with many such flyers mounted horizontally. The flyer was operated by a crank handle. He also introduced a completely new technique for guiding the thread onto the bobbin. To ensure the uniform distribution of the

*'60,000 ducats a year.' Leonardo hoped to make a fortune with his needle-sharpening machine.*

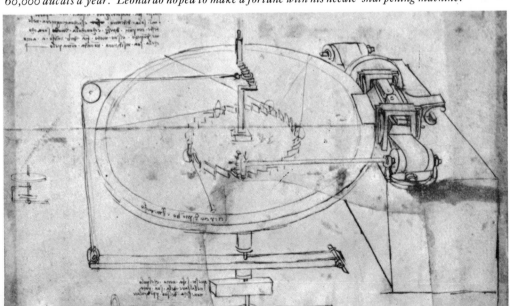

thread, he embodied in his design a set of gears which operated a forked lever to guide the thread and moved the bobbin up and down to receive it.[13] This was not brought into use in England until the Industrial Revolution was well on its way.

Leonardo recorded many ideas for weaving-looms. Since the remote time when textile weaving first evolved from basket-making human arms and human fingers had had to contrive to lace the woof through the weft. On a broad weave the shuttle had to be pushed from one side to the other. Leonardo had the right ideas about mechanizing the process. He certainly produced the primary principles of an automatic loom around 1490, in which a mechanical arm would carry the shuttle through the arranged, separated and stretched threads and another arm would complete the crossover. As Luigi Boldetti the modern reconstructor found to his cost, Leonardo was almost too fertile in his ideas and kept drawing them as they occurred to him or just doodling them on the blank space of some other drawing he was doing. Unlike present-day draughtsmen, he did not have refinements in projection drawing and he could not convey the back of a machine when drawing only its front. This made it often very difficult to know what his precise intentions were. Moreover, the sketches were later sliced up by Pompeo Leoni in his misguided attempt to fulfil the manifest intentions of the Master and compile a book, and related pieces are now all over the place. Just to make it all more difficult, Leonardo included his deliberate mistakes—that redundant wheel and so on. One sympathizes therefore with the contributor to the *History of Technology*, who wrote, 'The mechanism was incomplete and the loom remained purely hypothetical'.[D] Boldetti, when he deciphered and debugged it, proved otherwise.

This, however, raises a whole lot of fascinating questions. Obviously, Leonardo did not dream up looms out of nothing, or simply to satisfy his own inquisitiveness. He must have got his promptings from somewhere. Was he called in as a business-efficiency expert? Did he, once he got involved, catch on to the ideas of others and jot them down with his own shrewd improvements? His dozens of items on the loom, try-outs and discards, suggest he did and Boldetti has no doubt of it. Were those sketches demonstrations for machine-makers leaning over his shoulder? And did they make them? And—a rush of questions—were they found unmakeable? Were they ahead of their time? Were they suppressed by vested interests? Were they just lost in the confusion of unsettled times, the more unsettled presently when Ludovico was beaten by the French and carried off to his prison at Loches?

On a torn sheet of Leonardo's notes one finds the draft of another letter to Ludovico, poignant in premonition: '. . . works of fame by which I could show to those who shall see it that I have been. . . .'[14]

116    *Ludovico Sforza*, Il Moro. *Fifteenth-century Lombardy school, detail.*
OVERLEAF *Model of a car driven by springs, with one of Leonardo's drawings for the car.*

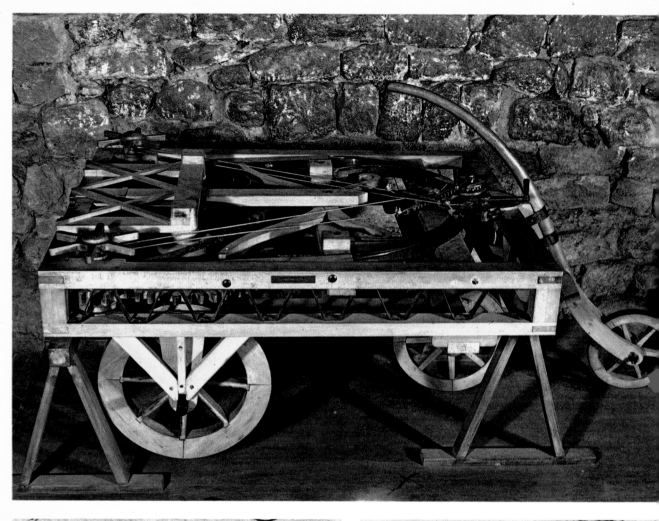

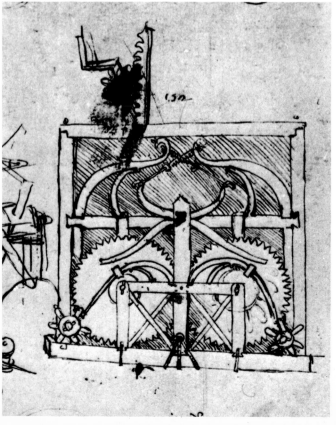

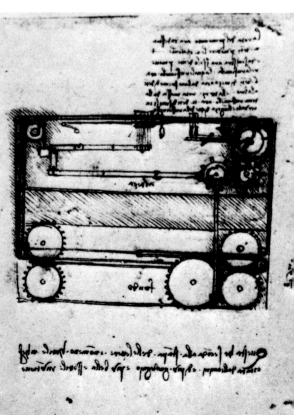

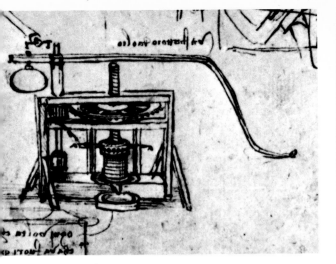

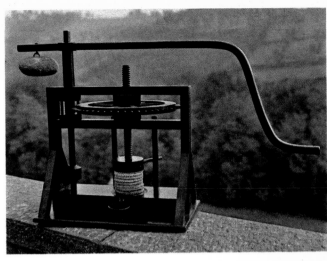

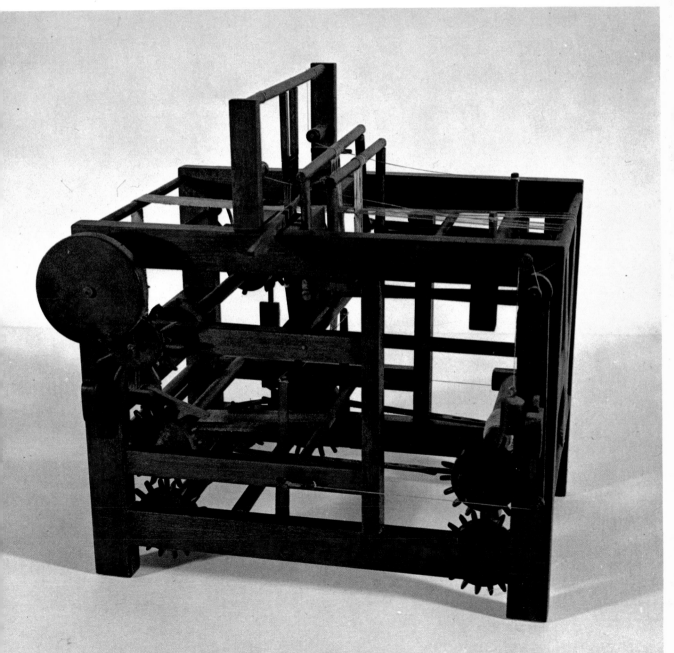

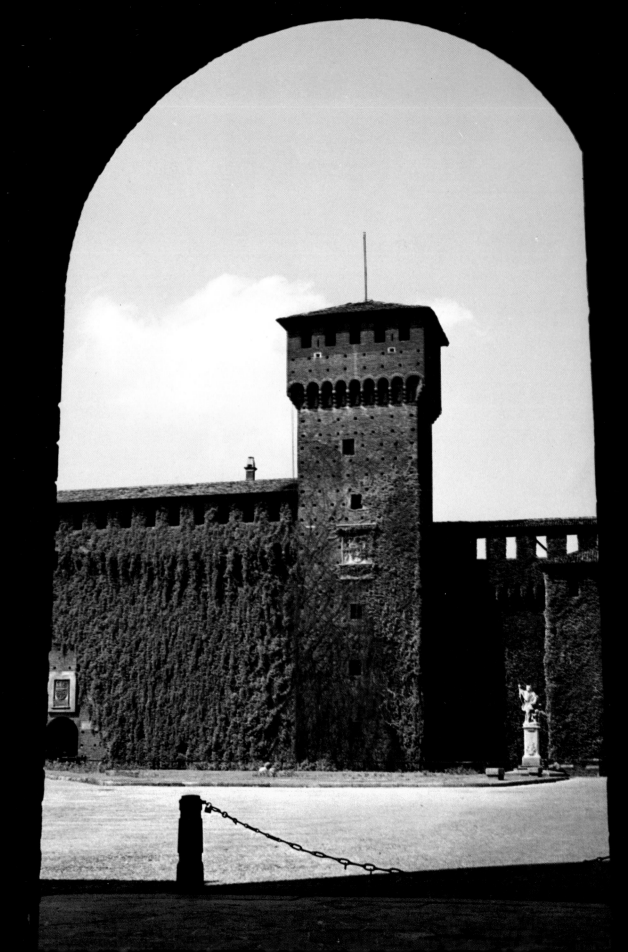

CHAPTER SIX

# The Fifteenth-Century Edison

My little work is going to benefit those investigators so that they won't need any more to run away because of the impossible things they promised to sovereigns and heads of state.[1]

Four hundred years after Leonardo, Thomas Alva Edison patented over 1,000 inventions. They included major ones by which he is remembered but also hundreds of bits of ironmongery, important in their way. He made only one scientific discovery—the Edison Effect which, typically, he patented but did not pursue. The rest were derived from the scientific developments and the creative ferment around him. Edison saw the profitable relevancies which lesser men missed. He fitted the mental nut to the mental bolt and created things.

Leonardo was a fifteenth-century Edison. There was no patent system when he was in Milan from 1482–1499 but if one catalogued all the designs on all Leonardo's sheets and notes, they would outnumber Edison's inventions. Leonardo, like Edison, lived in an age of new thinking and burgeoning of ideas. He had a magpie mind, picking up ill-considered trifles and considering them, making the insignificant significant. One day, he promised himself, he was going to put them all into books for the benefit of posterity. Even the notes we are now sifting went into limbo for centuries.

One invention can be definitely traced to him and—a fact which is overlooked when one talks about Luddism and machine-wrecking—caused more widespread rioting in Britain than Arkwright, or Cartwright or the legendary Ned Ludd himself. This was Leonardo's gig-mill.

An indispensable part of the preparation of woollen cloth was the raising of the surface or nap, by means of wooden or metal instruments containing teasel-heads. The heads of the teasel *(Dipsacus fullonum)* have claw-like prickles. These burrs were mounted with a handle, like the curry-comb used for grooming horses. The cloth, sprinkled with water, was hung over a pole or laid on a bench while its surface was brushed with the teasels. The first gentle raising strokes were followed by brisker action, and the cloth was raised first against the pile and then with it. It was dried and then the nap was cropped by the shearmen.

*The tower of Bona of Savoy, in the Sforza Castle, Milan.*　　　　　121
PREVIOUS PAGE, TOP *Working model of an olive press, together with Leonardo's drawing.* BELOW *A working model of Leonardo's loom, with his drawing on the left.*

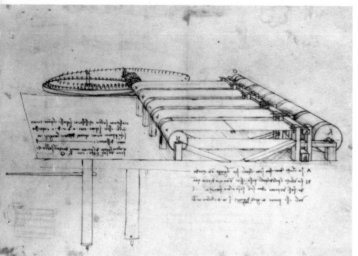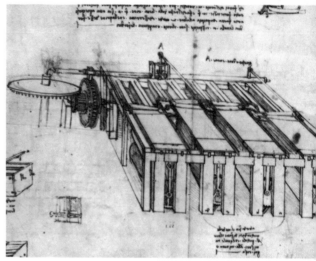

LEFT *Leonardo's teaseling machine, showing five lengths of cloth stretched between two rollers.* RIGHT *Leonardo's shearing machine. In his notes on the same sheet he describes the shears, closed by a cord attached to the top of one blade.*

Teaseling was the most labour-intensive process in the textile trade; such skill as it needed could be quickly acquired, and whole families could be employed, men, women and children. Whatever pittance they might be paid, it was their livelihood. Leonardo the productivity expert, taking time off from his own unpaid court activities, took a look at teaseling. It was inefficient, slow and, at any price, expensive in labour. He invented the gig-mill. It was as revolutionary in its purpose as Eli Whitney's cotton-gin (1793) which combed the seeds out of cotton fifty times faster than by hand.

Leonardo had two designs—a hand-driven device, which was obviously a 'prentice effort, and quickly discarded for a more ambitious creation which was in the modern tradition of machines for mass-production. Five lengths of cloth were sewn end to end to make an endless band, and stretched between two rollers. One roller was driven by a gearing system, operated by a horse turning a winch. The moving cloth passed under an adjustable beam, the underside of which was covered with teasel heads. So the nap was raised without a human hand.

This was the machine which was prohibited by an English Act of Parliament in 1551 because of the hardship it would cause to those whom it would deprive of their livelihood. A hundred years later it was in use, but localized in Gloucestershire. In the early days of the Industrial Revolution the extension of its use throughout the country caused riots everywhere, in the countryside as well as in the towns. Even before the factories were set up with their powered machines inviting the violent and desperate action of the hand spinners and hand weavers, the gig-mill had affected the 'putting-out' system. This was the practice by which the entre-

122

preneurs 'put out' the raw materials to the farm workers, and paid them piece-rates for the cloth. The rates were cut because the middle-men had their own gig-mills. So the fruits of Leonardo's strike action against his employer Ludovico in the fifteenth century led to labour troubles in Britain in the eighteenth century.

To finish off the cloth which had been napped in this way Leonardo invented a shearing machine. It was not one of his best efforts. In the manual process the shearmen, using enormous scissors, cropped the nap like a barber. It was a slow and laborious operation. What Leonardo did was to make a moving table on which was stretched the cloth. This table was drawn by a cord through a machine which had one blade fixed, and the second was made to close over it scissor-wise. It was operated by a cord taken to a lever worked by a gear-wheel on the upper shaft.

With remarkable agility and imagination Leonardo moved into heavy industry. When one begins to sort out and assemble the sketches, the doodles, the scattered

*Leonardo's drawing of a crane*
*for lifting heavy weights and transporting them along a*
*cantilevered beam.*

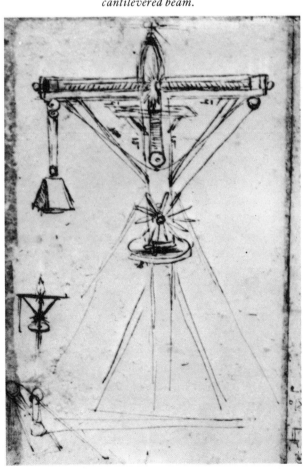

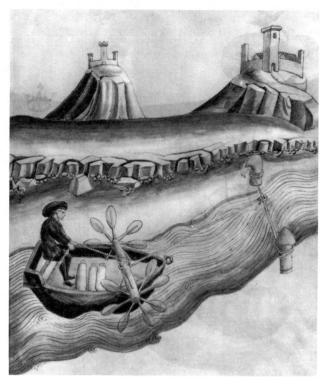
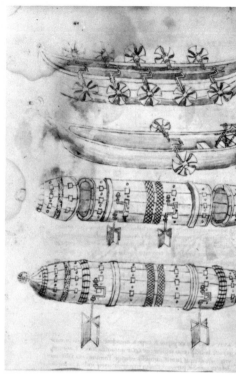

*There are drawings of paddle boats in most of the medieval military manuscripts, including those of Taccola* LEFT *and Valturio (1472)* RIGHT. *Valturio's boats have crankshafts, though it is hard to see how some of them could have been turned.*

fragments and the references in his notebooks, one has what could be a catalogue of an industrial fair. They range over everything—the iron and steel industry; primary power movers; cranes; muck-shifters; pumps; machine tools; rope making; lens grinding; pile driving; and die-stamping for coins.

In an age when the source of power was basically muscle power, he recognized, through his scientific studies of water, the potential of the water-wheel. Like the Sienese engineer Taccola, he made drawings of boats propelled by paddle-wheels. He glimpsed the possibilities of pneumatics. He knew the force of steam because, as has been mentioned, he developed the idea of a steam-cannon which he called 'Architonitro' and attributed to Archimedes. Leonardo refers in his notes to the work of Hero of Alexandria (*c.* A.D. 100) and he made several drawings of Hero's 'fountain'. He drew experiments to measure the force of steam and in an age more receptive than his own to labour-saving ideas, Leonardo might have given us steam power nearly three hundred years before James Watt, or more probably he would have invented the steam turbine four hundred years before Parsons. One wonders what he would have done if he had had a hint of electricity or the internal combustion engine.

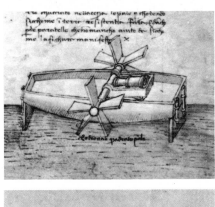

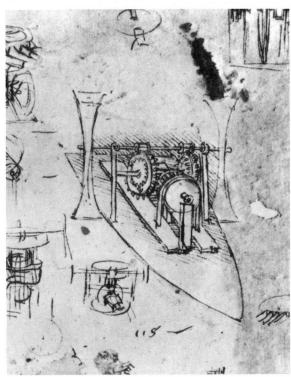

*Francesco di Giorgio uses paddle wheels for a military device* ABOVE LEFT. *Leonardo* BELOW LEFT *shows a hand-propelled paddle boat, and* RIGHT *a complete gearing system which will rotate the paddles by means of treadles.*

His interest in smelting and founding is simple to explain: he had been apprenticed to a goldsmith and, as a sculptor, was familiar with bronze founding. He had some knowledge of metallurgical chemistry and invented secret alloys—using in his private diaries the alchemists' symbolism—Jupiter (iron), Venus (copper), and Mercury (quicksilver). Mark you, those were the days of the alchemists and mystery was part of their stock-in-trade. In his Milan days, however, he took a really hard look at the multifarious furnaces and processes. He made several sketches of the reverberatory furnace which was of great importance for melting the large amount of metal needed for founding cannons and bells. In such a furnace the metal is exposed to the naked flame. Leonardo's method was very much like that still in use, except that he did not provide it with a chimney-stack to enhance the draught. The products of combustion escaped through small vents above the furnace doors. He did, however, apply the draught very effectively in another design, this time for a crucible furnace in which the melt was not exposed to the flame but was heated in pots. Leonardo's furnace[2] has been reconstructed as 'the furnace of the controlled flame' in the Science Museum in Milan. It is an elegant idea in which a powerful horizontal draught is fed into the furnace chamber and the flame and heat

125

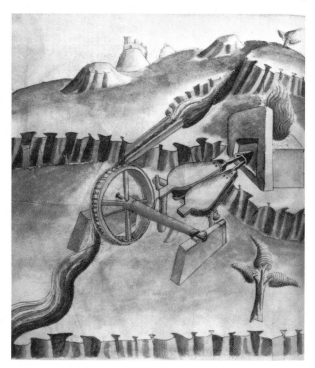
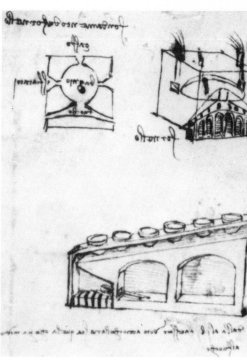

LEFT *'The furnace of the controlled flame' : Leonardo's drawing showing six crucible pots in position.*
RIGHT *Taccola's drawing to show the bellows for a furnace operated by a water wheel.*

is forced into an inclined flue, a carefully angled chimney, along which six crucible pots are inset side by side. The up-going flame like a blowtorch is carried to the highest point before it escapes through the vent.

Like the other elements, water had an obsessive fascination for Leonardo. Anyone who has experienced a storm in the Tuscan hills, when the rain comes down like a cataract, or who thinks of what the Arno floods have done to Florence both in our times and in earlier centuries, can understand their effects on the imagination of the ultra-sensitive Leonardo. It explains the awe-inspiring sketches of the Deluge. But the rationalist in Leonardo comes through loud and clear, in the systematic studies of water which he proposed to pursue in no less than fifteen 'books'. Like all his schemes for books, of course, they never materialized, but the synopses are there in his notebooks.[3] In his Milan days, while he already had a good deal of insight into the scientific nature of the elemental forces, he was concerned with the purely functional possibilities of an inadequately used source of power.

Water-power had long been harnessed in the orient. The Chinese, in the second century B.C., had had water-wheels operating trip-hammers and, in the first century, they had water-powered bellows for furnaces and forges. What is known as

the Vitruvian Wheel, because it was described in the works of Marcus Vitruvius Pollio, was in existence in the days of the Roman Emperor Augustus. It was on the principle of the vertical paddle-wheel, operated by falling water.

Leonardo was familiar with the works of Vitruvius and with those of Archimedes. He was absorbed in the scientific study of natural forces, but he separated these studies from the practical application of hydraulics because, he said, 'You would have to mix up practice with theory which would produce a confused and incoherent work'. There are over thirty drawings of water-wheels and their applications in his sketch-sheets and notes. Most of them are refinements of the existing primary power wheels or their harnessing to machine processes.

He described the centrifugal pump. He noted that 'if the water in a half filled vessel, is stirred with the hand, a whirling current is produced which will expose the bottom of the vessel to the air.'[4] He proposed a large vessel with a feed-pipe at the bottom and he produced a whirling current with a beam the axis of which was fixed with a fly-wheel set in motion by a water turbine. The vortex thus produced caused the water to rise up the sides of the vessel high above the original level and to spill over. His idea was to use this pump for draining marshes.

In line with these intentions he developed a machine based on the Archimedes

*Leonardo's version of the Archimedes Screw, a hollow tube spiralled around the outside of a cylinder. When the handle was turned water came up inside the cylinder. On the right, a water wheel for raising water.*

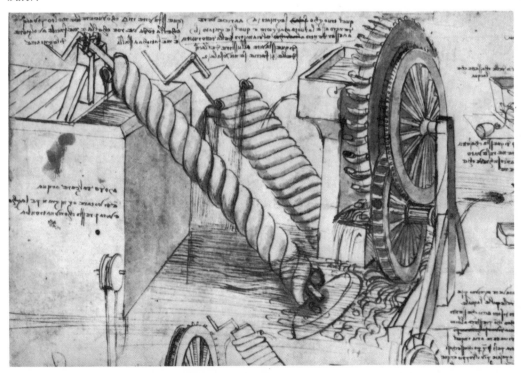

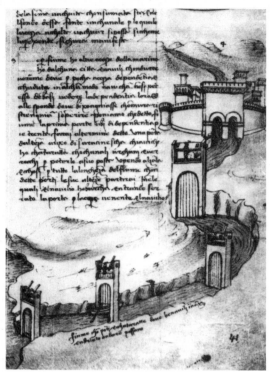

Screw. The classic version was a long cylinder with a screw fitted tightly inside, noted by Francesco di Giorgio and others. When the lower end of the cylinder was immersed in water and turned, the water was carried up the spiral channel formed by the screw. Leonardo's version was a hollow tube spiralled round the outside of the cylinder, and the water came up inside this exterior tube. He had combinations of both these in his schemes for water lifting. He also considered the use of siphons. In his records, these sorts of things, pumps, turbines, suction-pumps and conduits, are all mixed up with the sketches for his artistic work—horses rearing, men's faces contorted in passion, love and pain, and with reminders to himself to get books. He was obviously borrowing heavily on classical information or on the experience of practical men.

Then he had ambitious ideas for canals, for transport and for irrigation. From the time he arrived in Milan he interested himself in the canal system which had been conceived by the Visconti when they were the ruling family at the beginning of the fifteenth century. In a period of thirty-five years over fifty miles of canal were built with twenty-five locks. Leonardo's habit was to go round and chat with the workmen operating the canal system. He quizzed them about construction, about maintenance costs, about weaknesses which demanded repairs and about what was wrong with the canals. He was particularly interested in the system of locks which here, in Milan, was in advance of the rest of Europe. They enabled

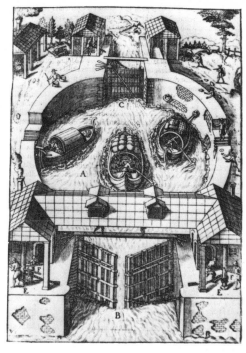

*A boat can be seen passing under a vertical gate in Francesco di Giorgio's drawing of locks* FAR LEFT. *Leonardo's revolutionary improvement, the angled lock gates or mitre-gate, is clearly drawn alongside. It can be seen again in the engraving,* RIGHT, *from the guidebook to modern machinery by Zonca, published in 1607.*

boats to climb hills. As noted by Alberti in *De Re Aedificatoria*, a lock is a water-tight chamber usually rectangular in shape which by means of gates at either of its ends allows passage between two reaches of canal at different levels. The boat, which is to be lifted from one level to the next, enters through the bottom, or downstream, gates which are then closed. The water level is now raised to that of the higher reach and the upstream gates are opened to allow the boat to leave the lock. In descending from a higher reach the procedure is reversed. The lock chamber is filled and emptied through sluices fitted into the lock gates.

The locks at which Leonardo was looking were of the old type, as depicted by Francesco di Giorgio, and had vertical gates like a portcullis, which had to be hoisted above the height of the boat in transit. Leonardo's improvement is so elegantly simple that it is still the basic model for lock gates great and small today. He substituted a pair of hinged gates which met at an obtuse angle pointing towards the higher reach and their mitred edges made a watertight joint, sealed by the pressure of the water. This is an interesting example of the way Leonardo's mind worked and how he associated ideas. At this time (around 1492) he was also thinking about architectural structures, the strength of arches and theories of pressures. He said, 'As the arch is the composite force it remains in equilibrium because the thrust is equal from both sides',[5] and he showed the angle of the thrust. What he did in the lock was to transfer that angle to face the thrust of the water—in

129

effect, he laid the arch on its side. Into the bottom of the lock gate he introduced a sluice hatch which could easily be opened by remote control (rope and pulley) to release the water and level up the reaches.

We keep on looking for evidence that Leonardo's ideas were put into practice and we find his ambitious ideas so often discouraged that it is always a relief to find something that actually did materialize. The canal historian, A. W. Skempton, has no doubt that he completed six new locks on the *Naviglio Interno* by 1497; that his drawing of the lock gate is veritably that of 'the lock at San Marco, situated just below the terminal basin of the Martesana canal' and that another Leonardo drawing shows the lock itself built of masonry, ninety-five feet long and eighteen feet wide. Skempton comments, 'These drawings, which give the first complete design of a modern form of lock, are of highest importance in the history of canal-construction.'[A] But, alas, he goes on to point out that Leonardo's later plans for a summit-canal from Florence, all carefully surveyed, scientifically worked out and costed even to the return on the investment, did not work out and that such a canal did not exist anywhere in the world until a century later.

Leonardo's subsequent scheme for carrying the water of the Arno across the hills to the sea was certainly ambitious—too ambitious for the imagination of the authorities and probably for the technics available at the time, although Leonardo had already prescribed the tools—mechanical diggers, mountain borers like giant corkscrews, wheelbarrows, cranes (very like our present ones), lifting grabs with hinged claws, a vertical lift, and a semi-automatic pile-driver. He even had a

*'This plough will be able to dislodge the mud from the bottom, and unload it upon the barge which is placed underneath it.' Leonardo designed a dredger like a catamaran.*

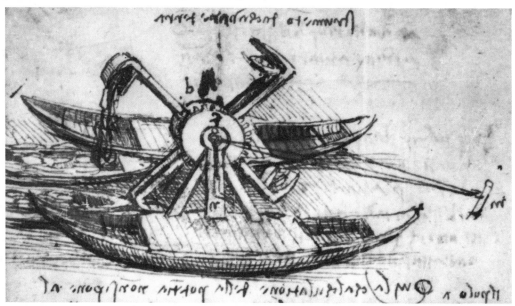

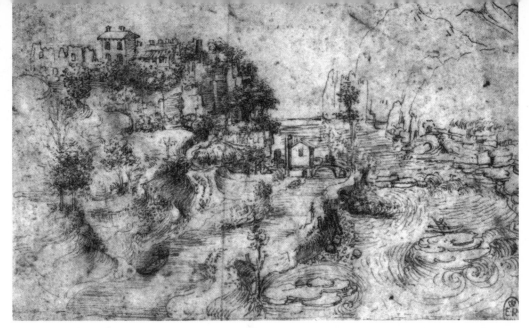

*A landscape showing the River Adda by the 'Tre Corni' rocks. On another sheet, Leonardo gives instructions for adjusting the river level to make the Adda navigable.*

dredger-barge and a muck-shifter which could be floated on a sort of catamaran and which had four arms, in the form of a cross, each with a scoop at the end, mounted on a geared drum. As the arms turned round they scooped up the mud.

'Every day', wrote Vasari, 'he made models and designs for the removal of mountains with ease and to pierce them to pass from one place to another, and by means of levers, cranes and winches to raise and draw heavy weights; he devised a method for cleansing ports, and to raise water from great depths, schemes which his brain never ceased to evolve.'[B]

There was nothing whimsical—only premature—about his canal project: 'Since the Lago di Sesto will be navigable make it (the canal) pass by way of Prato and Pistoia and cut through at Serravalle and go out into the lake....'[6]

But at Serravalle he had to cope with a rise of 470 feet, through which he could not cut. He immediately designed a huge suction pump saying: 'Every large river may be led up the highest mountains on the principle of the siphon.'[7] He proposed to operate through locks forty feet deep and to use the fall of water from the highest rise to work the suction pumps.

The city fathers of Florence were no more convinced of the practicality of the canal than they were by his offer to lift the church of S. Giovanni bodily from its foundations on to a plinth so that it could be approached by a flight of stairs and reassert the importance it had lost by being dwarfed by the Duomo.

Nor in his first Milan period was Ludovico prepared to encourage his other great project—to make the Adda navigable. His proposal was that a great dam be built on the Adda. He even surveyed the location, between the rocks known as *Tre Corni*. The ship passage between Trezzo and Brivio would be shortened by two miles by means of a canal. This enterprise would have completed a link between

Milan and Lake Como. In 1519, the year of Leonardo's death, Benedetto da Missaglia was commissioned by François I, King of France and also master of Milan, to undertake the project but not according to Leonardo's design. Work was on the way when Emperor Charles V took Milan from François in 1522 and the work was suspended.

A cynic has said, 'Presumably, if cans had existed Leonardo would have invented a can-opener.' Well, he did not invent the can nor the can-opener but he did describe a rolling mill for producing the first sheet tin. He did not invent the bicycle but he did provide a bicycle chain. This was confirmed by the discovery of the missing manuscripts in Madrid in 1967. The idea of a hinged-link chain was first drawn by Taccola, and used by Leonardo in his diagram for a wheel-lock of a gun, although this employed only a few links. The Madrid manuscripts revealed beautifully drawn and perfectly detailed diagrams of endless chain-drives and sprocket wheels with which every small boy is familiar from his earliest tricycle days.

And if that small boy were inquisitive enough he would find in the hubs of the wheels another Leonardo improvement—the ball-bearing. The invention of roller bearings can scarcely be ascribed to Leonardo since even our prehistoric ancestors used the roller device to reduce friction. The wheel itself was a product of this. Ancestral man discovered that it was easier to move heavy objects by shuffling them along from one revolving tree trunk to another, as on the roller-conveyors of today. The next big step in imagination and technology was to take narrow cross-sections of that tree-trunk, make holes (hubs) in the centres, attach them to a fixed axle, so to create a continuous rolling motion. There is some evidence that the

*Detail of a hinged-link chain, like a bicycle chain, and a metal spring, bottom right.*

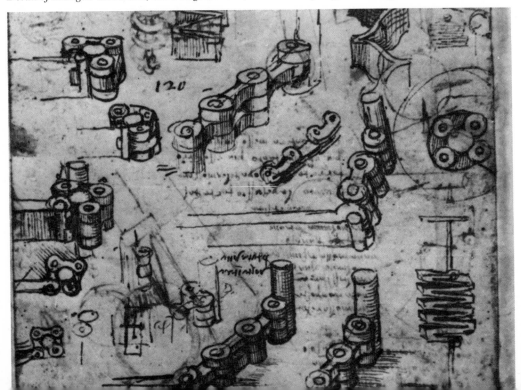

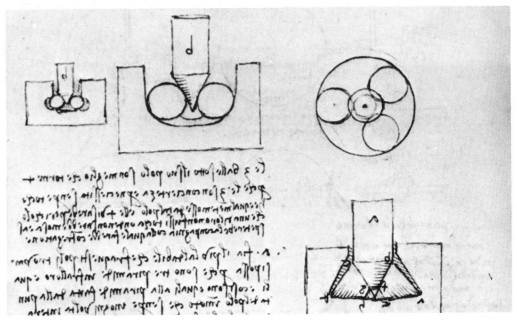

*'These are marvels of the mechanical art' wrote Leonardo of his ball-bearings. They are, and his drawings are the first. The conical pivot ball-bearing from the* Codex Madrid I.

Chinese as well as the Romans had the idea of ball-bearings. Roman capstans had fixed balls, that is, they did not rotate but merely reduced friction by applying the least surface (curve) to the shaft. Another variant of the roller-bearing—the disk-bearing—has long been attributed to Leonardo, but the Madrid manuscripts revealed that when he proposed their use he was aware of their existence in Germany.

There seems to be no doubt, however, that Leonardo was responsible for the true free-moving ball-bearing. His note in the *Codex Madrid I* explains his idea precisely:

> I affirm, that if a weight of flat surface moves on a similar plane their movement will be facilitated by inter-posing between them balls or rollers; and I do not see any difference between balls and rollers save the fact that balls have universal motion while rollers can move in one direction alone. But if balls or rollers touch each other in their motion, they will make the movement more difficult than if there were no contact between them, because their touching is by contrary motions and this friction causes contrariwise movements.
>
> But if the balls or the rollers are kept at a distance from each other, they will touch at one point only between the load and its resistance . . . and consequently it will be easy to generate this movement.[8]

When the illustrations from the Madrid manuscripts were published in *Life* magazine, 3 March 1967, Dr Preston Bassett, former president of the Sperry Gyroscope Company wrote, '. . . . my greatest shock in looking over the Da Vinci sketches was the balls rested around a conical pivot. When we were developing our

blind-flying gyro instruments in the 1920s we had the problem of designing a ball-bearing that would have absolutely no end play. We thought we had an innovation with our conical pivot ball-bearing, but it is a dead-ringer of Da Vinci's sketch!'[C]

As though that were not enough, it was found in the *Codex Madrid I* that Leonardo anticipated by two hundred and forty years the first previously recorded anti-friction alloy (tin-antimony-copper) patented by the American inventor Isaac Babbit in 1839. Leonardo's formula which he called a 'mirror metal' was a hard tin-copper metal embedded in a softer tin-copper alloy. Moreover, in clearest detail he shows the two-part bearing block providing this anti-friction bush. The two semi-circular parts of the block were clamped over the axle shaft and tightened, in one diagram by a wedge and in another by a screw which meant that it could be adjusted according to wear.

Although he may have derived some of these ideas from practical hints or observations of existing machinery, there is no doubt that he gave a great deal of attention to the theory of friction. In his studies of motion he had found that there was a gap between his theoretical calculations of the expenditure of power and the practical results. His crude conclusion was that the resistance due to friction on a horizontal surface was equivalent for all bodies to a quarter of their weight.[e] His first practical experiment showed how the use of oil on bearings reduces friction. He went on to demonstrate his rollers and finally his ball-bearings about which he had no modesty, 'This device gives circular motion a duration that seems marvellous and miraculous . . . these are marvels of the mechanical art'.[9]

He grasped the law of inertia and understood the nature of friction not only as between solids but in air and in water, so that he streamlined his boats, for he was a naval architect as well.

His reason resented the credulity of his time. Indeed, the fables and bestiaries with which he Scheherazaded the court can be taken as the measure of his contempt for the decadents. And he despised charlatans. There is his diatribe in which he condemns for all eternity 'alchemists, the would-be creators of gold and silver, and engineers who would have dead water stir itself into life and perpetual motion, and those supreme fools, the necromancer and the enchanter.'[10]

The *Codex Madrid I* restored to us this resounding passage:

Among the superfluous and impossible delusions of man there is the search for continuous motion, called by some perpetual wheel. For many centuries almost all those who worked on hydraulic machines, war engines and similar matters, dedicated to this problem long research and experiments, incurring great expense. But always the same happened to them as to the alchemists; for a little detail everything was lost. My little work is going to benefit those investigators so that they won't need any more to run away because of the impossible things they promised to sovereigns and heads of state. I remember that many people, from different countries . . . went to Venice, with great expectation of gain to make mills in still water, and after much expense and effort, unable to set the machine in motion, they were obliged to escape.[11]

Just as he could afford to be disdainful of the court nincompoops, so he could afford to feel superior to his engineering contemporaries. They might be good at this or good at that but he, with his scientific method, knew the theoretical significance of what he was doing and thought integratively. He 'packaged' his ideas. Just as in the twentieth century the speed of change accelerated when the scientists' laws and laboratory experiments were transferred to the factory floor by the technologists, and the technologists in exchange gave the scientists ingenious instruments to promote more science, so in the person of Leonardo, at the watershed of the ages, we had the scientist applying his theories in practice, and from that practice having to find further scientific explanations. For example, one of the requirements in making anything was to know the strength of the materials available. Leonardo designed an apparatus for the measurement of the tensile strength of wire. On this he made the comment,

> The object of this test is to find the load an iron wire can carry. Attach an iron wire, about three feet long, to something that will fairly support it; then attach a basket to the wire, and feed into it fine sand through a small hole at the end of the hopper. A spring is fixed so that it will close the hole as soon as the wire breaks. . . . The weight of the sand and the location of the fracture are to be recorded. Repeat the test several times to check the results.[12]

From this kind of test he was led into the science of statics and we find him studying the strength of loaded struts and pillars, 'a field in which he had no scientific predecessors', according to Martin S. Briggs in the *History of Technology*.[D]

In the same way when dealing with water-wheels, he had to find out the strengths of the currents and so made himself a water-gauge, and when he started designing windmills with both vertical and horizontal vanes he made himself a wind-gauge. For measuring surface distances and for surveying he borrowed the idea of the hodometer from Vitruvius. This 'road measurer' was an instrument with a wheel like that of a wheel-barrow, with a measured circumference. As it turned it operated a gear which turned a horizontal wheel, a sort of cogged tray. From this tray, at the completion of each wheel revolution a pebble dropped into a box. The number of pebbles gave the distance. With this measured base line he could triangulate a distant object.

Among the mechanical inventions which marked the close of the Middle Ages the most important was that of the crank and the connecting rod. This was the key to the conversion of continuous rotary motion into a reciprocated motion, or the converse. Leonardo got interested in the latter from his studies of suction and force pumps. He drew several methods. The first used a cylinder around which he cut an undulating spiral groove. A peg fixed to a piston rod fitted into this groove and the rotation of the shaft carrying the cylinder imparted an alternating motion to the piston. In another design, a fly-wheel operated another wheel to which two piston rods were attached, with alternating movements. His third device was adopted by all the constructors of machines in the sixteenth century. A continuous

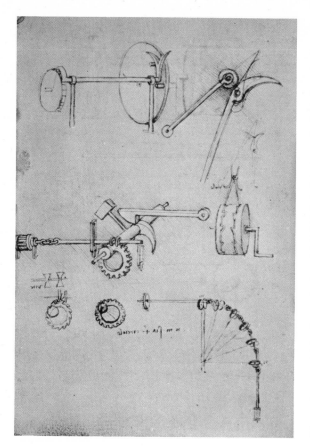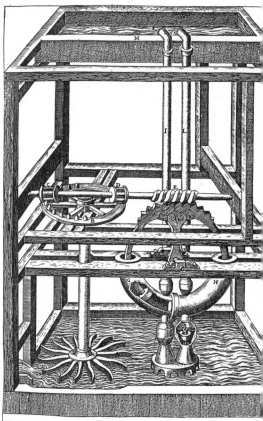

LEFT *Odd mechanisms from the* Codex Madrid I. RIGHT *A half-toothed wheel rotated by a water vane converts rotary motion to reciprocal motion, and water pumps itself up. From Ramelli, 1588.*

rotary motion was transmitted to a disk with teeth cut round half its circumference. These teeth engaged with two lantern pinions mounted on a single shaft at right angles to that carrying the tooth-disk. The two pinions were so placed that the first was driven in one direction as the teeth of the half-gear meshed, and the other was driven in the reverse direction thus again producing an alternating rotary motion, which could be geared into an alternating rectilineal motion.

Leonardo revelled in gears of every kind, including, as the belated recovery of the Madrid manuscripts have shown, gears with epicycloidal (curved) teeth, which were acclaimed as the discovery of Olaus Roemer and Christiaan Huygens by the Paris *Académie des Sciences* in 1674 and 1675. Leonardo devised eccentric gears. He sketched all kinds of joints: ball-and-socket joints like those of the human arm; knuckle joints and the universal swivel joint, clearly, and with unambiguous detail and description, anticipating Robert Hooke (1675).

What is particularly interesting about the revelations in the Madrid manuscripts is that they disclose Leonardo's intentions. He was not just playing the

136

improviser, saying 'try this; try that'. He was not concerned with perfecting complete machines so much as demonstrating mechanical principles and producing a treatise on kinetics. He was looking for examples, so that his works might be an annotated catalogue of technics which already existed. He rarely acknowledged his contemporaries' works, either in art or in mechanics. They were just grist to his voracious mill. Prototypes suggested improvements and gaps demanded innovations. In addition, though he protested his lack of scholarship, Leonardo had a remarkable reading-list and a personal library of at least 116 books. He was also a good listener and avid for travellers' tales. He picked the brains of voyagers for practical hints about distant practices. His ideas for windmills almost certainly were borrowed from the Middle East. What he saw around him impinged on an informed mind, disciplined by the scientific method, and items fell into place.

Ironmongery, too, fascinated him. It is largely true that he rarely brought things to completion but, contrary to the lament of Leo X, concerning his making varnish for a painting he had not started, he usually began at the beginning: he designed tools to make the machines, or the instruments for his scientific experiments.

He did not invent the file; this dates back to the Assyrians at least. Files were hand-made, by striking a series of closely spaced blows on a flat piece of iron with a sharp-edged hammer—a highly skilled job. The metal was then tempered and quenched to make it hard. What Leonardo did was to mechanize the precision-denting. He aligned the incision hammer with the file on a movable platform pushed forward by a screw, operated by a gear system and a handle, which co-ordinated the rise and fall of the hammer with each turn of the screw, and at the same time advanced the file precisely the distance of each notch. But this, of course, required long guide screws. Leonardo's rolling-mills could produce rods of the required diameter for such screws. He therefore designed a machine to cut the thread. The rod was mounted in the centre and turned by a crank. The carriage bearing the cutting tool was moved by two guide screws, geared to the same crank and the gauge of the thread could be varied by altering the gear-ratios.

In tools for working wood Leonardo was not the inventor. He did not invent the saw, for flint saws were used in Mesolithic times (10,000 B.C.) and iron saws with raked teeth have been found in Theban tombs of the eighth century B.C. By the Middle Ages there were many different types of manual saws, including bow-saws, like the modern hack-saw, with the metal blade stretched. The bow drill, in which the string of the bow was twisted around the centre bit, and the tautened bow was worked in a sawing motion, was known in Palaeolithic times. A machine for hollowing tree trunks is drawn in the Hussite Manuscript, and Francesco di Giorgio improved the hydraulic saw mill. In this, rotary motion was converted by gearing into reciprocal motion, like the thrust of the human arm, and the trunk of the tree on a carriage was drawn automatically against the blade. Leonardo was aware of all these devices, improved them, and contributed the treadle-lathe.

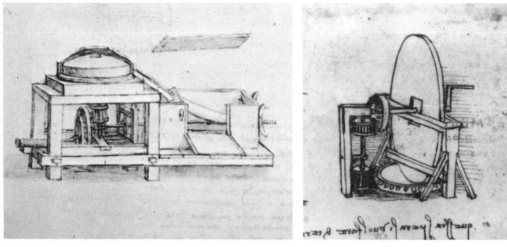

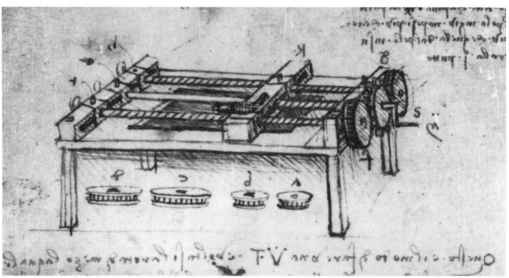

*The grain mill* TOP LEFT *has a mechanical bolter, or cylindrical sieve. Leonardo's drawing is the first of its kind. When the handle of the lens grinder* TOP RIGHT *is turned, both grindstone and lens revolve, at different speeds. The screw being made on the thread-cutting machine* ABOVE *is in the centre. The gauge of the thread is altered by changing the size of the gears. A set of gear-wheels is shown below.*

He needed wires, cords and ropes of different gauges, so he modified and mechanized existing practices. He showed how a rolling-mill, driven by a turbine water-wheel, could, with a draw-bench, reduce iron bars into rods sixty feet long, and how wire could be drawn through an orifice. His cord and rope making machinery consisted of spindles arranged in a semi-circle; it could spin and twist together as many as fifteen strands.

He needed mirrors and lenses to meet his special optical specifications. The craftsman's practice was to cut a disk of glass and then with abrasive rub it into

shape—concave or convex. Leonardo showed how it could be done more easily and with greater precision by machinery. He contrived different types of glass grinders and polishers. One was for levelling and polishing plain glass; another for grinding curvatures; and a third, particularly ingenious, which gave to the abrasive tool a combined rotary and orbital movement – like a waltzing couple circling round a ballroom.

As Ladislao Reti says, concerning the elegant illustration of a grain milling-and-sieving assembly in the Madrid manuscript which coincides with the Milan period: 'Was this important device invented by Leonardo? I do not know. The only possible statement is that as far as we know, Leonardo's drawing is the first.'[E]

That reservation could apply to hundreds of Leonardo's mechanical items. Occasionally he was convinced that he was the sole begetter of some contrivance. Often he thought an invention was novel enough to be commercially valuable, hence the deliberate mistakes which Luigi Boldetti found. Sometimes what has been eagerly ascribed as a Leonardo 'first' is no more than a personal reminder of something he had seen, or heard or read about. This is true of what is unmistakeably a magnetic needle on a horizontal board, 'thereby giving us the compass as we know it today', according to Donald Peattie.[F] But as early as 1190 Alexander Neckham had described the floating compass (introduced from China) and two types of boxed compass were described by Roger Bacon's friend and teacher Peter Peregrinus in 1269. One was a floating compass containing a lodestone and the other a pivoted needle magnetized by being rubbed with lodestone. The pivoted needle and the compass-card which gave the cardinal points had been combined by the beginning of the fourteenth century and in Leonardo's time 'clocks of the needle', pocket sundials with a magnetic needle inset to give the meridian, were familiar to the seafarers who came calling on Leonardo's friend Toscanelli. More likely than its being an inspirational discovery, Leonardo was probably once again using his sketch-sheets as a scratch-pad, and it presumably belonged to his thinking about the rays of magnetic force, concerning light-rays and sound-waves.

In addition to his engineering agility and ability, he made scientific discoveries which will be dealt with in later chapters. We recognize by hindsight the importance of his inventions and his original scientific thinking. He reminds us of what was missed for centuries:

Peruse me, O reader, if you find delight in my work, since I shall very seldom return to this world, because only few have the perseverance to pursue such a profession and to invent such things anew. And come men and see the miracles which by these studies can be discovered in nature.[13]

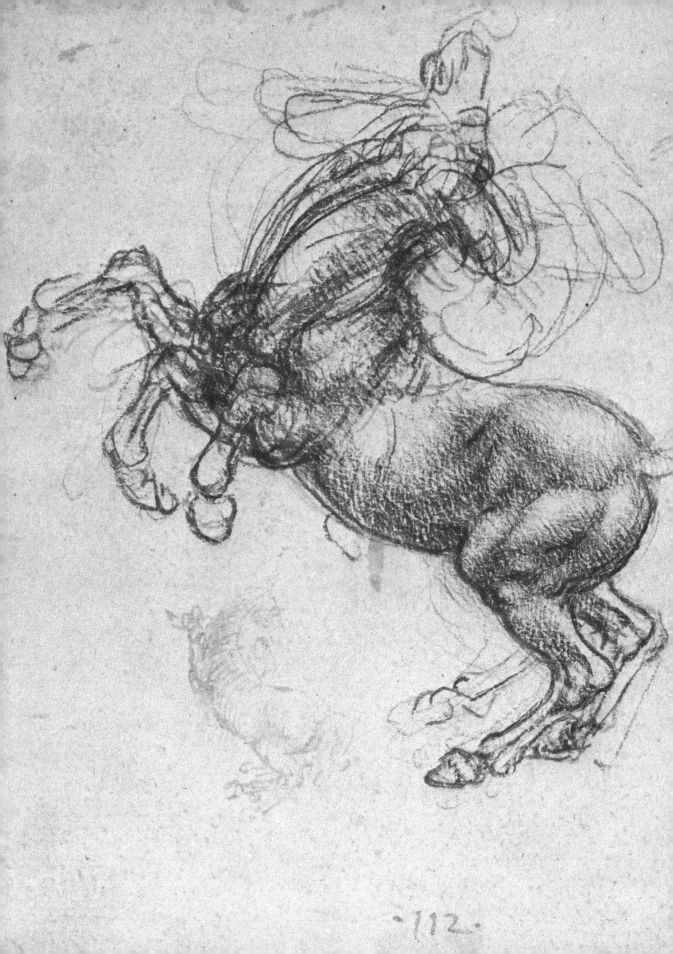

·112·

CHAPTER SEVEN

# Anatomy of the Gioconda Smile

It is necessary to note first as to the bones of the face, in what part
arise and whence come the nerves which first open and then close
the lips of the mouth. . . .[1]

While Leonardo was playing cabaret-entertainer at the Sforza court and occupying
himself with commercial invention, he was still obsessed by The Horse. It was
always referred to as that—*The Horse*. The colossal equestrian statue of Francesco
Sforza was a prestige project like building the Concorde supersonic air liner or
Man-on-the-Moon-before-1970. Others had already been hired and had failed
before Leonardo made his offer to *Il Moro*: '. . . the bronze horse may be taken in
hand, which shall endue with immortal glory and eternal honour the happy
memory of the Prince your father. . . .'[2] The first recognizable attempts are an
engraving and two drawings in the Windsor Collection dateable as 1484. He
thought that his prancing horses of the *Adoration of the Magi* could be transferred
to sculpture. If he could have achieved this he would have excelled all the ex-
perience of his time—how to poise a rearing horse, with all that weight of bronze
on its hind legs. His compromises, supporting the forefeet on a tree trunk or on a
prostrate enemy, were at that time uncastable. The usurper prince, his pay-
master, knew this and looked around for another sculptor without success.

Leonardo was given another chance. This time he was less ambitious; he settled
for the walking horse to be seen in another small sketch at Windsor. He constructed
a full-scale model in clay and he had worked out the details of the casting, including
the preparation of the alloy and a new moulding system. It never materialized.
The clay model stood and was admired in the palace courtyard until the rude and
licentious French soldiery of the conquering Louis XII used it as a target for
archery practice. The remains were rescued and taken to the Court of Ferrara
where the horse finally decomposed.

For this ambitious work, Leonardo prepared himself in his usual, thorough
fashion—thorough in preparation but not in execution. He not only made his
dramatic sketches of horses from life but he dissected horses better to understand

*A rearing horse. Study* c. *1504, for* The Battle of Anghiari.                    141

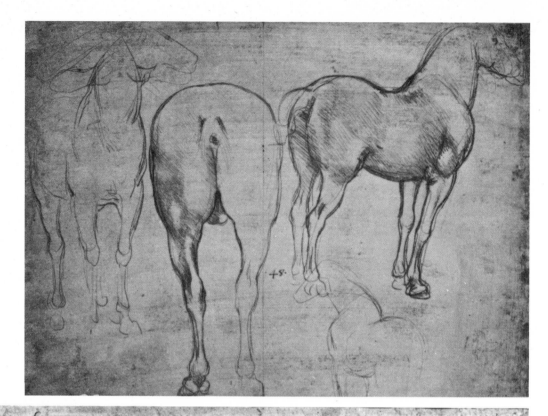

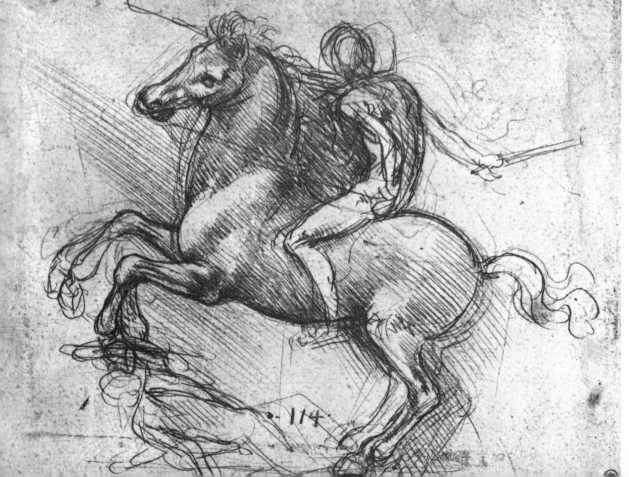

their muscle structure and discovered an abiding interest in anatomy and anatomical drawing, which was destined to become another area of his fame.

Interest in anatomy had been a professional concern of the Greek sculptors from Praxiteles in the fourth century B.C. onwards. They had studied the muscle-structures of the naked athletes. The painters and sculptors of The Age of the Eye looked again. They were not content with the superficial; they got beneath the skin. As a pupil of Verrocchio, Leonardo had acquired his master's interest in the detail of the body-structure. The Florentine coterie was already dabbling in anatomy. There is Donatello's bronze tablet 'The anatomy of a miser's heart', and we have it from Vasari that Antonio Pollaiuolo, 1432–98, 'dissected many human bodies to study anatomy and was the first who investigated the action of the muscles by this means'.[A] Verrocchio himself restored the limbs to an ancient statue of the flayed Marsyas, with a faithful reproduction of the naked muscles which could have come only from the first-hand study of a flayed corpse.

*The design of a conquering horseman for the Sforza monument occupied Leonardo for nearly twenty years. The two drawings on the facing page, were made with the silverpoint technique, using a needle on specially prepared paper. Pollaiuolo also drew a rearing horseman* BELOW *for the Sforza monument and perhaps both artists were inspired by a classical relief.*

There was an explanation for this active interest. Artists in Florence, in spite of carrying out religious commissions, were assertive free-thinkers. They did not pay much attention to the prevailing and misunderstood dogma about the treatment of corpses. There was supposed to be a papal anathema against dissection of bodies. This dated back to the papal bull *De Sepulturis* of Boniface VIII (1300) which proclaimed excommunication for any who boiled up bodies, according to the practice of Crusaders, for shipping home the bones in small bulk for interment in the family vaults. The bull was construed as a total ban on dissection. But in 1316, Mundinus of Bologna compiled *Anothomia* which was first published in 1478 at

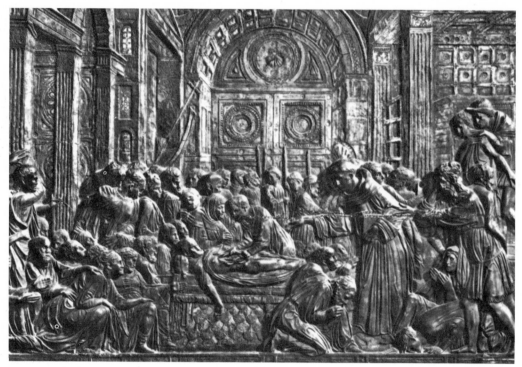

*The anatomy of a miser's heart. Bronze tablet* c. *1450 by Donatello, Basilica di S. Antonio, Padua.*

Pavia, having been available 'under the counter' all the time. Bologna recognized dissection by university statute in 1405 and Padua followed suit in 1429. Academic anatomy, however, was singularly unadventurous. The ruling masters repeated the studies and mistakes of Aristotle and Galen, and often discouraged illustrations because they wanted the fees for giving anatomical demonstrations. The impetus towards initiative in anatomy probably came from artists seeking realism in their representations.

The circumstances were peculiarly favourable in Florence where the artists enjoyed the patronage and protection of the Medici, the princes, and had a craft

*Cesare Borgia, Leonardo's patron 1502–3. Painting attributed to Giorgione.*

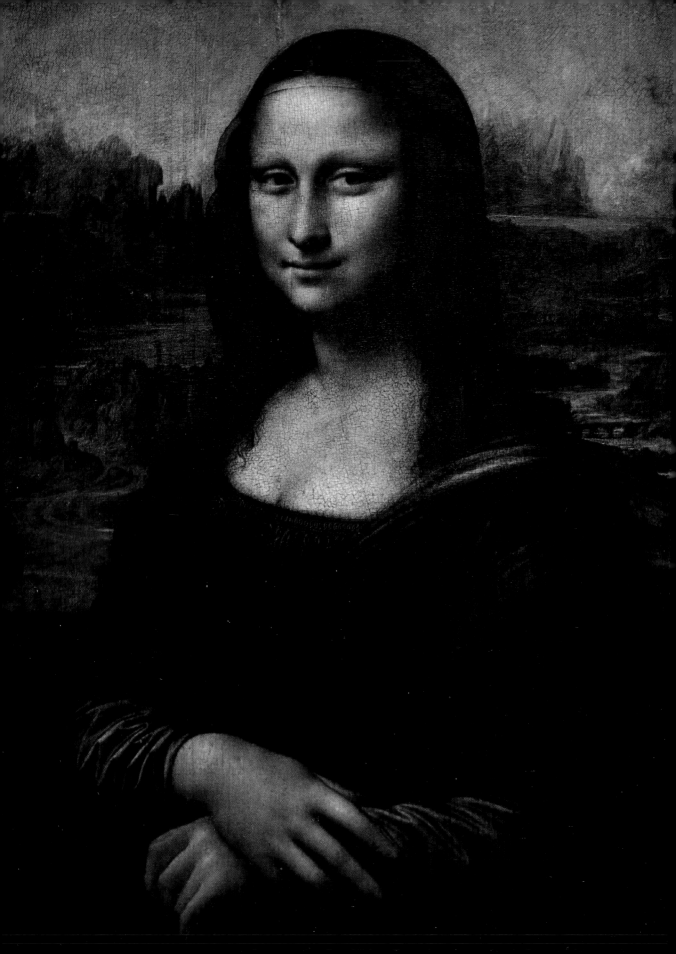

association with the *medici*, the doctors. Both artists and doctors were customers of the apothecaries, the first for their pigments and the others for their pills. In 1303 and for two and a half centuries afterwards, artists and doctors often had collateral membership in each other's guilds.

In Florence, anatomy got an early start. When in 1387 dissection was first permitted in the University of Florence, the artists were called in to help their guild-brothers in the anatomy theatre, as cine-technicians are now used to record the progress of a dissection or an operation. Indeed, Vesalius, the renowned medical

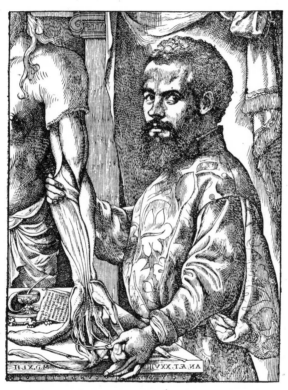

*Andreas Vesalius, from* De Humani Corporis Fabrica, *first published in 1543.*

anatomist (1514–64), resented the anatomical pretensions of the artists who 'flocked around' his demonstrations.

The young Leonardo, like his immediate elders, was interested in bone and muscle structures. The artists attended medical anatomy demonstrations and public executions. They competed for the corpses of felons, and the implications are (in the case of Luca Signorelli, Leonardo's direct contemporary) that grave-robbing for artistic reasons anticipated, by four hundred years, the activities of Burke and Hare, for Dr Knox's pedagogical purposes. But material for dissection

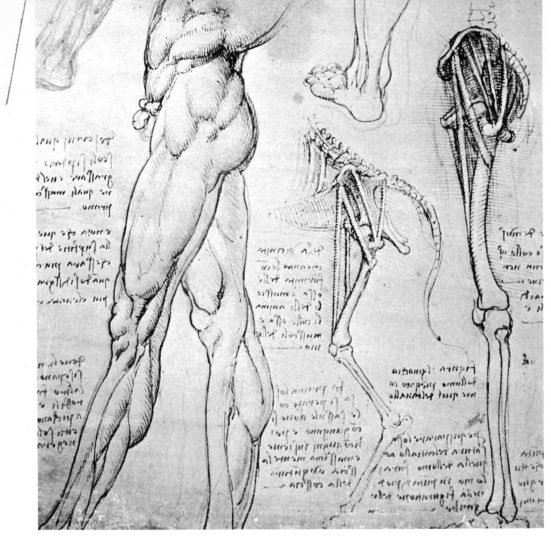

*'Make a man on tiptoe, that you may better compare man with other animals.' Leonardo draws the bones and muscles of a man's leg, and those of a horse.*

was still hard to come by. It seems from Leonardo's notes that one of his subjects for anatomy might have been that Bernardo di Bandino Baroncelli, whose hanged body he had sketched after the Pazzi plot.

Most of his vigorous studies of the muscular action of horses are surface anatomy, but there are studies of the uncovered leg-muscles and the comparison of the muscles of the horse's thigh and the corresponding muscles in man. Legs, as we have seen in connection with the structural-engineering problems of The Horse in Milan, were of more than biological interest to him at that time.

Around 1490 in Milan, it becomes obvious that Leonardo was beginning to consider anatomy and physiology not just as ancillary to art, but as a science to be systematically studied. His scholarly interest was still dominated by the traditional writers—Aristotle, Galen, Avicenna and Mundinus and like them he thought that in comparative anatomy, animals and man were more closely identi-

148

*The frontispiece of Pacioli's* Somma di aritmetica *shows a dedication to Guidobaldo da Montefeltro, Duke of Urbino. From the edition of 1494, formerly in the possession of William Morris, Kelmscott.*

fied with one another than they really are. (The misleading experience with the ox's eye has already been cited.)

In 1497, Luca Pacioli, the Florentine mathematician, was 'brain-drained' from the court of the Montefeltre in Urbino to Milan where he enlisted Leonardo's help in illustrating his thesis *De Divina Proportione* published in Venice in 1509. While most of the drawings are of geometric solids, there is also a drawing of the proportions of the human head. In his introduction to this work Pacioli says that Leonardo had finished an admirable book on the depiction and movement of men. If this be true then the book has been lost, and what remains of Leonardo's anatomical work at the end of his first Milan period are the disconnected bits and pieces in the Windsor Collection and oddments elsewhere.

Anyway, it is clear that Leonardo was getting more and more engrossed in the mortuary. Centuries later John Ruskin attacked him and Pollaiuolo, Castagno and

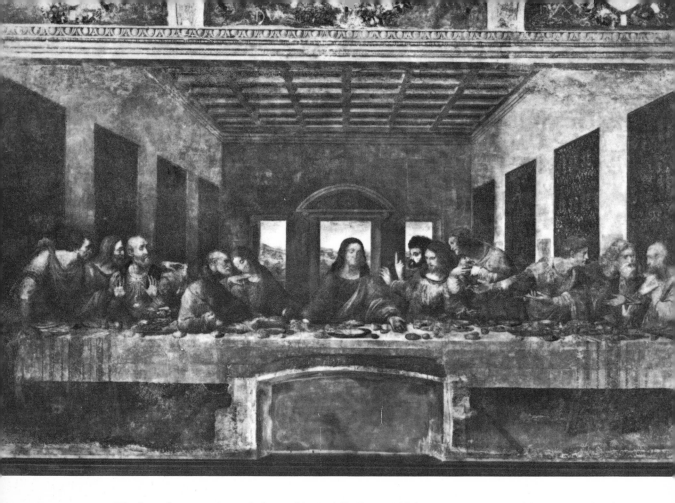

The Last Supper, *1495–98. Santa Maria delle Grazie, Milan. Amongst Leonardo's drawings for the composition are the studies for the heads of St James Major* BELOW RIGHT, *and* BELOW LEFT, *of Judas.*

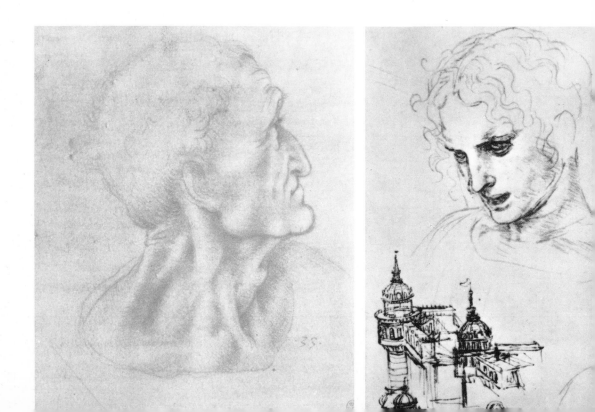

Mantegna for 'polluting their work with the science of the sepulchre'.[B] This declaration of contempt recalls that in his industrial activities at this time Leonardo was offending also against Plato who, according to Plutarch, inveighed against those who 'corrupted and debased the excellence of geometry by causing her to descend from incorporeal and intellectual things and obliging her to make use of matter which requires much manual labour and is the object of servile trades'.

Leonardo's first period in Milan was coming to a bleak end. Ludovico *Il Moro* had outsmarted himself. In his intrigues to legalize his usurpation of the ducal throne had had aligned himself with Charles VIII of France. Under the agreement, Charles was invited to invade Italy through the Milanese north, in order to enforce an old Angevin claim on the kingdom of Naples with whose rulers *Il Moro* was then at loggerheads. This was a blunder which *Il Moro* quickly realized and he tried to mend his fences by expensive deals with Venice, the Papacy, Spain and the Holy League.

His wife, Beatrice d'Este, had died in childbirth in January 1497, and with an excessive display of grief, he instructed his court painter, Leonardo, to decorate a black chapel adjoining the banqueting hall. Even before Leonardo had completed the work, he was being ordered to redecorate the hall itself for purposes remote from mourning. At the same time Leonardo was, off and on, addressing himself to the painting of *The Last Supper*, which Ludovico had commissioned for the refectory of Santa Maria delle Grazie.

This masterpiece, which successive generations have so admired, was one of Leonardo's technical failures. About his artistic vision there can be no reservations: the composition, the configurations, the gestures are all Leonardo at his best. But, as a technical effort, it was like his other lost masterpiece *The Battle of Anghiari*, a botched job. His method of working was erratic. Sometimes he worked with frenetic energy; sometimes he seemed to do little. Matteo Bandello, writing as a contemporary, gives a description of the master at work: 'Many times I have seen Leonardo go to work early in the morning on the platform before *The Last Supper*; and he would stay there from sunrise till darkness, never laying down the brush but continuing to paint without eating or drinking. Then three or four days would pass without his touching the work, yet each day he would spend several hours examining it and criticizing the figures to himself. I have also seen him, when fancy took him, leave the Corte Vecchia where he was at work on the stupendous horse of clay, and go straight to the Grazie. There climbing on the platform, he would take a brush and give a few touches to one of the figures, and then he would leave and go elsewhere.'[C]

These bursts of enthusiasm followed by long periods of inactivity were spread over at least two years. The picture was probably begun in 1495, and two years later we have the irritated Duke ordering his secretary to 'get after' Leonardo and make him finish the job. Pacioli suggests that it was completed by 9 February 1498,

*Leonardo's treatise on movement of men is lost, but the drawing above shows Leonardo, like a time and motion expert, interested in the efficiency of the movements of men at work.*

but Vasari implies that it was still unfinished when Leonardo quit Milan at the end of 1499.

In any event, his methods showed that he was trying *tempera* since it could not be *fresco*. Used by the Minoans before 1500 B.C., by the Romans and by Leonardo's own contemporaries, *fresco* meant embodying the pigments in the walls. The traditional technique was to produce the picture on freshly applied *(fresco)* lime-plastered walls, with colours made by grinding dry powder pigments in pure water. The colours dried and set with the plaster, in the same chemical process. The pigments were ingrained as durably as a skin-tattoo, which can only be removed by plastic surgery just as, in modern restoration of a genuine fresco, the layers of plaster have to be scaled off, bringing the picture with them.

Leonardo tried to substitute ingenuity for the speed and patience which fresco calls for. Instead of relying on the chemistry by which the lime slowly absorbs carbon dioxide and becomes calcium carbonate, binding the pigments by the crystals, he treated the wall with a medium containing oil and varnish so that the pigment-paints were applied superficially. Moreover he was putting this scale on a damp wall and any do-it-yourself home-decorator knows what *sealing in damp* means. Already in 1517, within twenty years, Antonio de' Beatis was grieving that such a superb work had begun to perish and Vasari, who saw it in 1556 when 'restorers' had got at it, described it as so badly handled that there was nothing

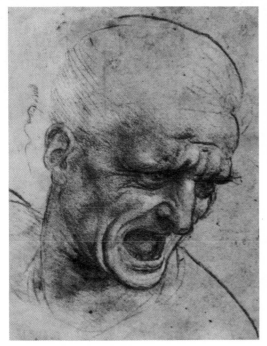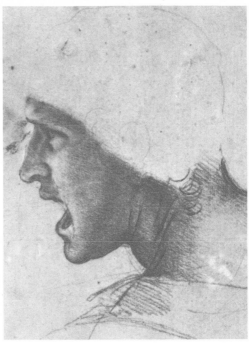

*Anxious and angry faces drawn as studies for* The Battle of Anghiari.

visible except a muddle of blots. A hundred years after that Scanelli was saying that of the original only traces of the figures remained.

The painting has been restored four times since the beginning of the eighteenth century, and in recent times the peeling paint has been put back flake by flake, with a reverence it would deserve if it were, in fact, Leonardo's original paint, which it certainly is not. Lord Clark makes the tampering abundantly clear by comparing the present heads of the Apostles with Leonardo's original intentions in his detailed sketches for the complete cartoon and from copies made from the original by Leonardo's pupils. He shows that Judas has lost Leonardo's tormented expression; that St Andrew, from a dignified profile, has been turned into a three-quarter face 'of Simian hypocrisy'[D] and St Peter has been made Neanderthalean. The expressions to which Leonardo gave so much careful attention and rehearsal have been clumsily modified. The dramatic composition and the gestures remain. One can only comment that Leonardo was a better draughtsman than he was a chemist.

Here may be the place to consider his other technical fiasco *The Battle of Anghiari*. It was his first big commission on his return to Florence from Milan. The *Signoria* decided to exploit the rivalry between the up-and-coming Michelangelo and the established master. Leonardo was given one wall of the Great Council Chamber of the Palazzo Vecchio to paint and Michelangelo the other. It

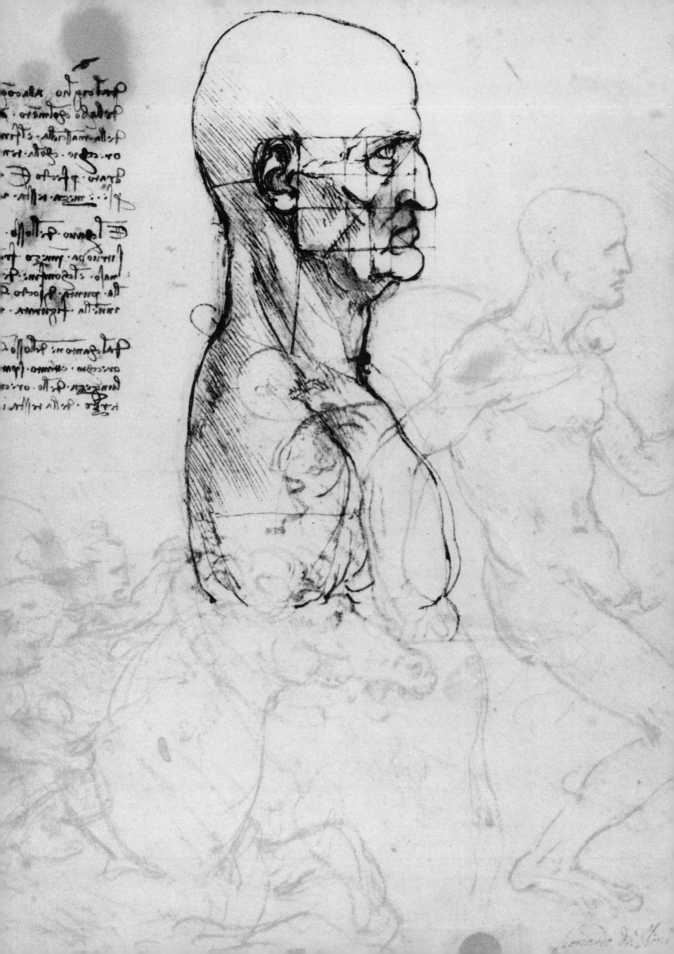

was a gladiatorial confrontation for they had formed a violent personal dislike for each other and obviously Leonardo regarded his role as that of the challenged champion. He chose the subject of a battle *mêlée* in which he could embody all his studies and perfected sketches of the movement of horses and of the expression of man. He had prescribed for such a painting:

> You must make the conquered and beaten pale, their brows raised and knit, and the skin above their brows furrowed with pain, the sides of the nose with wrinkles going in an arch from the nostrils to the eyes, and make the nostrils drawn up . . . and the lips arched upwards and discovering the upper teeth; and the teeth apart as with crying out in lamentation.[3]

There have been many accounts of the factors contributing to the disaster of his spectacular concept. He was perhaps in a hurry to outstrip his rival who had chosen as his subject bathing soldiers surprized at the Battle of Cascina. Once again he is supposed to have 'doctored' the walls by sealing the plaster pores with wax or resin, and to have tried an encaustic method recommended by Pliny. 'Encaustic' means fixing by heat, and is a modified form of enamelling to be used on hard surfaces, like wood. But if this is what Leonardo tried, he had not read Pliny properly:

> Those among the colours which require a dry, cretaceous, coating, and refuse to adhere to a wet surface, are purpurissum, indicum, caeruleum, milinum, orpiment, appianum, and ceruse. Wax, too, is stained with all these colouring substances, for encaustic painting; a process which does not admit of being applied to walls. . . .[E]

*'From the eyebrow to the junction of the lip with the chin, the angle of the jaw, and the angle where the ear joins the temple will be a perfect square. . . .' Proportions of the human head, with horsemen for* The Battle of Anghiari, LEFT. BELOW *Study for* The Battle of Anghiari, c. *1503.*

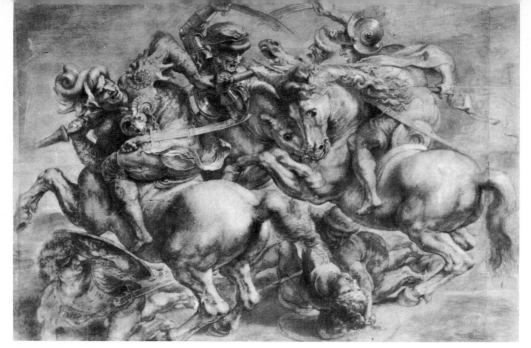

The Battle of the Standard, *by Rubens* c. *1615.*

According to plausible accounts, his heat treatment consisted of lighting a great fire in the Council Chamber. The result was tragically unsuccessful. The upper half dried too hard and the lower half melted and the colours ran.

With the rediscovery of the mislaid manuscripts in Madrid, we have a further version of the tragedy, from Leonardo himself. It accounts for the loss of the cartoon on which the mural was based:

> Friday the 6th of June, 1505, at the stroke of the 13th hour, I started to paint in the Palace. As I took up the brush, the weather changed for the worse and the bell started to toll, calling the men back to the Ragione. The cartoon was torn, water poured down and the vessel of the water that was carried broke. Immediately the weather worsened still more and it rained very heavily till nightfall and the day turned to night.[4]

This suggests another explanation. Perhaps Leonardo was making not a misguided variation of the Pliny encaustic process, but a desperate attempt to dry out after the storm, using the bonfire as space-heating to hasten the process. One sympathizes with the attempt, especially if Leonardo were trying to keep his time-advantage over his rival, Michelangelo, who had started his cartoon of the bathing soldiers some time after Leonardo.

The existence of copies of the central motif suggests that the masterpiece was not entirely ruined. Fifty years later Rubens apparently still had access to some true impressions of the cartoon which he reproduced in his own *Battle of the Standard*. Certainly at the time it attracted attention and according to Vasari, Raphael Sanzio of Urbino having 'heard reports of Leonardo's cartoon for the great hall of the palace and the cartoon of the Nude Bathers by Michelangelo . . . set aside his own interests . . . and at once proceeded to Florence.'[F] This was

156

Raphael, later to become painter-extraordinary to the popes. Vasari who so eulogized Leonardo was to complete the tragedy. In the reconstruction of the Council Chamber in 1565 he smothered the master's mural with one of his own inadequate decorations.

When in October 1499 the French under Louis XII occupied Milan, and Ludovico was betrayed by those whom he had bribed to betray others and carried off to imprisonment in France, Leonardo was a victim of the fortunes of war. His querulously deferential complaints to *Il Moro* had finally registered with his fickle paymaster, who in October 1498 had ceded to Leonardo the property of a vineyard outside the Porta Vercellina on which to build a house and so 'strengthen the bonds which already unites him with Our person'.

But not for long: one year later Leonardo, with his mathematician friend Luca Pacioli, left the city of Milan. For several months he sojourned in Venice, where Alessandro Benedetti was at the height of his fame, lecturing and demonstrating systematic anatomy. Leonardo was familiar with his *Historia corporis humani sive anatomice* which he mentioned in his notebooks in connection with his own study of animals' lungs: 'The increase of the lung when it is filled with air is latitudinal and not in its length, as may be seen by inflating the lung of a pig. . . .'[5]

He was, however, looking again for a princely patron and in 1502, after a brief period in Florence, he threw in his lot with the ineffable Cesare Borgia, one of the acknowledged sons (just as Lucretia was the acknowledged daughter) of the libidinous Pope, Alexander VI. In 1492, Cesare's father had made him Archbishop of

LEFT *Woodcut of Venice from a gazetteer by Bergomensis, 1491, a copy of which was owned by Leonardo. Leonardo left for Venice in 1499, about the time his portrait* RIGHT *was drawn by Ambrogio de Predis.*

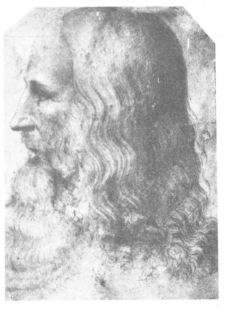

Valencia and then Cardinal but when, with his complicity, his elder brother, Giovanni Duke of Gandia, was murdered, he was released from holy orders and made the Duke of Valentinois by Louis XII in return for the papal annulment of the king's marriage. He became the military commander of the Pope's forces which were carving up central Italy. He conspired for the death of Lucretia's husband, the Duke of Bisceglie, as part of his designs on the Kingdom of Naples. This unpleasant character Cesare was the model for *The Prince* whom Niccolò Machiavelli, Leonardo's contemporary, glorified as the exemplar for all rulers.

Cesare was in the course of reducing the Duchy of Urbino and was threatening Bologna when he recruited the services of Leonardo. In the summer of 1502, Leonardo was appointed architect and engineer-in-chief and was to inspect the towns and fortresses which were captured. In this capacity he made topographical maps of the cities and areas of central Italy.

His association with Cesare was intense but short-lived. Cesare had intentions of conquering Florence about which neither Machiavelli, who was Florentine ambassador to the Borgia's court, nor Leonardo, seem to have had any patriotic misgivings. What revolted Leonardo was an orgy of assassination by the treacherous prince, which included the strangling of Vitellozzo Vitelli, a friend of the artist. In March 1503, Leonardo returned to Florence and had himself restored to the painters' confraternity from which his membership had lapsed for non-payment of dues. A few months later Pope Alexander VI died and the ruin of Cesare began. He was arrested by the new Pope and subsequently was imprisoned in Spain. He escaped and took service with his brother-in-law, the King of Navarre, and was killed in the siege of Viana.

It was almost twenty years since Leonardo had left Florence to deliver the silver lute to Ludovico. Lorenzo de' Medici was dead and the mood of the place had changed. Leonardo was received back with enthusiasm. His painting, which had been almost incidental in the Milan period now, by flattery and by commissions, excited him again. He was a most sought-after painter at this particular time. Isabella d'Este, whose portrait he had drawn in Mantua on his return from Milan, was pursuing him through her intermediaries. She appears to have developed an unrequited passion for him and her continued efforts to get him to paint some subject (but particularly herself) were probably the pretext of a languishing lady. But Leonardo was no more disposed to be her painter than he was to be her lover. He did however accept a Florentine commission which, according to Vasari, Filippino Lippi generously surrendered to him, to paint an altar-piece of the *Madonna and Child with St Anne*, another work he never finished. He worked on a painting for the King of France, a Madonna and Child. There was *The Battle of Anghiari*. And there was above all the *Mona Lisa*.

He could spurn a princess but he agreed to paint the portrait of the young wife of a Florentine tradesman. Francesco del Giocondo, rich and already twice a

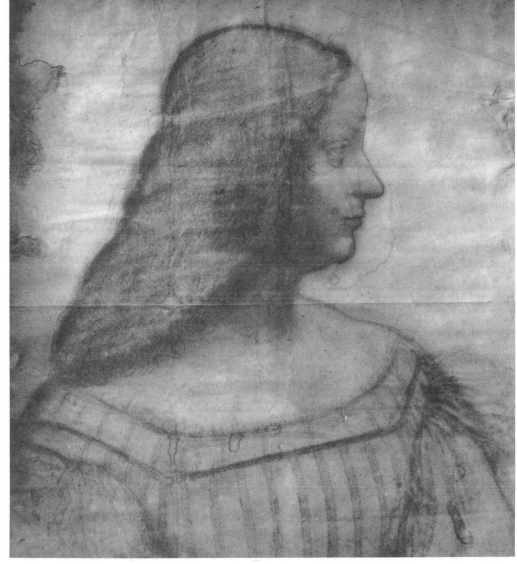

*'Leonardo da Vinci, who is in Venice, has shewed to me a portrait of Your Highness . . . in every way a most truthful likeness', Lorenzo da Pavia writes to Isabella d'Este in 1500.*

widower, had married a penniless girl, twenty years younger, Lisa the daughter of Antonio Maria di Noldo Gherardini. When Leonardo saw her she was over twenty-four years of age. She was not by the tastes of the time regarded as particularly beautiful, but Leonardo saw in her qualities which have made her the perpetual enigma, and the most heavily insured woman in history. Leonardo, the rejector of women, formed a devoted attachment not to his sitter but to his own painting. He kept it unfinished so that he could withhold delivery from the husband who had commissioned it and he took it with him on his subsequent wanderings, even to his final retreat at Amboise in France. Whatever its subsequent vicissitudes, we have Vasari's statement, 'It is now in the possession of Francis, king of France',[G] Leonardo's final patron.

159

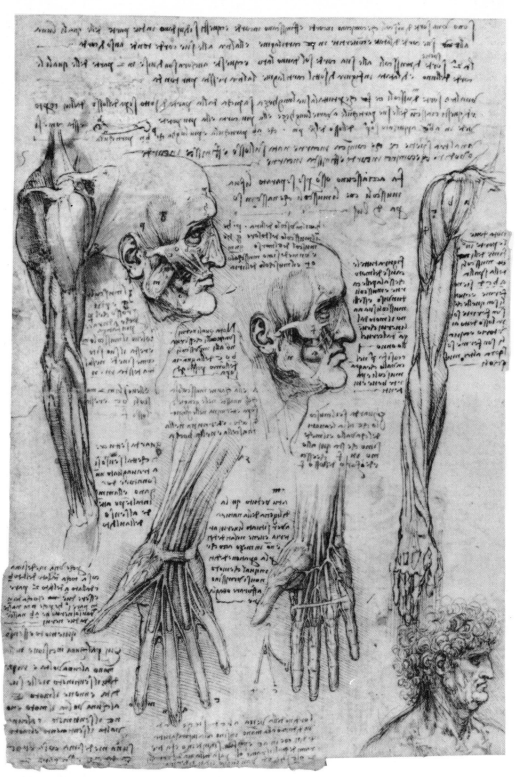

*Muscles of the hand, arm and face, drawn* c. 1510.

There are accounts of how Leonardo induced and maintained that smile by employing musicians to play to her and story-tellers to keep her amused. According to his own injunctions in the *Treatise on Painting*, he abjured the hard light of a bright day and painted her when the clouds hung low and a pale light filtered through. Lord Clark called her 'the submarine goddess of the Louvre'. Antonina Vallentin, however, suggests that this effect was intended and speaks of the lighting of the Tuscan landscape in the background 'as if it were sifted through moving water or greenish glass, a light like that at the bottom of the sea. . . .'

When all the arguments about the composition, the techniques and the detail and even about the authenticity of the Louvre version are exhausted, the one point of agreement is the 'Gioconda Smile'. This rates with the riddle of the Sphinx as an enigma which has teased generations of observers. If the whole picture dissolved so that, like Lewis Carroll's Cheshire Cat, all that were left was the smile it would glorify Leonardo.

Was that Lisa's smile the inspiration of the picture or was it something which Leonardo gave to Lisa? John Ruskin would rise roaring from the grave at the suggestion that a smile was a piece of topographical anatomy, but the suggestion could be sustained. In the notebooks of that precise period Leonardo writes:

> The movements that the lips make as they tighten are two, of which one is that which presses and strains the one lip against the other, the second movement is that which compresses or shortens the length of the mouth; but that which presses the one lip against the other does not proceed beyond the last molars of the mouth, and these when they are drawn are of such great power that, keeping the teeth somewhat open, they would draw the lips of the mouth within the teeth. . . .
>
> The muscles that tighten the mouth across . . . are the lips themselves, which draw the sides of the mouth towards the centre; and this is shown us by the fourth of this which says: the skin which forms the covering of the muscles that draw always points with its wrinkles to the spot where is the cause of the movement; and by the fifth rule: no muscle uses its power in pushing but always in drawing to itself the parts that are joined to it; therefore the centre of the muscles called the lips of the mouth draws to itself the extremities of this mouth with part of the cheeks, and for this reason the mouth in this function is always filled with wrinkles.[6]

He gives instructions to the would-be anatomist dissecting a head, and he goes on to describe the proportions of the extended lips to the contracted lips and to the nostrils and to the eyes in the facial movements.

Whether the 'Gioconda Smile' was the sublimation of his anatomical dissections—a living face which mutely lent itself to continued scrutiny—or whether his anatomy lent accuracy to the transfer of a transient smile which had first attracted Leonardo to Lisa, the portrait shows 'beauty wrought out from within upon the flesh little cell by cell'.[11]

He triumphed, too, with the hands. In his notebooks, at the same time as he was painting, Leonardo was writing:

When you begin [to dissect] the hand from within first separate all the bones a little from each other so that you may be able quickly to recognize the true shape of each bone from the palmar side of the hand, and also the real number and position of each, and have some sawn through down the centre of their thickness, that is lengthwise, so as to show which is empty and which full. . . . Then set down the complete figures of the first ligaments of the bones. The next demonstration should be of the muscles which bind together the wrist and the remainder of the hand. The fifth shall represent the tendons which move the first joints of the fingers. The sixth the tendons which move the second joints of the fingers. The seventh those which move the third joints of these fingers. The eighth shall represent the nerves which give them the sense of touch. The ninth the veins and the arteries. The tenth shall show the whole hand complete with its skin and its measurements, and measurements should also be made of the bones. And whatever you do for this side of the hand you should do the same for the other three sides, that is from the palmar or under side, from the dorsal side and from the sides of the extensor and the flexor muscles. And thus in the chapter on the hand you will make forty demonstrations; and you should do the same with each member. And in this way you will attain complete knowledge.[7]

If this seems a ghoulish way of looking at an attractive young woman or construing one of the world's greatest pictures, it is a reminder that Leonardo was a giant of anatomy as well as a great artist.

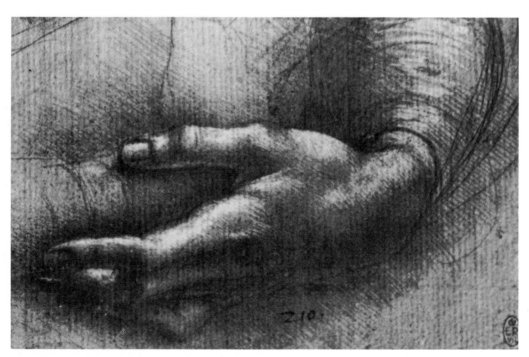

*Silverpoint study of hands,* c. *1474.*

*Leonardo: anatomical drawing of a man, showing heart, lungs and main arteries, drawn before 1500.*

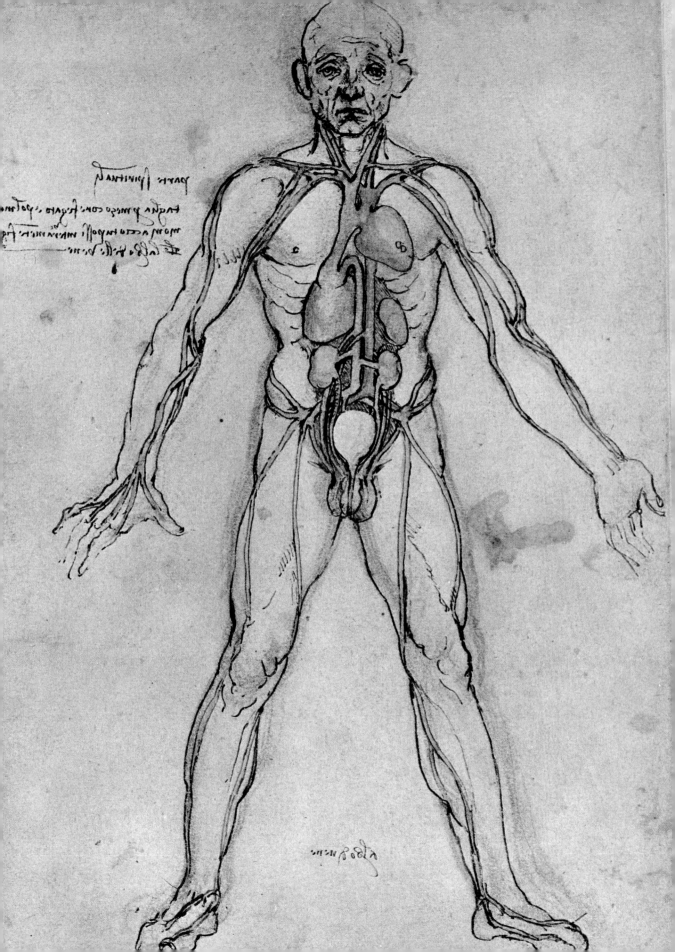

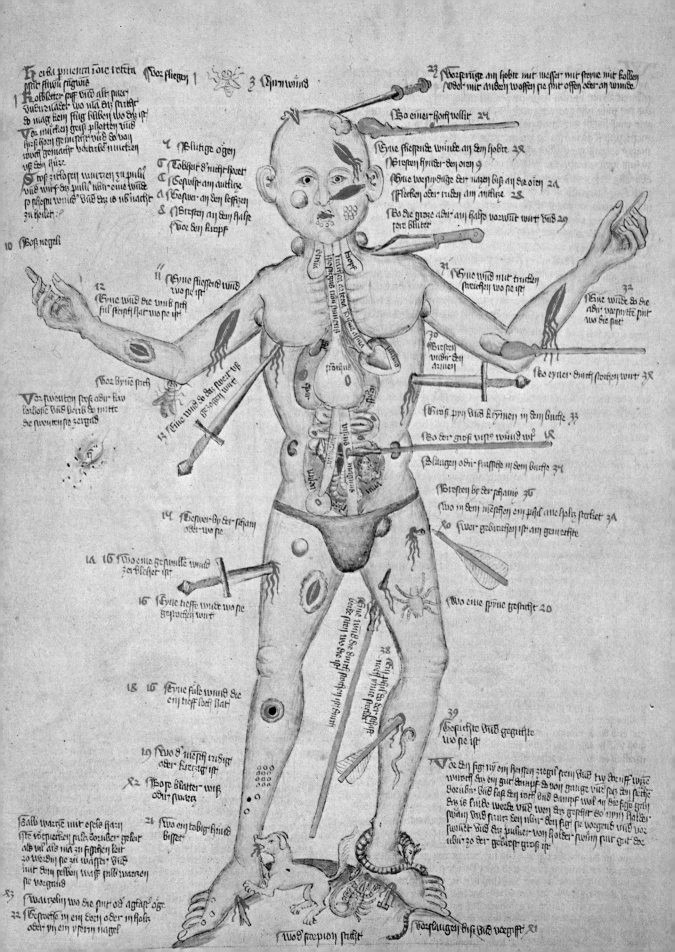

# Science of the Sepulchre

This gentleman has compiled a particular treatise of anatomy,
with the demonstration in draft not only of the members, but also
of the muscles, nerves, veins, joints, intestines, and of whatever can
be reasoned about in the bodies both of men and women, in a way
that has never yet been done by any other person. All which we
have seen with our eyes; and he said that he has already dissected
more than thirty bodies, both men and women of all ages.

*Antonio de' Beatis* [A]

When William Hunter, the great eighteenth-century surgeon, was shown the
Leonardo drawings found by Robert Dalton, George III's librarian, in the for-
gotten chest at Kensington Palace in London, he was flabbergasted: 'I saw, and
indeed with astonishment, that Leonardo had been a general and deep student.
When I consider what pains he has taken upon every part of the body . . . I am fully
persuaded that Leonardo was the best Anatomist, at that time, in the world . . .
Leonardo was certainly the first man we know of who introduced the practice of
making anatomical drawings.' [B]

Such anatomical drawings as were available at the end of the fifteenth century
were about as life-like as the schematic maps of modern underground railways.
They were few and imitative. They were of mannikins, jumping-jack figures, and
were often associated with the signs of the zodiac. Any observant artist, with a mite
of talent, could have improved on them. What is interesting is that William Hunter,
who certainly could not have read Leonardo's mirror Italian, could recognize from
the drawings 'the best anatomist in the world', before the time of Vesalius. Garri-
son's *History of Medicine* describes him as 'the founder of iconographic and physio-
logic anatomy.' [C]

From the library list in the *Codex Madrid II*, it is clear that Leonardo briefed
himself as well as he could on anatomy, surgery, medicine and dietetics, from the
works of Guy de Chauliac, Rhazes, Platina, Arnaldus de Villanova, Mundinus,
Benedetti and Montagnana. A remarkable list! Through it, he had the guidance
(or more often misguidance) of the exponents of the various schools of anatomy,
principally Galenic and Arabic. At first he diffidently followed and tried to check
the results of his learned predecessors, but later by the proofs of his own eyes and
his own experiments he often contradicted them and railed at them in his note-
books as though he were arguing with them in a room. In the latter years, when he

*A 'wound man'. A typical illustration from a fifteenth-century manuscript
shows with some relish the sites and causes of common injuries.*

had cleaned out the lumber-room of the past, his methods and his observations were entirely his own.

Leonardo was a fastidious person. That is obvious from his instructions to his pupils about looking after the studio; from his preference for painting because sculpture was a dusty, messy job; from his care in dress; from his faddiness in food and, as has already been suggested, his revulsion from the sexual act. He loved animals, buying caged birds to set them free and choosing to be a vegetarian rather than to eat their flesh. He denounced killing and cruelty. As Vasari claims, 'whatever his brain or mind took up he displayed unrivalled divinity, vigour, vivacity, excellence, beauty and grace.'[D]

Yet this was the man who spent days and nights in the stinking charnel-house, waded through blood and grease in the slaughter-house, and dissected corpses, removing minute portions of decaying material to expose the structure he was studying in particular detail. He was, in this disagreeable, painstaking operation, working against time, because of the putrefaction. There was no refrigeration to arrest the process. There is no mention of any artificial preservation.

His own repressed revulsion, his self-martyrdom in pursuit of knowledge, is

166

*Respected medieval textbooks in Leonardo's time were sometimes misleading, and often irrelevant. Leonardo had an edition of Guy de Chauliac's book on surgery (FAR LEFT an illustration from a manuscript version), and he was familiar with Mundinus' Anothomia which emphasized astrology (LEFT a woodcut from an edition of 1513). Leonardo also owned Cibaldone's popular poem on how to stay healthy, based on the works of the Arab physician Rhazes. The first page from an edition of 1493 RIGHT promises to teach about the merits of fruits, grain, wine and water, meats and fish.*

expressed in his warning to those who would study his book on anatomy, which we have not got:

> And if you should have a love for such things [the persons or animals to be dissected] you might be prevented by loathing, and if that did not prevent you, you might be deterred by the fear of living in the night hours in the company of those corpses, quartered and flayed and horrible to see.[1]

On his return from Milan to Florence, Leonardo was given facilities for dissection at the hospital of Santa Maria Nuova, and he was a witness of public dissections in Santa Croce. Subsequently, under the protection of Pope Leo X (Giovanni de' Medici), he dissected at the hospital Santo Spirito in Rome. Then through the malevolence of 'John the mirror-maker', a German who was jealous of him as a rival for papal patronage, he was accused of sacrilege because of his anatomical work and the Pope forbade him from carrying on.

He also dissected in his own quarters, taking home bits and pieces from the slaughterhouse, the mortuary or from the public executioner. The picture which can be reconstructed from his own notebooks is macabre: those night hours in the mortuary, most often alone, for, unlike the traditional anatomists who sat, wand

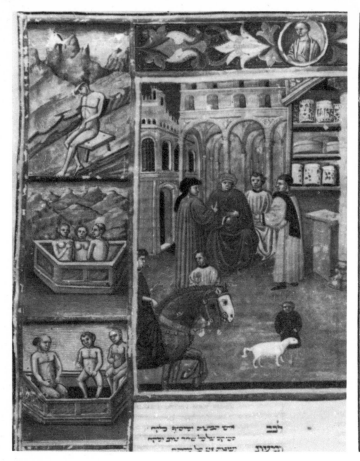

*The* Canon Maior *of Avicenna, the Arab physician born about* A.D. *980, was a medical Bible in Leonardo's time. The illuminated page* LEFT *is from a Hebrew manuscript of the* Canon. *The lacquer design* RIGHT *is from the binding of a Persian manuscript of 1609.*

in hand, enthroned in the theatre, while assistants did the butcher-work, his methods demanded close concentration and no distractions. He had even evolved his own oil-lamp to provide a steady flame in the gloom of the dissecting chamber.

He prepared for a dissection as meticulously as a modern operating surgeon. He wrote himself a memo: 'spectacles with the case, steel and fork and bistoury [curved surgical knife], charcoal, boards, and paper, and chalk, and pipe-clay and wax; thongs and glass beaker, a saw for bones with fine teeth, a chisel, inkstand, pen-knife. . . .'[2] Considering that none of his preceptors, classical or contemporary, could give him any clues, his system of anatomy was perforce original. It was centuries ahead, giving hints to William Hunter three hundred years later, and providing studies in depth which were only surpassed by X-rays. From his earliest venture into anatomy, he insisted that dissection was meaningless unless the subject could be presented from four aspects, which meant drawing it four times.

168

If you wish to know thoroughly the parts of a man after he has been dissected you must either turn him or your eye so that you are examining from different aspects, from below, from above, and from the sides, turning him over and studying the origin of each limb. . . . Therefore by my plan you will become acquainted with every part and every whole. . . .[3]

*Leonardo follows his principles and draws the shoulder region and biceps from many aspects. The drawing* BELOW *also shows the head of an old man Leonardo dissected after death, and includes a detailed description of veins and capillaries.*

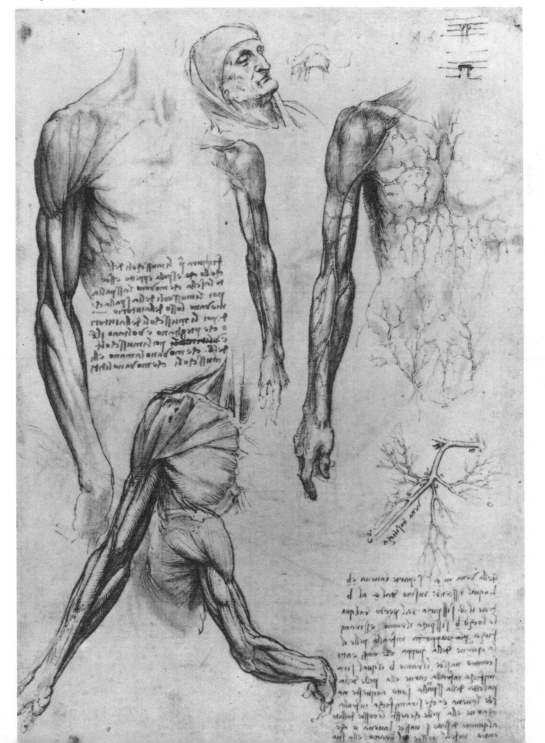

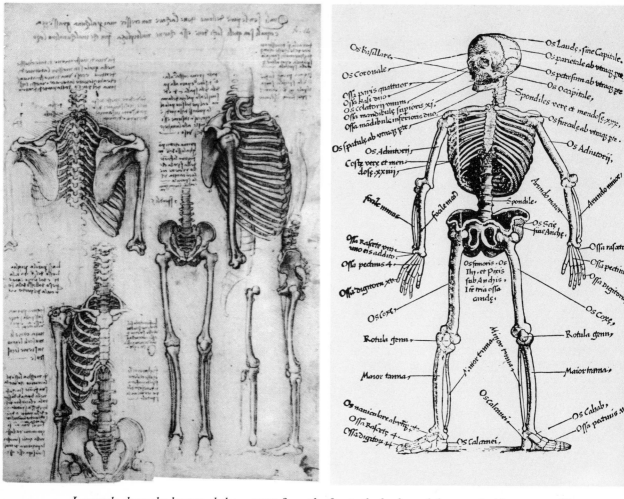

*Leonardo drew the human skeleton* LEFT *from the front, the back, and from each side* c. *1510. The skeleton* RIGHT *from an edition of Priscianus, 1532, is more stylized and shows the pelvis at a very odd angle.*

He followed this procedure in detail. He would take a bone, having carefully described its relation to the rest of the skeleton; measure it; draw it in front-view, back-view and from each side; saw it in cross-section and split it in length.

He rarely used diagrams, that is, schematic illustrations. One notable exception is his blueprint of the frog's spinal cord. He usually drew with photographic care. As he built up his illustrations, his skill as a draughtsman gave a sense of transparency as though one were looking through a limb. Today he is surpassed only by the method of using illustrations on transparent plastic sheets to give the effect of peeling off layer after layer. As we flip over such modern pages, we might remind ourselves that this was what Leonardo was doing the hard way, in the worst conditions, and he was transferring it all to two-dimensional paper.

He illustrated every bone of the body. When he is found to mis-align something, like the tibia and fibula with the tarsal (ankle) bones, it justifies a learned footnote

in modern textbooks. He demonstrated the actions of the bones as levers when acted on by the muscles. He illustrated accurately for the first time the double curvature of the spine, the true tilt of the pelvis and the correct number of vertebrae, correctly portraying each. He was the first to show the twenty-seven bones of the hand, and he detailed the extensor and flexor muscles by which the fingers worked. He was quite clear about the mechanical principles involved—no pushing muscles, just different sets pulling against one another. As visual aids to demonstrate this kind of thing Leonardo used cords and wires to indicate the origin, direction and attachment of the muscles. In his cross-section anatomy, he always showed the section within the contour of the limb from which it had been taken. He 'exploded' complicated structures—drew the portions separately but with guide-lines to show how they were connected in depth.

Modern commentators condescendingly remind us that Leonardo's glossary of medical terms was rather limited (mainly Arabic) and that he had overloaded his verbal descriptions with a lot of wordy detail, even being flummoxed sometimes as when he noted 'the vein which was searched for on Sunday' as though to remind

*Leonardo's drawings show the bones as levers when acted on by the muscles. On the drawing of the scapula* RIGHT *he notes* 'Endeavour to preserve thy health, in which thou will succeed the better the more thou guardest thyself from physicians'.

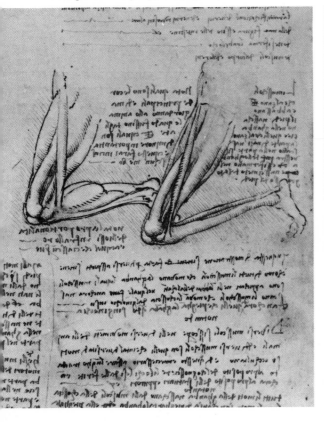
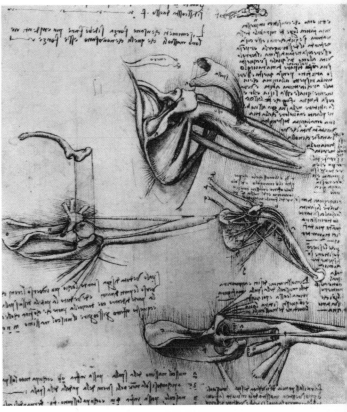

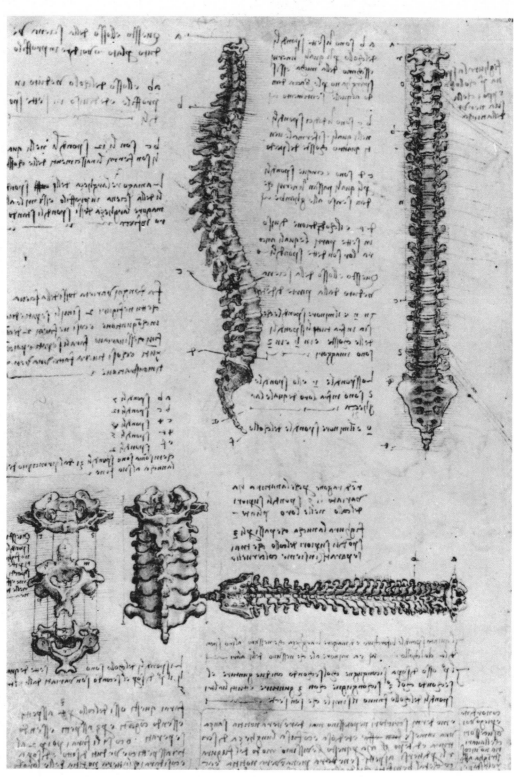

*Leonardo's drawing shows accurately for the first time the double curvature of the spine.*

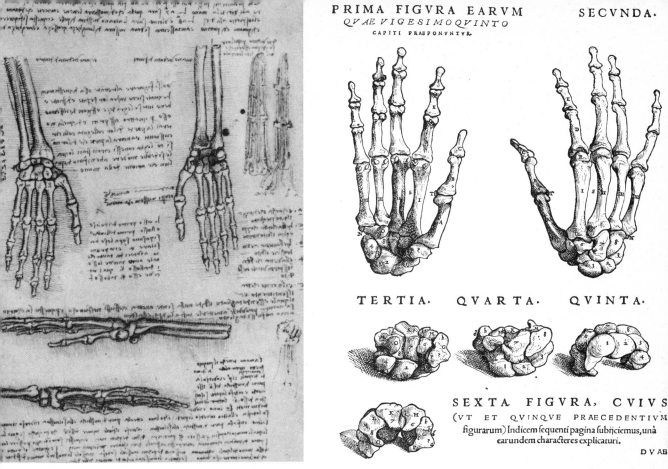

TERTIA. QVARTA. QVINTA.

SEXTA FIGVRA, CVIVS

(VT ET QVINQVE PRAECEDENTIVM

figurarum) Indicem fequenti pagina fubíjciemus, unà

earundem characteres explicaturi.

D V AE

*'Represent these hands with their bones detached from one another, so that the number and shape . . .
may be clearly understood', notes Leonardo on his drawing of the bones of the hand,* LEFT. RIGHT *An
engraving from Vesalius'* De Humani Corporis Fabrica, *1543.*

himself to ask somebody else what the proper description should be. But such
commentators should remember with humility that even today nomenclature is so
varied and unstandardized that anatomists might envy Leonardo's powers of
description.

Leonardo was on good terms with the monks of Santa Maria Nuova in Florence.
He had access to the hospital wards and, both for his paintings and his anatomical
work, he used to go there to study the patients—with a post-mortem interest in at
least two cases whom he observed. The first was a very old man. Leonardo was
talking to him when he suddenly sat up and 'without any movement or sign of
anything amiss, he passed away from this life'.[4] Leonardo carried out an autopsy
to find out '*la causa di si dolce morte*' (the cause of so gentle a death), and found:

> . . . that it proceeded from weakness through failure of blood and of the artery that feeds the
> heart and the other members, which I found to be very parched and shrunk and withered; and
> the result of this autopsy I wrote down very carefully and with great ease, for the body was
> devoid of either fat or moisture, and these form the chief hindrance to the knowledge of its
> parts.[5]

From his findings he gave the first clear description of what we now call *arteriosclerosis*, thickening of the arteries.

> And this network of veins acts in man as in oranges, in which the peel becomes thicker and the pulp diminishes the more they become old. And if you say that as the blood becomes thicker it ceases to flow through the veins, this is not true, for the blood in the veins does not thicken because it continually dies and is removed.[6]

He went on with practically no technical terms, because they were not available, to describe the conditions of blood-vessels in the aged—the very first expression of the science of gerontology which belongs almost entirely to the present day. He described the condition in which he found the vessels. He distinguished between arteries and veins, but still accepted the Galenic idea that the arteries carried the 'vital spirit' and the veins the 'natural spirits', that is the nutriment. He wrote that the ageing vessels 'grow in length and twist themselves after the manner of a snake', and in the vessels below the chest he found obstructions 'as large as chestnuts, of the colour and shape of truffles or of dross or clinkers of iron'. These stones were hard and had formed sacs attached to the vessels 'after the manner of goitres'.[7]

He dissected the body of the other case, a two-year-old boy, and 'found everything the contrary to what it was in the case of the old man' in the state of the blood-vessels. These differences he illustrated, showing the crooked, twisted, coarsened network of the old man and the strong, supple blood-vessels of the boy. This insight persuaded Leonardo that he must make a systematic study of the body at all ages.

Leonardo planned a complete book on anatomy. Among the notes for this systematic study is found the following:

> This work should commence with the conception of man, and should describe the nature of the womb, and how the child inhabits it, and in what stage it dwells there, and the manner of its quickening and feeding, and its growth, and what interval there is between one stage of growth and another, and what thing drives it forth from the body of the mother, and for what reason it sometimes emerges from the belly of its mother before the due time.[8]

Somehow he secured the dispensation of the religious authorities to dissect a woman who had died during pregnancy. For the first time in the recorded history of science he showed the correct position of a foetus in a womb. He was the first to explain properly the function of the placenta:

> The vessels of the infant do not ramify in the substance of the uterus of its mother but in the secundines which take the place of a shirt in the interior of the uterus which it coats, and to which it is connected (but not united) by means of the cotyledons....[9]

The cotyledons he compared to 'little sponges' fitting into each other 'like the fingers of one hand placed between the digits of the other'. This discontinuity between the blood-system of the mother and the embryo was, in ignorance of Leonardo's discovery, disputed for centuries. When in 1760 the locked chest in Kensington Palace was opened, William Hunter was amazed to find that Leonardo

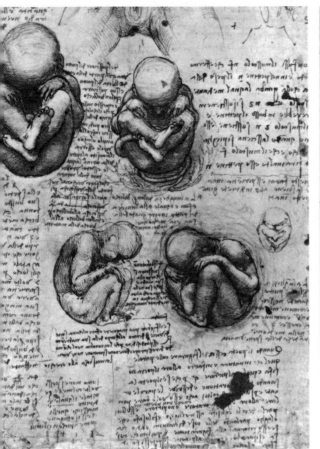
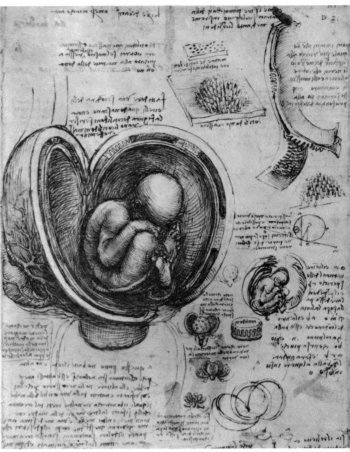

*The correct position of the foetus in the womb, drawn for the first time, c. 1510–12* LEFT. *In the drawing* RIGHT *he shows the cotyledons, 'little sponges', fitting into one another, but it is the uterus of a cow he has drawn. On the same sheet is an important note about stereoscopic vision.*

had already described what he, Hunter, had only recently discovered. Like Leonardo he had, in 1751, carried out an autopsy on the corpse of a woman who had died near the end of her pregnancy and when 'the season of the year was favourable for dissection', a consideration as important in eighteenth-century Britain as in fifteenth-century Italy. He had concentrated on the placenta and had established the discontinuity of the blood-supply between mother and child by injection of the blood-vessels. Leonardo had likewise used tracers, some identifiable substance injected into the blood-system.

Leonardo was all the time carrying on studies in comparative anatomy over a whole range of species. This could be, and in some cases was, misleading. For example, he studied pregnancy in the cow but, surprisingly for one so meticulous, his human foetus, correctly positioned, is shown in what is unmistakably a cow's uterus. He provided no explanation.

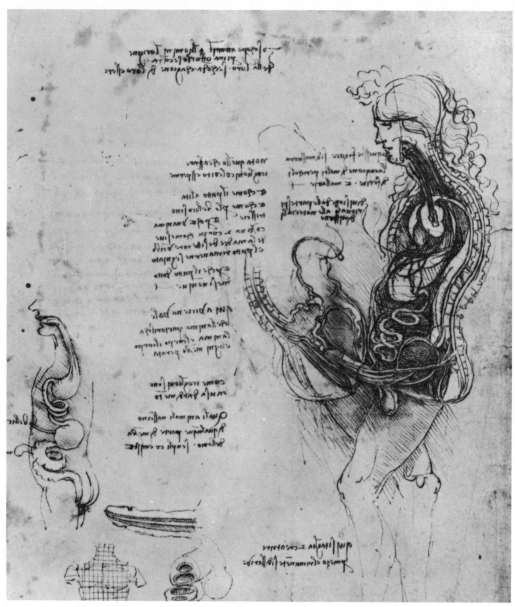

*At the top of his drawing of coition Leonardo writes: 'I display to man the origin of their second—first or perhaps second cause of existence.' In his drawing* RIGHT *of the organs of a woman, he follows Galenic tradition, and makes many mistakes.*

He described and depicted the sexual process with a frankness which made his drawing well known to later generations of medical students. He maintained that the gonads were only intermediaries and that the sex-process began in the brain. In the fullness of present-day knowledge of endocrinology and of the functioning of the pituitary, the 'split-pea' gland at the base of the brain, he was not far wrong.

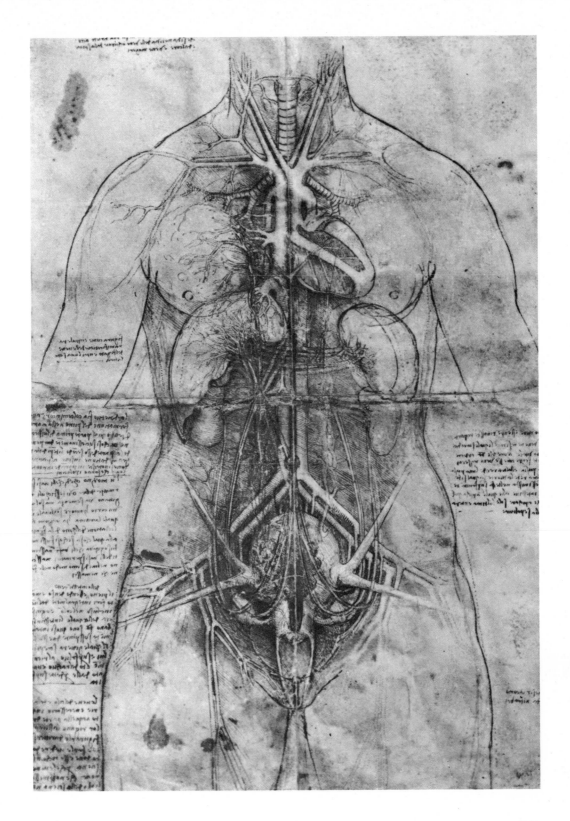

177

For one who was such a scrupulous observer, it is surprising to find him perpetuating a myth. On the same sheet on which he gives his four-aspect drawings of the foetus, valid in any modern textbook, he notes: 'Eggs which are round in shape produce males and those which are long produce females.'[10] This is the medieval fallacy of the spheres. The pedants then argued 'Platonic perfection': all heavenly spheres moved in perfect circles; the male sex was more perfect than the female; the female being the imperfect sex could not lay perfect spheres, only pointed ovals; but some eggs were less imperfect than others—nearer the round—and from these, cockerels would hatch. One would have expected Leonardo at least to go out to the hen-house and see what actually happened.

There is rather more insight in his exposition on genetics:

> The black races in Ethiopia are not the product of the sun; for if black gets black with child in Scythia, the offspring is black; but if a black gets a white woman with child the offspring is grey. And this shows that the seed of the mother has power in the embryo equal with that of the father.[11]

He shows his usual systematic thoroughness in his studies of the respiratory organs, the muscular system, the blood system, the nerves, the genito-urinary system, the alimentary organs, the eye (as has already been described), and the larynx.

Using a dead goose, he inflated the lungs and then pressed them, producing the characteristic honk through its throat mechanisms. This led him on to further

*The alimentary system, showing liver, stomach and spleen, based on the dissection of an old man.*

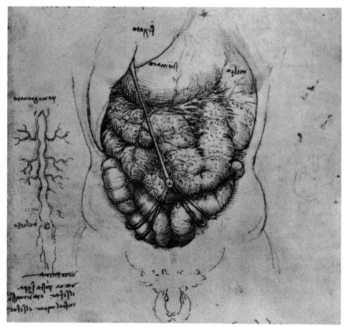

studies of the voice processes. He not only mapped the human nervous system; he used the frog to study nerve reflexes centuries before Galvani's twitching frog and before Pavlov. For each separate muscle, he defined its nerve-connections and its blood supply and its role in the living engineering of the body. Under a sensible teacher, Leonardo's accounts of the genito-urinary system could guide any elementary student today. As a piece of mapping, Leonardo's digestive system is quite clear, but he failed to note the muscles of the bowel wall and how they produce the wave-like contractions. Instead he attributed the onward movement of the bowel-contents to the diaphragm and the downward thrust of the abdominal walls. He was the first to identify the appendix, and made a guess that it was a means of relieving gases within the bowel, a sort of safety valve.

> The nerves with their muscles serve the tendons even as soldiers serve their leaders, and the tendons serve the common sense as the leaders their captain, and this is common sense serves the soul as the captain serves his lord.[12]

This poetic version of the nervous system Leonardo supported by systematic dissection which, considering the crude tools with which he had to work, was remarkably efficient. He used 'nervi' for both nerve and tendon but, allowing for that, his comprehension of the nervous system was far ahead of his time and of the classical authorities he had started by accepting but whom he had challenged after experiment. He saw the nervous structure as a completely related system, the brain substance being connected with the central nervous system and with the ramifications of motor and sensory nerves. He wrote:

> The soul apparently resides in the seat of judgment, and the judgment apparently resides in the place where all the senses meet, which is called the common sense; and it is not all of it in the whole body as many have believed, but it is all in this part; for if it were all in the whole, and all in every part, it would not have been necessary for the instruments of the senses to come together in concourse to one particular spot; rather would it have sufficed for the eye to register its function of perception on its surface, and not to transmit the images of the things seen to the sense by way of the optic nerves; because the soul . . . would comprehend them upon the surface of the eye.
> Similarly, with the sense of hearing, it would be sufficient merely for the voice to resound in the arched recesses of the rock-like bone which is within the ear, without there being another passage from this bone to the common sense. . . .
> The sense of smell also is seen to be forced of necessity to have recourse to this same judgment.
> The touch passes through the perforated *nervi* and is transmitted to this sense; these *nervi* proceed to spread out with infinite ramifications into the skin which encloses the body members and the bowels. The perforating *nervi* carry impulse and sensation to the subject limbs; these *nervi* passing between the muscles and the sinews dictate to these their movement, and these obey, and in the act of obeying they contract, for the reason that the swelling reduces their length and draws with it the *nervi*, which are interwoven amid the particles of the limbs, and being spread throughout the extremities of the fingers, they transmit to the sense the impression of that they touch. . . .
> . . . the common sense is the seat of the soul, and the memory is its monitor, and its faculty of receiving impressions serves as its standard of reference.[13]

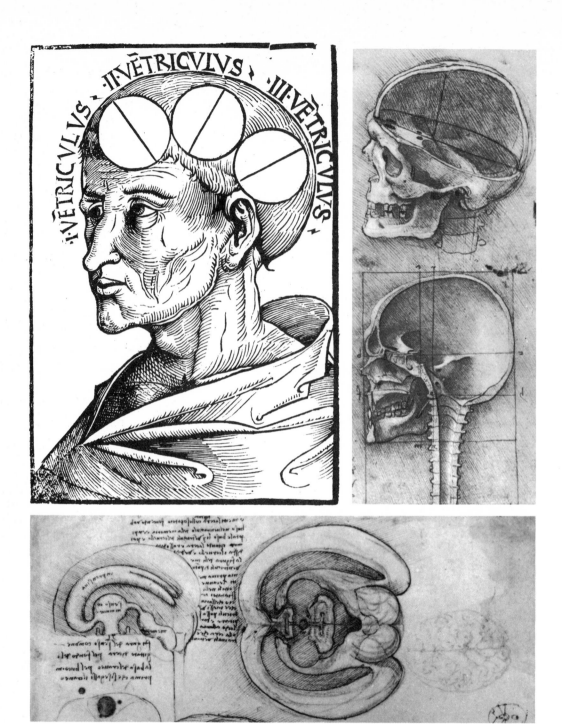

*Leonardo owned a copy of Albertus Magnus'* Philosophia naturalis. *The woodcut* ABOVE LEFT *from an edition of 1506 shows three ventricles in the head of a man.* RIGHT *Leonardo shows the human skull more accurately in cross section and,* BELOW, *using the brain of an ox, gives instructions for the insertion of wax to make a perfect model of the ventricles.*

No modern expert on cybernetics could give a more lucid or succinct description if for 'soul' we use 'mind', and for 'common sense' we use 'brain'.

Leonardo lacked one clue which could have simplified and clarified his researches and his thinking—electricity. Without it, he had to explain the means of transmission as a fluid. He needed a reservoir within the brain, from which the fluid, transporting the impulses, could flow through the minutely hollow nerves, as blood did through the capillaries—the word which he used for the thread-like blood-vessels.

With his usual thoroughness he had cross-sectioned the skull, and he was confronted with the tissues of the soft-brain within which he had to find his cisterns or nerve-fluid. This he did (to his own satisfaction, anyway) by borrowing from his experience as a sculptor trained in the casting of bronze figures. And he described exactly how he set about establishing the form of the ventricles:

> Make two air holes in the horns of the great ventricles and insert melted wax by means of a syringe, making a hole in the ventricle of the memoria, and through this hole fill the three ventricles of the brain; and afterwards when the wax has set take away the brain and you will see the shape of the three ventricles exactly. But first insert thin tubes in the air holes in order that the air which is in these ventricles may escape and so make room for the wax. . . .[14]

This experiment was not to be repeated until Frederik Ruysch used the same method in the seventeenth century and was actually acclaimed by the French Academy as rating with Newton.

Leonardo traced the vagus nerve to the floor of the third ventricle of the brain and, finding that the left branch ran to the heart, he decided that this, and not the heart, was the shrine of the soul. While apostrophizing the heart as 'O Marvellous Instrument invented by the supreme Master', he matter-of-factly proved that it was a muscle. He had inherited through Mundinus from Aristotle the idea of the heart as a two-chambered organ. This was true for the internal ventricles but, eventually, on the evidence of his own eyes, Leonardo described four sections, with the two external auricles as the chambers in which 'the blood is subtilized where it is more beaten'.

He carried out exhaustive studies of the valves. He made a glass model of the aorta in order to study the blood currents. To do this he took the heart of an ox, filled the aorta with wax, took a plaster impression of it and then blew glass to the shape. He showed how by introducing an artificial membrane it was possible to represent the valve, and tried to explain from his studies of hydrodynamics how the valve would operate in response to eddies produced in the aorta.

All this he had to study by dissection of cadavers and, for all his love of animals, he frequented the slaughterhouses to watch the killing of pigs—a gruesome performance. The squealing pig was thrown on its back by the butcher's assistant and stabbed through the heart by the butcher using a stiletto. Leonardo observed that when the pig was already motionless the stiletto still quivered, in a regular rhythm

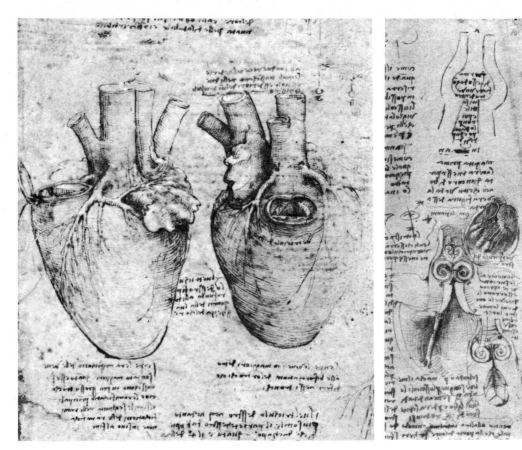

*'The blood is more subtilized where it is more beaten', in the external auricles of the heart. On this drawing of the heart of an ox, made in 1513, Leonardo describes four chambers. On the notebook page* RIGHT, *he draws diagrams and gives instructions for making a glass model of the aorta.*

until the carcass was almost cold. Leonardo, standing by the butcher, seized the instant when the heart was pierced to cut open the body and count the spasms, with the stiletto still in the organ. He made careful notes and timings—not very precise before the perfection of the spring time-piece, which it should be remembered, Leonardo helped to improve.

In his mechanical work, Leonardo had formed clear ideas about friction producing heat. Abandoning with difficulty the notion of sacred fire as the source of blood heat, he traced the origin of warmth to the right ventricle of the heart where he decided heat was produced by:

> ... the swift and continuous motions made by the blood with the intrinsic friction caused by its churnings and also with the friction which it produces with the cellular wall of the right upper ventricle into or out of which it continually enters or escapes with impetus, these frictions ... proceed to heat, subtilize and cause the blood to pass through the narrow passages giving life and spirit to all the members into which it is infused.[15]

Noting the increase in the pulse-rate in fevers, he ascribed this to increased friction.

He accepted in principle Galen's theory of the ebb and flow of the blood, and that the arteries were the vessels which carried the vital spirits and the veins were those which carried the nutriment. He believed that the blood surged in pulses from both ventricles of the heart, and that it spent its force and its heat as it moved to the periphery. This was obligingly consistent with his wave theories of light and sound. The arteries had thicker walls because otherwise the vital spirits would escape, and the purpose of the valves in the veins was to slow down the outward rush of blood and regulate its suffusion into the tissues. As each pulse subsided, the blood surged back into the heart, minus the fractions absorbed. (He knew that the blood was renewed and its deficiencies replenished.) The returned blood was regurgitated in the auricles and from them passed through the valves into the appropriate ventricles. His studies showed that air could not pass from the trachea to the right heart through the lung and pulmonary vessel, and he followed Galen in assuming that there was a porous membrane, 'the sieve of the heart', between the ventricles. He was guessing because his anatomy was not sufficiently refined to trace the pores which he described as 'invisible'. Only when Janssen had invented the compound microscope (c. 1590) and Malpighi had applied it (1661) to capillaries was Harvey's hypothesis of the transfer of blood from the arteries to the veins properly demonstrated.

What he did not fully appreciate was the significance of the lungs, which fascinated him as a mechanism—the lifting of the ribs by the muscles and the sinking of the diaphragm producing a vacuum in the thorax ('like a pair of bellows') and the resulting inrush of air. He knew that the blood flowed into the lung tissues, but he followed the belief that the lungs are a blood–cooling system to offset the frictional heat of the heart.

But he was tantalizingly near the truth. About two hundred and seventy years before Priestley discovered oxygen (1774), he was groping for its significance. He was investigating the loss of vital spirit in air, consumed by a burning flame which rendered the air unfit to sustain animal life. He also knew something of the metabolic process by which food is converted:

> The body of anything whatever that takes nourishment constantly dies and is constantly renewed....
>
> And if you do not supply nourishment equal to the nourishment which is gone, life will fail in vigour, and if you take away this nourishment, the life is entirely destroyed. But if you restore as much as is destroyed day by day, then as much of the life is renewed as is consumed, just as the flame of a candle is fed by the nourishment afforded by the liquid of this candle, which flame . . . restores to it from below as much as is consumed in dying above: and from a brilliant light is converted in dying into a murky smoke.[16]

It was left to William Harvey to discover the circulation of the blood and to others to recognize that the function of lungs was to expel the body's combustion

products—the smoke of the candle—and to inhale air to provide the oxygen which would recharge the blood and promote the metabolism of the nutriment.

Sheets upon sheets of careful drawings, page upon page of detailed notes, and much more still missing, set down his anatomical observations of dissections carried out on thirty human corpses and on many more animals and birds. And, such as they are, they fall short of the heads of enquiry which he imposed upon himself in preparing the synopsis of his books. Beyond his systematic dissection of every part of the body he proposed to investigate—to quote just a few—sneezing, yawning, fits, spasm, paralysis, trembling, perspiration, fatigue, hunger, sleep, thirst, sensuality, laughing, wondering.

He complained about those who tried to obstruct him, like the German mirror-maker who 'peached' to Pope Leo X, but never acknowledges what help he had—except indirectly in his library list. There is one known friend and confidant in the anatomical field, Marc Antonio della Torre. According to Vasari he 'gave his attention to human anatomy, in company with Messer Marc Antonio della Torre, an eminent philosopher. Messer Marc Antonio was then lecturing in Pavia and writing on anatomy . . . Leonardo filled Marc Antonio's book with drawings in red crayon outlined with the pen.'[E] From this, nineteenth-century writers on Leonardo assumed that he was merely the illustrator for the professional anatomist. This does not bear examination. Leonardo, being almost thirty years older, was well advanced as a practising anatomist before actually meeting Marc Antonio. He had already, by direct observation, himself discarded many of the classical ideas which continued to be taught until Vesalius went to Padua forty years later, routed the pedants and threw the Galenic tradition out of the window.

Marc Antonio was the son of a princely house. He, by precociousness or privilege, became a professor at Padua in his early twenties and attracted a large student following. In 1509, he was accused of intriguing against the state and fled to Pavia. There he was less lucky with his students. The accounts of Pavia at that time have a familiar, twentieth-century, ring. The student body was in protest. Unsettled by the political uncertainties of their time, they rebelled against the university authorities. They barracked their professors, violently complaining against the education system and especially the tedious method of teaching. They rioted in the streets and staged sit-ins in the palaces of the rich. It was a fifteenth-century version of the Berkeley Campus, of Warsaw, and Berlin's Free University, of the Sorbonne and the London School of Economics. They wanted a say in what they should be taught and how they should be taught it.

There is an entry in Leonardo's notebook: 'In the winter of this year 1510 I expect to complete all this anatomy.'[17] It has been suggested that he was proposing to get together with his collaborator, or mentor, Marc Antonio in Pavia, but this seems unlikely. He was at that time back in Milan under the patronage of Charles d'Amboise, the vice-regent of Louis XII of France, who had expropriated the

duchy. He was there on leave-of-absence from Florence, with the penalty of a heavy fine if he stayed away more than three months. But that period was repeatedly extended on the demand of the powerful vice-regent whom the *Signoria* could not afford to offend. The favour of Charles d'Amboise was also more important to Leonardo than the attractions of scholastic retreat in Pavia.

The only period when Leonardo and Marc Antonio could have been in association, either in Milan or Pavia, was between 1509 and 1510. In 1512, Marc Antonio died in his thirtieth year after carrying out an autopsy on a bubonic plague victim to try to discover the nature of the disease. On the strength of Vasari's hearsay account of collaboration and a single surviving reference in the notebooks which implies that Leonardo was sending a book to Marc Antonio, we can speculate on the relationship of Leonardo, at fifty-nine, and Marc Antonio, at twenty-nine. It certainly was not that of an amateur seeking help of a professional, nor of an illustrator in search of an author.

Leonardo had every intention of publishing his anatomical works long before he could have known Marc Antonio. But like all his ambitious conceptions it remained unfinished, and his research had no influence on medical thinking until William Hunter saw his papers from the chest 'in the Buroe of His Majesty's Great Closet at Kensington'.

In it was a reproach from the grave:

> In order that this advantage which I am giving to men may not be lost, I am setting out the way of proper printing and I beg you, my successors, not to allow avarice to induce you to leave the printing un . . . .[18]

The sentence itself is unfinished.

*Marc Antonio della Torre (1473–1512).*

# Ars Sine Scientia Nihil Est

> By drawing, which is her beginning, she [Painting] teaches the architect to make his edifices agreeable to the eye, she guides the potters in the making of various vases, the goldsmiths, the weavers and embroiderers. She has invented the characters in which the different languages are written, she has given the ciphers to the mathematician, and has described the figures of geometry, she teaches opticians, astronomers, mechanics and engineers.[1]

At the end of the fifteenth century, architecture, sculpture and painting were excluded from the hierarchy of the Liberal Arts which were confined to the Seven Disciplines, the intellectual exercises of grammar, dialectic and rhetoric (the 'Trivium' based on logic) and geometry, arithmetic, astronomy and music (the 'Quadrivium' based on mathematics). The latter four were again divided into two groups, according to whether they dealt with numbers or with magnitudes: arithmetic, dealing with numbers; geometry, with magnitudes; music, with numbers in motion, and astronomy with magnitudes in motion. Leonardo was one who hoped to elevate the graphic, plastic and structural artists from the craftsman class to the cultural aristocracy.

Over four centuries later in Germany, Walter Gropius was trying to reduce the snobbish distinction which the artists had meanwhile acquired, in order to create a cultural democracy of artists and craftsmen. He set out to incorporate the arts and the crafts in the *Bauhaus*, in a training in which the caste-distinction would disappear.

The Bauhaus was a school of design, building and craftsmanship founded in 1919 in Weimar. It was transferred to Dessau in 1925, to Berlin in 1928, and finally raided and closed down by the Nazis in 1933. Few institutions in human history have had a more profound influence on the physiognomy of our cities and features of our homes.

Gropius, at the behest of the Grand Duke of Saxe-Weimar, had combined a school of art and a school of crafts, remarrying the designer and the maker, as in Leonardo's day. He contended that the artist or the architect should also be the craftsman, that he should have experience of working with materials while studying theories of form and design. He also contended that a building should be a collective effort, and that each artist-craftsman should add his particular piece with

LEFT *Model from a Bauhaus project of Josef Albers, exhibited near Milan Cathedral in 1961.*

187

an awareness of the complete intention. This applied not only to the external design but to the items of furniture, the wall-coverings, the ornaments, the table-ware, and even the door-knobs. (Compare this with Leonardo's 'guiding the potters in the making of various vases, the goldsmiths, the weavers and embroiderers.') The artists not only went into the workshops to master the craft of materials, they went into the factories to learn the methods of industrial production. Unlike William Morris, who also wanted to combine the artist and the craftsman, Gropius did not despise industrial production. He regarded the machine as the elaboration of the hand-tools and finger-skills of the craftsman. The designers had to handle the actual substances—the clay, the metal, or the wood—from which their products were to be made. They had to study its precise nature and, in examining the crystalline structure of a metal, the Bauhaus students recognized the structure of the crystals themselves and found in them new design patterns. They examined wood, to know its strength and limitations, and again saw the natural forms of the grains as artistic expressions for new designs. The key to design was the understanding of the nature of the material and this led, in the case of glass, for example, to the design of more adventurous architectural structures. As craftsmen they had to make prototype goods and in doing so came to understand the limitations or opportunities of materials for industrial mass-production. They designed to suit the machines. So they learned engineering as well. The Bauhaus course investigated every kind of design—colours, for their own sake; geometrical shapes; woven patterns; furniture-making as structural engineering, which produced cantilever chairs; 'modular' units which fitted together in the building of a house or the furnishing of a room; typography and poster design; bringing function to elegance and elegance to function in things as common-place as lamps or teapots. Thus to the Bauhaus, as to Leonardo, drawing was the mistress of the graphic and structural arts.

In 1968, the Royal Academy, London, staged the Bauhaus Exhibition recalling the inspiration and the tangible achievements but also the great teachers, like Gropius; Johannes Itten; Paul Klee, painter, graphic artist and writer; Wassily Kandinsky, painter and graphic artist; Laszlo Moholy-Nagy, painter, theatrical designer, photographer and typographer; and Ludwig Mies van der Rohe, architect.

At that exhibition, the ghost of Leonardo walked. The galleries were saying in twentieth-century idiom, what his scattered sketches and notebooks had been seeking to express, from the proportions of the body, and the details of the functional objects, to the machine-for-living, which is the finished building and its urban setting. The difference is that the Bauhaus actually influenced architecture and town-planning and left its conspicuous imprint on the constructions of every continent. Not one of Leonardo's ambitious conceptions for buildings and whole cities (including satellite towns) ever came to pass. In spite of that very

From these studies he reconstructed the ancient practices of architecture and went back to Florence hoping to complete the dome. As has been explained he got the commission to install the dome. This he eventually did on the principle of the double cupola. It was a remarkable achievement of which Michelangelo said when called upon to design the dome of St Peter's in Rome, 'I am going to make its sister, bigger, yes, but not more beautiful.'[B]

Brunelleschi died before Leonardo was born, but, apart from the physical presence of his dome, his personality still survived in his coterie, which had included Toscanelli and Verrocchio. There was also (in Leonardo's apprenticeship days) Leone Battista Alberti. He was, among all the names that roll out, the most effective communicator of Renaissance art theory. His treatises were published which was more than Leonardo achieved, and his *De Re Aedificatoria* (1452) was an architectural text-book modelled on the manuscripts of the Roman architect, Vitruvius, reviving the techniques of ancient architecture but also introducing quite new concepts, such as employing in architecture ideas of musical harmony ('numbers in motion') and mathematical techniques to produce pleasing proportion in plan, and elevation and the relationship of parts.

Alberti's theories directly influenced Leonardo with his insistence on mathematics as the true key to the arts. Leonardo wrote:

> The painter measures the distance of things as they recede from the eye by degrees just as the musician measures the intervals of the voices heard by the ear. Although the objects observed by the eye touch one another as they recede, I shall nevertheless found my rule on a series of intervals measuring 20 braccia each, just as the musician who, though his voices are united and strung together, has created intervals according to the distance from voice to voice calling them unison, second, third, fourth, and fifth and so on, until names have been given to the various degrees of pitch proper to the human voice.[2]

What he was saying was that objects of equal size placed so as to recede at regular intervals each diminish one-half, one-quarter and so on in harmonious progression, with the analogy of the octave, fourth, fifth, etc. Alberti applied those proportions to architecture. He wrote 'The numbers through which the consensus of voices appeal most agreeable to the ears of men are very much the same proportions which also fill man's eyes and soul with marvellous pleasure.'[C]

At a later date Leonardo associated with Bramante, the painter-turned-architect, who produced the original plans for St Peter's, Rome. It is difficult to know who most influenced whom. There are the imprints of Bramante in some of Leonardo's drawings and imprints of Leonardo in much of Bramante's actual work. There was every reason why they should work congenially together; they were kindred spirits. Bramante, eight years older than Leonardo, was born of poor parents at Castello Durante in the state of Urbino. His education was sound, though elementary, and his father recognizing his aptitude succeeded in apprenticing him to a painter. As a journeyman-artist he wandered around picking up

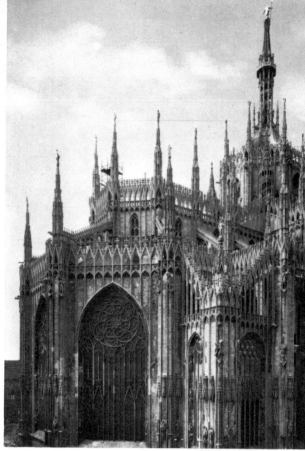

'Art without knowledge is nothing', said Master Jean Mignot in 1400, 'whether the vaults are pointed or round, they are worthless unless they have a good foundation.' He was criticising the design for Milan Cathedral. Ninety years later the controversy over the Cathedral design was still raging. Leonardo made many drawings, diagrams like the one ABOVE LEFT, and a model for the dome above the crossing of the Cathedral. In the end the commission to build the 'tiburio' RIGHT went elsewhere.

modest commissions until he found his way to Milan where he encountered Cesare Cesariano, a good geometrician and architect, and Bernardino Zenali da Treviglio, the engineer of Milan Cathedral. Under their inspiration he decided to devote himself to architecture but 'worked his passage' to Rome by painting and by arduous commissions which earned him enough to leave him free to take measurements of ancient buildings in Rome. Later he became papal architect and ultimately was given the assignment by Julius II to rebuild St Peter's. He died before its completion and others, including Raphael, modified his ideas. Michelangelo regarded himself as an executor of Bramante in his contribution to the design.

The common interest between Leonardo and Bramante, however, was Milan Cathedral. In his early days in Milan, Bramante desperately wanted to get an assignment. Like Leonardo he was dependent on the patronage of Ludovico Sforza, and he too was engaged as an 'engineer'. Bramante was paid five ducats a month, a third of what Ludovico paid his troubadours. He wrote poetry about his poverty and worked patiently doing frescoes which, to his unappreciative court

clients, were no more than interior decorations. Later he submitted a plan for Milan Cathedral.

Leonardo, when he got to Milan, was also prepared to justify the claim he had made in his letter to Ludovico: 'In time of peace I believe I can give perfect satisfaction, equal to that of any other, in architecture and the construction of buildings both private and public. . . .'[3] Leonardo, too, wanted the commission to design the Cathedral dome. His entry for the competition for the building of the cupola was the first official identification of Leonardo in the public records of Milan. The cathedral authorities were getting desperate; they had recruited a succession of German architects one of whom was dismissed for 'having done great damage to the building', and others left discouraged.

*Ars sine scientia nihil est*[D] (art without knowledge is nothing) was the view of some of the advisors. Leonardo obviously agreed, and with his usual self-confidence, addressed a letter to the cathedral authorities:

> My Lords, Father Deputies, just as for doctors, guardians, nurses it is necessary that they should understand what man is, what life is, what health is, and how it is maintained by a balance and a harmony of elements, while a discord of these is its ruin and undoing; and one with a good knowledge of these conditions will be better able to repair than one who is without it.
>
> You know that medicines well used restore health to the sick, and he who knows them well will use them well if he also understands what man is. . . . The need of the invalid cathedral is similar—it requires a doctor architect who well understands what an edifice is, and on what rules the correct method of building is based, and whence these rules are derived and into how many parts they are divided, and what are the causes that hold the structure together, and make it last, and what is the nature of weight, and what is the desire of force and in what manner they should be combined and related, and what effect their union produces. Whoever has a true knowledge of these things will satisfy you by his intelligence and his work. . . .
>
> But in order not to diffuse to your Excellencies, I will begin by the plan of the first architect of the cathedral and show clearly what was his intention as revealed by the edifice begun by him, and having understood this you will be able clearly to recognize that the model which I have made embodies that symmetry, that harmony and that conformity, which belongs to the building already. . . .[4]

The analogy of the architect and the physician is borrowed from Alberti's *De Re Aedificatoria*. One would scarcely think that such a sermon would be an effective piece of sales-promotion but it was. He got a subsidy for his construction of a model from the cathedral authorities and with the help of a carpenter, Bernardo da Abiate, he made a wooden model. Sheets of drawings are covered with studies in which, as he was trying to explain in his letter, he was hoping to combine the Gothic elements in the original conception with the current preference for domed architecture. In most of his sketches he retained the octagonal plan with the dome supported by eight buttresses on eight pillars. He was lavish with his ideas but he went harking back to Brunelleschi's cupola. In one drawing the dome was

made of stones which dove-tailed into each other to give a perfectly smooth sur-face—a remarkable exercise in geometrical jig-sawing, but a feat which would have been well-nigh impossible under the construction facilities of the time.

While Leonardo was proceeding hopefully thus, Ludovico 'got in on the act'. He brought another Florentine, Luca Fancelli, to Milan. He was not as accom-modating as Leonardo; he just declared that the building was all wrong and pro-posed scrapping the massive work which had been done. Needless to say, this advice was not welcomed. Bramante waited in vain. Leonardo, as always, was dissatisfied with what he had done, and kept asking the authorities to give him back the model so that he could modify it. They eventually agreed and on 10 May 1490, it was returned to him. But during the following week he was paid twelve lire to construct a new model—to be kept in readiness. The new model was never delivered, and four years later the cathedral authorities were dunning him for the money. In the meantime, on 27 June 1490, the Duke and the Archbishop, their patience exhausted, had brought everyone except Leonardo together to force a decision, which went in favour of two Lombards, Giovanni Antonio Amadeo and Giovanni Giacomo Dolcebuono.

Leonardo was not present. A week before at the behest of Ludovico (to get him out of the way?) he had set off on horseback for Pavia accompanied by Francesco

*In June 1490 Leonardo set off on horseback for Pavia accompanied by Francesco di Giorgio. A woodcut of Pavia from Bergomensis,* Supplementum Chronicarum, *1491.*

194

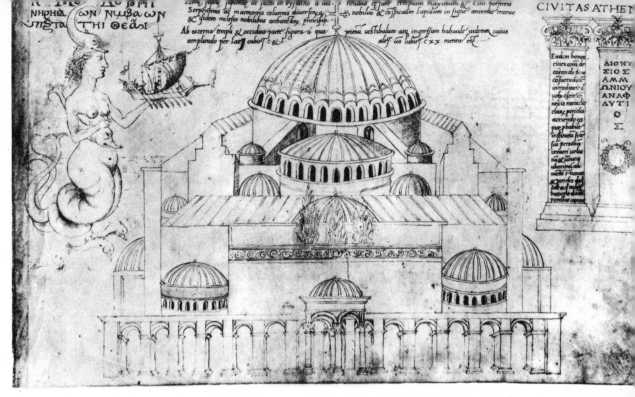

*The controversy at Pavia centred around the design prepared for the Cathedral by Cristoforo Rocchi. Rocchi copied the Byzantine design of Santa Sophia in Constantinople, built A.D. 532–7 and shown here in a drawing by Giuliano da Sangallo, architect to Lorenzo de' Medici.*

di Giorgio and a retinue of engineers. Their bill at the Saracino Inn, amounting to twenty lire, was paid on 21 June 1490, by the Works Department of Pavia Cathedral. Amadeo, who had already submitted plans for Pavia, was supposed to be with them, but presumably he had been 'tipped-off' by Ludovico that his presence was likely to be needed when the Milan contract was awarded.

Leonardo's expedition to Pavia was involving him in a typical Renaissance row. The vogue was for oriental designs. Cristoforo Rocchi, who did not call himself an 'architect' or a 'cathedral doctor' but just a 'master-modeller', had submitted a design which was a copy of Santa Sophia at Constantinople, on a smaller scale. The people of Pavia liked it, but the Cardinal-Bishop, Ludovico's brother, was finding most of the money and he did not care for the imitation. Many people had been called in to alter the design, but the Pavians doggedly preferred Rocchi's version. Leonardo's visit was another attempt at persuasion. He probably had a whole sheaf of samples with him, because some eleven sheets of the *Codex Atlanticus*, undated but which probably relate to this time, are devoted to cathedrals with a preference which he shared with Bramante for the form of the Greek cross. There are other sheets in the collection of the Institut de France in Paris. He tried out octagonal substructures, rings of chapels surrounding a central octagon, and Latin crosses which he knew the Sforzas liked. Lord Clark regards as far-fetched any suggestion that Leonardo's ideas were used in Pavia Cathedral,

This page contains a handwritten manuscript in an archaic Italian script (Renaissance period), accompanied by architectural drawings of columns and capitals in the margins. The text is largely illegible due to the faded ink, the archaic handwriting, and the quality of the reproduction.

but it is just possible that in his wooden model Rocchi did accept one or two modifications, details recognizable in Leonardo's drawings. It is almost irrelevant, anyway, because the cathedral remained unfinished until the dome and the façade were completed in 1898 according to Rocchi's basic conception. Thus Leonardo was never to be a cathedral builder, but he was a good clinical architect. He worked out the theory of the origins and progress of cracks in buildings which is valid to this day.

Perhaps that was his trouble. When it came to buildings the superb designer was constrained by the scientist and engineer. Some of his cathedral drawings looked like cruet stands—fussy pepper-pots round the dome mustard-pot—but on closer examination it is obvious that he was distributing the stresses and compromising with the heavy materials of his day. At this time he was interested in geology and was working on the nature of strata: 'In order to find the solid part of these strata, it is necessary to make a shaft at the foot of the wall of great depth through the strata.'[5] He was studying the strength of materials, and on the construction of walls he wrote:

> ... the walls must be all built up equally, and by degrees, to equal heights all round the building, and the whole thickness at once, whatever kind of walls they may be ... if double the amount of it dries in one day, one of double the thickness will dry in two days ... thus the small addition of weight will be balanced by the smaller difference of time.[6]

*'Here a campanile neither can nor ought to be made', wrote Leonardo alongside his drawing of a domed church ringed with chapels,* BELOW LEFT. BELOW RIGHT *Leonardo's cruciform church plan. On the same sheet is the note 'The streets shall be as wide as the universal height of the houses'*

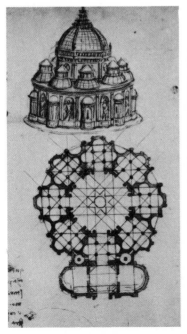 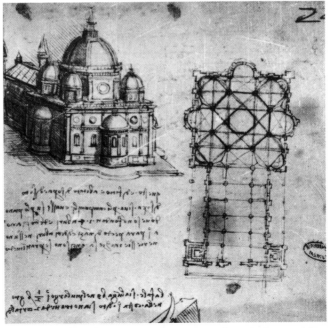

LEFT *Francesco di Giorgio (1439–1502), architect and engineer, was the source of many of Leonardo's ideas. Leonardo had a copy of di Giorgio's* Trattato dell'architettura *and made his own characteristic notes, top left and right.*

A wall though of equal thickness will not dry in the same time if it is not everywhere in contact with the same medium. Thus, if one side of a wall were in contact with a damp slope and the other were in contact with the air, then this latter side shrinks ... while the wet part would remain of the same size as before ... And the dry portion will break away readily from the damp portion, because the damp part does not cohere and follows the movement of the part which dries continuously.[7]

He had the object lesson of the leaning tower of Pisa. On 5 January 1172, Berta Bernardi left sixty sous, her widow's mite, for the construction of a tower. It was to be her staircase to paradise, 360 feet high. On that widow's mite, on foundations not more than ten feet deep and their circumference only that of the walls, the campanile was built. Bonannus Pisano and Guglielmo Tedesco directed the undertaking. The yielding of the strata did not disclose itself until they reached the third floor. By then it was definitely leaning out of true and the building was abandoned for ninety years until its construction, with an attempt to build the masonry in a twist toward the perpendicular, was resumed by Giovanni di Simone. The walls at the base were thirteen feet thick—quite a weight—and at the top about half as much. They were constructed of marble, the abundant stone of the neighbourhood. The ground floor was surrounded by semi-circular arches supported by fifteen columns; above this rose six arcades of thirty columns each. The eighth storey containing the bells had only twelve columns. At 179 feet, the builders went no higher. The result was the architectural freak which existed in Leonardo's time—three centuries later—a tower which leaned but did not fall. In the seventeenth century, its tilt lent itself to the apocryphal story of Galileo dropping his weights and proving the laws of gravity it seemed to be defying. In the nineteenth century it was $15\frac{1}{2}$ feet out of perpendicular. In the twentieth century it was $16\frac{1}{2}$ feet out and the battle to preserve it as an architectural curiosity was between the cement-grouters and the rumbling coaches of the tourists attracted by it.

Leonardo knew it as a freak which represented the indifference of builders to all the rules which he was revealing only to himself in the mirror handwriting of his notebooks:

The first and most essential requisite is stability. As regards the foundations of the component parts of temples and other public buildings, their depths should bear the same relation one to another as do the weights which are to rest upon them. Each section of the depth of the earth in a given space is arranged in layers, the layers having each a heavier and a lighter part, the heavier being at the bottom. This comes from the fact that these layers are formed by the sediment from the water discharged into the sea by the current of the rivers which are poured into it. The heaviest part of this sediment was the part that was discharged first, and this process continued ... the level of the waters has receded ... and caused the substance to become dry and to be changed to hard stone. . . .[8]

The entry has more significance than its relevance to the foundations of build-

ings; it was in his day and age a challenge to the whole biblical doctrine of Creation.

One has to keep on reminding oneself that none of Leonardo's thought processes was compartmentalized. While he was thinking about architectural design, he was also thinking about the nature of the universe and the mathematics of forces. For example, his observations on the stresses on arches could scarcely be faulted today:

> An arch is nothing other than a strength caused by two weaknesses; for the arch in buildings is made up of two segments of a circle, and each of these segments being in itself very weak desires to fall, and as the one withstands the downfall of the other the two weaknesses are converted into a single strength.

*The strengths of different shapes of arches, compared and tested.*

> When once the arch has been set up it remains in a state of equilibrium, for the one side pushes the other as much as the other pushes it; but if one of the segments of the circle weighs more than the other the stability is ended and destroyed, because the greater weight will subdue the less.[9]

He proposed an experiment to show that the weight of the arch is not entirely taken up by the columns, but that the greater the weight placed on the arches the less the arch transmits weight to the columns:

> Let a man be placed on a steelyard in the middle of the shaft of a well, then let him spread out his hands and feet between the walls of the well, and you will see him weigh much less on the steelyard; give him a weight on the shoulders, you will see . . . that the greater the weight you

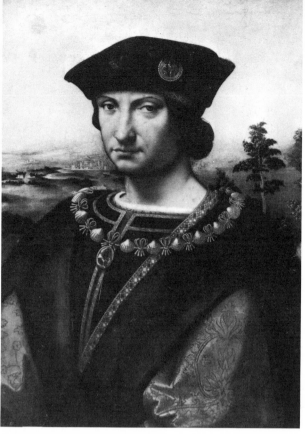

*Charles d'Amboise, governor of Milan, shown* ABOVE RIGHT *in a painting by Solario, was Leonardo's patron from 1503–11.* LEFT *One of the drawings Leonardo made for a country house, with porticoes, for Charles d'Amboise. 'I shall create a wind at all times in the summer by means of a mill', wrote Leonardo. Neither the house nor the mill was built.*

give him the greater effort he will make in spreading his arms and legs and in pressing against the wall, and the less weight will be thrown on the steelyard.[10]

And he purveyed to himself the kind of advice the television handyman gives to do-it-yourselfers:

That beam which is more than twenty times as long as its greatest thickness will be of brief duration and will break in half. . . . Again I remind you never to put plaster over timber. Since by expansion and shrinking of the timber produced by damp and dryness such floors often crack. . . .[11]

Leonardo's Bauhaus proclivities are surely demonstrated in his concern about domestic detail right down to the service hatch. With drawings he expatiated:

Large room for the master, room, kitchen, larder, guardroom, large room for the family, and hall.

The large room for the master and that for the family should have the kitchen between them, and in both the food may be served through wide and low windows or by tables that turn on swivels. The large room of the family is on the other side of the kitchen so that the master of the house may not hear the clatter. The wife should have her own apartment and hall apart from that of the family, so that she may set her serving maids to eat at another table in the

same hall. She should have two other apartments as well as her own, one for the serving maids, the other for the nurses, and ample space for their utensils. And the apartment will be in communication with the various conveniences; and the garden and stable in contact.

He who is stationed in the buttery ought to have behind him the entrance to the kitchen, in order to be able to do his work expeditiously. . . . And let the kitchen be convenient for cleaning pewter so that it may not be seen being carried through the house. I wish to have one door to close the whole house.[12]

We remember that he designed the hinged seat for the lavatory, and that he installed a bath with running hot and cold water, and a drainpipe, for Isabella d'Este. And on the same sheet on which he drew it, he noted that he had started his thesis on 'Motion and Weight'.

While he was advising on the building of the cathedral of Pavia he was simultaneously sketching plans for a brothel. He regarded the improvised *bordelli* with professional distaste; he did not think they were properly functional. He therefore

*'A place for preaching in' is written beside Leonardo's design for a vertiginous amphitheatre c. 1488–89,* BELOW LEFT. *The preacher's pulpit is a column in the centre. In the drawing* BELOW RIGHT *the tiered preaching arena is boxed inside a rectangular church plan.*

 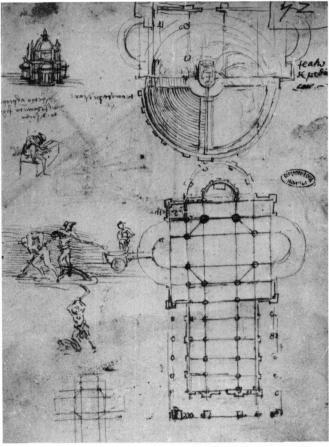

proposed a house with three entrances so that, properly drilled, the whoring citizenry could enter and leave without being noticed, while internally a system of baffled corridors prevented them from encountering one another.

About the same time, while planning for their carnal pleasures, he was thinking about their carnary future as well; he designed tombs. He planned a gigantic mausoleum which could have vied with the edifices of the Egyptians. On an artificially elevated site he proposed a conical structure on a massive platform approached by impressive stairways from which six entrances gave access, through a circle of galleries, to three vast burial chambers. The diameter was 600 metres and the height was over 160 metres. The summit was a temple with a colonnade. The cubic capacity would have accommodated 500 funerary urns. His basic design was curiously akin to the *tumuli* of the ancient Etruscans in his own countryside, but it is unlikely that he would have known of them for the archaeologists had not got busy in his time.

He had clients neither for his brothel-house nor for his burial-house. Nor for another design, this time for a 'preaching theatre'. In one he took the circular tiered arena of the Coliseum type, and boxed it in a rectangular church with a nave, aisles and an apse. In the centre of the tiered arena he placed the pulpit. Again it never got off the drawing-board but it was not just irresponsible fancy, because at the same time he was working on acoustics and the physics of radiating sound-waves.

Like the fraternity of the Bauhaus, he went in for stage-scenery and theatrical costume-designing, all of it ephemeral, splendid but rather pathetic, because he was contriving in lath and plaster the ideas he wanted to construct in mortar and masonry. All that remains are fragmentary drawings. His triumphal arches and his dream-façades were as impermanent as a film-set. They had their brief hour and vanished like the characters he dressed for their parts in the Masque of Paradise.

On a more mundane level, he gave his attention to stables. His 'How to make a clean stable' might commend itself to modern factory-farmers:

> You must first divide its width in three parts, its depth matters not; and let these three divisions be equal and six braccia broad . . . and ten braccia high, and the middle part shall be for the use of stablemasters; the two side ones for the horses. . . . Let the manger be at two braccia from the ground, to the bottom of the rack, three braccia, and the top of it four braccia. Now, in order to attain to what I promise, that is, to make this place, contrary to the general custom, clean and neat: as to the upper part of the stable, that is where the hay is . . . must have at its outer end a window six braccia high and six broad, through which by simple means the hay is brought up to the loft. . . .[13]

He describes the lay-out of the loft and how hay could be fed 'to the mangers, by means of funnels, narrow at the top and wide over the manger. . . . They must be of stone and above them [a cistern of] water.' For Giuliano de' Medici he designed an equine palace 220 feet long and eighty feet broad:

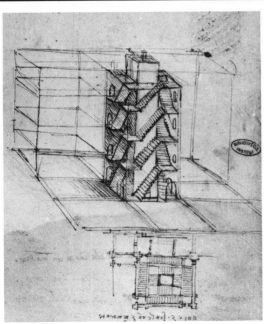

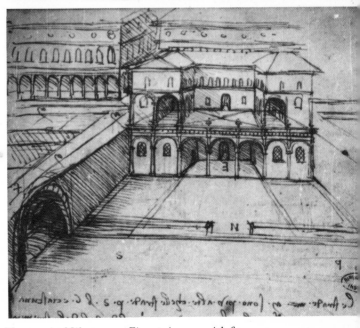

TOP *A model of Leonardo's ideal city in the Science Museum in Milan.* LEFT *Five staircases with five entrances, designed for privacy.* RIGHT *High and low level roads around a house.*

... the lower part ... is divided into four rows for horses, and each of these rows is divided into thirty-two spaces, called intercolumnar, and each intercolumnar space has a capacity for two horses, between which is interposed a swing-bar. This stable therefore has a capacity for a hundred and twenty-eight horses.[14]

Leonardo was the pioneer of prefabricated houses, the forerunners of trailer caravans. He wanted movable constructions. This was not a covered wagon, go-west-young-man idea of adventurous youth, but a creature-comfort invention from his advanced years when he was the tame magician of François I of France. From 1517 he was in prosperous exile at Cloux near the royal castle of Amboise. François indulged him not only as a painter and as a thinker, but as the deviser of uncommon jests. He liked to take visitors and members of his court over the path that led from Amboise to Cloux to visit the master, then in his sixties. Benvenuto Cellini wrote later: 'And inasmuch as Leonardo possessed so vast a genius in such abundance, having also some knowledge of Latin and Greek, King François was most strongly enamoured with his great virtues, and took such pleasure in hearing him discourse that there were few days on which he parted from him.'[E] Very flattering, but for Leonardo this was utterly time-wasting and distracting. He was trying to get down to the job of producing the books, for which we have only the notes, and here he was being treated as the greatest human being in captivity. Worse still, the court did not only come to him; he was compelled to go with the court. Those were the days of royal progresses in which kings and princes moved like circuses, and imposed themselves on their vassal-lords who had to provide bed and board for their demanding sovereigns and everybody they chose to bring. A progress was like mounting a modern political conference; it was an elaborate piece of logistics and of woe-betide protocol. The restless young French king had always to be on the move and the whole court, including Leonardo, had to be ready to follow. The servants of the court went ahead to sequester hospitality at some remote château, and a caravan of wagons would follow with carpets, tapestries, and all the trimmings which François demanded even for one night's stop-over.

Leonardo was always on stand-by to obey the humours of the king and, summer or winter, he would travel the bad roads in great discomfort to draughty, artificially hospitable châteaux or to royal hunting lodges which were maintained just for the occasional visit, or in tents. The first thing he suggested was that it would be smoother to go by royal barges, and he proposed to François that the rivers should be surveyed, improved and linked by canals. As always his schemes went further than royal convenience. He worked out how much land could be brought into cultivation by control of the river floods, and by the resulting irrigation:

If the river *m n*, an effluent of the river Loire, were turned with its turbid waters into the river of Romorantin, this would fatten the land which it would water and would render the country fertile to supply food to the inhabitants, and would make navigable canals for mercantile purposes.[15]

*Bramante's dome for the monastery of Santa Maria delle Grazie. Leonardo's* Last Supper *fresco is in the refectory.*
OVERLEAF *The city of towers. Florence about 1490.*

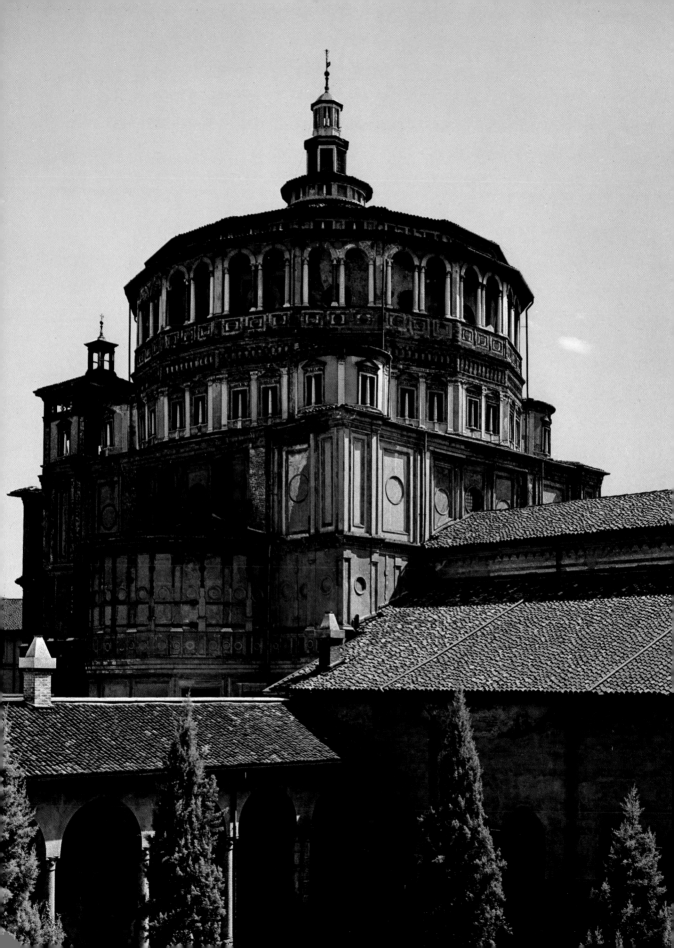

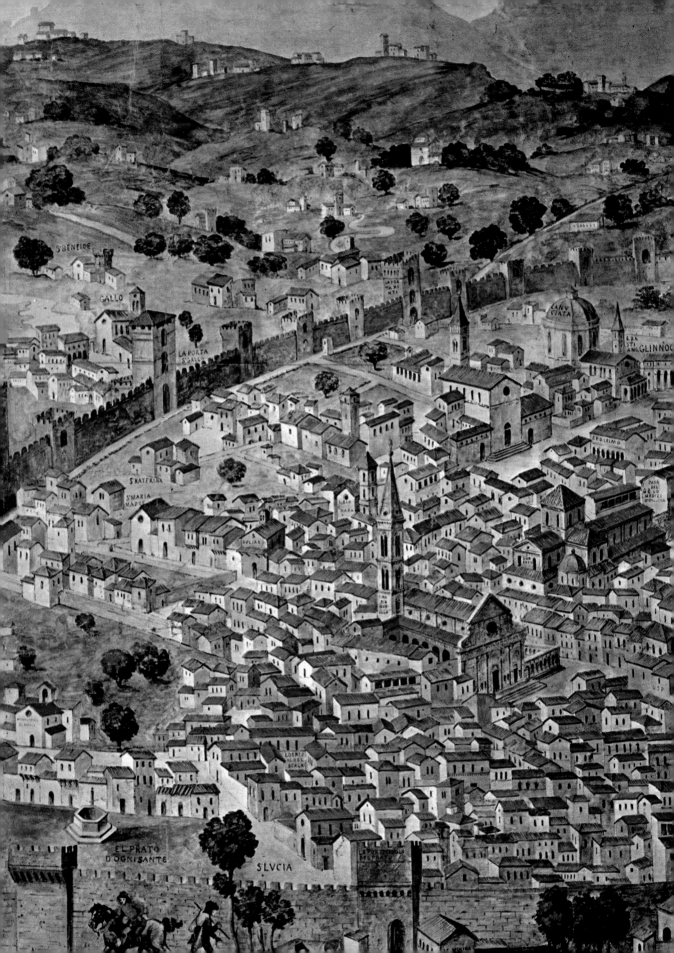

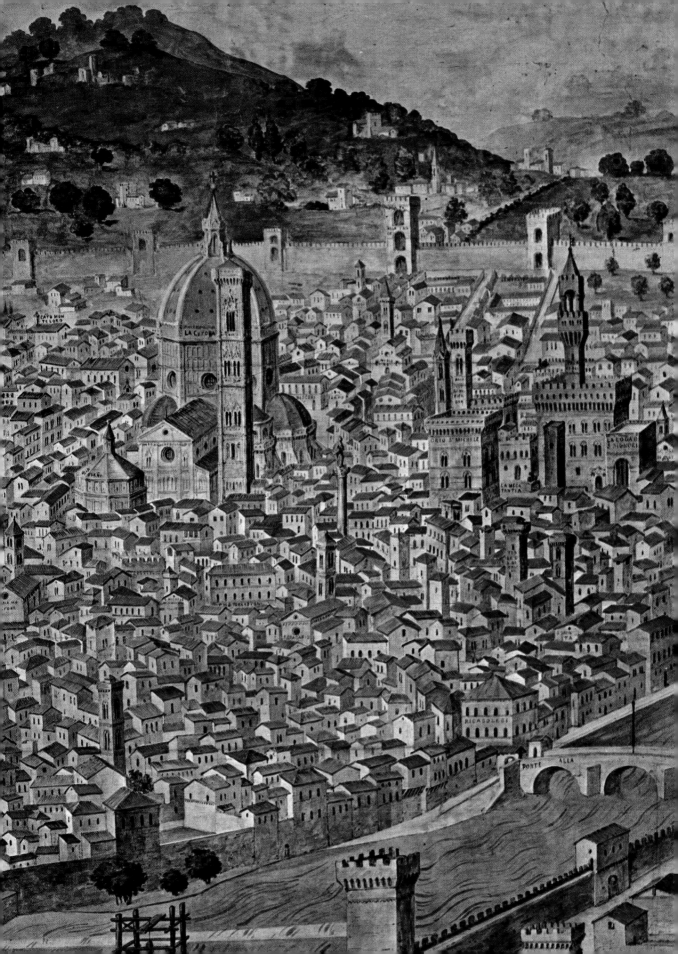

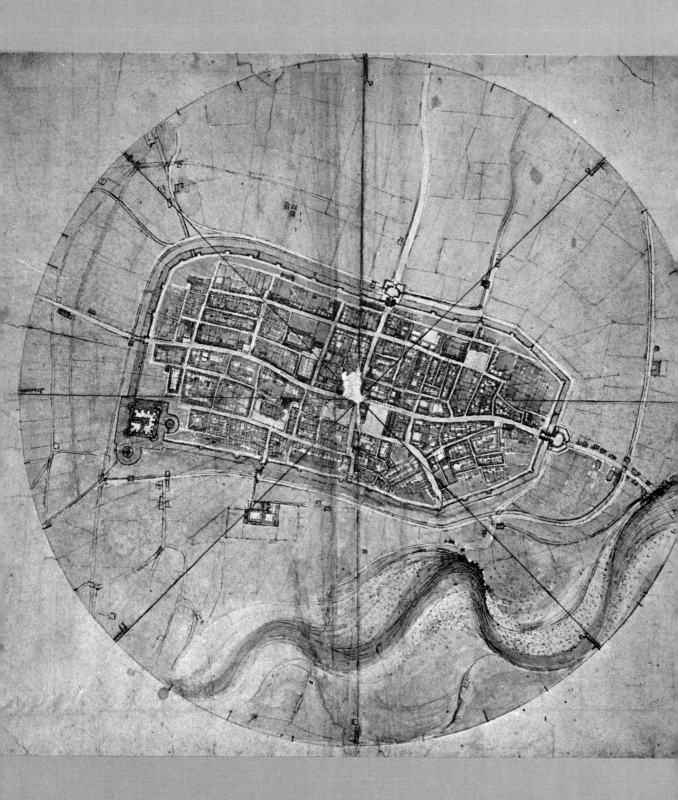

At the same time he proposed his prefabricated houses. Their parts were to be made in the towns and transported to the royal staging posts. They could be rapidly assembled on the site and so arranged that they formed a courtyard with access to common services. They could be dismantled and re-assembled but he also suggested they might be left for the country people when the court was elsewhere.

As socially imaginative as the work of any disciple of the Bauhaus or of any other modern school or urban planning was Leonardo's conception of a re-planned Milan, with satellite cities to take its overspill. The compulsion is obvious: in the years 1484–85 there had been disastrous plagues, and plagues have a way of reminding even princes and their courts that infections could not be blockaded to fester only in the slums, and that wealth could not buy immunity. Leonardo had no doubt that city congestion and insanitary conditions were responsible for the recurring plagues. In his memorandum exhorting Ludovico Sforza, as ruler of Milan, to re-plan the city, he wrote:

> There will be eternal fame also for the inhabitants of that town, constructed and enlarged (by the ruler) . . . and he shall have from ten towns five thousand houses with thirty thousand inhabitants, and you will disperse this great congregation of people which stand like goats one behind the other, filling every place with fetid smells and sowing seeds of pestilence and death! And the city will gain beauty worthy of its name and to you it will be useful by its revenues, and the eternal fame of its aggrandizement.[16]

He even suggested how this slum-clearance and urban renewal was to be promoted: by compelling the 'magnates' to give proof of their loyalty by getting them to build one or more houses in the new development. His argument, suggestive of that of the modern real-estate man, was that they would get a big return on their investment through the enhancement of property values in the new development areas.

An impressive model of Leonardo's elements for an ideal city is to be found in the Leonardo da Vinci Gallery of the Science Museum in Milan. Soldatini reconstructed it from Leonardo's fragmentary drawings and his written notes. It may be a refinement of sketchy ideas—Leonardo's rough jottings—but it embodies his intentions. There we see the split-level city; the fly-overs and the underpass; the pedestrian precinct and the traffic flow; and the common services—including, thoughtfully, the public lavatories at prescribed intervals.

The lay-out was governed by Leonardo's dictum: 'The streets shall be as wide as the universal height of the houses.' The windows were to be of such dimension as to ensure 'light, air and cleanliness' in the houses. His intention was obviously to build apartment houses and, so that the tenants would never see one another's comings and goings, he arranged an ingenious system of access on different levels by providing staircases both inside and outside the buildings.

His ideal city had approach roads, and ramps to provide access to high-level

streets from the perimeter of the town. These were to be not less than forty feet wide. The buildings therefore could be no more than forty feet high, but there were piazzas where, presumably, the buildings might have been correspondingly higher. The roads were designed with an incline down to the centre, where slits allowed the rain-water to drain into conduits. The streets were lined with arcades twelve feet wide, and the lower streets were lit from above.

> By the high streets no vehicles and similar objects should circulate, but they are exclusively for the use of gentlemen. The carts and burdens for the use and convenience of the inhabitants have to go by the low [streets]. . . . Provisions, such as wood, wine and such things are carried in by the doors *n*, and the privies, stables, and other fetid matter must be emptied away underground from one arch to the next.[17]

He specified that at regular intervals, there must be circular staircases leading from one level to the other. They must be spiral because he had observed that people had the nasty habit of relieving themselves on landings between stair-flights. This contingency he provided for by having, between the upper and the lower streets, doors leading to public privies, from which the refuse would join the street-sweepings in water-flushed sewers and be carried away to the river. Therefore he insisted that these city units, metropolitan and satellite, must be near a river or the sea.

Perhaps the fragments are unfair to his more generous vision but, as we have them, they are singularly inconsiderate and unhygienic in their treatment of those who would be literally 'lower classes'. We know they were to trundle their carts and carry their burdens in the underpass, while the 'gentlemen' *(gentiluomini)* were to parade the traffic-free streets and live in sun-trap houses, with the smoke carried upwards from the chimneys through cowls. One does not usually find Leonardo giving the impression of 'sweeping the problem under the carpet' in this way.

He did not get his Milan-of-the-Ten-Cities. The plague passed. Ludovico and his court who, like the dubious nobility in Boccaccio's *Decameron* had fled the pestilence, came back to the capital. The prince provided 30,000 ducats for the Ospedale Maggiore, with 1,600 beds for the sick poor, but nothing was done to prevent a recurrence of the pestilence and urban renewal was forgotten. Leonardo was later encouraged by King François to apply his ideas of light and air and hygiene to design a royal palace at Romorantin; and he got a commission for a love-pavilion.

CHAPTER TEN

# *The Great Bird*

The first flight of the great bird from the summit of Monte Ceceri
will fill the universe with wonder; all writings will be full of its
fame, bringing eternal glory to the place of its origin.[1]

The flying machine, which Leonardo promised himself would make world history, was due to take off around 1505 from Swan Mountain, above Fiesole. Leonardo does not tell us what happened, unless silence speaks. There is no further reference to 'The Bird' which had been so much his preoccupation for so long. There is no eye-witness account of the success or failure of his promised attempt. All we have is the 'catty' remark of Girolamo Cardano, son of Leonardo's friend, Fazio Cardano, writing years after Leonardo's death: 'Both those who have recently attempted to fly came to grief. Leonardo da Vinci also tried to fly, but he too failed. He was a magnificent painter.'[A]

That is no way to dismiss Leonardo's extensive contributions to aviation. Contributions? They would have been if the notes had not been scattered and neglected for centuries. The point which he had reached when he made his unfulfilled prophesy, was approximately that of Otto Lilienthal, the German glider pioneer. And Lilienthal was the direct predecessor of the Wright brothers because when he was killed in 1896 after 2,000 glides in safety, the Wrights analysed his failure by wind-tunnel techniques, before they devised their success-ful heavier-than-air machine.

In 1505, Leonardo definitely had a plan for a flying apparatus. Whether it ever got off the drawing board is a matter of speculation. But Soldatini and Somenzi made a reconstruction from his drawings and produced a model which is in the Science Museum in Milan. He had discarded his earlier ideas of imitating the feathered wings of birds and had settled for the webbed wings of the bat. In his usual fashion of giving instructions to himself he wrote:

Remember that your flying-machine must imitate no other than the bat, because the mem-
branes serve as framework, or rather the connection of the framework, that is that which

211

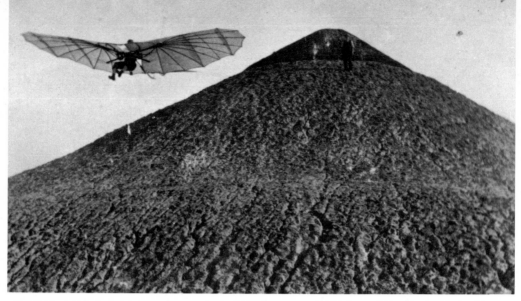

*Otto Lilienthal takes to the air in his glider from the top of his special 'flying hill'. Lilienthal's first 'flight' was in 1891, and this picture was taken in 1894.*

commands the wings . . . the bat is aided by the membrane that connects the whole and is not penetrated by the air.[2]

Dissect the bat, and keep to this study, and on this model arrange the machine.[3]

The machine which he designed had wings attached to the cockpit. The operator's legs dangled like those of a rider in a saddle, and the movement, the wing flapping and turning, was muscularly controlled by cranking. It had a great deal in common with Lilienthal's basic designs of four centuries later.

There is circumstantial evidence for the attempt. Leonardo was working in Florence. It was the period when he was also having trouble with the mural of *The Battle of Anghiari*, and he was finding consolation by escaping at intervals to Fiesole, four miles away in the hills. The Canon of Fiesole was Alessandro Amadori, Leonardo's 'uncle', the brother of his stepmother. There was a close attachment between the two men and Leonardo always turned to Alessandro for help and comfort. Swan Mountain, from which the promised flight was to be made, dominated Fiesole. It is 1300 feet high and is supposed to look like a swan. From its crest a gliding descent would be possible. But, remember, this machine was dependent on muscle-power. Leonardo was fifty-three. He was no jockey. He was tall and heavily framed, and even if he had had the courage, which there is no reason to doubt, and the strength, of which legend gives him plenty, his calculations of wing-span to weight would have suggested a lighter subject than himself for the experiment.

The failure of the take-off, if failure there was, is less significant than the laborious studies and original thinking which made Leonardo the first of the great aerodynamists. Others had dreamed of having the wings of a bird. The most famous of all legends is that of Daedalus and his son, Icarus, who attempted to

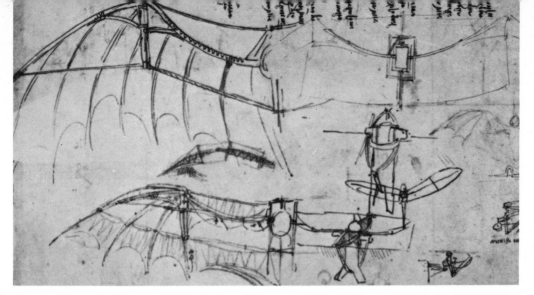

*In 1497 Leonardo drew a semi-fixed-wing glider remarkably similar to Lilienthal's design of four hundred years later. The pilot hung vertically down, but Leonardo thought that the wing tips should be made to flap.*

escape from imprisonment on the island of Crete by flying with artificial wings made from feathers secured to their arms with wax. Against his father's advice, Icarus flew too close to the sun, which melted the wax and plunged him to his death in the sea. There is the legend of King Bladud of Britain who lost his life in 825 B.C. while trying to fly. Saracen of Constantinople and Oliver of Malmesbury, both in the eleventh century, made attempted flights. The theorists, as distinct from experimenters, included Roger Bacon, of whose works Leonardo was certainly aware. Bacon had written in the previous century: 'An instrument may be made to fly withal if one sit in the midst of the instrument and do turn the engine, by which the wings, being artificially composed, may beat the air after the manner of the flying bird.'[B]

The childhood incident of the kite (that is, the falcon, not the frame-rig which the Chinese had been making since 100 B.C.) shows what a powerful impression the movement of birds made upon him. The falcon-kite remained one of his particular interests—not because of the specious mouth-wiping memory which to Freud was so significant but because he recognized the remarkable flight properties of its forked tail. This bird of prey, swooping in a vertical nose-dive, is specially equipped for braking and swerving. Leonardo was also fascinated by the kite's volplaning capacities:

> The kite and the other birds which beat their wings only a little, go in search of the current of the wind; and when the wind is blowing at a height they may be seen at a great elevation, but if it is blowing low down then they remain low. When there is no wind stirring . . . then the kite beats its wings more rapidly in its flight, in such a way that it rises to a height and acquires an impetus; with which impetus . . . it can travel for a great distance without moving its wings.[4]

213

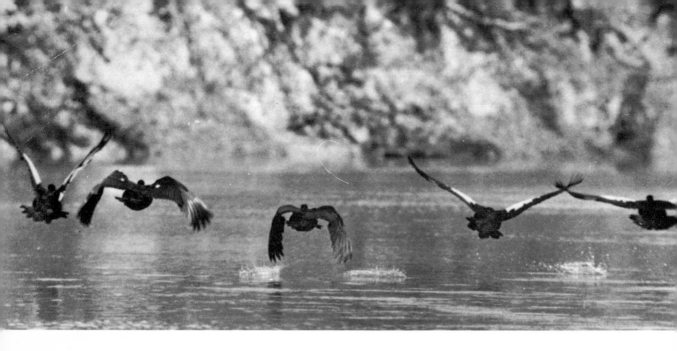

While any sensitive artist responds to the grace of a bird in flight, Leonardo throughout his life had an extra sense of observation. Lord Clark goes so far as to suggest that it was an actual, and superhuman sense: '... his studies of flight have a bearing on his art because they prove the extraordinary quickness of his eye. There is no doubt that the nerves of his eyes and his brain ... were really super-normal, and in consequence he was able to draw and describe movements of a bird which were not seen again until the invention of the slow-motion cinema.'[c]

The notebooks strongly suggest this. Movements which would be merged, as in the case of the normal 24-frames-a-second film, are apparent in detail to him:

> Sudden changes of the wings and tail of birds make sudden changes in the lines of their move-ments. For suppose the bird is moving in an eastwards direction and suddenly turns towards the west; this sudden turn is effected by extending one of its wings on the side on which it wishes to turn, and turning it so that it faces the percussion of the air in the line in which it is moving, drawing the opposite wing to itself and bending the tail in such a way that (as in the accompanying diagram) the extended wing ... *a*, *d*, *f*, is flying towards you, and as it flies immediately turns itself backward by its right side in *f*, and then extends this wing *d f* more than usual, displaying it more in front to the wind; and the opposite wing *a c* will be bent as in *c b*, and the tail *c d* will turn as in *e d*; ... the impetus is struck by the air, and works more on that part of the bird which is more remote from its centre of gravity....[5]

These details could be 'fixed' by a modern high-speed 64-frames-a-second camera which gives a slow-motion effect on the screen. But this was the observation of the naked eye, without even the bird-watcher's binoculars.

Leonardo did not set out, in the first instance, to make a flying contraption. His original interest was an artist's appreciation. Then he became interested in the behaviour of particular birds, which he extended to insects in flight. When he became a student of the atmosphere and recognized the air as a fluid, he did

214

*The camera can freeze the wing-beat of a bird, but Leonardo had to arrest the motion of the wings in his mind, and he drew, hundreds of times, the positions of birds in flight. 'A bird makes the same use of wings and tail in the air as a swimmer does of his arms and legs in the water.' Using the analogy of currents of water and air, he says, referring to the drawing* FAR RIGHT *'If the bird shown ... lowers its wings it makes itself more stable upon the air, and supports itself with less difficulty. . . . But it is more certain not to be overturned in keeping its wings high than in keeping them low.'*

comparative studies of fish and human swimmers and wrote: 'Write of swimming under water and you will have the flight of the bird through the air'.[6] With anticipation of what we now know as streamlining and the effects of air-turbulence, he observed the flow of air around the shape of the bird and the wing form, with its relevance to lift: '. . . its wings . . . receive the air underneath . . . after the manner of a wedge, and this wedge has its greater angle upon the side that slopes less. . . .'[7]

H. T. Pledge in *Science since 1500* wrote: 'As early as 1506 Leonardo da Vinci was concerned with another application of the theory of fluids, namely, flight. In this and in other connections he rejected the Aristotelian idea that motion 'naturally' slows down, and he set up a uniform motion slowed by *resistance* due to air. Nevertheless, it was nearly two centuries more before Newton began the long series of attempts to determine this resistance.'[D]

In this, as in all things, Leonardo was applying his synoptic mind—his capacity for seeing the relationship of one set of observations in one field to problems in another. His mind was not compartmentalized like the departments of modern science. It could slide easily from kinetics and dynamics to weather, to birds in flight, to the anatomy of the avian muscles and their mechanical function, and from that to the engineering specifications for heavier-than-air machines. When he was drawing conclusions from his own direct observations, or maybe from conversations with his contemporaries, his writing is highly perceptive, but when he was struggling with authorities to whom he felt he ought to defer, like Aristotle or Galen, he became argumentative like a man talking to himself in his sleep. It was only when his repeated observations brooked no questions that he would discard or ignore the pundits. He occasionally, but rarely, did it by frontal attack; he just allowed his statement of fact to refute them.

Once he had convinced himself of the analogy between air and water, he could

*A current of water swirling past an obstacle standing in a stream; the forms assumed by water flowing from a conduit. Leonardo's drawing of c. 1507–9 shows his understanding of vortices in currents. The photograph* RIGHT *shows vortices in benzene vapour around a wing tip in a simulated wind-tunnel.*

think of the air 'as a river which carries the clouds with it, as running water carries all things that float upon it'. He could conceive the currents, the eddies and the vortices which give that awesome grandeur to the drawings of The Deluge. The motive forces of water he could understand as gravitation—water seeking the lowest level. He had to provide such motive power for air, and saw it as convection —the heating of the air and the vaporization of the surface water and its upward rise until it met the colder effects at height. His winds were the inrush of air to fill the vacuum. He had a pretty shrewd idea of the climatic machinery—sufficient at least to meet his requirements of currents and thrusts—air-wedges, necessary to sustain a bird or a machine in flight.

In notes dating from his first period in Milan, Leonardo lays down the fundamental principle of movement through air, later defined as a law by Newton: 'An object exerts the same force against the air as the air against the object'. This is the principle of the wind-tunnel, on which ground experiments are made on body-shapes and wing-sections. The tunnel generates measured wind-pressures and the resistances set up by a fixed model will be the same as those which would be created if it were moving in flight through the air, at a speed equivalent to that of the artificial wind.

Another factor, indispensible to modern aeronautics whether it be designing a subsonic, supersonic or rocket vehicle, is the 'boundary layer'. Present-day experience of this dates back a hundred years to the days when Froude began to study ship-behaviour under controlled conditions in the ship-tank, and Rankine suggested the principle of stream-line. This was applied by Penaud in France,

Lilienthal in Germany, and Langley in America, to heavier-than-air structures when failures forced them to analyse the lift and drag on aerofoils. Lanchester, in England, first pointed out in 1894, that 'if the downflow due to an aeroplane wing was not to be supposed permanent, there must somewhere be an upflow to cancel it out.'[E] He showed that what the travelling wing in fact induces is an accompanying air-circulation up behind it and over it. This forced attention on the wing-created vortices, like the turbulence created by a current of water swirling past a rock standing in a stream.

Resistance, however, includes viscosity—that is the 'gooeyness' of matter, whether air or treacle, which drags on a moving body and creates a sort of clinging turbulence. Laminar (that is, streamlined) motion turns into turbulence at a certain value now called 'Reynold's number' which is derived by dividing viscosity by velocity and length. Further mathematical determination shows that a thin boundary-layer contains most of the effects of viscosity. This layer, between the air and the travelling object, can separate from the walls, like stripping off a varnish, and curl up as a vortex. This boundary-layer is of critical, even catastrophic, significance in the designing and operation of machines at present-day velocities.

*At supersonic speeds enormous vortices develop above the wings of the Concorde airliner. The wind-tunnel picture of a Concorde model viewed from the rear* BELOW *shows a striking parallel with Leonardo's diagram of currents below a bird's wings. In his notes, Leonardo says that the curve in the bird's outstretched wing increases the power of flight by condensing the air beneath it.*

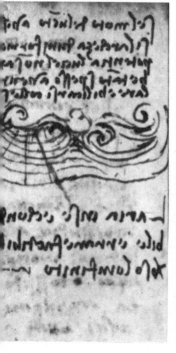
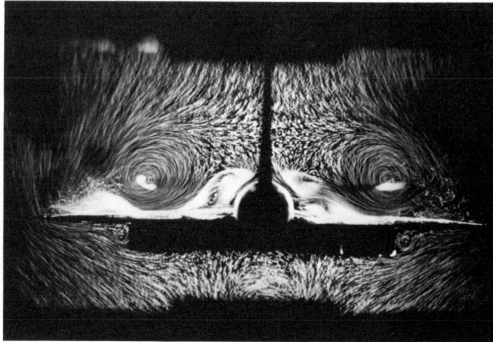

Five hundred years ago, Leonardo defined the boundary, but not the layer. Indeed, his theoretical reasoning excluded the layer:

> Surface is the name given to the boundaries of bodies with air or I should say of the air with bodies, that is what is enclosed between the body and the air that surrounds it; and if the air makes contact with the body there is no space to put another body there; consequently it may be concluded that surface has no body and therefore no need of position. . . . Not having place it resembles nothingness which has name without substance.[8]

His prescription for the wind-tunnel, however, is quite clear:

> . . . when a bird finds itself within the wind, it can sustain itself above it without beating its wings, because the functions which the wing performs against the air when the air is motionless is the same as that of the air moved against the wings when these are without motion.[9]

While he was studying the atmospheric-ocean in which birds swim (he repeatedly makes comparisons with fish), he was also studying the birds themselves. With his unaided vision, he was noting their great variety and their differing flight behaviour.

Once again he was hopefully contemplating a treatise on birds which he proposed to divide into four books: '. . . the first treats of their flight by beating their wings; the second of flight without beating their wings and with the help of the wind; the third of flight in general, such as that of birds, bats, fishes, animals and insects; the last of the mechanism of motion.'[10]

Once again nothing came of his publishing ambition, only the manuscript pages

*Sketches and notes about flight intermingle with Leonardo's caricatures and household accounts. For thirty years from 1486, flying is a recurring theme in his notebooks. Here he makes comparative studies of a bat, a dragonfly, a flying fish, and a butterfly.*

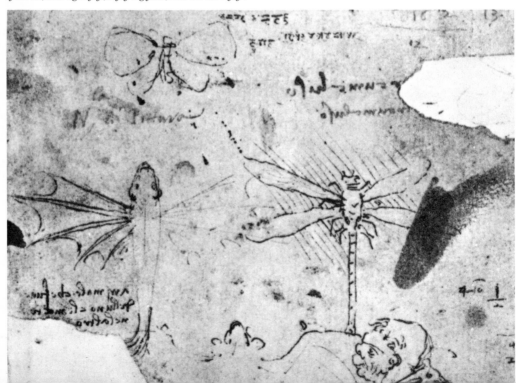

in which he was noting or drawing what he observed, and putting down his thoughts. His scratch-pad details, however, show his concern for function:

> Unless the movement of the wing which presses the air is swifter than the flight of the air when pressed, the air will not become condensed beneath the wing, and in consequence the bird will not support itself above the air. The part of the air which is nearest to the wing will most resemble in its movement the movement of the wing which presses on it; and that part will be more stable which is farther removed from the said wing. . . . The air has greater density when it is nearer to water, and [greater rarity] when it is nearer to the cold region. . . . The air of the cold region offers no resistance to the movement of the birds unless they have already passed through a considerable space of the air beneath them. The extremities of the wings are of necessity flexible.[11]

While the poet and artist in him might see the beauty of the shape and the grace of the movements, the physicist-engineer was studying the mechanics of motion. He saw the bird proceeding in leaps, flapping its wings for each bound forward. The forward thrust 'makes a wave of air which strikes upwards at the bird's breast from below' thus producing an upward movement 'driving the bird to a height'. Similarly, he watched a bird circling in order to attain height, with the breadth of its wings in a slanting position 'and the circle in which it revolves will be so much greater in proportion as its position is more slanting and smaller, and this circle will be so much smaller as its position is less slanting'.[12] He registered the movements and positions of the wings and the tail 'horns' and spelled out the effects. He watched the performance not just of the bird, but of the wing feathers and tail feathers to see their particular purpose. He paid a great deal of attention to the centres of gravity of different types of birds and how this affected their flying behaviour, subject to the absolute rule 'The bird will never descend backwards because its centre of gravity is nearer to the head than towards the tail'.[13]

Vasari has handed on the account of Leonardo, the bird-lover, setting loose caged creatures. But again, as in the case of the animals whose flesh he would not eat, his affection for live birds did not prevent him from meticulously dissecting dead birds to discover the mechanism of their flight-movements:

> You will make an anatomy of the wings of a bird together with the muscles of the breast which are the movers of these wings. And you will do the same for a man, in order to show the possibility that there is in man who desires to sustain himself amid the air by beating of wings.[14]

In one of his anatomical drawings he shows the extension of the wing and compares it to a hand. The big finger is the important one because, in the flapping of the wing, it is this which closes and prevents the exit of the stream of air which has been 'condensed'. It therefore consists of strong bone and powerful sinews. But when the closed wing spreads again this 'big finger' in the extended hand becomes the leading edge of the wing cross-section, and it also acts as an aileron in a helm-like function of manoeuvre. He describes the 'elbow' and the 'shoulder' of the wing, the muscles and tendons of the back and chest of the bird, and the

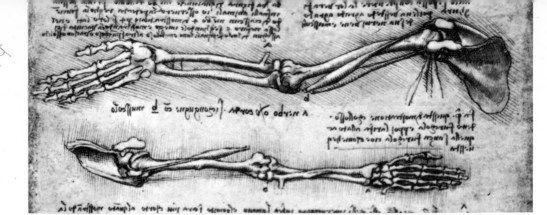

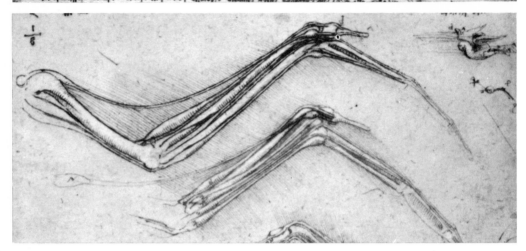

*Leonardo lays bare the bones of the human arm and the skeleton of a bird's wing. Though these drawings are not related in Leonardo's notes, he calls for comparative study to show the '. . . possibility there is in man who desires to sustain himself amid the air by beating of wings.' The idea haunted Leonardo, but no man has ever flapped his way into the sky.*

operations of the tail. Having examined the impressive apparatus with which nature has especially equipped birds for flight and having shown in his human dissections the comparative muscular attributes of man, he presents his argument.

> You will perhaps say that the sinews and muscles of a bird are incomparably more powerful than those of man, because all the girth of so many muscles and of the fleshy parts of the breast goes to aid and increase the movement of the wings while the bone in the breast is all in one piece and consequently affords the bird very great power, the wings also being all covered with a network of thick sinews and other very strong ligaments of gristle, and the skin being very thick with various muscles. But the reply to this is that such great strength gives it a reserve of power beyond what it ordinarily uses to support itself . . . it is necessary for it whenever it may so desire either to double or treble its rate of speed in order to escape its pursuer or to follow its prey . . . and in addition to this to carry through the air in its talons a weight corresponding to its own weight. So one sees a falcon carrying a duck and an eagle carrying a hare; which . . . shows clearly enough where the excess of strength is spent; for they need but little force in order to sustain themselves, and to balance themselves on their wings, and flap them in the pathway of the wind and so direct the course of their journeyings; and a slight movement of the wings is sufficient for this, and the movement will be slower in proportion as the bird is

greater in size. Man is also possessed of a greater amount of strength in his legs than is required by his weight. And in order to show the truth of this, place a man to stand upon the sea-shore, and observe how far the marks of his feet sink in; and then set another man on his back, and you will see how much deeper the marks of his feet will be. Then take away the man from his back, set him to jump straight up as high as he can; you will then find that the marks of his feet make a deeper impression where he has jumped than where he has had the other man on his back. This affords us a double proof that man is possessed of more than twice the amount of strength that is required to enable him to support himself.[15]

On the same page of the manuscript he described and drew a double chain of leather bags to be worn as a protective device so that a man falling from a height 'whether he falls into water or on land' would be unhurt.

By this stage in the argument he is talking himself into a manned ornithopter or bird-machine. In this the wings would flap and man would swim through the air. Unfortunately, his anatomy, his statics and dynamics and his 'fluid' cannot do much about man's shape, assuming that he had the muscular attributes. This 'centre of gravity' business is aggravating.

> The man in the flying machine has to be free from the waist upward in order to be able to balance himself as he does in a boat, so that his centre of gravity and that of his machine may oscillate and change where necessity requires through a change in the centre of resistance.[16]

He provides a model of an instrument to find the bird's centre of gravity. Without such an instrument, he says, a flying machine would have little value. The accompanying note points out that:

> The bird can stay in the air without keeping its wings in a position of equality because owing to its not having the centre of gravity in the middle of its axis as balances have, it is not necessarily obliged to keep its wings at an equal height like the said balances. But if these wings are outside this position of equality the bird will descend by the line of the slant of the wings . . . if we say that the slant of the wings points to the south, and the slant of the head and the tail points to the east, then the bird will descend slanting towards the south-east. And if the slant of the bird is double the slant of its wings the bird will descend by a line mid-way between the south-east and east. . . .[17]

There is a lot of this which is 'kids' stuff'—not even up to the sophisticated paper darts of junior school and very tame compared with the routines, familiar to child watchers at any modern airport, let alone the gymnastics of an air-display. But this was about 1500. No one had seriously asked those questions and, outside the myths, no one had tried experimental proof. Leonardo was carrying out a feasibility study to convince himself that manned flight was possible, and was getting himself so involved that it is difficult sometimes in the notes to determine whether he is discussing his 'bird', the machine, or the natural bird he was watching.

> The movement of the bird ought always to be above the clouds so that the wing may not be wetted, and in order to survey more country and to escape the danger caused by the revolutions of the winds among the mountain defiles which are always full of gusts and eddies of winds.

And if moreover the bird should be overturned you will have plenty of time to turn it back again following the instructions I have given, before it falls down again to the ground.

With this he gives a drawing

*a b c d* are the four cords above for raising the wing, and they are as powerful in action as the cords below, *e f g h* because of the bird being overturned so that they may offer as much resistance above as they do below, although a single strip of hide dressed with alum . . . may chance to suffice: but finally however we must put it to the test.[18]

He claimed that his 'bird' ought to be able, by the help of the wind, to rise to a great height and survive overturning and righting 'provided that its various parts have a great power of resistance, so that they can safely withstand the fury and violence of the descent . . . its joints should be made of strong tanned hide, and sewn with cords of very strong raw silk'.[19] But he barred the use of iron bands because they would break at the joints or get worn out.

He was carrying out tests to determine the bearing surface needed to lift a load of about 300 lb avoirdupois. He did balance tests on the capacity of a wing in relation to the weight of a human body:

If you wish to see a real test of the wings make them of pasteboard covered by net, and make the rods of cane, the wings being at least twenty braccia in length and breadth, and fix it over a plank of a weight of two hundred pounds and make in the manner represented above a force that is rapid; and if the plank . . . is raised up before the wing is lowered the test is satisfactory . . . and if the aforesaid result does not follow do not lose any more time.[20]

He kept trying materials for the wing—net, cane, paper ('Try first with sheets from the Chancery'), fustian, taffeta, gauze. He was trying springs 'of ox-horn', and then 'of thin and tempered steel'. His cords were 'of ox-hide, well-greased' and 'joints, soaped with fine soap'. He thought of fine leather and gave the recipe for the glue to attach it to the frame.

In his Milan days he was working on a wing-system with gauze shutters in place of feathers but a patron, Gian Antonio Mariolo, thought that the wing material should be continuous and, later, Leonardo from his study of bats with their webbed wings, came to the same conclusion.

Around 1496, ten years before 'The Great Bird of Swan Mountain', he was not just doodling his ideas and prevailing upon himself through his theories. Work was under way. He was testing human subjects: 'Make it so that the man is held firm above, *a b*, so that he will not be able to go up or down, and will exert his natural force with his arms and the same with his legs.'[21] He had found himself a large room at the top of a tall building near the Cathedral: 'Make the model large and high, and you will have space upon the roof above. . . . And if you stand upon the roof at the side of the tower the men at work upon the cupola will not see you.'[22]

On the same manuscript there is a rough map of Europe, with places in Spain, France and Germany. It could be an aviator's map. Perhaps he was just doing a

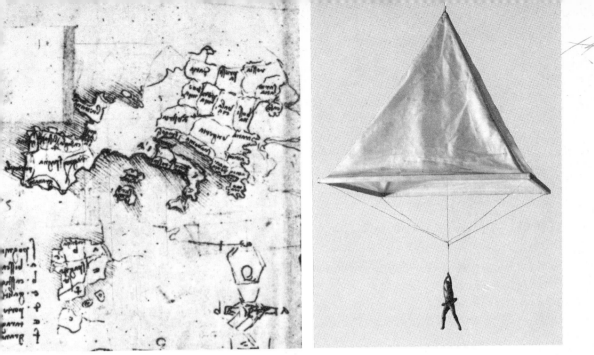

LEFT *Leonardo's tiny map of Europe from the* Codex Atlanticus *361v-b*. RIGHT *A model of a pyramidál parachute built according to Leonardo's design of* c. *1485. It is unlikely that it was ever built, but Leonardo intended it to have a pole running down from the apex to help to give it rigidity.*

sales talk to his patron—how with the flying machine he could go hither and yon. Or maybe he was reminding himself of the limited range of muscle-power—a human puppet, inverted in the sense that with his arms and legs he pulled the strings. Anyway, this sheet from the *Codex Atlanticus* (361 v b) might well qualify as the first air travel folder.

He certainly was convinced that man could master air:

A bird is an instrument working according to mathematical law, which instrument it is within the capacity of man to reproduce with all its movements. . . . We may therefore say that such an instrument constructed by man is lacking in nothing except the life of the bird, and this life must needs be supplied from that of man and that he will to a great extent be able to provide against the destruction of that instrument of which he had become the living principle and the propeller.[23]

On another sheet he waxes poetical:

Observe how the beating of its wings against the air suffices to bear up the weight of the eagle in the highly rarefied air which borders on the fiery element! Observe how the air moving over the sea, beaten back by the bellying sails, causes the heavily laden ship to glide onwards. So . . . you may be able to realize that man when he has great wings attached to him, by exerting his strength against the resistance of the air and conquering it, is enabled . . . to raise himself upon it.[24]

There is, however, on that self-same sheet, a finger-crossing addition—it is his sketch of a parachute and the note:

223

If a man have a tent made of linen of which the apertures have all been stopped up, and it be twelve braccia across and twelve in depth, he will be able to throw himself down from any great height without sustaining any injury.[25]

Parachutes, like man-made kites, had been known to the ancient Chinese and had been used to carry man, although the *History of Technology*[F] ascribes its first suggested use to Leonardo. In the absence of any evidence that he used it, the practical demonstration of the parachute had to await the first ballooners. Blanchard released a small parachute carrying a dog, from his balloon, ascending over Vauxhall Gardens, London, in June 1785. The first human descent from a balloon was made by A. J. Garnerin over Paris on 22 October 1797.

Leonardo's first proposed aircraft was the aerial equivalent of a surf-board. It was a tapering plank with wings fitted at the broader end. The flier lay flat on the board to which he was strapped by hoops. He moved the wings by pulling with his arms and treading with his legs. He had worked out the routine: the flier would lift the wings with one foot and lower them with the other. He added later improvements. The prone figure had to work a windlass and pedal with his feet. With that Leonardo maintained that he could get a force equal to 400 lbs lift. Another

*One of Leonardo's earliest aircraft designs 1486–90. The aviator lies on the board with his head through the front hoop. The wings, pivoting above the head at 'm', are raised by the left foot and lowered by the right.*

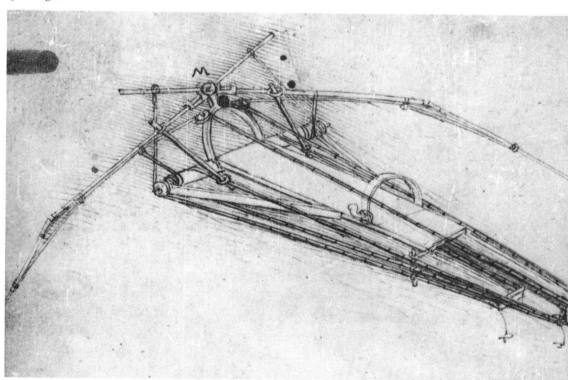

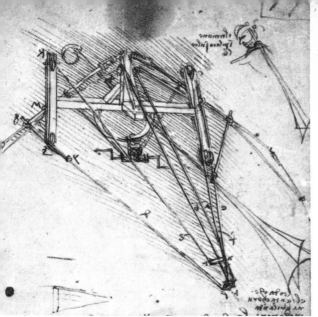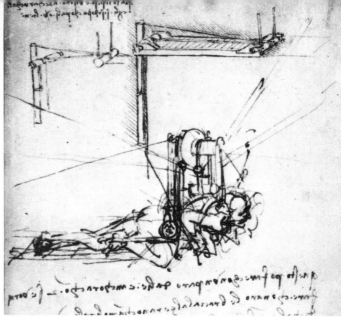

addition was a rudder like a bird's tail, which was operated by a collar fastened round the aviator's neck; when he turned his head to the right the tail-rudder moved to the left and *vice versa*.

His conclusion 'that the upright position is more useful than face downwards, because the instrument cannot get overturned'[26] might well be read to mean that it did not work.

He had been looking at insects and had begun to see the advantages of a double set of wings. He had studied the fly:

> The lower wings are more slanting than those above, both as to length and as to breadth. The fly when it hovers in the air upon its wings beats its wings with great speed and din, raising them from the horizontal position up as high as the wing is long. And as it raises them, it brings them forward in a slanting position in such a way as almost to strike the air edgewise; and as it lowers them it strikes the air and so would rise somewhat if it were not that the creature threw its weight in the opposite direction by means of its slant.[27]

He also observed that the fly used its back legs as a rudder.

So in his next attempt he experimented with a model in which he set the human upright in a kind of saddle, or truss, connected with the superstructure. One version had two pairs of wings, resting on the flyer's shoulders. The operations were controlled partly by lever and partly by stirrups through which the rider applied his leg-power. This biplane may have been 'The Great Bird of Swan Mountain'.

Whatever its fate, it was in its essentials revived four centuries later by Lilienthal, whose double-winged glider (in which the German aviator was finally killed) was

systematically studied by the Wright Brothers using wind-tunnel techniques before they arrived at their fixed wing biplane, powered by the internal combustion engine.

People still go on trying to produce the flapping wing, muscle-powered flying machine. It looks, however, as though Leonardo in spite of all the years watching birds, studying the movements and their muscles, had in the end abandoned the idea either of the bird or the bat. Maybe it was the discouragement of successive failures. More likely it was his new insight into aerodynamic principles and his other idea.

The other idea was revolutionary in both senses of the word; it was a helicopter. In his thinking and his models, Leonardo had been trying to convert limb movements into machine-flight—and he had repeatedly compared the movements of the flapping wing, of the swimming man and of the oar, with those of the wing. Once he was seized of the idea of air as a fluid, like water, swimming and rowing motions seemed the clue to flight. Hence his ornithopters, or bird-like machines.

Rotary motion, except in the limited movements of joint-in-socket, is not part of the living-mechanisms of humans or animals. That is why the discovery of the wheel is reckoned among the great conceptual achievements of *Homo sapiens*. Ancestral man had no natural prototype for the wheel; it required a great jump in imagination. Much later, the change from the reciprocal (arm-and-mangle) movement of the original steam-engine to the direct rotary movement of the steam-turbine was a similar great advance.

So we go back to Florence at the beginning of the sixteenth century and imagine

*'I find that if this instrument be well made . . . and be turned swiftly, the said screw will makes its spiral in the air and will rise high', wrote Leonardo alongside his drawing of a helicopter. With this design Leonardo contributed to the development of vertical lift.*

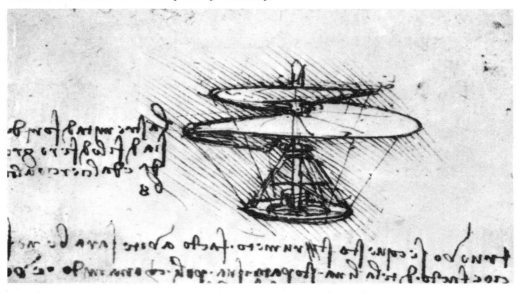

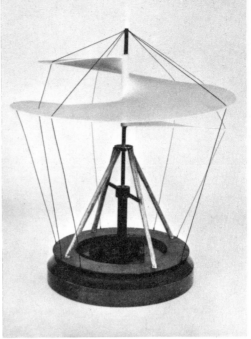

*Pull a string, and a spinning propeller will soar free. The earliest free-flying whirlibird dates from about 1320, and the one shown* LEFT *is from a painting of 1460 in Le Mans. The model* RIGHT *of Leonardo's design has its power unit on board—a tightly-wound spring.*

Leonardo contemplating the wreckage of his abortive wing-flapping machines and thinking of a machine which would revolve its way skywards.

This was not just a blinding inspiration. It came out of a whole complex of studies. The supreme merit of Leonardo was that he could combine all the relevant factors. He combined his interest in gravity and impetus; the planimetrical trans-formation of curvilinear figures and their geometrical equivalents; his studies of 'simple and composite circular movements' in relation to the ascent and descent of birds; his mechanical experience of screws and his familiarity with and respect for Archimedes. He had worked on the Archimedian Screw which by its spiral motion raises water from depth but he had also conceived the corollary: if an up-turning screw could lift water, a current of water could turn a screw. He had experimented with producing artificial currents and eddies of water, and he had drawn a screw not as a worm-thread but as a series of curved blades—a clear anticipation of the ship's propeller first introduced into naval engineering in the nineteenth century.

There is evidence in his notes and drawings of his analytical concern with spinning-tops. Tops were children's toys then as now. He studied the geometry of these gravity-cheating inverted cones, checking and measuring the relation of the speed of the revolutions to the angle of the axis—the topple of the top. He used such measurements to calculate the fly-wheel principle—'a revolving movement of such duration as appears incredible and contrary to nature, because it will make such movements beyond that of the mover . . . remaining free after the manner of the spinning top.'[28]

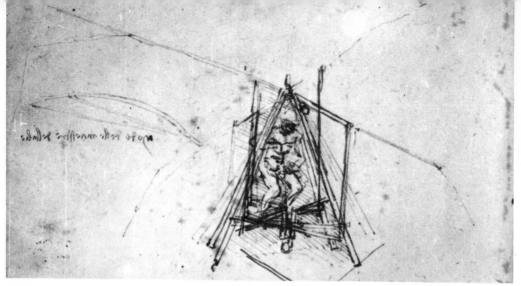

*'The great bird of Swan Mountain' may have been a bi-plane with a pilot standing vertically. In this drawing, he is working the two pairs of wings by means of a windlass. On another drawing of this design, the aircraft has a retractable undercarriage.*

The spinning top dated back to the ancient Chinese, and it may be that Leonardo, perhaps through the travellers he met at Toscanelli's house, had seen a Chinese refinement of the top, the flying propeller. This, too, is familiar to the modern child: the twisted blade spinning off a worm-screw and soaring free.

He saw the possibilities of vertical lift by means of an air-screw: 'Take the example of a wide and thin ruler whirled very rapidly in the air, you will see that your arm will be guided by the line of the edge of the said flat surface.'[29]

He proceeded to design a screw revolving round a vertical axis. The screw was a spiral collar made of linen with the 'pores stopped up with starch' on a frame made of cane. The leading edge was made of 'steel wire as thick as a cord', and the distance from the circumference to the centre was eight arm-lengths. 'I find that if this instrument made with a screw be well made . . . and be turned swiftly, the said screw will make its spiral in the air and it will rise high.'[30] He said this could easily be proved by making a small model of pasteboard 'of which the axis is formed of fine steel wire, bent by force, and as it is released it will turn the screw'.[31]

The spring-driven model would certainly work but, judging by the model now in the Science Museum, Milan, of the air-machine reconstructed by Soldatini and Somenzi from Leonardo's description and specifications, it is questionable whether a manned structure could have been airborne.

The machine was man-powered by four men standing on a platform, but Leonardo does not seem to have realized that the platform would have rotated in the opposite direction, thus halving the lifting effect once airborne. The men were to push the capstan arms 'rapidly' and so rotate the mast, the axis of the screw, fast enough to propel the helix spiralling into the air. Practical or not, it embodies the principles of present-day whirlibirds and of vertical lift.

In studying Leonardo's notes and drawings, one has constantly to remind one-

self, while admiring his imagination and his grasp of the mathematical principles involved, that he had little choice of motive power. His land-anchored machines might use water-driven wheels or his turret windmill might use wind-driven blades, but there was no *mobile* power-unit except man and his calorie-fuelled muscles. Their energy was offset by their weight and while he worked out weight-lift ratios and calculated the wing-span necessary to support an average man, he could not achieve power and speed on the galley-slave principle.

A great scientific or technological advance depends upon the man, the method and the moment. The man has the hunch, the imagination and the insight. He requires the method, the systematic laws and experimental principles, but he will still fail if the moment has not arrived. The moment depends on a combination of circumstances—the availability of suitable materials or, in Leonardo's case, the existence of compatible power-sources.

He was right when he said that 'a bird is an instrument working according to mathematical law' and that such an instrument constructed by man would 'lack nothing except the life of the bird'. He was wrong in thinking that this 'life' could be supplied by the body of man. It could only be supplied by the brain—by the invention of power-units which could be airborne. That had to await the development of the internal combustion engine, with its powerful oil-calories. This engine was applied to the fixed-wing machine, not to the 'bird' swimming in an ocean of air, but in accordance with Leonardo's principle: 'The movement of the air against a fixed thing is as great as the movement of the movable thing against the air which is immovable.'[32]

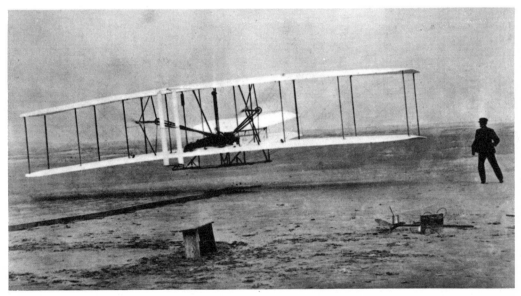

*Wilbur Wright watches as Orville Wright pilots the first powered flight. 17 December 1903.*

CHAPTER ELEVEN

# The Heretic

*Il sole nó si move.*[1]

*Il sole nó si move.* Just these five words—'The sun does not move'; written in Leonardo's mirror-writing, but rather larger than usual. Leonardo did not elaborate; it was a private defiance, like scrawling graffiti on a wall when no one was about. Leonardo was not the stuff that martyrs are made of; he was not going to incur the wrath of the Inquisition; nor invite the rack or, like his exact contemporary, Savonarola, the burning faggots of the stake.

What he was writing was a heresy against the prevailing dogma: that Man was God's special creation; that the Universe was geocentric and everything, including the sun, revolved around Man. To suggest that it was heliocentric was an affront to divinity. What happened to Galileo, a century and a half later, for saying the same thing, could have happened to Leonardo.

The circumstances of the note suggests a sudden thought, a blinding observation, which confounded all authorities including the theologians. But was it really spontaneous? It is unlikely, for Leonardo was familiar with the work of Archimedes, who gives a description of the heliocentric universe of Aristarchus (*c.* 270 B.C.). Further, at this time there was a great deal of irreverent doubt and critical revaluation of Plato, Aristotle, Hipparchus and Ptolemy, who had provided the clock-work of the Christian theologians' universe. The inner man was breaking out; people were beginning to use their eyes and to ignore Augustine's injunction: 'Go not out of doors. Return into yourself; in the inner man dwells truth.'[A] Even theologians were flirting with free thought and the humanist innovations. As long as they could present their observations as a working hypothesis and not as a flagrant contradiction of the Holy Scriptures, and as long as someone did not denounce them and their heresies to the Inquisition, they could get away with it. Disquisition to evade the Inquisition became a subtle business. It explains the artificiality of many of Leonardo's notes in which he enjoined: 'You will do so-and-

LEFT *The signs of the zodiac encircle the celestial sphere in the frontispiece of* Epytoma *by Johann Müller, called Regiomontanus, an experimental scientist and astronomer from Königsberg, whose work was known to Leonardo.*

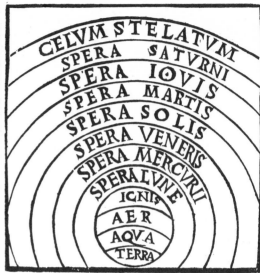

*The Earth appears at the centre of the Universe in Albertus Magnus'* Philosophia Naturalis, *a copy of which Leonardo owned. The portrait* LEFT *of Albertus Magnus, 1200–80, is by Justus von Ghent.*

so . . .', when he meant 'I am going to do so-and-so. . . .' Or when he wrote 'The adversary says . . .' when he meant Plato or Aristotle or Galen or some sanctified authority of the Church.

This led to apparent contradictions in his writings and actual confusion some-times in his thinking. His inferiority complex about his lack of scholarliness, *homo sanza lettere*, 'a man without letters',[2] alternated between deference and contempt for erudition. Unsure of himself but sure of the truth of his direct observations, he would occasionally explode:

> If indeed I have no power to quote from authors as they have, it is a far bigger and more worthy thing to read by the light of experience, which is the instructress of their masters. They strut about puffed up, and pompous, decked out and adorned not with their own labours but by those of others, and they will not even allow me my own. And if they despise me who am an inventor how much more should blame be given to themselves who are not inventors but trumpeter and reciters of the works of others?[3]

There were occasions, however, when Leonardo, even after making his own observations, did allow the old authorities to blind him to the evident as in the case, already referred to, of his research on the blood flow which was hindered by his adherence to the ideas of Galen.

He was even more chary about the theologians who had other means than words with which to break men. He would generalize his criticism: 'Falsehood is so utterly vile that though it should praise the great works of God it offends against His

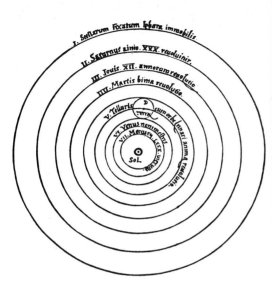

*Nicholas Copernicus displaced the Earth. In this diagram from Copernicus'* De Revolutionibus Orbium Coelestium, *1530, the Earth takes its correct place in the Solar System circling around the sun.* RIGHT *Portrait of Copernicus, 1473–1543. School of Holbein.*

divinity. Truth is of such excellence that if it praise the meanest things they become ennobled.'[4] But, as a re-insurance, he insisted, 'I leave alone the sacred books; for they are the supreme truth.'[5] That did not prevent him from showing, by devious ways, that scriptural 'truths' could be inconsistent with observable facts.

The Heavens were the special reserve of the theologians and to trespass was to transgress; so much so that the Ptolemaic System, hallowed by priestly scholars, had persisted with all the observed inconsistencies which generations of astronomers had failed to reconcile, and dared not refute. We can take it that Leonardo's astronomical observations had added up to the inference that the Earth could not be the centre of the Universe. Two contemporaries were definitely thinking along similar lines. Both of them were ecclesiastics—Nicholas da Cusa and Nicholas Copernicus.

Da Cusa had certainly displaced the Earth from the centre of the Universe before Leonardo got around to saying so. Nicholas da Cusa, taking time off from trying to square the circle, measuring the absorption of plants and working for co-existence with Islam, had concluded that the firmament was not there just for man's delectation. As a working hypothesis, which would not get him into too much trouble with his fellow cardinals or the Inquisition, da Cusa had concluded that the Earth moved. He did not for his purposes have to say that the sun stood still.

Leonardo need not have read Nicholas da Cusa, as some latter-day scholars have tried to prove or disprove. It is only necessary to remember that Nicholas da Cusa

233

and Toscanelli had been fellow students, and that they had maintained a correspondence, with Nicholas using Toscanelli as his mathematical and astronomical confidant. We should remember that Toscanelli was the friend of Verrocchio, Leonardo's master; that his house near the Ponte Vecchio of Florence was the meeting place of scholars, travellers and artists; and that he was the means of interesting Leonardo in astronomy. The aged Toscanelli was to Leonardo's generation what Bertrand Russell or Herbert Marcuse are to the protest generation of today; his interests and thinking bridged the generations gap. Whatever was being questioned by Toscanelli, the observer, and Nicholas, the theologian, would be grist to the younger intellectuals, already impatient with the new-old thinking of the academicians. If da Cusa was moving the Earth, Leonardo would know about it, and it would not strain his remarkable intelligence to ask 'moving in reference to what?'

It is much less likely that Leonardo would have known his younger contemporary, Copernicus. The Pole, twenty-one years younger than Leonardo, was in Italy from about 1496 to 1505. He enrolled as a student at Bologna. For three and a half years he studied Greek in order to familiarize himself with Plato in the original. At the same time he attended the lectures of Domenico Novarra of Ferrara, the astronomer, and made his first recorded observation (an occultation of Aldebaran) on 9 March 1497. In 1501, he entered the University of Padua, where he studied law and medicine, and continued his researches in astronomy. His interest was at that time conventional so that, in his Italian student period, he was not likely to have excited the attention of Leonardo, nor anyone else in his circle. On the other hand, the divergent views prevalent in Italy had sowed the seeds of dissatisfaction with the Ptolemaic system in the mind of Copernicus. When, as a canon, he settled in Frauenburg, he began to question the article of faith which imposed the geocentric concept—the Earth at the centre of the Universe. Difficulties had arisen over the centuries because of inconsistencies in the accumulated observations of the sun, the moon and the planets. These had destroyed the elegance of the Ptolemaic System, because so many adjustments had to be made to compute the future position of the bodies. Copernicus, later called 'The Timid Canon' by Arthur Koestler, had great trepidation in accepting the obvious. If, like da Cusa, he moved the Earth instead of the sun everything became so much simpler. He made the sun the centre of the system, but retained the idea that the planets (of which the Earth now became one) moved in uniform circular motion. He convinced himself, but made no attempt to publish his findings until his pupil, Joachim Rheticus, pestered him into doing so. What a pity Leonardo never had a Rheticus to force him into publication.

By the time the Copernican Theory with all its imperfections, later to be corrected by Kepler, was being debated, Leonardo had been dead for a quarter of a century. So his 'The sun does not move' owed nothing to the canon, but Copernicus

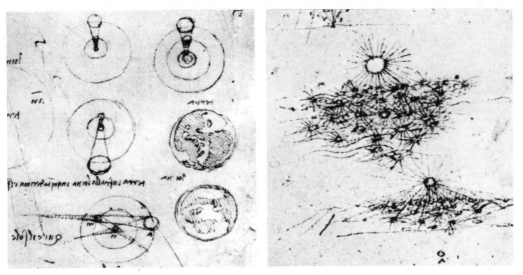

*Leonardo* ABOVE LEFT *compares the surface of the Earth and the moon. 'The moon does not receive the light of the sun on its surface continuously, but in the crests and hollows of the waves of its waters.'* RIGHT *Leonardo draws sunlight and its reflections on water.*

owed something to the atmosphere of doubts and disputations prevalent in Italy in the period he shared with Leonardo.

Twentieth-century earthlings were rather taken aback by the colour pictures of the world as seen from moon-distance by the astronauts; they had to adjust to thinking the other way round. Leonardo did just that five hundred years ago: 'Anyone standing on the moon, when it and the sun are both beneath us, would see this our earth and the element of water upon it just as we see the moon, and the earth would light it as the moon lights us.'[6]

He was quite clear about the relationship of the Earth to the moon and the nature of the moon itself, 'The moon is not of itself luminous, but is highly fitted to assimilate the character of light after the manner of the mirror, or of water.'[7] He explained that 'the moon has every month a winter and a summer . . . it has greater colds and greater heats and its equinoxes are colder than ours'.[8] 'The moon', said Leonardo, 'has its days and nights as has the earth: the night in the part which does not shine and the day in that which does . . . the night of the moon sees the light of the earth, that is to say of its water, grow dim—the darkened water sees the darkness of the sun, and to the night of the moon there is lacking the reverberation of the solar rays which are reflected there from this earth.' The night of the moon sees the light of the earth but (he pointed out) the earthlight would not be reflected by the moon back to the earth. When '. . . the day of the moon is darkened . . . the night of the Earth remains deprived of the solar rays reflected from the moon'.[9] Thus, like Anaxagoras (*c.* 450 B.C.) with whose work he was familiar, Leonardo believed that our moonlight is reflected sunlight.

But he was convinced that there were waters on the moon, like our oceans. He needed this to justify his argument that the reflection of sunlight (as we see it in moonlight) required a rough surface of a kind which existed only in liquid bodies when stirred by the wind, like waves on the sea: 'every wave takes the light from the sun; and the great multitude of waves beyond number reflect the solar body an infinite number of times; and the sun thus reflected will be as bright as the sun. . . . But the shadows also are beyond number . . . and these are interspersed between the waves; and their shapes blend with the shapes of the images of the sun . . . so they obscure the luminous rays and make them work, as clearly shown us by the light of the moon'[10] as compared with the pristine sun.

This, though wrong, is an example of Leonardo's thinking. To him, astronomy was born of perspective. 'In astronomy there is no part which is not a product of visual lines and of perspective, the daughter of painting.'[11] He used the term 'perspective' in our present sense of 'optics', geometrical and physiological. And in his deductions about the nature of the moon's surface, he was using the 'perspective' which he had elaborated mathematically in the *Treatise on Painting*. If the moon were a spherical mirror, the visual lines of the sun would be reflected back as a single image of the sun, therefore he had to have multimillions of cat's-eyes (his waves) to reflect back multimillions of suns as the diffused light of the moon but he had to account for loss of brilliance, so he had to have the shadows. When he had to explain why the moon and the stars were invisible in daylight, he wrote: 'The stars are visible by night and not by day owing to our being beneath the dense atmosphere which is full of an infinite number of particles of moisture. Each of those is lit up when it is struck by the rays of the sun and consequently the innumerable radiant particles veil those stars; and if it were not for this atmosphere the sky would always show the stars against the darkness.'[12] He did not need a space-rocket to go and find out; he just applied 'perspective'.

There are his instructions to himself, 'Make glasses in order to see the moon large',[13] and the suggestion of an observatory fitted with some kind of optical instrument: 'to observe the nature of the planets have an opening made in the roof and show at the base one planet singly: the reflected movement on this base will record the structure of the said planet, but arrange so that this base only reflects one at a time.'[14] During his period in Rome, living at the Belvedere on top of the Vatican Hill in 1514, he was definitely working on some elaborate device (mirror telescope?), which was so secret that he would not trust his ideas to craftsmen, but was designing his own machines to grind and polish lenses: 'wishing to treat of the nature of the moon it is necessary in the first place that I should describe the perspective of mirrors, whether flat, concave or convex'.[15]

With whatever equipment he had, but especially with his own extraordinarily acute eyesight, he was observing the heavenly bodies. He did not regard them as sacrosanct but as natural objects, the behaviour or substance of which could be

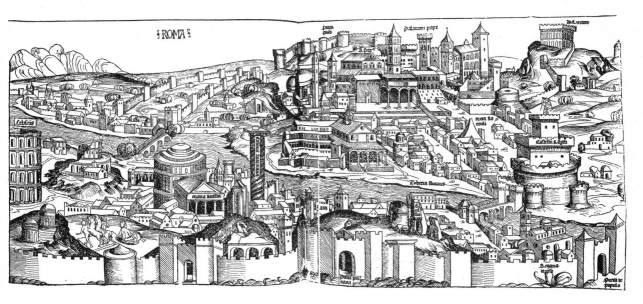

*When Leonardo stayed in Rome in 1514, he lived at the Belvedere on the Vatican Hill, top right. An engraving of Rome, 1493, from Schledel*, Nuremberg Chronicle.

verified by measurement and experiment. He believed only what he saw and checked. He did not think, any more than Anaxagoras did before him, that by identifying the Earth as a planet like the moon, he was dismissing what he called its 'majesty'.

Even before the categorical statement, 'The sun does not move', he had averred: '. . . the earth is not in the centre of the circle of the sun, nor in the centre of the universe, but is in fact in the centre of its elements which accompany it and are united to it.'[16] He kept on comparing the Earth with a point in the Universe, 'If you look at the stars without their rays—as may be done by looking at them through a small hole made with the extreme point of a fine needle and placed so as almost to touch the eye—you will perceive these stars to be so small that nothing appears less; and in truth the great distance gives them a natural diminution, although there are many there which are a great many times larger than the star which is our earth together with the water. Think, then what this star of ours would seem like at so great a distance, and then consider how many stars might be set longitudinally and latitudinally amid these stars which are scattered throughout this great expanse.'[17]

If he was to reduce the order of the Earth in the cosmic hierarchy he was determined to enthrone the sun, to the extent of repudiating Epicurus and mocking Socrates, the first for suggesting that the sun was no larger than it appeared to men, and the latter for comparing it to a burning stone 'as big as the Peloponnese'.

I could wish that I had such power of language as should avail me to censure those who would

*The sun moves across the sky in a chariot. Woodcut from Albumasar,* Flores astrologiae *1488. Leonardo scorned popular astrology, but he had a copy of this book on fortune-telling by the stars.*

fain extol the worship of men above that of the sun . . . and indeed those who have wished to worship men as gods, such as Jupiter, Saturn, Mars and the like, have made a very grave error seeing that even if man were as large as our earth he would seem like one of the least of the stars, which appears but a speck in the universe.[18]

He ridiculed Epicurus by measurement. He set up an experiment based on the sun going round the Earth.

In this way one may see whether Epicurus was right in saying that the sun is as large as it seems to be, for as the apparent diameter of the sun is about a foot and as the sun would go a thousand times into its course in twenty-four hours, the length of its course would be a thousand feet . . . which is the sixth of a mile; so then the course of the sun between night and day would be the sixth part of a mile, and this venerable snail the sun would have travelled twenty-five braccia [3·6 metres] an hour.[19]

Leonardo practised astrology, but it was 'mathematical astrology' which is astronomy, and not what he called 'false divination or popular astrology'. Leonardo added, 'Let him who makes a living from fools by means of it forgive me.'[20] Let it be said, however, that for all his rational scorn of astrology, in moments of insecurity he was not above consulting fortune-tellers himself. He even entered such visits in his household accounts.

If, however, he compromised with astrology, he rejected all belief in magic, in the supernatural gift of calling up spirits; in alchemy, seeking to change base metals into gold; and in the pursuit of perpetual motion. His views on these things were not only unusual, they were 'asking for trouble', because many of Leonardo's powerful patrons encouraged such things and if Leonardo fell foul of the court magicians they could work on the fears or avarice of princes. Nevertheless, at least in his notebooks, Leonardo was utterly contemptuous: 'But of all human discourses that must be considered as most foolish which affirms a belief in necro-

mancy, which is the sister of alchemy . . . this necromancy, an ensign or flying banner, blown by the wind, is the guide of the foolish multitude.'[21]

He declared, 'Mental things which have not passed through the understanding are vain and give birth to no truth other than what is harmful. And because such discourses spring from poverty of intellect those who make them are always poor. . . . For nature as it would seem takes vengeance on such as would work miracles . . . as happens and will to all eternity to the alchemists, the would-be creators of gold and silver, and to the engineers who think to make dead water stir itself into life with perpetual motion.'[22] However, he conceded that alchemists sometimes discovered useful things through experimentation, for he believed that though man was not capable of creating elementary substances, he could, by being nature's instrument, create an infinite number of compound substances which are not present in nature.

He was inviting the wrath not only of magicians who claimed that they could expel demons, but of the church by challenging the spirits. Those were the days when theologians solemnly discussed whether the Archangel Gabriel made his announcement to the Virgin Mary in a material or immaterial voice, and whether he spoke in Greek or Latin. Savonarola wrote and preached on questions of how angels appeared in dreams and how supernatural voices were heard. Leonardo disposed of spirits:

> We have proved that a spirit cannot of itself exist amid the elements without a body, nor can it move of itself by voluntary motion except to rise upwards. We now say that such a spirit in taking a body of air must of necessity mingle with this air because if it remained united the air would be separate and fall when the vacuum is generated, as is said above; therefore it is necessary if it is to be able to remain suspended in the air, that it should absorb a certain quantity of air; and if it were mingled with the air, two difficulties ensue, namely that it rarefies that portion of the air where-with it mingles and for this reason the rarefied air will fly upwards of its own accord and will not remain among the air that is heavier than itself; and moreover, that as this spiritual essence is spread out it becomes separated and its nature becomes modified, and it thereby loses some of its first power. Added to these there is a third difficulty, and that is that this body of air taken from the spirit is exposed to the penetrating winds, which are incessantly sundering and tearing to pieces the united portions of the air, revolving and whirling them amid the other air; therefore the spirit which is infused in this air would be dismembered or rent and broken up. . . .[23]

This could have been construed as disputing the Resurrection and Christ.
About spirit voices, Leonardo had emphatic views:

> There can be no voice where there is no motion or percussion of air; there can be no percussion of the air where there is no instrument; there can be no instrument without a body; this being so a spirit can have neither voice, nor form, nor force; and if it were to assume a body it could not penetrate nor enter where doors are closed. And if any should say that through air collected together and compressed a spirit may assume bodies of various forms, and by such an instrument may speak and move with force—to him I reply that where there are neither nerves nor bones there can be no forces exerted in any movement made by imaginary spirits.[24]

Without getting involved in an argument about spiritualism, a modern material-ist might point to the physical nature of electro-magnetic waves which can carry voices and images through solid walls. In this instance, Leonardo's essential instrument for percussion is the loudspeaker which reconstitutes electro-magnetic pulses into sound vibrations audible to the human ear, whilst the cathode ray tube makes images visible on the television screen.

The role of the devil's advocate was a perfectly respectable one—provided the devil did not win the argument. The sceptic of 1500 could get away with a lot as long as he did not flatly and publicly contradict the Holy Scriptures. Leonardo flatly denied the story of the Flood. Whether he did so publicly is another matter. We do not know how far Leonardo went in discussing what he wrote in the privacy of his notebooks. He certainly did not nail his heresies on church doors nor harangue the multitude. To challenge the book of Genesis was to repudiate the Creator. To question divine punishment was to dispute the sanctions of the Church.

To Leonardo, destruction by water was the greatest calamity which could be visited upon mankind. The Deluge had a morbid fascination for him, the quality of a horrifying nightmare. The most graphic of all his writing and the most powerful of all his sketches (for the apocalyptic painting which he never produced) deal with catastrophes of wind and water.

Amid all the causes of the destruction of human property, rivers hold the foremost place on account of their excessive and violent inundations. If anyone should wish to uphold fire against the fury of impetuous rivers, he would seem to me to be lacking in judgment, for fire remains spent and dead when fuel fails, but against the irreparable inundation caused by swollen and proud rivers no resource of human foresight can avail; for in a succession of raging and seething waves gnawing and tearing away high banks, growing turbid with the earth from ploughed fields, destroying the houses therein and uprooting the tall trees, it carries these as its prey down to the sea which is its lair, bearing along with it men, trees, animals, houses, and lands, sweeping away every dike and every kind of barrier, bearing along the light things, and devastating and destroying those of weight, creating big landslips out of small fissures, filling up with floods the low valleys, and rushing headlong with destructive and inexorable mass of waters . . . oh, how many cities, how many lands, castles, villas, and houses has it consumed! How many of the labours of wretched husbandmen have been rendered idle and profitless! How many families have been ruined and overwhelmed! What shall I say of the herds of cattle which are drowned and lost![25]

His scenario for his super-colossal production, the End of the World, which never materialized is even more terrific and horrific. It begins with an avalanche:

First let there be presented the summit of a rugged mountain with valleys that surround its base, and on its sides let the surface of the soil be seen to slide together with the little roots of small shrubs; and leaving bare a great portion of the surrounding rocks. Descending in devastation from these precipices let it pursue its headlong course striking and laying bare the twisted and gnarled roots of the great trees overturning them in ruin; and let the mountains as

*The Ponte Vecchio obstructs the swollen river Arno in the Florence floods of November 1966.*
OVERLEAF *Leonardo's map of Tuscany, showing possible canal routes between Florence and Pistoia. From the* Codex Madrid II.

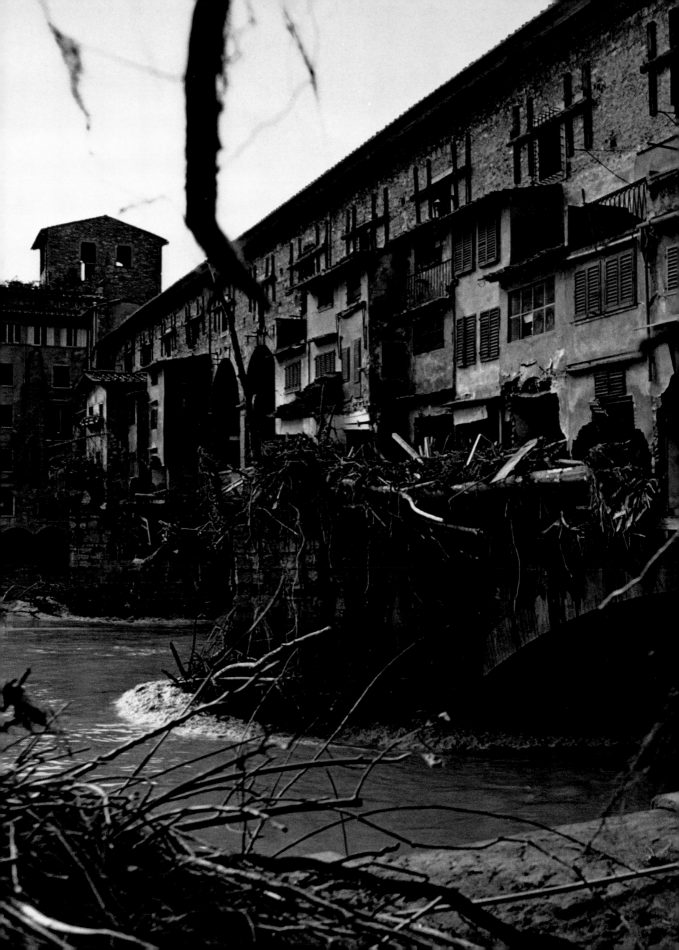

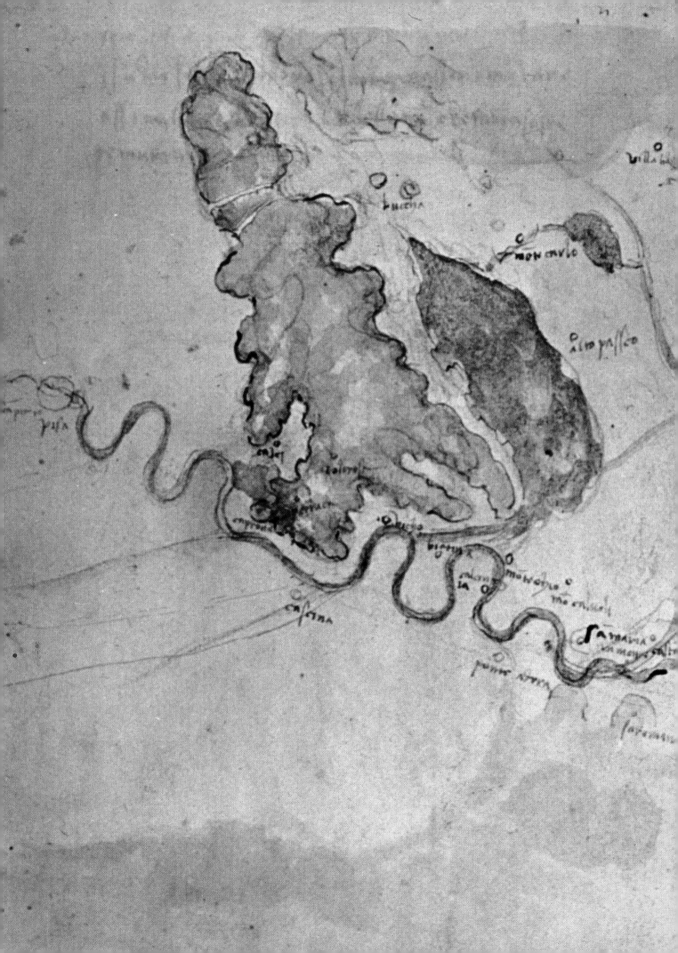

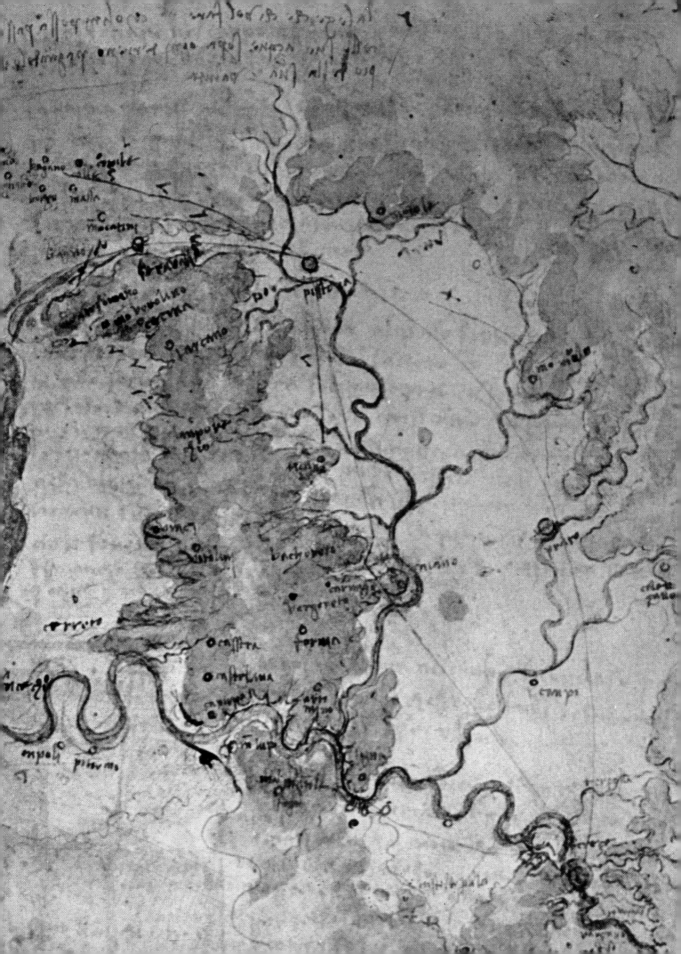

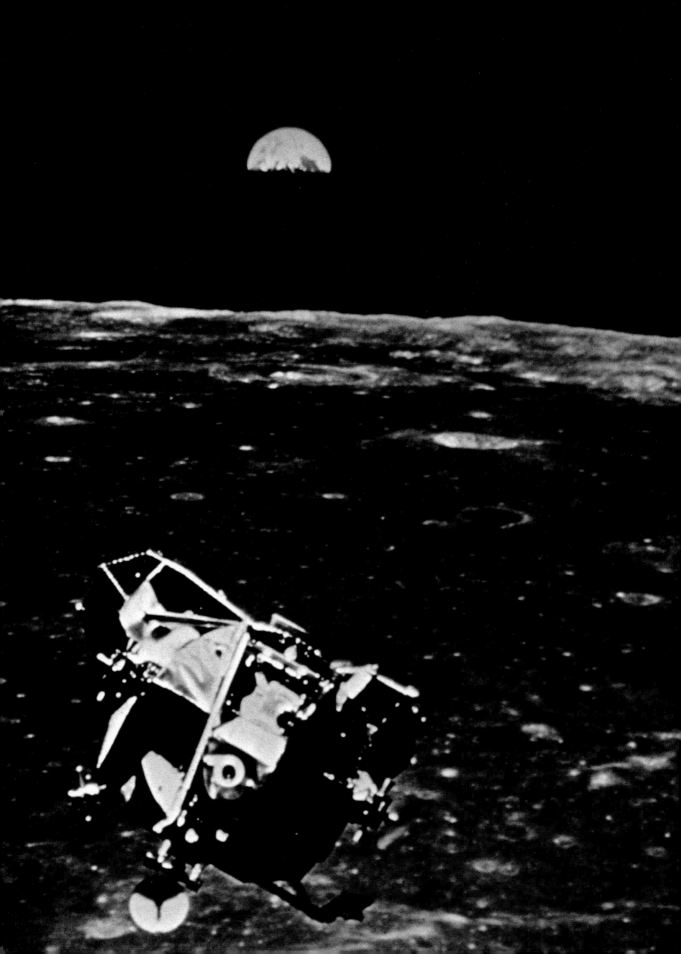

they become bare reveal the deep fissures made in them by ancient earthquakes; and let the bases of the mountains be in great part covered and clad with the debris of shrubs which have fallen from the sides of the lofty mountain peaks; and let these be mingled with mud, roots, branches of trees with different kinds of leaves . . . let the fragments of some of the mountains descend into the depth of some valley and there form a bank to the swollen waters of its river; which having already burst its banks is rushing on with enormous waves, striking and destroying the walls of the cities and farms . . . let the ruins of the high buildings of these cities throw up much dust rising up in shapes of smoke or wreathing clouds against the descending rain. . . .[26]

His tempest sequence would show:

. . . the clouds riven and torn and flying with the wind, together with storms of sand blown up from the sea-shores, and boughs and leaves swept up by the strength and fury of the gale. . . . Trees and plants should be bent to the ground . . . of the men who are there, some should have fallen and be lying wrapped round by their garments, and almost indistinguishable on account of the dust, while those remain standing should be behind some tree with their arms thrown around it that the wind may not tear them away. . . . Let the sea be wild and tempestuous, and full of foam whirled between the big waves . . . of the ships that are there, some should be shown with sails rent and the shreds fluttering in the air in company with broken ropes and some of the masts split and fallen, and the vessel itself lying disabled and broken by the fury of the waves, with the men shrieking and clinging to the fragments of the wreck. Make

*To Leonardo destruction by water was the greatest calamity which could be visited on mankind. A drawing for the Deluge c. 1515, showing a gigantic explosion.*

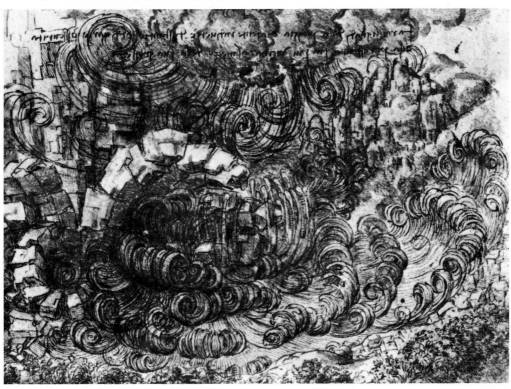

*In 1509 Leonardo wrote, in answer to those who said the sun was no bigger than it appeared to be, 'think then what this star of ours would seem like at so great a distance.' Earthrise, seen by the crew of Apollo 11, July 1969.*
OVERLEAF *The Deluge: a drawing c. 1514. Actual size.*

107

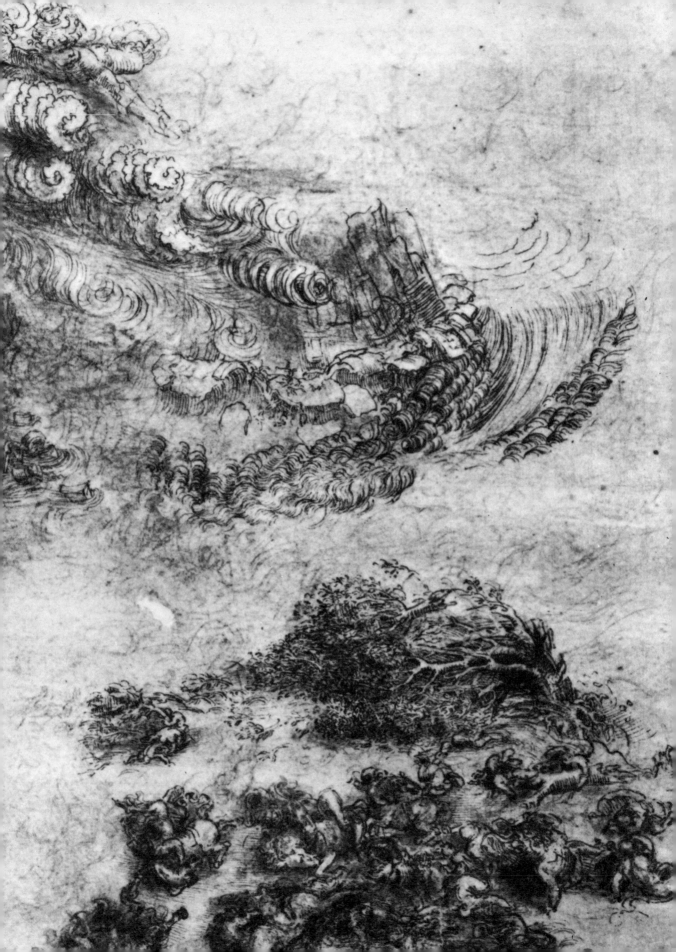

the clouds driven by the impetuous winds, hurled against the high mountain tops, and there wreathing and eddying like waves that beat upon rocks; the very air should strike terror through the deep darkness caused by the dust and mist and heavy clouds.[27]

What he calls 'the judgment scene', the culmination of catastrophe, was, like the others, meant to be painted, but the description has the cinematic quality of a modern film script:

> . . . let there be seen fragments of mountains which have already been scoured bare by their torrents fall into these very torrents and choke up their valleys; until the swollen rivers overflow and submerge the wide lands with their inhabitants. Again you might see on many of the mountain-tops many different kinds of animals huddled together, terrified and subdued to tameness in company with men and women who had fled there with their children. And the waters which cover the fields with their waves are in great part strewn with tables, bedsteads, boats and various other contrivances improvised through necessity and fear of death, on which are women and men with their children uttering lamentations and cries terrified by the fury of the winds which are causing the waters to roll over and over in mighty hurricane, bearing with them the bodies of the drowned; nor was there any object . . . but was covered with different animals who have made a truce and stood together in terror, among them being wolves, foxes, snakes, and creatures of every kind—fugitives from death . . . you might see groups of men with weapons in their hands defending the small spots that remained to them from the lions, wolves, and beasts of prey which sought safety there.
>
> Ah! what dreadful screams were heard in the dark air rent by the fury of the thunder and the lightning it flashed forth which darted through the clouds bearing ruin and striking down all that withstood its course! Ah, you might see many stopping their ears with their hands in order to shut out the tremendous sounds made in the darkened air by the fury of the winds mingling with the rain, the thunder of heaven, and the fury of the thunderbolts! Others, not content to shut their eyes, laid their hands over them . . . in order not to see the pitiless slaughter of the human race by the wrath of God. . . .
>
> Ah, how many laments! How many in their terror flung themselves from the rocks! . . . Others with gestures of despair were taking their own lives . . . others seized their own children and with violence slew them at one blow . . . others falling upon their knees recommended themselves to God. Ah! how many mothers were weeping over their drowned sons, supported upon their knees, with arms open and raised towards heaven, and with cries and shrieks declaiming against the wrath of the gods! Others with hands clasped and fingers clenched gnawed them and devoured them with bites that ran blood . . . in their intense and unbearable anguish. . . .
>
> And the birds had already begun to settle on men and on other animals no longer finding any land left unsubmerged . . . already had hunger, the minister of death, taken the lives of the greater number . . . the dead bodies now inflated began to rise from the bottom of the deep waters . . . and like balls puffed up with wind, rebound from the spot where they strike. . . .
>
> And above these judgment scenes the air was seen covered with dark clouds, riven by the jagged course of the raging bolts of heaven, lighting up now here, now there, the depths of gloom.[28]

Obviously, Leonardo was not quarrelling with the idea of a wrathful God who meted out punishment. What he disagreed with, from his own direct observation, was the involvement of the entire world in Noah's Flood. Such a modification of the terms of reference would not necessarily have acquitted him of heresy.

Here a doubt arises, and that is: whether the Flood which came at the time of Noah was universal or not. And it would seem not, for the reasons which will now be given: we have it in the Bible that the said Flood consisted in forty days and forty nights of continuous and universal rain, and that this rain rose ten cubits above the highest mountain in the world. But if it had been the case that the rain was universal it would have formed a covering around the globe spherical in shape. And this spherical surface is in every part equidistant from the centre of its sphere; and the waters of the sphere finding themselves in the aforesaid condition it is impossible for the water upon the surface to move; because the water does not move of its own accord unless to descend. How then did the water of so great a flood depart, if it is proved that it had no power or motion? And if it departed, how did it move unless it went upwards? Here, then, natural reasons fail us; and therefore to resolve such a doubt we must needs either call in a miracle to aid us, or else say that all this water was evaporated by the heat of the sun.[29]

Leonardo, however, was questioning Noah's Flood not only as a hydraulics engineer familiar with the behaviour of water, but also as a geologist. From his surveys of Tuscany, Lombardy and the Italian Alps, he came to the same conclusion as classical writers: that waters had once or even several times covered the land, but that they were the waters of the oceans and not of the Deluge. Sufficient for us, he said, is the testimony of things produced in salt waters and found in the high mountains far from the seas today. In one of those instructions to himself as though he were telling his inquisitors that he was merely the investigator, not the initiator, he wrote:

In this work of yours you have first to prove that the shells at a height of a thousand braccia were not carried there by the Deluge, because they are seen at one and the same level, and many mountains are seen to rise considerably above that level. [Hence, could not have been covered as the Book of Genesis suggested.]
... and to inquire whether the Deluge was caused by rain or by the swelling of the sea; and then you must show how that neither by rain which makes the rivers swell, nor by the overflow of the sea could the shells, being heavy objects ... be driven by the sea up the mountains or be carried there by the rivers.[30] [i.e. they must have developed *in situ*.]

You now have to prove that the shells cannot have originated if not in salt water, almost all being of that sort; and that the shells in Lombardy are at four levels, and thus it is everywhere, having been made at various times.[31]

If the Deluge had carried the shells for distances of three and four hundred miles from the sea it would have carried them mixed with various other natural objects all heaped up together; but even at such distances from the sea we see the oysters all together and also the shellfish and the cuttlefish and all the other shells which congregate together ... they were still living when the strait of Gibraltar was cut through. ... The red stone of the mountains of Verona is found all intermingled with shells turned into this stone; some of them have been sealed at the mouth by the cement which is of the substance of the stone. ... And if you were to say that these shells had been created and still constantly are being created in such places by the nature of the locality and through the potency of the heavens ... such an opinion cannot exist in brains of any extensive powers of reasoning, because the years of their growth are here numbered upon the outer coverings of the shells; and large and small ones may be seen, and these would not have grown without food. ...[32]

And if you should say that it was the Deluge that carried these shells away from the sea for hundreds of miles, this cannot have happened since the Deluge was caused by rains; because rains naturally force the rivers towards the sea with the objects carried by them, and they do not draw up to the mountains the dead things on the sea-shores. . . . How are we to account for the corals which are found every day towards Monferrato in Lombardy. . . . These rocks are all covered with stocks and families of oysters, which as we know do not move, but always remain fixed by one of their valves to the rocks, and the other they open to feed upon the animalcules that swim in water. . . .[33]

Leonardo did not believe in a once-for-all Creation. For one thing he accepted the theory (implicit in what he wrote about the shells) of the slow uplifting of the continents. One says 'accepted' because it had been expounded in the fourteenth century by Jean Buridan and Albert of Saxony. Leonardo may not have studied Buridan but we know that he read Albert from his entry in his notes: 'Albertus *On Heaven and Earth*, from Bernardino'. Although most of what he speculated about was based on his direct experience, he depended for a considerable part of his thinking on others' works or on travellers' observations, but he tried neither to deceive nor to be deceived. He checked. In his interest in the Mediterranean basin he anticipated modern hydrological research.

Thus you make a model of the Mediterranean Sea. . . . In this model let the rivers be commensurate with the size and outlines of the sea. Then, by experimental observation of the streams of water, you will learn what they carry away of things covered and not covered by water. And you will let the waters of the Nile, Don, Po, and other rivers of that size flow into that sea, which will have its outlet through the straits of Gibraltar. Its bottom should be made of sand, with a level surface. In this way you will soon see whence the water currents take objects and where they deposit them.[34]

He never easily accepted an authority, not even Aristotle, and always tried to confirm by contemporary experience. 'Write to Bartolomeo the Turk about the ebb and flow of the Black Sea and ask whether he knows if there is the same ebb and flow in the Hyrcanian or the Caspian Sea.'[35] He believed that the Caspian was part of the Mediterranean Sea system, discharging itself into the Black Sea through subterranean channels and thence through the Bosphorus into the Aegean. One of his hypotheses was that the Black Sea once stretched as far as Austria and occupied the entire plain through which the Danube now flows. 'The sign of this', he said, 'is shown by the oysters and the cockle-shells and scallops and bones of great fishes which are still found . . . on the high slopes of the said mountains.'[36] The sea was contained by the spurs of the Alps in the west and the spurs of the Taurus range in the east. The Black Sea sank down and drained the land exposing the valley of the Danube, the lower parts of Asia Minor, the plains between the Caucasus and the Black Sea, and the plain of the Don. He accepted the creation of the Dead Sea by a rift and with it the biblical story of Sodom and Gomorrah. From navigators' charts he established the distance from the Don to the straits of Gibraltar as 3,500 miles and the fall in level between the two as two feet per mile 'for all water that moves at

*'In every hollow at the summit of the mountains you will always find the folds of the strata of the rocks.'*
*Upheavals in the Earth's crust. A drawing of boulders, 1508.*

a moderate rate of speed'. He held that at one time the Mediterranean flowed abundantly into the Red Sea 'and wore away the sides of Mount Sinai'.[37] He accounted for the sealing off, as he did for some of the changes in his own North Italy, by the slipping of a mountain.

The oceanic waters which accounted for the shells on the hills of Lombardy were those of the Mediterranean at its full extent. He described the map as it once was:

> The bosom of the Mediterranean like a sea received the principal waters of Africa and Europe; for they were turned towards it and came with their waters to the base of the mountains which surrounded it and formed its banks. And the peaks of the Apennines stood up in this sea in the form of islands surrounded by salt water. Nor did Africa as yet behind its Atlas mountains reveal the earth of its great plains naked to the sky some three thousand miles in extent; and on the shore of this sea stood Memphis; and above the plains of Italy where flocks of birds are flying today fishes were once moving in large shoals.[38]

This was the great sweeping vision of the man who painted the details of the smile of Mona Lisa.

Leonardo recognized water as the sculptor of the Earth's features. He also regarded it as 'Nature's carter' moving things from place to place in geological refurnishing. He described its building up of alluvial soil and its role in creating sedimentary rocks in which shells and other things were trapped and petrified. He did not, except poetically, recognize the significance of volcanic action. He spoke of Stromboli and Etna where 'pent up sulphurous fires, bursting open and rending asunder the mighty mountain . . . hurling through the air rocks and earth mingled together in the issuing belching flames',[39] but he missed the significance of the

igneous rocks. Thus the 'Plutonic Theory' had to wait until the eighteenth century.

Through his agility in debate or through the discretion of his private thinking, released to us in his notes, long after the fires of the Inquisition, he evaded the consequences of his scientific heresies. He was, however, openly anticlerical: 'Pharisees—that is to say, holy friars'.[40] And he castigated the selling of indulgences which he called 'trafficking in paradise'. 'A countless multitude will sell publicly and without hindrance things of the very greatest value, without licence from the Lord of these things, which were never theirs nor in their power; and human justice will take no account of this.'[41] He painted religious pictures but he scorned those who worshipped them: 'they will ask pardon from one who has ears and does not hear, they will offer light to one who is blind'.[42]

Sometimes his criticisms were oblique: 'in some parts of India . . . when the images have according to them performed some miracle, the priests cut them in pieces, being of wood, and give them to all the people . . . not without payment; and each one grates his portion very fine, and puts it upon the first food he eats; and thus believes that by faith he has eaten his saint who then preserves him from all perils.'[43] He would not have dared to impugn the Eucharist directly.

A curious thing happened in Vasari's biography. In the first edition published thirty-one years after Leonardo's death at Amboise, he wrote: 'Philosophizing of natural things, he set himself to seek out the properties of herbs, going on even to observe the motions of the heavens, the path of the moon and the courses of the sun. That is why he formed in his mind a heretical view of things, not in agreement with any religion; evidently he preferred being a philosopher to being a Christian.'[B]

In the next edition the passage was omitted. Instead he settled for the account of Leonardo's deathbed repentance: 'At length . . . seeing himself near death, he desired to occupy himself with the truths of the Catholic Faith and the holy Christian religion. Then, having confessed and shown his penitence with much lamentation, he devoutly took the Sacrament out of his bed, supported by his friends and servants, as he could not stand. The king arriving . . . he sat up in bed from respect, and related the circumstances of his sickness, showing how greatly he had offended God and man in not having worked at his art as he ought. He was then seized with a paroxysm, the harbinger of death, so that the king rose and took his head to assist him and show him favour as well as to alleviate his pain. Leonardo's divine spirit, then recognizing that he could not enjoy a greater honour, expired in the king's arms, at the age of seventy-five.'[C]

If this account were true, the repentant artist was a recanting scientist who had written: 'if we are doubtful about the certainty of things that pass through the senses how much more should we question the many things against which these senses rebel, such as the nature of God and the soul and the like, about which there are endless disputes and controversies. And truly it so happens that where reason is not, its place is taken by clamour.'[44]

*Leonardo*: Virgin of the Rocks, *1506–8.*

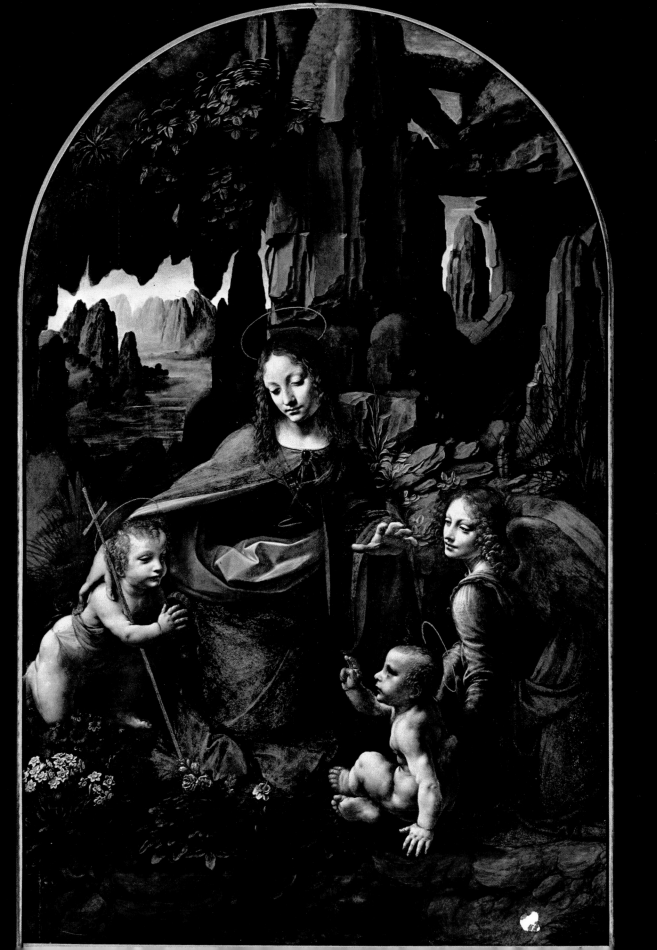

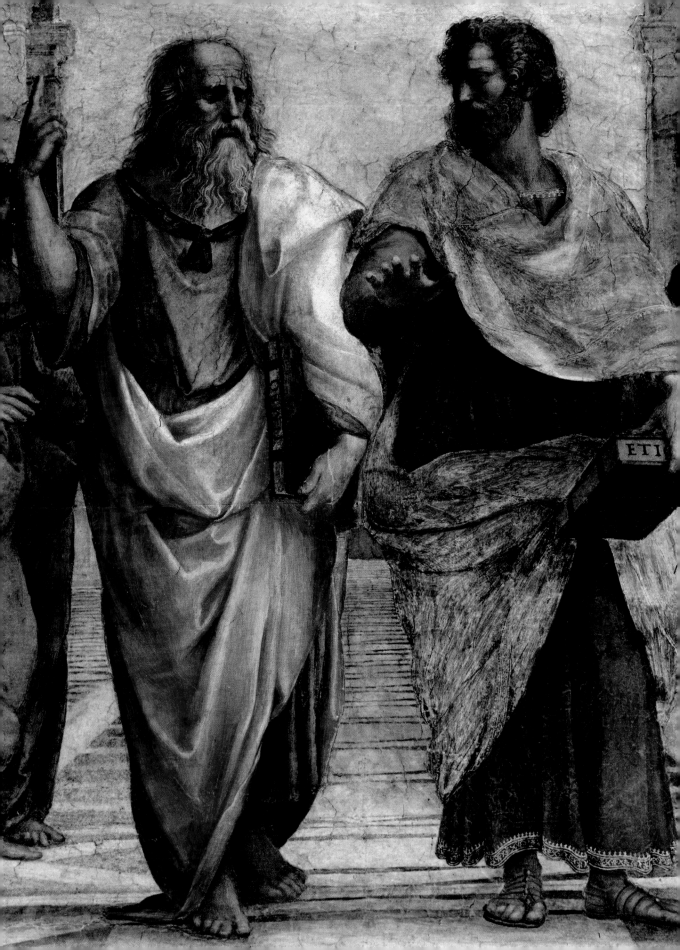

# Academia Leonardo Vici

> To me it seems that all sciences are vain and full of errors that are
> not born of Experience, mother of all certainty, and that are not
> tested by Experience; that is to say, that do not . . . pass through
> any of the five senses.[1]

To the end, Leonardo remained a practical joker. Even at Amboise, where he had
been received as 'The Divine Leonardo', he lent himself to the extravagant follies
of François I and his popinjay courtiers. The tired genius would rouse himself
with the weariness which he feared more than death, and humour the King with
elaborate entertainments. For these he would invent mechanical tricks—birds
that would swoop down from the ceiling on concealed pulleys; the allegorical lion
that would prance on the stage and open its breast to show lilies; living artefacts,
like the terrifying lizard he devised at the court of Pope Leo X, by taking a natural
specimen and sticking on a horn and a beard and scales covered in quicksilver; or
the animal's gut which he blew up with hidden bellows in the middle of a crowded
room until it squashed the courtiers against the wall.

He would regale the Court with the fantastic stories, allegories and fables he had
collected together, most of them borrowed but some of them original. Solmi's
exhaustive researches have failed to find precedents for his Aesop-like fables, but
his 'Bestiary', animal tales with a moral, was almost entirely derived from others.
He took them straight from Pliny's *Historia Naturale;* from *Physiologus*, a com-
pilation dating back to the third century A.D. beginning with Didymus of Alexan-
dria; from *Fior di Virtu* published in Venice in 1488 and from *L'Acerba* by Cecco
d'Ascoli. Some commentators have used the 'Bestiary' to show that Leonardo was
still floundering in the credulity of the Middle Ages, accepting such creatures as:

*The Catoblepas:* It is found in Ethiopia near to the source of Nigricapo . . . its head is so
large . . . that it always droops towards the ground; otherwise it would be a great pest to man,
for any one on whom it fixes its eyes dies immediately.[2]

*The Basilisk:* This is found in the province of Cyrenaica and is not more than twelve fingers
long. . . . It scares all serpents with its whistling . . . one of these, being killed with a spear by
one who was on horse-back, and its venom flowing on the spear, not only the man but the
horse also died.[3]

*The philosophers Plato and Aristotle from Raphael's* School of Athens.
*Raphael painted Plato, left, in the likeness of the ageing Leonardo.*

*The Amphisboena:* This has two heads, one in its proper place, and the other at the tail; as if one place were not enough from which to fling its venom.[4]

These and many others are from books that were in Leonardo's own library. They made good talking points and his listeners were not likely to go to the source of the Nile or to Cyrenaica to disprove him. He was simply providing them with a fantastic zoo, and as a painter he was also thinking of 'how to make an imaginary animal appear natural'. He created a dragon: 'Take for its head that of a mastiff or setter, for its eyes those of a cat, for its ears those of a porcupine, for its nose that of a greyhound, with the eyebrows of a lion, the temples of an old cock and the neck of a water-tortoise.'[5]

Leonardo was, in fact, a compulsive note-taker. He would copy things without acknowledgment and expound them as his views on philosophy, or morals; as his

*profetie* (which are not so much predictions as projections of his moods); and as his speculations, his riddles and his jests. Of course, he added his own thinking or refurbished them sufficiently to make them his own. When he saw in what he was reading an element of scientific truth, he would pursue his own experiments and confirm or refute. Sometimes as we have seen he dallied too long with the established authority.

Unless it is realized that his notes are full of self-reminders and aphorisms which occurred to him, 'quotable quotes' or paraphrases of someone else which he jotted down at random, one might get the impression that he flung out dogmatic statements like a bible-thumper at a tent-mission. Or one might ascribe to him credit for even greater originality than he, prodigiously, deserves. For example, there is the much-quoted passage on Helen of Troy looking at her mirror in old age:

Oh Time, thou that consumest all things! Or envious age, thou destroyest all things and

devourest all things with the hard teeth of the years, little by little, in slow death! Helen, when she looked in her mirror and saw the withered wrinkles which old age had made in her face, wept, and wondered to herself why ever she had twice been carried away. Oh Time, thou that consumest all things! Or envious age, whereby all things are consumed![6]

This was a straight crib from Ovid's *Metamorphoses*.

Leonardo was also a writer of fiction. There is his extraordinary and entirely plausible account of a journey to the Levant. Scholars have tried very hard to fit such a wide-ranging and detailed journey into what is known of his time-schedule. It could have been done today, but not then. Indeed, there is only one passage in all his notes that might suggest that he was ever at sea: 'When I was in a place at equal distance from the shore and the mountains, the distance from the shore looked much greater than that of the mountains.'[7] It is extremely unlikely that he

*Fabulous beasts and dragons abound in the wood-cuts of early printed books. From* Fior di Virtu *1491 comes the Basilisk* FAR LEFT *symbol of cruelty, venomous, scorching the earth with its breath. Leonardo describes it more than once and it seems to vary enormously in size. The many-headed dragon* LEFT *comes from a long moralizing poem* Quatriregio *by Federico Frezzi. Leonardo had editions of both these books in his library. Leonardo's own dragons* RIGHT *are studies for a dragon fight and were made about 1480.*

ever visited Egypt, Armenia or the Taurus Mountains, or even the Bosphorus, although he designed a bridge for it. He was, however, a good listener and onward from his young days when he listened to the seafarers and caravan-traders he had ample opportunity to interrogate them on details which give his accounts their sense of actuality.

He was also a great friend of Benedetto Dei who was a hardened *tuba del bene* (a 'shouter of good stories') and some of Leonardo's far distant and far-fetched stories were deliberate parodies, even to style, of Benedetto. One such was pure 'Gulliver' and, indeed, if it were not impossible, one might have thought Jonathan Swift had read it. This tale, which takes the form of a letter to Benedetto Dei, is the account of a giant who was born on Mount Atlas; who waged war against the Egyptians, the Medes and the Persians, and who lived in the sea upon whales and great leviathans. Leonardo begins the letter: 'Dear Benedetto,—To give you the

news . . . from the east, you must know that in the month of June there appeared a giant who came from the Libyan desert.' He describes how this savage giant fell down because the ground was covered with blood and mire, whereupon the people set upon him 'like a flock of ants that range about hither and thither furiously among the brambles beaten down by the axe of the sturdy peasant . . . hurrying over his huge limbs and piercing them with frequent wounds. At this the giant being roused and, perceiving himself to be almost covered by the crowd . . . uttered a roar which seemed as though it were a terrific peal of thunder . . . and at this point he shook his head and sent the men flying through the air. . . .'[8] After all even today, eminent scientists such as Fred Hoyle write fiction for fun.

With all his versatility, Leonardo was quintessentially a 'man of science'. This, as H. G. Wells always insisted, is something more than a 'scientist'. The distinction is important. The word 'scientist' did not figure in the English language, or any other, until the middle of the nineteenth century and the '-ist' carried with it the implications, excessively exaggerated today, of specialization. The term foreboded the jargon of science which is mainly responsible for the divorce of the 'Two Cultures', science and the humanities, and which, by intimidating ordinary, intelligent people, prevents common understanding. With the advent of the 'scientist', terminology which had once been descriptive became cryptic, like the code names devised to disguise military operations. Previously, the 'man of science' could speak intelligently to his fellow men. Furthermore, he could range over the whole gamut of natural phenomena and share with others the results of his natural curiosity.

One thinks of Francis Bacon, who as a lawyer had no inhibitions about spelling out what are now the guide lines of modern science. His ideas have a good deal in common with those of Leonardo, of whom, at least in terms of science, Bacon had never heard. One remembers the virtuosi who formed the 'Invisible College' which became the Royal Society of London and who, as a coterie, also had a deal in common with Leonardo: Wilkins, the liberal theologian; Petty, the founder of political economy; Christopher Wren, the architect of St Paul's; Robert Boyle of 'Boyle's Law'; Robert Hooke of optics and clocks; John Evelyn the diarist and divers others. Or, even more appropriately, we may consider the Lunar Society of Birmingham. That was the extraordinary body which, through such members as James Watt and Matthew Boulton, gave the Industrial Revolution its steam power and a great deal more. It was called the Lunar Society because it met every month at the full moon, so that Erasmus Darwin, the physician-poet, grandfather of Charles Darwin, could be lit home to Lichfield and Josiah Wedgwood, the potter, could get back to The Potteries. Its members included Benjamin Franklin; Joseph Priestley, the Unitarian minister who turned into one of the greatest chemists of all time; Herschel, the German bandmaster who became Astronomer Royal; William Withering, who first introduced digitalis for the treatment of

heart disease; and William Small, who as professor of natural philosophy at Williamsburg had taught Thomas Jefferson the physics of Newton and so influenced the checks and balances of the American Constitution. Their discussions were free-ranging—everyone talking everyone else's 'shop'—and covering the whole scope of human interests. Leonardo might be described as a one-man Lunar Society.

He consorted with associates, and he assimilated what was going on around him. He was a pressure-cooker of ideas. He just assumed them. That is what makes so amusing the measures which he took to prevent others from 'cashing in' on his

*The chivalrous knight, Meschino.*
*The frontispiece of a romantic novel by Barberino. Leonardo had a copy.*

innovations. Unlike Edison he could not patent; hence those furtive sketches of components and the deliberate mistakes in completed designs. What he had beyond inquisitiveness and imagination was methodology, which makes him the first of the systematic scientists and the first of the systems-engineers.

Of course, he evolved a philosophy of science, but the operative word is 'evolved'. As this book has tried to show, he progressed from the particular to the general. He defined it himself when he wrote: '. . . follow the method of Ptolemy in his *Cosmography* in the reverse order; put first the knowledge of the parts and then you will have a better understanding of the whole put together.'[9] It is quite easy to go through Leonardo's notebooks and construct a philosophy. We must remember

that the sheets were scattered about and reshuffled and are rarely precisely dated. It has become a trick of writers on Leonardo to take a cogent remark written (possibly) at the age of sixty to justify what he was doing (possibly) at the age of twenty. That will not work in science: his techniques and thought processes were born of experience and grew and integrated into general concepts. A brief recapitulation will help to remind us how Leonardo the man of science developed from Leonardo the craftsman-painter.

He started with a country schoolboy's education. It cannot have been too bad. It gave him a vivid power of expression in the Italian of Dante and Boccaccio. He grumbled about not having Latin and Greek but set out to teach himself, just as he taught himself, very effectively, advanced forms of mathematics to the point where he could vaunt 'Let no man who is not a mathematician read the elements of my work',[10] echoing Plato who inscribed over the entrance to his Academy 'Let no one ignorant of geometry enter here'. But two things his early schooling did not do: it did not force the left-handed child to be right-handed and it did not discourage that natural curiosity innate in most children but particularly lively in Leonardo.

Apart from his uncommon 'common sense'—the brain, the recipient sense common to all the physical senses, his faculties, certainly those of sight and hearing, were exceptionally acute. Although he wore spectacles in his advancing years, his eyesight must have been remarkable. It is there in the precision of his descriptions. As has been suggested, his eyes had the capacity of a slow-motion camera (which means the faster than normal register of movement sequences). There is absolutely no other way to account for his descriptions of the details of flickering pinions in his bird studies. He had no microscope yet he was the first to describe the blood capillaries and fine details of the tissues and the nerves. We do not know whether he had a telescope, although he 'indented' himself for one, but he must have been long-sighted to see as much as he did of the face of the moon, even if he did make a false assumption about its waters. Even with his pin-holes for observing individual planets or stars and his pinpointing them on the base beneath his skylight his astronomical sorting-out of the firmament shows a visual acuity which may not be uniquely rare, but is not usually accompanied by such concentration and optical resolution.

His colour-register was similarly exceptional, not just in seeing the obvious colour differences in painting, but in the subtlety of hues which he expressed in his theory of colours. In this he had some help from his *camera obscura* which 'transmitted the images of objects and the colours of bodies illuminated by sunlight through a small round perforation and into a dark chamber on to a plane surface, which itself is quite white . . . but everything will be upside down.'[11] Lord Clark says: 'His notes on the perspective of colour and what he calls the perspective of disappearance, however, contain many of those acute observations in which he anticipated the doctrines of impressionism; but he was so far from carrying out

these delicate observations of colour and atmosphere in his painting that they were entirely without influence.'[A]

His hearing must also have been exceptional. This is not necessarily determined by the accounts (like those of 'Anonimo') of his performances on the lute or (according to Vasari) his 'divine singing'. But it emerges in his writing about music (which he called 'the sister of painting, for she is dependent upon hearing a sense second to sight'[12]), in his studies of sound-waves and the harmony of falling waters and indeed in his anatomical studies of the vocal organ and the ear. His sensitivity suggests a range and a precision which was not really available scientifically until we had the microphone and high-fidelity recordings, and the cathode ray oscillograph to make sound visible.

Leonardo was the observer with the naked eye and the naked ear. He also had, and never lost, his childlike curiosity which, however much we may specialize in the more-and-more-about-less-and-less, is the essential nature of science. His was not the structured life of the child who having revealed an aptitude for what is scholastically called 'science' at some immature age is told that he should be a physicist, a chemist or a biologist, and from then on is academically escorted through the science stream, the science faculty, and the post-graduate course into the learned societies. He learned where he went and where the interests took him.

His science began as a painter. He was lucky to be apprenticed to Verrocchio at a time when perspective had become a preoccupation with artists. This at its simplest was the geometry of drawing ('The art of perspective is of such a nature as to make what is flat appear in relief and what is in relief flat.'[13]), and even as a boy around Verrocchio's workshop Leonardo acquired the elements of that. But among the master's cronies the subject of perspective was not just a matter of working practice; it was a matter of winebibbing debate, as well as quasi-mystical dissertations on spatiality. In a way it was putting them, the artists, on speaking terms with the intellectuals around the Medici Garden.

Paolo Uccello was still alive and still as enthusiastic as he had been when he had done his fresco of *The Annunciation* in Santa Maria Maggiore. This, according to Vasari, had been a difficult thing 'because it was the first work which showed to artists . . . how lines may be made to diminish towards the vanishing-point with grace and proportion, and demonstrated how a small and insignificant space on a plain surface may be made to appear large and remote, and those who are able to add the lights and shadows to this . . . cause a veritable illusion to the eye, so that a painting is made to appear real and in relief.'[B]

Probably the most powerful formative influence on Leonardo was Toscanelli, physician, astronomer and natural philosopher. The tracker of the comet, the cartographer and mentor of Columbus kept open house for the likes of Leonardo, whom he encouraged in the systematic study of mathematics, and introduced to astronomy.

With the mathematical insight which he acquired, Leonardo's interest was converted from the linear perspectives of painting to what in its fullest sense we call 'optics'. That led him on to the study of the physics of light rays, which in turn took him to the anatomy of the eye. It was a progression—the mathematical justification of a feature of his craft, the application of the tool thus acquired to the phenomena which made the scene which the painter saw, and then to the mechanism by which the light and the picture it made impinged on the consciousness of the observer. One thing he proved to his own satisfaction: that beauty was not in the eye of the beholder; that it, and ugliness, were illumined by the sun (or the reflected sunlight from the moon), and the image was mirrored, not originated, by the eye. Thus the conscious vision was that image transferred by the optic nerve to the 'common-sense'. It is difficult to believe that at the end of the fifteenth century people could still think that the scene was illumined by the eye, as a modern flash photograph is lit by the flash.

We can look back again to the childhood in which his natural curiosity was engendered and, forgetting Freud's 'vulture', remember the opportunities a country boy had of observing birds, animals and plants. We can fairly assume that it was his conscientiousness as a painter which made him take up an intensive study of living creatures and things. He was not satisfied that a painting should be a montage of stylized items which were assumed to be birds, animals or plants. But when he came to look hard at them with special curiosity (as in the perfect reproduction of an ermine in the portrait of Cecilia Gallerani) he became intensely interested in them for their own sakes and not as details for a picture.

His sketches of plants, as thorough as those of any professional botanist, were artist's drawings until, in meticulously reproducing the details, he began to ask *why?* He never doubted that every form created by nature had a rational purpose. With a mechanic's eye, he was intrigued by the engineering efficiency of trunks and boughs and leaves which ensure that the tree or the plant captures as much sunlight as possible. He found that different species of plants had their leaves differently arranged. He looked closer and found that there were four modes of leaves growing one above the other. They could be arranged spirally with the sixth leaf always emerging over the sixth below, or with the two third ones above the two third ones below, or with the third above over the third below, or, as in the case of the fir tree 'arranged in tiers'—and all devised so that none should be robbed of sunlight. Sir Thomas Browne rediscovered the laws of phyllotaxis in 1698. Leonardo recognized that the number of rings which trees show in section gives their age. He attempted to explain the rising of sap—although as a hydraulic engineer he maintained that moisture must go downwards—and in ignorance of osmotic pressure ascribed it to capillary attraction over 200 years before Stephen Hales explained capillarity.

Verrocchio, in struggling free from the fretwork figures and stylized animals of

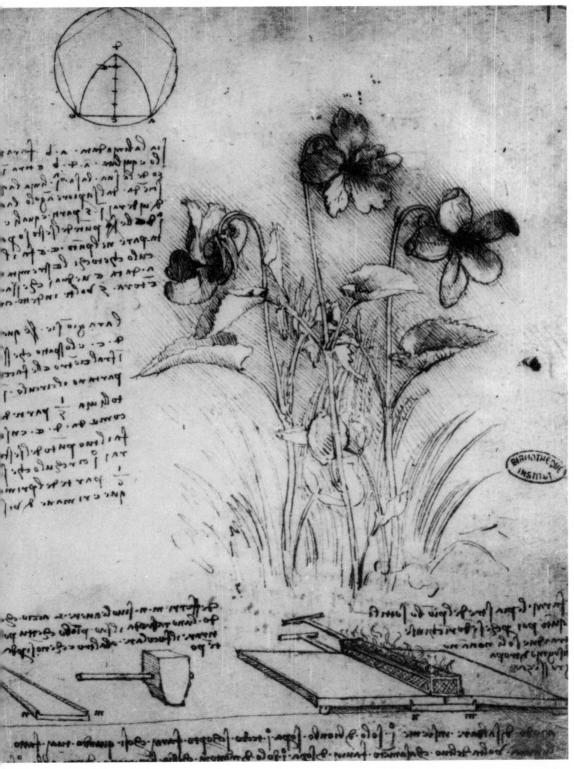

*Leonardo's drawing of violas, made in connection with the* Virgin of the Rocks *painting, is surrounded by notes on geometry and, below, on a method of soldering lead roofs.*

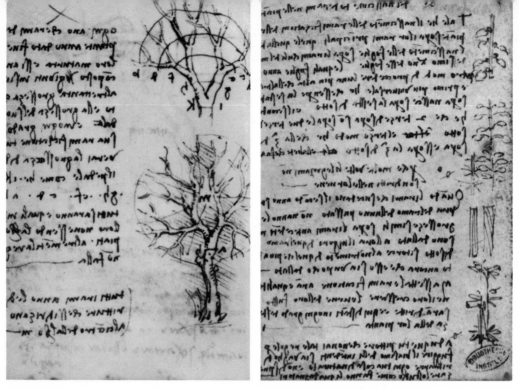

LEFT '*When the boughs of a plant have made an end of maturing their growth, they will have, . . . when put together, a thickness equal to the main stem.*' RIGHT *The four modes of leaf growth, with a note to the painter not to scorn the study of nature.*

the conventional art of the Middle Ages, had impressed upon his pupil the need for study literally in depth. He himself had not been content with the muscles rippling under the skin; he had flayed cadavers to see the structure of the muscles themselves; but his inquisitive pupil went much further. Leonardo delved into the inner recesses of the body, led on by the fascination of the workings, from tendon to muscle, muscle to nerve, nerve to senses; blood-vessel to heart, heart to blood-vessel and his near approximation to the circulation; senses back to organ and the structure of the eye, the ear and the throat; from sex to reproduction and the embryo in the womb; and from bone-structure to the architecture and mechanics of the skeleton.

What is interesting is how in everything he examined he found extension by analogy. His interest in perspective gave him a mathematical explanation of the function of the biological eye. His experiments with musical instruments and his wave theory of sound explained the role of the lungs as the bellows and the honk of the dead goose's vocal cords. His interest in machinery simplified his understanding of the muscles and the skeletal joints. One could find a contemporary though more sophisticated analogy in the science of cybernetics. The term derives from the Greek for steersman and implies the helm reacting to the forces on the rudder and the rudder responding to the correction of the helm. Once the idea of 'feedback' had been grasped it applied over a whole range of disciplines—physiology, neurology, psychology, sociology, and computerized automation. In the

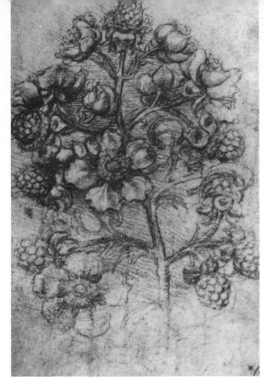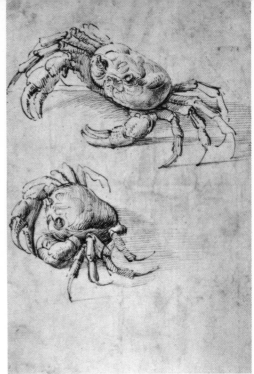

LEFT *A spray of brambles, drawn about 1506, in connection with Leonardo's painting* Leda and the Swan, *now lost.* RIGHT *A study of crabs, 1481–2, attributed to Leonardo. The shading is cross-hatched; Leonardo usually shaded from top left to bottom right.*

same way Leonardo, when seized of an idea, could see its relevance in widely different circumstances. The neat example was the canal lockgate; his work on the mathematical stresses of the architectural arch and his recognition of the strength of the obtuse angle gave him the idea of turning the arch on its side to make half-gates coming together and being sealed by the pressure of the water they were containing.

One cannot say that the rock structures of the *Virgin of the Rocks* or of *St Jerome* could be reliably used as illustrations for the teaching of geology. His systematic geology, which involved him in palaeontology and his contradictions of the Book of Genesis, owes less to his training as an artist (except in increasing his powers of observation) than to his experience as a hydraulic engineer and surveyor. His earth-science belongs principally to the period from 1504 to 1506 when he was over fifty years of age, and the Leicester Codex contains most of the notes on geology. Geological references occur among descriptions of the movement of water in rivers and his comments on hydrostatics and hydrodynamics. He nevertheless invoked his practical experience as an architect, builder and sculptor as the supporting evidence: 'In the mountains of Parma and Piacenza multitudes of shells and corals filled with worm-holes may be seen still adhering to the rocks, and when I was making the great horse at Milan a large sack of those which had been found in these parts was brought to my workshop by some peasants....'[14]

His thoughts on the Earth's past are mixed up with his water projects: Gonfolina,

Prato, Pistoia, and his ambitious schemes for cutting canals, which apart from their transport and irrigation values would have averted the recurring floods which have brought disasters to Florence. He was engrossed by the eroded ravine at Gonfolina. He assumed that the Arno had been dammed here by a great rock. His imagination

*Study of Star of Bethlehem amid swirling grasses, with leaves of crowsfoot and wood anemone, and flowers of spurge. Drawn in connection with Leonardo's* Leda, *c. 1504–8.*

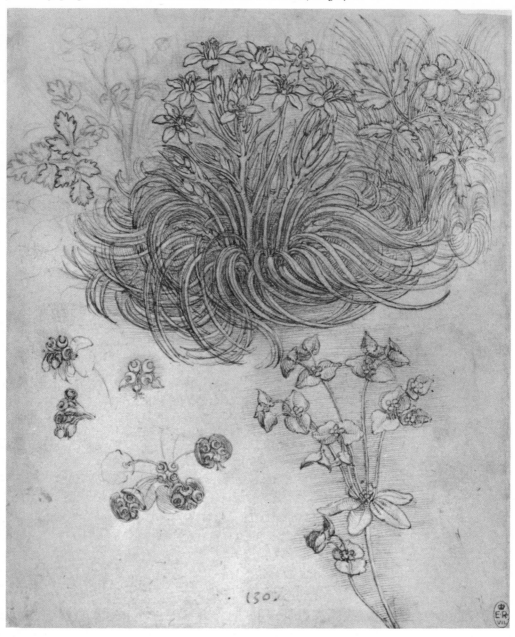

266

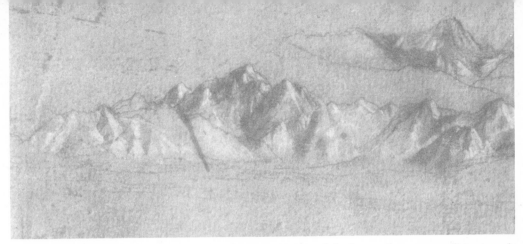

*Snow-covered mountains. Probably a drawing of the Alps, made by Leonardo on an expedition into the mountains in 1511.*

reconstructed the great freshwater lakes which had existed in the geological past and distinguished these from the oceanic waters which had submerged other parts:

> Where the valleys have never been covered by the salt waters of the sea there the shells are never found; as is plainly visible in the great valley of the Arno above Gonfolina, a rock which was once united with Monte Albano in the form of a very high bank. This kept the river dammed up in such a way that before it could empty itself into the sea which was afterwards at the foot of this rock it formed two large lakes, the first of which is where we now see the city of Florence flourish together with Prato and Pistoia; and Monte Albano followed the rest of the bank down to where now stands Serravalle. In the upper part of the Val d'Arno as far as Arezzo a second lake was formed and this emptied its waters into the above-mentioned lake . . . it filled all the valley above for a distance of forty miles. . . . This lake was joined to that of Perugia.[15]

He may have got the idea from the *Chronicle* of Giovanni Villani (1275–1348) but his conviction about the freshwater lakes was derived not only from the absence of sea-shells but from the alluvial nature of the soil of the valley, and his hydraulic work had already satisfied him that such soil was the silt of rivers, scoured, as in his account of The Deluge, from the mountains.

In some ways more remarkable than his deductions are his topographical maps of this and other areas which he surveyed. Many of them are superb landscapes in which artistry is combined with functional detail and data for the military engineer or the canal builder. Some of the most exquisite are those 'drawn with short delicate strokes of the pen in a pale ink impossible to reproduce'.[c] His method of procedure in drawing maps was first to chart the river systems, and this had to be done by foot-slogging surveys; then to locate the towns, and finally around the watersheds to draw in the mountains, and by shading or colour to show up contours and heights. Some of them are uncannily like an aerial photograph. They must have been done from heights but even the peaks in the neighbourhood could not have given him the depth adequate for the bird's-eye view he presents. Two qualities help to account for the up-there-looking-down effect. First was the

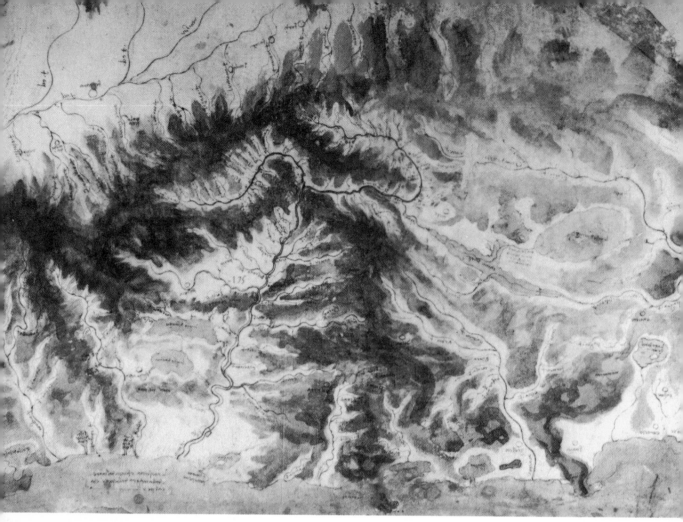

*Uncannily like an aerial photograph, Leonardo's map of Northern Italy, drawn about 1503, refers to his plans for constructing a canal connecting Florence with the sea. It shows the Tuscan region of the Apennines, with the Arno–Tiber watershed.*

conceptual ability to transfer himself—as in astronomy when he could think of looking at the Earth from the moon. Secondly (although this is only known by reference) he was a model-maker with the three-dimensional skills of the sculptor. He either made, or thought in terms of, plastic relief maps, like the sandtables of staff college military exercises.

Today we have created a hierarchy of the sciences: the 'pure' scientists; the applied scientists; the technologists; and the technicians. Those who pursue academic science, pure knowledge for its own sake, are rated above those who in basic, or orientated research, are trying to discover principles for the industrial researchers to apply or to hand over to the technologists for them to transfer to the factory-floor so that the process workers can produce the goods. Leonardo combined the aims of all these scientists in one person.

He pursued knowledge as he saw it revealed by direct observation. His research

on forces or dynamics, on hydrostatics, on optics and so on was 'orientated' in the sense that he was trying to explain, or assist, work on which he was engaged. He was an applied scientist bringing revealed knowledge to experimental proof. He was certainly a technologist and he was the technician too, grinding his own lenses, making his own mirrors or preparing his own artists' materials.

Leonardo is distinguished from his contemporaries and his predecessors like Brunelleschi and Ghiberti by his persistence in applying general laws to practical efforts. When he said 'Science is the captain, practice the soldiers'[16] he meant that no technician and no artist should be continually improvizing and learning by mistakes when he could work within nature's laws as revealed by measurement and experiment. He certainly did not mean that Plato's arrogant 'contemplative intellect' was superior to sensory observation or to experimental proof. He made the relationship of theory to practice very clear in one of his injunctions to himself: 'When you put together the science of the movements of water remember to put beneath each proposition its applications, so that such science may not be without its uses.'[17]

Leonardo had a complete grasp of cause and effect. To discover the 'cause' meant to discover the 'reason', that is the laws governing the phenomenon: '. . . although nature begins with the cause and ends with the experience, we must follow the opposite course, namely, begin with the experience, and by means of it

*The château of François I at Amboise, where Leonardo organized courtly festivities and displays from 1516. A footpath leads to Cloux, Leonardo's home, 500 metres away.*

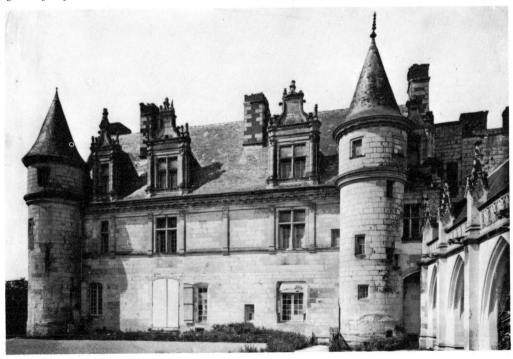

269

investigate the cause.'[18] He said that when the causes and the reasons were known, experiment was superfluous except as a graphic illustration, convincing others of the verification of a known 'rule' by a specific example. He said that nature does not break its own law, which is a fifteenth-century version of Einstein's remark: 'God is subtle but He is not malicious'. Nature is reticent about revealing its complex secrets but never perjures itself.

In his lifetime Leonardo had become a legend, and Popes and Princes competed for his company. In the end it was François I, King of France, who acquired him. Leonardo's protector, Giuliano de' Medici, brother of Pope Leo X, had died. Leonardo had written that bitter comment: 'The medici made me and ruined me'.

*Leonardo. Self-portrait* c. *1512, when Leonardo was sixty years old.*

At the age of 64 Leonardo left Italy to be received at the French Court at Amboise as 'The Divine Leonardo'. He looked the part. He had long hair, bushy eyebrows, deep set, hypnotic eyes and a beard so long that 'he appeared one of learning's true nobility'.[D] He was installed at Cloux on the banks of the Loire, in a house near the royal palace. There he kept a court of his own, receiving distinguished visitors, as well as being King François' prize exhibit. Flighty courtiers were brought to behold Leonardo, for as the King later told Cellini, he believed 'no other man had been born who knew as much....'[E] He insisted on Leonardo accompanying him on his royal cavalcades visiting royal lodges and lordly châteaux. He made Leonardo the arbiter of courtly fashion—the Dior of the sixteenth century.

*King François I of France. Painting attributed to Clouet.*

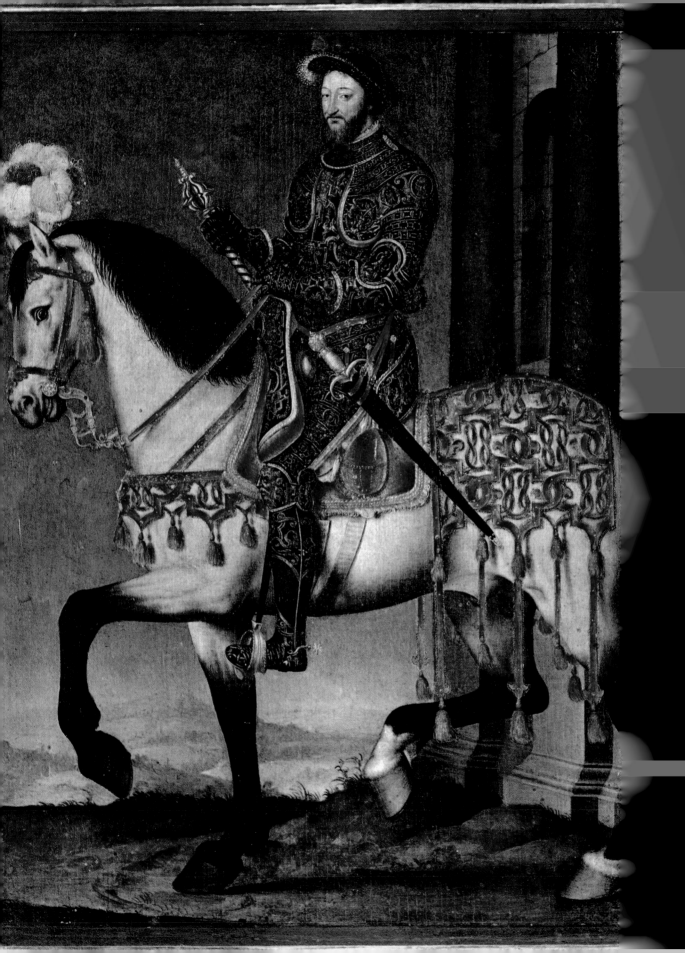

In return he humoured Leonardo by encouraging his projects, like the grand plan for connecting the Loire and the Sâone to 'make the country fertile, so that it would supply food for the inhabitants and . . . serve as a navigable canal for purposes of commerce'.[19] He promised to publish a large atlas of anatomy based on Leonardo's dissections. Neither materialized.

Leonardo was getting weary—he, who had written 'Death sooner than weariness'.[20] On 23 April 1519 'considering the certainty of death and the uncertainty of its time' Leonardo sent for the notary to make his will. His chief beneficiary was his pupil, Francesco Melzi, who, when Salai and his other favourites had left him, had remained by him. To Melzi 'nobleman of Milan, in remuneration for services and favours done to him in the past' he left 'each and all of the books the Testator is at present possessed of, and the instruments and portraits appertaining to his art and calling as a painter.'[21] On 2 May he died.

What happened to his works (see Appendix) adds poignancy to Leonardo's unfinished injunction to his heirs: 'In order that this advantage which I am giving to men shall not be lost, I am setting out the way of proper printing and I beg you, my successors, not to allow avarice to induce you to leave the printing un . . . . . .'[22]

'Publish or perish', that ruthless injunction to modern scientists, was almost true in Leonardo's case. The mishandling of his notebooks and their disappearance into limbo meant that while we have restored him to pride of place in the history-books of science and technology he had little or no influence on intervening historic events. He had little or no effect, except through his visible paintings and a few machines, on the course of human progress. Others had to discover afresh what he had thoroughly investigated. We, his remote posterity, can now give him credit for his originality but, by tragic default, he originated little of direct application.

The resurrection of Leonardo, or what he represented, is however of profound importance to our times. The end of the fifteenth century and the end of the twentieth century have a great deal in common. Both are periods of frenetic change. The change today is of a different order of magnitude—far more happening, far more quickly, far more to learn and less time to learn it—but the problem is the same: how to encompass what is happening?

Leonardo, in his day and age, did it. He could evaluate and distrust the New Learning which, however much we glorify the Renaissance, was merely the Old Learning, with less obscurantism than the scholiasts, still inward looking while Leonardo and his like were outward looking. They believed, in art and in science, what the eye saw and not what the pedants told them they ought to see. Today, the parallel is with the unshackled minds of young people, taking for granted the forces of material change, and rejecting political and economic philosophies which are no longer consistent with those forces.

Leonardo could encompass, as well as create, the knowledge of his times. He was exceptional in his perceptions and his breadth of awareness. No single man

*The sombre château of Cloux at Amboise was Leonardo's last home. He died here in 1519.*

273

today could embrace all the knowledge of all the disciplines which he embodied. Science has ceased to be natural philosophy and has become an aggregation of experimental achievements, spectacular and world shaking. Research is in danger of becoming a substitute for thinking, whereas, for Leonardo, it was finding answers to things which fitted together in the grand plan of nature and the scheme of human existence. He relied upon his senses, but always insisted that the senses were the servants of 'the common-sense', the brain.

Today, there is an extension of the senses. The microphone for specified purposes is more sensitive than the human ear; the television camera, refining the sense of sight in colour-wavelengths, is more precise and more tireless than the human eye; there are machine-methods many times more sensitive than the human touch. These senses can, telemetrically, reach out to the edge of the Universe and hear and see and measure cosmic events which happened billions of years ago. The computer has acquired the logical faculties of the human brain. It has a memory so prodigious that we are led to believe that a know-all computer may be able to store and retrieve all the knowledge of all the libraries of all the world in a casket no bigger than the human cranium. But the computer has no imagination. It cannot make value judgments—unless, as we are in danger of doing, we accept facts as Yes–No judgments. It cannot, as Leonardo did, yearn over the conditions of the human race. Nor can it distinguish beauty from ugliness nor give to painting the subtlety of the *Mona Lisa*. It cannot say 'I shall not disclose my submarine by reason of the evil nature of men who would use them as a means of destruction at the bottom of the sea.' The computer cannot do our reasoning for us nor accept responsibility for judgments on the uses of science. Nor can the learned societies, each dedicated to its own discipline or the promotion of experimental science. But a body of thinkers, an *Academia Leonardi Vici*, would help us to do in our time what Leonardo did in his—to see science in its third dimension of meaning and purpose.

Academia Leonardo Vici. *An engraving from Leonardo's emblem design.*

# *Appendix*

Whilst Francesco Melzi, inheritor of all Leonardo's drawings, notes, models and maquettes, treasured them and kept them with miserly care for more than fifty years up to his death in 1570, history could ascribe to him, more than to the agents, pilferers and dealers of later years, the role of principal villain, the unfaithful steward. Leonardo's genius was to be locked away by others—guardians of royal treasures, librarians of the Spanish state, but Leonardo's earnest request—that his life work should not be hidden from the world, was stifled from the moment of the bequest by Melzi himself. Francesco Melzi undertook extensive cataloguing, and perhaps had some vague intention of eventual publication, but throughout the sixteenth century, when they would have been of the greatest benefit to mankind, the manuscripts were lost to view and forgotten.

In the next century, they became collectors' items, the object of urgent bargaining and some suspect deals, and indeed, they had to wait until the end of the eighteenth century before they drew the attention of men of science rather than collectors.

On Francesco Melzi's death his son Orazio, collegiate doctor, dumped the books in the attic of the family Villa Vaprio, in Milan, where the curiosity of a tutor, Lelio Gavardi, recovered them. Gavardi took away thirteen volumes with the intention of selling them as mementoes of the renowned Leonardo to Duke Francesco in Florence. Gavardi was abused as a self-seeking pilferer by his contemporary, Giovanni Mazzenta, but at least he recognized the value of Leonardo's work, whilst he still lived in the memory of Florentines and others. Gavardi, the thief, lost his nerve, and handed the books over to Mazzenta asking him to return them to Orazio Melzi. This Melzi, who regarded Leonardo's notes as inconsiderable trifles, gave them back to Mazzenta and the traffic began. Soon the collectors and curio hunters of Milan were trying to get the remaining note-

*Francesco Melzi by Boltraffio. Leonardo made friends with Melzi in Milan in 1512, and took him to Rome in 1513. When Leonardo died in Amboise in 1519, Melzi went back to Milan taking his inheritance.*

books from Melzi. Thus Melzi's priceless collection was dispersed. At best it can be said that it was rescued from the oblivion of a dusty attic.

The most determined collector was Pompeo Leoni, sculptor to the Spanish court, who acquired a large collection which he catalogued, rebound and reorganized with misplaced enthusiasm. At the same time he destroyed the chronology and the sequence and he mutilated sheets.

It is difficult to follow the exact history of Leonardo's work from 1600 when much was in the hands of Leoni. Individual items have turned up even in the present century. Many notebooks and manuscripts have probably been irretrievably lost, but perhaps there are still some waiting rediscovery. The wanderings of the Leonardo treasures have not been fully charted. The great bulk of Leonardo da Vinci's written work is now housed in five European libraries and even their vagrant history is tantalizingly obscure.

Although Leoni attempted to sell his collection, there was at his death a considerable store of work which came to his heir, Polidoro Calchi. Calchi sold one huge book to Count Galleazzo Arconati for 300 scudi. Arconati had acquired ten smaller manuscripts from Leoni himself, and in 1637 he donated the lot to the Ambrosiana Library in Milan. Frederico Borromeo, founder of this library, had

come by one manuscript himself, and by the time another was donated by Count Orazio Archinti in 1674, the library's total collection ran to fourteen manuscripts.

On the instructions of Napoleon in 1796, *'le carton des ouvrages de Leonardo d'Avinci'* was carried off to Paris and in the beginning of the nineteenth century the knowledge from these manuscripts began to filter through to the world of science through the agency of an Italian professor of science, Venturi. In 1815, after the Congress of Vienna, the biggest volume was returned to Milan, where, enshrined in a crystal casket like the ashes of a great man, it remains to this day: the *Codex Atlanticus*. It contains 1222 pages of Leonardo's writings and drawings. Twelve manuscripts stayed in Paris and they are now in the Institut de France.

It was long believed that the English king Charles I obtained Leonardo manuscripts from Arconati in Italy through the offices of the Duke of Arundel, or from Spain. The King certainly did own a collection which he is said to have placed with his own hands in a 'large and strong chest' about the year 1640. When this was opened in the 1760s by Robert Dalton, Leonardo's anatomical work was rediscovered, used in anatomy teaching and critically assessed by 1790. The manuscript, with Leoni's name on the fly leaf, contained inscriptions in Spanish. It includes some 600 of Leonardo's drawings and is now housed in the Royal Library at Windsor. King Charles's agent the Duke of Arundel obtained a large Leonardo manuscript for himself. The Duke died an exile and his grandson Henry Howard, had 'so little inclination to books' (John Evelyn *Diary*, 9 January 1666) that he was persuaded to give the Leonardo manuscript to the newly-created Royal Society. It now belongs to the British Museum, the *Codex Arundel, 263*.

The collector and collator, Pompeo Leoni, had died in Spain in 1608, and such possessions as he had in Spain were auctioned there in that year. Two Leonardo manuscripts from Leoni's collection passed into the hands of Don Juan de Espina. Charles I of England, when visiting Spain as Prince of Wales, had tried to buy these in 1623, and regularly urged his ambassadors to persuade de Espina to sell. In 1637 we find Arundel himself writing on the King's behalf to Lord Aston, then ambassador in Spain, 'be mindful of D. Jhon de Spina's book, if his foolish humour change'. (Saintsbury, *Life of Rubens*, 1859.) De Espina stuck it out, for he wanted to give his manuscripts to the King of Spain. When he died in 1642 he left his collection to Philip IV. In the seventeenth and eighteenth centuries the records of the Royal Library in Madrid mentioned two volumes of Leonardo's manuscripts, presumably those of de Espina. They were mislaid—wrongly catalogued—for two centuries and were accidentally rediscovered by Dr Jules Piccus in 1967. They are now described as *Codex Madrid I* and *Codex Madrid II*.

Thus the pilferers, hoarders and conservators have combined between them to obscure and disperse Leonardo's work from the time of his death to the present day. Many manuscripts referred to in Leonardo's known works are missing. Perhaps he never wrote them. He was just promising himself that he would.

# Bibliography

The written material on Leonardo da Vinci is enormous, and any short bibliography is bound to be very selective. The following books may be found useful for further reading.

L. B. Alberti. *Ten books on architecture.* Leoni translation. London 1955.

M. Aston. *The Fifteenth Century.* London 1968.

Elmer Belt. *Manuscripts of Leonardo da Vinci.* Los Angeles, California 1948.

L. Beltrami. *Documenti e memorie riguardanti la vita e le opere di Leonardo da Vinci.* Milan 1919.

Lord Clark and Carlo Pedretti. *The drawings of Leonardo da Vinci in the collection of Her Majesty The Queen at Windsor Castle.* 2nd edition. 3 vols. London 1969.

Lord Clark. *Leonardo da Vinci.* London 1939.

S. Freud. *Leonardo da Vinci a study in psychosexuality.* Translated by A. A. Brill. New York 1916.

R. Friedenthal. *Leonardo.* Translated by Margaret Shenfield. London 1959.

C. H. Gibbs-Smith. *Leonardo da Vinci's Aeronautics.* Science Museum, London 1967.

B. Gille. *Les ingénieurs de la Renaissance.* Paris 1964.

F. H. Garrison. *An introduction to the History of Medicine.* 4th ed. Philadelphia and London 1929.

L. Goldsheider. *Leonardo da Vinci.* London 1919.

I. B. Hart. *The world of Leonardo da Vinci.* London 1961.

L. H. Heydenreich. *Leonardo da Vinci.* London and New York 1954.

Istituto Geografico De Agostini. *Leonardo da Vinci.* 2 vols. Essays by numerous authors. Novara 1964.

J. Lucas-Dubreton. *La Vie Quotidienne à Florence au temps des Medicis.* Paris 1959.

E. MacCurdy. *The notebooks of Leonardo da Vinci.* New edition. 2 vols. London 1956.

M. McCarthy. *The Stones of Florence.* London and New York 1959.

G. Martinelli. *Tutto su Firenze Rinascimentale.* Florence 1964.

I. Noble. *Leonardo da Vinci.* New York 1965.

C. D. O'Malley and J. B. de C. M. Saunders. *Leonardo da Vinci on the Human Body.* New York 1952.

H. T. Pledge. *Science since 1500.* London 1939.

A. E. Popham. *The drawings of Leonardo da Vinci.* London 1946.

L. Reti. 'Two unpublished manuscripts of Leonardo da Vinci in the Biblioteca Nacional of Madrid': two articles in the *Burlington Magazine.* London, 1968.

J. P. Richter. *The Literary Works of Leonardo da Vinci.* 2nd ed. 2 vols. London, New York, Toronto 1939.

I. A. Richter. *Selections from the notebooks of Leonardo da Vinci.* London 1952.

G. Sarton. *Six Wings.* London 1958.

C. J. Singer et al. *A History of Technology.* 3 vols. Oxford 1957.

E. Solmi. *Leonardo.* 2nd ed. Florence 1907.

A. Vallentin. *Leonardo da Vinci.* Translated by E. W. Dickes. London 1939.

G. Vasari. *Lives of the Artists.* Edited by B. Burroughs. London 1960.

V. P. Zubov. *Leonardo da Vinci.* Translated by D. H. Kraus. Cambridge, Mass. 1968.

# References

Superior numbers in the text indicate references to the original works of Leonardo da Vinci.
Superior letters in the text are used where the quotations are from other sources.

The quotations from Leonardo's manuscripts which appear in this book are from the translations by J. P. Richter *The Literary Works of Leonardo da Vinci*, London 1939, 2 volumes; I. A. Richter *Selections from the Notebooks of Leonardo da Vinci*, London 1966; and E. MacCurdy *The Notebooks of Leonardo da Vinci*, London 1956, 2 volumes.

The collection of Leonardo's work in the Royal Library at Windsor has been classified in two different ways. Where the quotations have been taken from the volumes edited by J. P. Richter and I. A. Richter, the references have been given thus: W19118b. Where the quotations have been taken from MacCurdy, the references to the two manuscripts *Dell 'Anatomia* Fogli A and B have been given as Fogli A and B, and references to the six parts of the *Quaderni d' Anatomia*, as QI–VI.

Other abbreviations used in listing references to Leonardo's manuscripts and drawings are as follows:

| | | | |
|---|---|---|---|
| A, B, C, D, E, F, G, H, I, K, L, M | Manuscripts A–I, K–M in the Institut de France, Paris | Leic | Codex in the collection of the Earl of Leicester, Holkham Hall, Norfolk |
| BM | Codex Arundel 263, in the British Museum, London | R | J. P. Richter *The Literary Works of Leonardo da Vinci*, London 1939 |
| BN 2037 and BN 2038 | Two manuscripts formerly in the Bibliothèque Nationale, Paris, and now in the Institut de France | Trat | Manuscript *Trattato della Pittura*, in the Vatican Library |
| CA | Codex Atlanticus, in the Ambrosiana Library Milan | Triv | Codex Trivulzio, Castello Sforzesco, Milan |
| CM I and CM II | Codex Madrid I and II, in the Biblioteca Nacional, Madrid | Trn | Manuscript *Sul Volo degli Uccelli*, in the Royal Library, Turin |

CHAPTER ONE

A  G. Uzielli and G. Celoria *La vita e i tempi di Paolo dal Pozzo Toscanelli* 1894 p. 325
B  J. Lucas-Dubreton *Daily Life in Florence in the time of the Medici* 1960 p. 57
C  St Augustine *De vera religione* 1932

CHAPTER TWO

1  CA 66v-b
2  E 51r
3  Fogli A 80
4  CA 358v-a

A  I. A. Richter *Selections from the notebooks of Leonardo da Vinci* 1966 p. 285
B  Lord Clark *Leonardo da Vinci* 1939 p. 4
C  D. C. Peattie *Lives of Destiny* 1954 p. 99
D  Lord Clark *Leonardo da Vinci* 1939 p. 153
E  I. Noble *Leonardo da Vinci* 1965 p. 9
F  A. Vallentin *Leonardo da Vinci* 1939 p. 19
G  E. MacCurdy *The Notebooks of Leonardo da Vinci* 1956 Vol. 1 p. 27
H  Giorgio Vasari *Lives of the Artists* edited by Betty Burroughs 1960 pp. 189–90
I  Giorgio Vasari *Lives of the Artists* edited by Betty Burroughs 1960 p. 187
J  Lord Clark *Leonardo da Vinci* 1939 p. 55
K  Giorgio Vasari *Lives of the Artists* edited by Betty Burroughs 1960 p. 196
L  Giorgio Vasari *Lives of the Artists* edited by Betty Burroughs 1960 p. 187

CHAPTER THREE

1  A 27a
2  CA 119v
3  G 8r
4  CA 120r-d
5  CA 120r-d
6  W 19118b
7  CA 190r-a
8  CA 244r-a
9  D 1r
10  BN 2038 1a
11  BN 2038 1a
12  CA 204a
13  A 3a
14  CA 135b
15  H 49[I] r
16  CA 141b
17  F 75r
18  W 19152a
19  Trat 93
20  C 345v
21  D 7v
22  D 2v
23  F 39v
24  G 44a
25  W 19030b
26  Trat 24
27  Trat 28

A  Giorgio Vasari *Lives of the Artists* edited by Betty Burroughs 1960 p. 53
B  A. Vallentin *Leonardo da Vinci* 1939 p. 33
C  M. McCarthy *The Stones of Florence* 1959 p. 47

CHAPTER FOUR

1  Triv 17b
2  Collection of the Musée Bonnat, Bayonne
3  CA 76v
4  CA 34v-a
5  Uffizi 115, 446r
6  CA 159a
7  A 61a
8  C 16a
9  CA 391r-a

A  Giorgio Vasari *Lives of the Artists* edited by Betty Burroughs 1960 p. 148
B  N. Machiavelli *The History of Florence* 1872 p. 373
C  V. P. Zubov *Leonardo da Vinci* translated by D. H. Kraus 1968 p. 4
D  V. P. Zubov *Leonardo da Vinci* translated by D. H. Kraus 1968 p. 5
E  Giorgio Vasari *Lives of the Artists* edited by Betty Burroughs 1960 p. 187
F  J. P. Richter *The Literary Works of Leonardo da Vinci* 2nd edition 1939 Vol. I p. 3

CHAPTER FIVE

1  CA 315b
2  Triv 19a
3  B 10r
4  B 59r
5  B 10r
6  B 18r
7  Leic 22b
8  B 11r
9  CA 14r-a
10  CA 315b
11  CA 335b
12  CA 318v-a
13  CA 393v-a
14  CA 335b

A  *The Times* 1 February 1968
B  L. Thorndike *A History of
   Magic and Experimental
   Science* 1923 Vol. 2
   p. 654–5
C  Lord Clark *Leonardo da Vinci*
   1939 p. 51
D  *A History of Technology*
   edited by C. J. Singer,
   E. J. Holmyard and others
   1957 Vol. III p. 167

CHAPTER SIX

1  CM I 0
2  CA 32r-a
3  Leic 15v
4  F 13r
5  A 50a
6  CA 46r-b
7  CA 108v-a
8  CM I 26r
9  I 57v
10  W 19070b
11  CM I 0
12  CA 82v-b
13  CM I 6r

A  *A History of Technology*
   edited by C. J. Singer,
   E. J. Holmyard and others
   1957 Vol. III p. 448
B  Giorgio Vasari *Lives of the
   Artists* edited by William
   Gaunt 1963 Vol. 2 p. 157
C  Ladislao Reti 'The Two
   Unpublished Manuscripts
   of Leonardo da Vinci in the
   Biblioteca Nacional of
   Madrid' Part I in the
   *Burlington Magazine*
   January 1968 p. 14
D  *A History of Technology*
   edited by C. J. Singer,
   E. J. Holmyard and others
   1957 Vol. III p. 251
E  Ladislao Reti 'The Two
   Unpublished Manuscripts
   of Leonardo da Vinci in the
   Biblioteca Nacional of
   Madrid' Part I in the
   *Burlington Magazine*
   January 1968 p. 18
F  D. C. Peattie *Lives of Destiny*
   1954 p. 104

CHAPTER SEVEN

1  Fogli B 38v
2  CA 391r-a
3  BN 2038 31a
4  CM II 1
5  Fogli B 17r
6  Fogli B 38v
7  QI 2r

A  Giorgio Vasari *Lives of the
   Artists* edited by Betty
   Burroughs 1960 p. 144
B  F. H. Garrison *An
   Introduction to the History
   of Medicine* 4th edition
   1929 p. 215
C  I. A. Richter *Selections from
   the Notebooks of Leonardo
   da Vinci* 1966 p. 327
D  Lord Clark *Leonardo da Vinci*
   1939 p. 394

E  *The Natural History of Pliny*
   translated by J. Bostock
   and H. T. Riley 1898
   Vol. VI p. 244
F  Giorgio Vasari *Lives of the
   Artists* edited by Betty
   Burroughs 1960 p. 220
G  Giorgio Vasari *Lives of the
   Artists* edited by Betty
   Burroughs 1960 p. 194
H  W. Pater 'Notes on the
   Renaissance' in *The
   Fortnightly Review* 1869
   Vol. IV p. 506

CHAPTER EIGHT

1  W 19070b
2  W 19070b
3  QI 2r
4  Fogli B 10v
5  Fogli B 10v
6  Fogli B 10v
7  Fogli B 10v
8  Fogli B 20v
9  QI 1r
10  QIII 7r
11  QIII 8v
12  Fogli B 2r
13  Fogli B 2r
14  QV 7v
15  QI 4r
16  W 19045a
17  W 19016
18  Fogli A 9v

A  Lord Clark *Leonardo da Vinci*
   1939 p. 179
B  J. P. Richter *The Literary
   Works of Leonardo da Vinci*
   1939 Vol. 2 p. 84
C  F. H. Garrison *An
   Introduction to the History
   of Medicine* 4th edition
   1929 p. 215
D  Giorgio Vasari *Lives of the
   Artists* edited by William
   Gaunt 1963 Vol. 2 p. 157
E  Giorgio Vasari *Lives of the
   Artists* edited by Betty
   Burroughs 1960 pp. 192–3

CHAPTER NINE

1  Trat 23
2  Trat 31
3  CA 391r-a
4  CA 270r
5  BM 157a
6  BM 157b
7  BM 138a
8  BM 138r
9  A 50r
10  B 27a
11  A 53a
12  CA 158v-a
13  B 39a
14  CA 96v-a
15  BM 270b
16  CA 65b
17  B 16a

A  M. McCarthy *The Stones of
   Florence* 1959 p. 68
B  M. McCarthy *The Stones of
   Florence* 1959 p. 71
C  L. B. Alberti *Ten Books of
   Architecture* translated

into English by J. Leoni
   1955 p. 197
D  J. S. Ackerman 'Gothic
   theory of architecture at
   the Cathedral of Milan' in
   *The Art Bulletin* 1949
   Vol. 31 p. 84
E  A. Vallentin *Leonardo da
   Vinci* 1939 p. 563

CHAPTER TEN

1  Trn M2 O
2  Trn (Mz) 16a
3  F 41b
4  Trn 6[5] v
5  CA 214r-d
6  CA 214r-d
7  CA 220r-a
8  CA 68v-a
9  CA 77r-b
10  K 13a
11  CA 161r-b
12  CA 97v-a
13  CA 66r-b
14  CA 45r-a
15  Trn 17[16] r
16  Trn 6[5] r
17  Trn 16[15] v
18  Trn 7[6] v
19  Trn 8[7] r
20  B 88v
21  CA 361v-b
22  CA 361v-b
23  CA 161r-a
24  CA 381v-a
25  CA 381v-a
26  CA 276v-b
27  G 92r
28  I 58(10) r
29  B 83v
30  B 83v
31  B 83v
32  CA 395r-b

A  A. Vallentin *Leonardo da
   Vinci* 1939 p. 406
B  I. B. Hart *The World of
   Leonardo da Vinci* 1961
   p. 310
C  Lord Clark *Leonardo da Vinci*
   1939 p. 132
D  H. T. Pledge *Science since
   1500* 1939 p. 314
E  H. T. Pledge *Science since
   1500* 1939 p. 315
F  *A History of Technology*
   edited by C. J. Singer,
   E. J. Holmyard and others
   1958 Vol. V p. 398

CHAPTER ELEVEN

1  W 12669a
2  CA 119b
3  CA 117r-b
4  Trn 12[11] r
5  W 19115a
6  F 41b
7  A 64a
8  CA 303v-b
9  F 64v
10  Leic 30r
11  Trat 25
12  F 5v
13  CA 190r-a
14  BM 279v
15  BM 94r

16  F 41v
17  F 5r
18  F 5r
19  F 10r
20  Trat 25
21  Fogli B 31v
22  QI 13v
23  W 19048r
24  B 4v
25  CA 361v
26  W 12665
27  BN 2038 21r
28  W 12665
29  CA 155r
30  Leic 3r
31  Leic 36r
32  Leic 9v
33  Leic 10v
34  CA 84v-a
35  CA 260r-a
36  Leic 1v
37  Leic 31r
38  Leic 10v
39  BM 155r
40  Triv 34a
41  CA 370v-a
42  CA 137v
43  W 19084a
44  Trat 33

A  St Augustine *De vera
   religione* 1932
B  V. P. Zubov *Leonardo da
   Vinci* translated by D. H.
   Kraus 1968 p. 89
C  Giorgio Vasari *Lives of the
   Artists* edited by William
   Gaunt 1963 Vol. 2 p. 167

CHAPTER TWELVE

1  Trat 33
2  H 24a
3  H 24b
4  H 25a
5  BN 2038 29r
6  CA 71r-a
7  L 77v
8  CA 311r-a
9  QIII 10v
10  W 19118v
11  CA 181a
12  Trat 29
13  A 38b
14  Leic 9v
15  Leic 9r
16  I 130r
17  F 2v
18  E 55r
19  BM 270v
20  W 12700a
21  R 1566
22  Fogli A 9v

A  Lord Clark *Leonardo da
   Vinci* 1939 p. 76
B  Giorgio Vasari *Lives of the
   Artists* edited by William
   Gaunt 1963 Vol. 1 p. 233
C  Lord Clark *Leonardo da
   Vinci* 1939 p. 122
D  L. Beltrami *Documenti e
   memorie riguardanti la vita
   e le opere di Leonardo da
   Vinci* 1919 p. 182
E  I. A. Richter *Selections from
   the Notebooks of Leonardo
   da Vinci* 1966 p. 383

# List of illustrations in black and sanguine

62 Sections of a man's head, showing the anatomy of the eye. Windsor 12603. 20.2 × 14.8 cm. Royal Library, Windsor.

63 Leonardo's experiments with candles. Detail from MS C folio 22 recto. 33 × 22.5 cm. Institut de France, Paris.

65 (left) Leonardo's drawing of a model of the human eye. Detail from MS D folio 3 verso. 25 × 16 cm. Institut de France, Paris.
(above right) A modern diagram of the eye, showing the lens correctly placed. *Godman Studios.*
(lower right) Leonardo's schematic drawing of the eye, showing the misplaced spherical lens. Detail from *Codex Atlanticus* folio 337 recto a. 27 × 16 cm. Ambrosiana Library, Milan.

66 (left) Drawing of the head of a dog. Detail from MS I folio 96 recto. 10 × 7.2 cm. Institut de France, Paris.
(right) The *Marzocco*, by Donatello (1386–1466). National Museum, Florence. *Photo: Scala.*

68 Reflection of light rays in a parabolic mirror. Detail from *Codex Arundel 263* folio 87 verso. 19 × 12.5 cm. British Museum, London. *Photo: Freeman.*

69 A study of the proportions of the eye and eye-lid. Detail from Turin 15574. 18.7 × 15.5 cm. Royal Library, Turin.

70 Six figures, a study for the *Adoration of the Magi.* 27.8 × 20.8 cm. Musée du Louvre. *Photo: Mansell.*

72 Perspective study for the *Adoration of the Magi.* 16.5 × 29 cm. Uffizi Gallery, Florence.

74 (left) Pope Sixtus IV appointing Platina as his librarian, *c.* 1477, by Melozzo da Forlì (1438–94). Detail. Vatican Museum, Rome.
(right) Giuliano de' Medici, by Botticelli (*c.* 1445–1510). Samuel H. Kress Collection, Nat. Gall. of Art, Wash'ton.

76 (left) Leonardo's drawing of Bernardo di Bandino Baroncelli, hanged. 19.2 × 7.8 cm. Musée Bonnat Bayonne. *Photo: Service de Documentation Photographique des Musées Nationaux.*
(right) Niccolò Machiavelli, by Giovanni Battista Rosso (1495–1540). Casa di Machiavelli, Florence. *Photo: Scala.*

77 (above left) Models of a breech-loading cannon and steamlined shells. Science Museum, Milan.
(above right) Streamlined shells. Detail from *Codex Arundel 263* folio 54 recto. 19 × 12.5 cm. British Museum, London. *Photo: Freeman.*
(below) Study of a breech-loading cannon. Detail from MS B folio 24 verso. 23.5 × 17 cm. Inst. de France, Paris.

78 Cannon mounted on a wooden turntable, by Konrad Kyeser (1366–after 1405). MS 16.0.7. folio 180 recto. Tiroler Landesmuseum Ferdinandeum, Innsbruck.

79 Leonardo's drawings of machine guns. *Codex Atlanticus* folio 56 verso a. 26.5 × 18.3 cm. Ambrosiana Library, Milan.

80 (left) A movable covered scaling ladder. Detail from *Codex Atlanticus* folio 15 recto a. 28.2 × 19.5 cm. Ambrosiana Library, Milan.
(right) A device to overturn scaling ladders. Detail from *Codex Atlanticus* folio 49 verso b. 25.5 × 19.4 cm. Ambrosiana Library, Milan. *Photo: Freeman.*

87 A musical instrument made in the shape of an animal's skull. Detail from MS B Insert C. 18 × 15 cm. Institut de France, Paris.

88 (left) Unfinished portrait of a musician, possibly Franchino Gafori (1451–1522), by Leonardo. 43 × 31 cm. Ambrosiana Gallery, Milan.
(right) Woodcut made in 1480 of a musician playing an organ, from *Angelicum ac divinum opus musicae*, by Franchino Gafori, Milan 1508. *Photo: Tony Birks.*

89 Study of acoustics. Detail from MS B folio 90 verso. 23.5 × 17 cm. Institut de France, Paris.

90 (above) A mechanical drum. Detail from *Codex Atlanticus* folio 355 recto c. 15 × 14.4 cm. Ambr. Libr., Milan.
(centre) A trumpet and drums. Detail from *Codex Arundel 263* folio 175 recto. 19 × 12.5 cm. British Museum, London. *Photo: Freeman.*
(below right) Mechanical bell. *Codex Forster* II, folio 10 verso. 9.9 × 7.2 cm. Photo by Derrick Witty from the facsimile 'I Codici Forster I–III nel Victoria and Albert Museum', published by the Reale Commissione Vinciana, La Libreria dello Stato, Rome, 1936–44.

91 (above) Method of constructing a trestle bridge. Detail from *Codex Atlanticus* folio 16 verso a. 21.3 × 29.7 cm. Ambrosiana Library, Milan.
(below) A swing bridge. Detail from *Codex Atlanticus* folio 312 recto a. 24.2 × 18.8 cm. Ambr. Libr., Milan.

92 (left) The 'escorpio', an armoured ship. Drawing reversed. Detail from MS B folio (9) 8 recto. 23.5 × 17 cm. Institut de France, Paris.
(right) An armoured ship. Detail from MS B folio 90 verso. 23.5 × 17 cm. Institut de France, Paris.

93 Bombards firing shrapnel shells. *Codex Atlanticus* folio 9 verso a. 21.3 × 40.2 cm. Ambrosiana Library, Milan.

94 (above) Flint lock and spring mechanism for a gun. Detail from *Codex Atlanticus* folio 56 verso b. 17 × 27.8 cm. Ambrosiana Library, Milan.
(below) Flint lock for a gun. Detail from a sheet in *Codex Madrid I.* 22.3 × 15.5 cm. Biblioteca Nacional, Madrid. *Photo: Life Magazine.*

96 (top left) Explosive bombs. Detail from MS B folio 4 recto. 23.5 × 17 cm. Institut de France, Paris.
(bottom left) Finned projectile. Detail from Windsor 12651. 20.5 × 15.3 cm. Royal Library, Windsor.
(right) Cart armed with scythes. Detail from *De Re Militari*, by Roberto Valturio (b. 1413). MS Lat. 7238 folio 312. Bibliothèque Nationale, Paris.

97 Chariot armed with scythes. Detail from Turin 15583. 20 × 28 cm. Royal Library, Turin. *Photo: Freeman.*

99 (top left) A wind propelled 'tank', from *De Re Militari*, by Roberto Valturio (b. 1413). *Photo: Sci. Mus., London.*
(top right) Wind propelled chariot, by Guido da Vigevano, *c.* 1335. From MS Lat. 11015 folio 52 verso. Bibliothèque Nationale, Paris.
(below) Detail of an armoured car, by Leonardo. 17.3 × 24.6 cm. British Museum, London. *Photo: Freeman.*

100 Alexander the Great descending in a diving bell. Miniature from a fifteenth-century manuscript. Fr. 9342 folio 182. Bibliothèque Nationale, Paris.

101 (left) Underwater fight, with divers wearing two different breathing devices, by Konrad Kyeser (1366–after 1405). MS 16.0.7. folio 53 recto. Tiroler Landesmuseum Ferdinandeum, Innsbruck.
(right) Webbed fins for swimming, and a swimmer wearing a life belt. Detail from MS B folio 81 verso. 23.5 × 17 cm. Institut de France, Paris.

102 (far left) Breathing tube for a diver, and a swimmer wearing a life belt. Detail from *Trattato dell'architettura*, by Francesco di Giorgio (1439–1502). MS Saluzzo 148 folio 66 verso. Royal Library, Turin.
(left) Breathing tube for a diver. Detail from *Codex Atlanticus* folio 386 recto b. 27.4 × 38.8 cm. Ambrosiana Library, Milan.
(centre) Breathing tube for a diver. Detail from *Codex Atlanticus* 346 verso a. 29.7 × 38.3 cm. Ambrosiana Library, Milan.
(right) Breathing tube for a diver. Detail from *Codex Arundel 263* folio 24 verso. 19 × 12.5 cm. British Museum, London. *Photo: Freeman.*

103 Leonardo's instructions for making a diving suit, and a method of boring a hole in an enemy ship. *Codex Atlanticus* folio 333 verso. 37.7 × 29.3 cm. Ambr. Libr., Milan.

104 Cross-section of the submarine *Turtle*, designed by David Bushell in 1776. The Mariners Museum, Newport News, Virginia.

106 (left) Fusees for extending the run of clockwork. Detail from MS B folio 50 verso. 23.5 × 17 cm. Institut de France, Paris.
(right) A turnspit operated by convection. Detail from *Codex Atlanticus* folio 5 verso a. 25 × 18.4 cm. Ambrosiana Library, Milan.

107 (left) Design for a car with rack and pinion steering. Detail from *Trattato dell'architettura*, by Francesco di Giorgio (1439–1502). MS Ashburnham 361 folio 47a. This manuscript was owned by Leonardo. Biblioteca Medicea-Laurenziana, Florence. *Photo: Sansoni.*
(right) A transmission unit for a wagon. Detail from *Codex Atlanticus* folio 4 verso a. 27 × 29.4 cm. Ambrosiana Library, Milan.

108 (left) Festival hats, drawn by Leonardo. *Codex Forster* III folio 9 recto. 9 × 6 cm. Photo by Derrick Witty from the facsimile 'I Codici Forster I–III nel Victoria and Albert Museum', published by the Reale Commissione Vinciana, La Libreria dello Stato, Rome, 1936–44.
(right) Costumes, drawn by Leonardo. *Codex Forster* III folio 9 verso. 9 × 6 cm. Photo by Derrick Witty from the facsimile in the Victoria and Albert Museum, London.

109 Costume for a masquerader on horseback. Windsor 12574. 24 × 15.2 cm. Royal Library, Windsor.

110 *The Lady with the Ermine*, a portrait of Cecilia Gallerani c. 1483, by Leonardo. 55 × 40.4 cm. Nat. Gall., Cracow.

112 (left) Head of a youth, probably Salai c. 1504. Windsor 12554. 21.7 × 15.3 cm. Royal Library, Windsor.
(right) Drawing of a young girl, by Giovanni Antonio Boltraffio (1476–1516). Ambrosiana Gallery, Milan.

113 Beatrice d'Este c. 1490, by Ambrogio de Predis (c. 1455–1508). 51 × 34 cm. Ambrosiana Gallery, Milan.

114 (left) Model of a spinning machine with a flyer spindle, made after a design by Leonardo. Sci. Mus., Milan.
(right) Leonardo's design for a spinning machine with a flyer spindle. Detail from *Codex Atlanticus* folio 393 verso a. 38.3 × 28.5 cm. Ambrosiana Library, Milan.

115 A needle-sharpening machine. Detail from *Codex Atlanticus* folio 31 verso a. 17.5 × 25 cm. Ambr. Libr., Milan.

122 (left) A teaseling machine. Detail from *Codex Atlanticus* folio 38 recto a. 24.4 × 37 cm. Ambr. Libr., Milan.
(right) A shearing machine. Detail from *Codex Atlanticus* folio 397 recto a. 28 × 40 cm. Ambrosiana Library, Milan.

123 A crane. Detail from *Codex Atlanticus* folio 37 verso b. 23.8 × 10.9 cm. Ambrosiana Library, Milan.

124 (left) Paddle boat, from *De machinis libri X*, by Taccola (d. before 1458). Detail from MS Lat. 7239 folio 87. Bibliothèque Nationale, Paris.
(right) Paddle boat, from *De Re Militari*, by Roberto Valturio (b. 1413). Detail from MS Lat. 7236 folio 170. Bibliothèque Nationale, Paris.

125 (above left) Paddle boats. Detail from *Trattato dell'architettura*, by Francesco di Giorgio (1439–1502). MS Ashburnham 361 folio 53 recto. Biblioteca Medicea-Laurenziana, Florence. *Photo: Sansoni.*
(right) Man rowing a paddle boat. Detail from MS B folio 83 recto. 23.5 × 17 cm. Institut de France, Paris.
(bottom left) Mechanism for a paddle boat. Detail from *Codex Atlanticus* folio 344 recto b. 24.9 × 18.8 cm. Ambrosiana Library, Milan.

126 (left) Furnace with six crucible pots. Detail from *Codex*

*Atlanticus* folio 32 recto a. 25.6 × 20.2 cm. Ambrosiana Library, Milan.
(right) Furnace with bellows operated by a water wheel, from *De machinis libri X*, by Taccola (d. before 1458). MS Lat. 7239 folio 47 verso. Bibliothèque Nationale, Paris.

127 Leonardo's version of the Archimedes Screw. Detail from *Codex Atlanticus* folio 7 verso a. 28.5 × 39.2 cm. Ambrosiana Library, Milan.

128 (left) Locks with vertical gates. Detail from *Trattato dell'architettura*, by Francesco di Giorgio (1439–1502). Codex Ashburnham 361 folio 41 a. Biblioteca Medicea-Laurenziana, Florence. *Photo: Sansoni.*
(right) Angled lock gates. Detail from *Codex Atlanticus* folio 7 verso b. 27.5 × 20 cm. Ambrosiana Library, Milan.

129 Canal with angled lock gates, from *Novo Teatro di Machine et Edificii*, by Vittorio Zonca (1568–1602), first published 1607. *Photo: Tony Birks.*

130 A dredger. Detail from MS E folio 75 verso. 15.4 × 9.3 cm. Institut de France, Paris.

131 Sketch of the River Adda near the 'Tre Corni' rocks. Windsor 12399. 10 × 14.7 cm. Royal Library, Windsor.

132 A hinged-link chain and a metal spring. Detail from *Codex Atlanticus* folio 357 recto a. 20.3 × 13 cm. Ambrosiana Library, Milan.

133 Conical pivot ball bearings. Detail from *Codex Madrid I*, folio 101 verso. 22.3 × 15.5 cm. Biblioteca Nacional, Madrid. *Photo: Life Magazine.*

136 (left) Various mechanisms, including a pair of mechanical clippers. Detail from a sheet in *Codex Madrid I*. 22.3 × 15.5 cm. Biblioteca Nacional, Madrid. *Photo: Life Magazine.*
(right) A piston pump driven by a water wheel, from *Le diverse et artificiose machine*, by Agostino Ramelli, 1588. *Photo: Science Museum, London.*

138 (above left) Grain mill with a mechanical bolter. Detail from *Codex Madrid I* folio 22 recto. 22.3 × 15.5 cm. Biblioteca Nacional, Madrid. *Photo: Life Magazine.*
(above right) Lens grinder. Detail from *Codex Atlanticus* folio 32 recto a. 25.6 × 20.2 cm. Ambr. Libr., Milan.
(below) Thread-cutting machine. Detail from MS B folio 70 verso. 23.5 × 17 cm. Institut de France, Paris.

140 Study of a rearing horse, for *The Battle of Anghiari*. Windsor 12336. 15.3 × 14.2 cm. Royal Library, Windsor.

142 (left) Sketches of standing horses. Windsor 12317. 20 × 28.4 cm. Royal Library, Windsor.
(right) Study of a horseman trampling a fallen foe, for the Sforza monument. Windsor 12358. 14.8 × 18.5 cm. Royal Library, Windsor.

143 Study of a horseman, probably for the Sforza monument, by Antonio Pollaiuolo (c. 1432–98). Staatliche Graphische Sammlung, Munich.

144 Detail from *The anatomy of a miser's heart*, by Donatello (1386–1466). Bas. di S. Antonio, Padua. *Photo: Alinari.*

147 Andreas Vesalius (1514–64). A woodcut portrait from his book *De Humani Corporis Fabrica*, Basle 1543. By courtesy of 'The Wellcome Trustees'.

148 Comparison of the bone structure and muscles in the legs of man and horse. Detail from Windsor 12625. 28.5 × 20.5 cm. Royal Library, Windsor.

149 Dedication page of *Somma di aritmetica, geometria, proporzioni, e proporzionalita*, by Luca Pacioli (1445–1514), Venice 1494. By courtesy of 'The Wellcome Trustees'.

150 (above) *The Last Supper*, by Leonardo. 420 × 910 cm. Santa Maria delle Grazie, Milan. *Photo: Mansell.*
(below left) Study for the head of the apostle Judas.

Windsor 12574. 18 × 15 cm. Royal Library, Windsor.
(below right) Study for the head of St James Major. Windsor 12552. 26.2 × 17.2 cm. Royal Library, Windsor.

152 Study of men working. Detail from MS B folio 51 verso. 23.5 × 17 cm. Institut de France, Paris.

153 (left) Detail from a study of warriors' heads, for *The Battle of Anghiari*. 19.2 × 18.8 cm. Fine Arts Mus., Budapest.
(right) Study of a warrior's head, for *The Battle of Anghiari*. 22.7 × 18.6 cm. Fine Arts Mus., Budapest.

154 Study of the proportions of a man's head, and horsemen for *The Battle of Anghiari*. 27.9 × 22.3 cm. Accademia, Venice. *Photo : Cameraphoto*.

155 Detail from a study of a battle scene, for *The Battle of Anghiari*. 14.5 × 15.2 cm. Accad. Venice. *Photo :* Mansell.

156 *The Battle of the Standard, c.* 1615, by Peter Paul Rubens (1577–1640). Cabinet des Dessins, Musée du Louvre.

157 (left) Venice. Woodcut from *Supplementum chronicarum*, by Jacobus Philippus Bergomensis (1434–1520), Venice 1491. By courtesy of 'The Wellcome Trustees'.
(right) Presumed portrait of Leonardo da Vinci *c.* 1499. Windsor 12726. 27.5 × 19 cm. Royal Library, Windsor.

159 Isabella d'Este *c.* 1500, by Leonardo. 63 × 46 cm. Musée du Louvre. *Photo: Archives Photographique des Musées Nationaux*.

161 Anatomical study of the muscles of the hand, arm and face. Detail from Windsor 19012 verso. 28.2 × 19.5 cm. Royal Library, Windsor.

162 Detail from the study of a woman's hands, probably made in connection with the portrait of Ginevra de' Benci. Windsor 12558. 21.5 × 15 cm. Royal Library, Windsor.

166 (left) A medieval dissection scene, from a fourteenth-century manuscript edition of *Chirurgia magna*, by Guy de Chauliac (1300–68). Montpellier Library, Montpellier. *Photo: O'Sughrue*.
(right) A 'zodiac' man, from *De omnibus humani corporis interioribus membris Anothomia*, by Mundinus (1275–1326), Strassburg 1513. By courtesy of 'The Wellcome Trustees'.

167 Title page from *Cibaldone ovvero opera utilissima a conservarsi sano*, by Rhazes (850–932), Brescia 1475. By courtesy of 'The Wellcome Trustees'.

168 (left) An illuminated page from a fourteenth-century manuscript edition of the *Canon Maior*, by Avicenna (980–1037). MS 2197 folio 492 r. Bibl. Univ. di Bologna.
(right) Print taken from the lacquer binding of a Persian manuscript edition of 1609, of the *Canon of medicine*, by Avicenna (980–1037). By courtesy of 'The Wellcome Trustees'.

169 Study of the shoulder and arm, and the head of an old man. Detail from Windsor 19005 recto. 28.2 × 19.5 cm. Royal Library, Windsor.

170 (left) Leonardo's drawing of the human skeleton. Detail from Windsor 19012 recto. 28.3 × 19.8 cm. Royal Library, Windsor.
(right) Human skeleton, from *Rerum medicarum libri quautor*, by Theodorus Priscianus (4th century), Strassburg 1532. By courtesy of 'The Wellcome Trustees'.

171 (left) Study of the right leg with the knee flexed. Detail from Windsor 19037. 19 × 13.3 cm. Roy. Libr., Windsor.
(right) Bones and muscles of the shoulder. Detail from Windsor 19001 recto. 28.2 × 19 cm. Roy. Libr., Windsor.

172 Leonardo's drawing of the double curve of the spine. Windsor 19007 verso. 28.2 × 20.5 cm. Roy. Libr., Windsor.

173 (left) The bones of the hand. Detail from Windsor 19009 verso. 28.3 × 19.9 cm. Royal Library, Windsor.

(right) The bones of the hand, from *De Humani Corporis Fabrica*, by Andreas Vesalius (1514–64), Basle 1543. *Photo : Freeman*.

175 (left) Position of the foetus in the uterus. Detail from Windsor 19101 recto. 30.1 × 21.7 cm. Roy. Libr., Windsor.
(right) An embryo in a uterus; the placenta is that of a cow. Detail from Windsor 19102 recto. 30.1 × 21.4 cm. Royal Library, Windsor.

176 Drawing of coition. Detail from Windsor 19097 verso. 27.3 × 20.2 cm. Royal Library, Windsor.

177 Dissection of the principal organs of a woman. Windsor 12281. 47 × 32.8 cm. Royal Library, Windsor.

178 Alimentary system, showing the liver, stomach and spleen. Detail from Windsor 19039 verso. 19 × 13.3 cm. Royal Library, Windsor.

180 (above left) Head of a man, showing the position of the ventricles, from *Philosophia naturalis*, by Albertus Magnus (1200–80), Basle 1506. By courtesy of 'The Wellcome Trustees'.
(above right) Drawings of the human skull. Detail from Windsor 19057 recto. 19 × 13.3 cm. Roy. Libr., Windsor.
(below) Ventricles in a human skull, and how to make a wax model of the ventricles using the brain of an ox. Detail from Windsor 19127 recto. 26.4 × 20.1 cm. Royal Library, Windsor.

182 (left) Studies made of an ox's heart. Windsor 19074 verso. 41 × 28 cm. Royal Library, Windsor.
(right) How to make a glass model of the aorta. Detail from Windsor 19082 recto. 28.3 × 20.7 cm. Royal Library, Windsor.

185 Marc Antonio della Torre (1473–1512). An engraved portrait from *Theatrum vivorum*, by P. Freher, Nuremburg 1688. By courtesy of 'The Wellcome Trustees'.

186 Reconstruction of a model from a Bauhaus project of Josef Albers, with Milan Cathedral in the background. *Photo: Roman Clemens*.

190 (left) Sketch for Florence Cathedral by Arnolfo di Cambio (*c.* 1232–1300) before 1296. Museo dell'Opera del Duomo, Florence.
(right) S. Francesco, Rimini, better known as the Tempio Malatestiana, designed by Leone Battista Alberti, and begun *c.* 1446. *Photo: Alinari*.

192 (left) Drawing for the dome of Milan Cathedral. Detail from *Codex Atlanticus* folio 310 verso b. 28 × 23.6 cm. Ambrosiana Library, Milan.
(right) Milan Cathedral showing the position of the 'tiburio'. *Photo: Alinari*.

194 Pavia. Woodcut from *Supplementum Chronicarum*, by Jacobus Philippus Bergomensis (1434–1520), Venice 1491. By courtesy of 'The Wellcome Trustees'.

195 Detail from a drawing of Santa Sophia, Constantinople, by Giuliano da Sangallo (1445–1516). Codex Barberini folio 28. Vatican Library, Rome.

196 Architectural drawings with Leonardo's notes in the margin, from *Trattato dell'architettura*, by Francesco di Giorgio (1439–1502). Codex Ashburnham 361 folio 13 b. Biblioteca Medicea-Laurenziana, Florence. *Photo: Sansoni*.

197 (left) Domed church ringed with chapels. Details from MS 2037 folio 5 verso. 23 × 16.5 cm. Inst. de France, Paris.
(right) Ground plan and elevation of a church based on the form of a Greek cross. Detail from MS B folio 24 recto. 23.5 × 17 cm. Institut de France, Paris.

199 Study of the strength of arches. *Codex Forster* II folio 92 recto. 9.9 × 7.2 cm. Photo by Derrick Witty from the facsimile in the Victoria and Albert Museum, London.

200 (left) Ground plans of a house for Charles d'Amboise. Detail from *Codex Atlanticus* folio 231 recto b. 27 × 29 cm. Ambrosiana Library, Milan.
(right) Charles d'Amboise, by Andrea del Gobbo called Solario (1458–1509). Musée du Louvre. *Photo: Giraudon.*

201 (left) Tiered circular chamber of a preaching theatre. Detail from MS B folio 5 recto. 23.5 × 17 cm. Institut de France, Paris.
(right) A church and preaching theatre. Detail from MS B folio 52 recto. 23.5 × 17 cm. Institut de France, Paris.

203 (above) A model of Leonardo's 'ideal city'. Science Museum, Milan.
(below left) Five staircases with five entrances. Detail from MS B folio 47 recto. 23.5 × 17 cm. Inst. de France, Paris.
(below right) A house with streets on different levels. Detail from MS B folio 16 recto. 23.5 × 17 cm. Institut de France, Paris.

212 Otto Lilienthal gliding from his 'flying hill' near Berlin-Lichterfelde, in 1894. *Photo: Deutsche Luftfahrt Sammlung, Museum der Weltluftfahrt, Berlin.*

213 Design for a semi-fixed-wing glider with the pilot suspended in a saddle. Detail from *Codex Atlanticus* folio 309 verso a. 20.5 × 28.5 cm. Ambrosiana Library, Milan.

214 Bird in flight. *Photo: Geoffrey Bridgett.*

215 (left) Flight of birds. Detail from MS E folio 22 verso. 15.4 × 9.3 cm. Institut de France, Paris.
(right) Flight of birds. Detail from Codex *Sul Volo* folio 8 recto. 21.3 × 15.4 cm. Roy. Libr., Turin. *Photo: Mansell.*

216 (left) Study of water flowing from a conduit. Detail from Windsor 12660 verso. 29 × 20.2 cm. Roy. Libr., Windsor.
(right) Vortices created by a wing tip in a simulated wind tunnel. *Photo: Royal Aircraft Establishment, Farnborough.*

217 (left) Eddy under a bird's wing. Detail from MS E folio 47 verso. 15.4 × 9.3 cm. Institut de France, Paris.
(right) Vortices created by a model of the Concorde in a wind tunnel. *Photo: British Aircraft Corporation, Filton.*

218 Study of the wings of a bat, a dragonfly, a flying fish and a butterfly. Detail from MS B folio (10) o verso. 23.5 × 17 cm. Institut de France, Paris.

220 (above) Bones of the human arm. Detail from Windsor 19000 verso. 28.5 × 19.7 cm. Royal Library, Windsor.
(below) Skeleton of a bird's wing. Detail from Windsor 12656. 22.5 × 20.5 cm. Royal Library, Windsor.

223 (left) Sketch-map of Europe. Detail from *Codex Atlanticus* folio 361 verso b. 28.6 × 20.1 cm. Ambr. Libr., Milan.
(right) Model of a pyramid-shaped parachute, made after a drawing by Leonardo. Science Museum, London.

224 Flying machine for prone pilot. Detail from MS B folio 74 verso. 23.5 × 17 cm. Institut de France, Paris.

225 (left) Flying machine for prone pilot, showing rudder tail. Detail from MS B folio 75 recto. 23.5 × 17 cm. Institut de France, Paris.
(right) Piloted ornithopter. Detail from MS B folio 79 recto. 23.5 × 17 cm. Institut de France, Paris.

226 Helicopter. Detail from MS B folio 83 verso. 23.5 × 17 cm. Institut de France, Paris.

227 (left) The Christ Child with a 'whirlibird' toy. Detail from a Medieval painting c. 1460. Musée du Mans, Le Mans.
(right) Model of a spring-driven helicopter, made after a drawing by Leonardo, MS B folio 83 verso. Science Museum, London.

228 A four-winged flying machine with a windlass to be operated by the pilot. Detail from MS B folio 77 verso. 23.5 × 17 cm. Institut de France, Paris.

229 Orville Wright piloting the first powered flight at Kitty Hawk, California, 17 December 1903. *Photo: Science Museum, London.*

230 Frontispiece woodcut from *Epytoma*, by Johann Müller called Regiomontanus (1436–76), Venice 1496. Victoria and Albert Museum, London.

232 (left) Albertus Magnus (c. 1200–80), by Justus van Ghent (b. 1410). Ducal Palace, Urbino. *Photo: Mella.*
(right) Diagram of the Earth, sun and planets, from *Philosophia Naturalis*, by Albertus Magnus, Basle 1506. By courtesy of 'The Wellcome Trustees'.

233 (left) The solar system, from *De Revolutionibus Orbium Coelestium*, by Nicholas Copernicus, 1530.
(right) Nicholas Copernicus (1473–1543). Attributed to the School of Holbein. Musée de l'Observatoire de Paris.

235 (left) Waters of the earth and moon. Detail from *Codex Arundel* 263 folio 104 recto. 19 × 12.5 cm. British Museum, London. *Photo: Freeman.*
(right) Reflections of sunlight on water. Detail from *Codex Atlanticus* folio 208 verso b. 26.2 × 20 cm. Ambrosiana Library, Milan.

237 View of Rome, from the *Nuremberg Chronicle*, by Schledel, 1493. British Museum, London. *Photo: Freeman.*

238 Woodcut of the sun in a chariot, from *Flores astrologiae*, by Albumasar Abalachi (d. AD 886), Augsburg 1488. By courtesy of 'The Wellcome Trustees'.

245 A study for the Deluge. Windsor 12380. 16.2 × 20.2 cm. Royal Library, Windsor.

246–7 A study for the Deluge. Windsor 12376. 27 × 40.8 cm. Royal Library, Windsor.

251 Study of rocks. Windsor 12397. 13.3 × 20.5 cm. Royal Library, Windsor.

256 (left) A basilisk. Woodcut from *The Florentine Fior di Virtu of 1491*. Facsimile edition translated into English by Nicholas Fersin, with original woodcuts, 1953.
(right) A dragon. Woodcut from *Quatriregio*, by Federico Frezzi, Florence 1508. *Photos: Tony Birks.*

257 Study of dragons. Detail from Windsor 12370. 15.9 × 24.3 cm. Royal Library, Windsor.

259 The knight, Meschino. Frontispiece woodcut from *Guerino dito Meschino*, by Andrea da Barberino, Venice 1508. *Photo: Tony Birks.*

263 Study of violas. Detail from MS B folio 14 recto. 23.5 × 17 cm. Institut de France, Paris.

264 (left) Arrangement of branches on trees. Detail from MS G folio 30 verso. 14 × 10 cm. Institut de France, Paris.
(right) Origin of leaves on plants. Detail from MS G folio 33 recto. 14 × 10 cm. Institut de France, Paris.

265 (left) A spray of blackberry bramble. Windsor 12425. 9 × 6 cm. Royal Library, Windsor.
(right) A study of two crabs, found on the verso of a study for the *Adoration of the Magi*, and attributed to Leonardo. 27 × 17.4 cm. Wallraf-Richartz Museum, Cologne. *Photo: Rheinisches Bildarchiv, Cologne Stadtmuseum.*

266 Star of Bethlehem, with the leaves of crowsfoot and wood anemone, and flowers of spurge. Windsor 12424. 19.8 × 15 cm. Royal Library, Windsor.

267 Snow-covered mountains. Windsor 12410. 10.5 × 16 cm. Royal Library, Windsor.

268 A map of Northern Italy. Windsor 12277. 31.7 × 44.9 cm. Royal Library, Windsor.

269 The château of Amboise. *Photo: Giraudon.*

270 Self-portrait by Leonardo c. 1512. 33.5 × 21.4 cm. Royal Library, Turin.

274 *Academia Leonardo Vici.* An engraving from a design by Leonardo. British Museum, London. *Photo: Freeman.*

276 Presumed portrait of Francesco Melzi, by Boltraffio (1467–1516). Gottfried Keller-Stiftung, Kunstmuseum, Bern.

# *Index*

288